Symposium: Chalcolithic Cyprus —————

Foreword

Articles published here comprise a combined volume of the *Bulletin of the American Schools of Oriental Research*, Numbers 282/283, May/August 1991. The papers will also appear in identical format but under a separate cover as a Getty Museum publication.

These articles originated as papers presented at the Getty Museum in February 1990 during a three-day symposium on Chalcolithic Cyprus. The event was a cooperative project of the Museum and the Department of Antiquities of the Republic of Cyprus.

The symposium and a concurrent exhibition of Chalcolithic material from the Cyprus Museum, *Cyprus Before the Bronze Age*, were first suggested by Dr. Vassos Karageorghis in 1987, while he was director of the Cyprus Department of Antiquities. Working together with Dr. Marion True, Curator of Antiquities at the Getty Museum, he proposed an international meeting of scholars to cover a wide range of topics on the material remains of Chalcolithic Cyprus and their interpretation. Sites such as the Vasilikos Valley and Kissonerga-Mosphilia, which are yielding important new information for prehistoric Cyprus, were presented by their excavators. Other papers examined the objects discovered in controlled excavations in an attempt better to understand the industries, social structures, and religious beliefs of Chalcolithic Cyprus. The topics ranged from stone tools to floral and faunal remains, and from metals and metallurgy to picrolite, a stone highly valued for sculpture and widely traded in the Chalcolithic period. Other papers looked more broadly at the art and artifacts of the period and at possible contacts between Cyprus, Anatolia, and other areas of the eastern Mediterranean. More was discussed and clarified about Chalcolithic Cyprus in those three days—thanks to the speakers as well as the other participants at the symposium—than is presented in the selection of papers published here. Excavations during the past few years on Cyprus have provided new material and have made important contributions to our understanding of the Chalcolithic period. The symposium provided an opportunity for archaeologists excavating on Cyprus, and many other scholars, to consider those finds and the questions they provoke.

We are grateful to each of the speakers of the symposium. We owe particular thanks to Marion True and Vassos Karageorghis for their inspiration and leadership. Thanks are due also to the staff of the Department of Antiquities of Cyprus, the staff of the Antiquities Department and Publications Department of the Getty Museum, and to James W. Flanagan and the editorial staff of the *Bulletin of the American Schools of Oriental Research*, who together made the exhibition, symposium, and publication possible.

John Walsh
Director
J. Paul Getty
 Museum

Athanasios Papa iou
 Di.. .tor
Department of Antiquities,
 Cyprus

Contents

The Vasilikos Valley and the Chalcolithic Period in Cyprus

IAN A. TODD

Kalavasos, Larnaca, Cyprus

Information concerning the Chalcolithic occupation of the Vasilikos valley has been derived principally from excavations at Kalavasos-Ayious and from the field survey of the valley. Limited data were also obtained by excavation at Kalavasos-Tenta. At Ayious no standing structures were found, only a series of pits of varied shapes, sizes, and purposes. The site probably represents a settlement of lightly built huts, most traces of which have been lost through erosion. A complex of pits and associated subterranean tunnels is of uncertain purpose. Small pits were also found in the Tenta excavations. The field survey revealed Early, Late, and probably Middle Chalcolithic sites in most of the valley. The density of settlements is not great, but uncertainty exists concerning the attribution of certain pottery types to a specific phase. The Chalcolithic occupation of the valley began as early as in western Cyprus, but the continuity of occupation throughout the period remains to be established.

INTRODUCTION

The significance of the Vasilikos valley for the study of the earlier prehistory of Cyprus has been apparent since Dikaios' small-scale pioneering excavations in the Kalavasos area in the 1940s. Excavations were undertaken at the two adjacent sites of Kalavasos-Kokkinoyia and Pamboules (Dikaios 1962: 106–12, 133–40) and at the nearby, predominantly Aceramic Neolithic site of Kalavasos-Tenta.[1] The existence of several other sites was also noted in the files of the Department of Antiquities of Cyprus at that time. Stanley Price visited the Kalavasos area sites during his research on the early prehistoric settlement of the island (Stanley Price 1979: 125–27), but it was not until 1976 that a long-term, multidisciplinary project was mounted in the Kalavasos area. The project began field operations in 1976, and has continued thus far over 14 summer seasons.

The aims and development of the Vasilikos Valley Project (hereafter V.V.P.) have been outlined previously (Todd 1987). The chronological scope of the fieldwork comprises all prehistoric phases. Excavations have so far been undertaken at the Aceramic Neolithic and Ceramic Neolithic/Early Chalcolithic site of Kalavasos-Tenta, at Early Chalcolithic Kalavasos-Ayious, at the Middle Bronze

Age cemetery within Kalavasos village (Todd 1986) and at the Late Bronze Age town site of Kalavasos-Ayios Dhimitrios (South 1988). There have also been several small rescue excavations. Excavations have also been started recently by an associated project directed by McClellan and Rautman at the Late Roman site of Kalavasos-Kopetra, south of Kalavasos. An archaeological field survey of the valley, utilizing a transect sampling procedure, has now been completed from the area of the Kalavasos copper mines north of the village down to the coast. The overall aim of the project was (and remains) the archaeological study of the Vasilikos valley as a whole in all its prehistoric phases. The chronological span of the field survey was extended through historic times until the present (Todd 1989). Complete surface collection of artifacts was also undertaken at several sites.

At the start of the present fieldwork program in 1976, knowledge of the Chalcolithic period in the Vasilikos valley was restricted to the enigmatic pits excavated by Dikaios at Kokkinoyia and Pamboules; these were published by Dikaios (1962) as Kalavasos Sites A and B. The pits were interpreted as pit-dwellings; those at Kokkinoyia were dated to the Ceramic Neolithic ("Neolithic II") and those at Pamboules to the Early Chalcolithic ("Chalcolithic I") (Dikaios 1962: 204, table). No standing

above-ground structures were known from Chalcolithic contexts in the valley, although Dikaios had earlier excavated such structures elsewhere at Erimi-Pamboules (Dikaios 1936). One of the aims of the present project was, therefore, to determine whether the pits did in fact serve as subterranean dwellings and whether or not above-ground structures existed in the valley in the Chalcolithic period.

Information pertaining to the nature of life in the Chalcolithic period in the Vasilikos valley has been derived in recent years from several sources. The small amount of excavated post-Aceramic Neolithic deposits at Tenta proved upon ceramic analysis to date mainly to the Early Chalcolithic period rather than the Ceramic Neolithic as previously thought; only the deposits in the lower levels of the small sounding in Square O 16 B can be attributed to the Ceramic Neolithic. The rescue excavations at Ayious have, however, yielded more knowledge of the earliest phase of the Chalcolithic in the valley. The later part of the Chalcolithic is not yet represented in any of the excavated sites. That occupation of the later phase exists in the valley is already clearly attested by the ceramic evidence recovered from the surface survey. On analogy with material from other regions of the island, some ceramic types can be attributed to the Late Chalcolithic with certainty, whereas the date of others can only be approximated. Some survey ceramics may also be attributed to a Middle Chalcolithic phase.

KALAVASOS-AYIOUS

The Site

Among the sites known to the project at the outset of the fieldwork was Kalavasos-Ayious. When first visited, the site consisted of a fairly flat-topped plateau on the east side of the valley due east of Tenta, which was then under excavation (Todd and Croft, in press). The plateau is limited on the west side by a steep, eroded slope down to the valley floor ca. 30 m below the top. To the south there is also a steep slope down to the gully that separates Ayious from Pamboules, through which runs the old Nicosia-Limassol road. North of the plateau, the ground gradually rises in the area of the Late Roman site of Kopetra, while to the east the terrain is mainly flat for a considerable distance. The site occupies a commanding position overlooking the valley.

The existence of a site at Ayious was first reported in the files of the Department of Antiquities of Cyprus in 1948 and 1949. Stanley Price visited it in 1972 (1979: 125–26); the staff of the V.V.P. examined it briefly in the summer of 1976 and provisionally dated it to the Chalcolithic (Todd 1977: 28). During the summer of 1978 a contour plan was made of the site, a grid of 10 m squares was established, and a surface collection of artifacts was made covering both the top of the site and the eroded western and southern slopes. Surface examination of the site indicated that excavation might well provide significant data pertinent to the solution of the problems posed by Dikaios' excavations at Kokkinoyia and Pamboules only a short distance south. Preliminary ceramic analysis of the surface pottery indicated that the closest affinities of the Ayious material were Chalcolithic (Kromholz 1981).

By the early autumn of 1978 it had become apparent that Ayious lay in the proposed line of the new Nicosia-Limassol highway; permission was therefore sought from the Department of Antiquities for two small soundings later in the autumn to ascertain the nature and condition of the extant remains. The results of the initial excavations were encouraging (Todd 1979: 278, 280–83); full-scale excavation of the site was begun the following summer, and continued sporadically throughout the winter and into the summer of 1980.[2]

The Excavations at Kalavasos-Ayious

Four separate areas were excavated in different parts of the quite flat top of the plateau (Todd and Croft, in press); the northwest, west central, and southwest areas were immediately adjacent to the slopes down to the valley floor on the west side, and the east-central area lay further east in the more central part of the plateau. No standing architecture was found anywhere on the site, but a considerable number of quite varied pits were found in the northwest and west central areas. Few features of any sort were found in the east central and southwest areas, but in the east central area deeper excavation might have revealed their presence.

In the northwest and the west central areas more than 100 pits of different forms and sizes were investigated (figs. 1, 2). The larger and deeper pits ranged from 1.50 m to 2.75 m in diameter, with a maximum depth of ca. 2.20 m. Their fill frequently

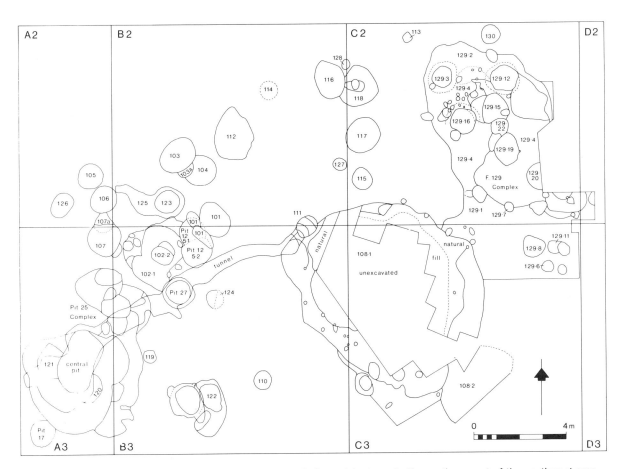

Fig. 1. Kalavasos-Ayious: general plan of the excavated pits and features in the northern part of the northwest area. Drawn by I. A. Todd from reductions of original plans by P. Croft.

contained varying quantities of lumps of pisé derived either from a collapsed roof or from the destruction of nearby structures. Compacted earth surfaces occurred in some pits; on several of those, clusters of ground stone artifacts, some complete pottery vessels, and quantities of sherds were found, implying use at least as short-lived activity surfaces. Small alcoves were found in the walls of several pits. Medium sized pits ca. 1.00 m in diameter and 0.30 m deep excavated in the same areas were extremely symmetrical. Frequently they were filled with tightly packed lumps of diabase and some ground stone artifacts in a matrix that often included ash. Little animal bone was found in those pits, but sizable quantities of sherds were always present, including both coarse and finer wares. Those pits were interspersed between the larger pits. Use of some of the medium sized pits as hearths or ovens was clearly indicated by the burn-

ing on their sides and bottoms, and by the quantities of fire-cracked stones found within them. Other pits containing ash and burnt material lacked positive evidence of burning *in situ*. Several bell-shaped pits were also found, the depth of which varied from less than 1.00 m to 2.20 m; they were notable for the regularity of their shape and their neatly cut concave sides. The size and shape of the bell-shaped pits have been compared to grain storage pits utilized in Cyprus until recent times. Throughout the site postholes and slightly larger pits occurred, but no consistent patterns of postholes were found surrounding the larger pits. Some slight depressions in the ground may have belonged to structures almost all traces of which had been erased; alternatively, they may represent areas from which raw material was obtained for making pisé.

In the northwest area, in addition to pits of the types already mentioned, three pits were found

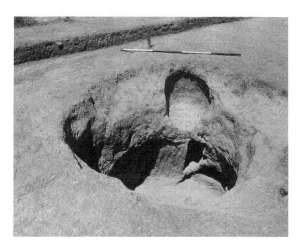

Fig. 2. Kalavasos-Ayious: the pit in Square C 11 C, Deposit 5.1 in the west central area, upon completion of the excavation, from the southeast. Photograph by I. A. Todd.

with interconnecting subterranean tunnels (fig. 3). A large, approximately circular pit (Pit 25), diameter ca. 2.75 m, was excavated to a depth of 1.95 m in the natural marl. Its sides were steeply cut back below the top. About 3.20 m northeast of it a small but deep shaft (Pit 27) had been cut to a depth of 1.95 m and had a small posthole at its center. The two pits were connected by a low, narrow tunnel, the maximum height of which is 1.10 m. A further tunnel was located, running in a generally northeasterly direction from the foot of the shaft to a small pit that formed the entrance to the complex (Feature 111). Four rough steps on the northeast side of Feature 111 led down to the tunnel entrance. Several distinct changes of angle occurred in the tunnel, and there was a porthole-like constriction in each stretch of tunnel, clearly designed to impede movement along the tunnels. Gypsum slabs seem to have been used to block the portholes when required. The fill of this complex of pits and tunnels contained domestic refuse including fragmentary ceramics, chipped stone tools, some ground stone artifacts, and a few ceramic figurine fragments. The complex is unique at Ayious, although it seems that a tunnel (Feature 125) was started from a chamber adjoining Feature 123; construction there was abandoned when unsuitable crumbly marl was encountered.

Other types of features also occurred in a few pits. Irregular rows of stake holes occasionally occurred in the side(s) of a pit, perhaps representing the location of small posts that may have formed

part of the roof or floor of a pit (e.g., in the pit in Square C 11 C, Deposit 5.1). Stone paving was found in Pit 27, probably from a reuse phase during which the pit was used for a purpose different from its original use. Within the pit in Square C 11 C, Deposit 5.1 a stone-lined pit (diameter 0.60 m, depth 0.30 m) approximately in the center of the main pit may have served as a support for roofing over the entire pit or for a ladder. The bottom of the stone-lined pit overlay a stone platform that may have served a similar purpose earlier. This stone platform was also large enough to have been a bench or a shelf. In the same pit several pisé features on the surface in Deposit 6.2 may also have been shelves or benches. A large pit lined with pisé was found adjacent to the stone-lined pit, occupying most of the southwest quadrant.

Only a very few human skeletal remains were uncovered by the Ayious excavations, and it is clear that the people who utilized the pits and other features were not buried in close association with them. No complete skeletons were found on the site, and none of the pits appear to have been designed for a funerary purpose. Skeletal remains included only the very incomplete, disturbed skeleton of a child (aged four to five years, sex unknown) in a shallow depression very close to the ground surface, two cranial fragments of an adult in a surface deposit, and some teeth of a child aged six years in a pit in the west central area. Since burials at other Chalcolithic Cypriot settlements were close to architectural remains, the lack of burials at Ayious may suggest that this was not primarily a domestic site. It is also possible that a cemetery exists in an unexcavated area of Ayious. Human skeletal remains also occurred only rarely in Dikaios' excavations at the nearby sites of Kokkinoyia and Pamboules (although his excavation areas were comparatively limited); none are reported from Kokkinoyia, and only one burial (age not stated), consisting of a very shallow pit dug in bedrock, was found at Pamboules (Dikaios 1961: 135).

Artifacts from Kalavasos-Ayious

Over 500 catalogued objects from Ayious provide considerable evidence concerning the activities of the site's inhabitants (South 1985; Todd and Croft, in press; A. K. South, personal communication). Unfortunately, most of the artifacts seem to have been discarded items included in deposits that filled the pits after their original use, so that the ob-

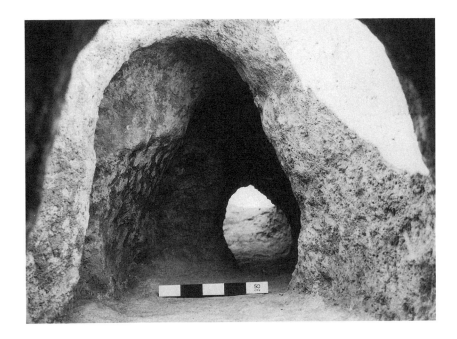

Fig. 3. Kalavasos-Ayious: tunnel between Pits 25 and 27, from inside the mouth of the tunnel leading northeast from Pit 27. Photograph by A. South.

jects contribute little to the interpretation of these features. Most of the usual Cypriot Chalcolithic types are represented, with the exception of a few (e.g., picrolite[3] figurines, conical stones, and bottle-shaped pestles), which may be confined to the later parts of the period.

Many ground stone artifacts were manufactured from igneous rocks available in the nearby Vasilikos river bed. The most numerous are axes, adzes, and chisels (fig. 4), which comprise about 20 percent of all objects, suggesting that woodworking may have been a major activity. Flaked tools (possibly scrapers) also occur. Pestles (usually conical), querns and rubbers, grinders, and pounders were also frequent. Stone vessels may be fairly clearly subdivided into relatively deep, curvilinear forms of both diabase and limestone and shallow, flat-bottomed, usually angular, limestone trays.

Smaller stone objects included a few pendants (most notably a rather large, mushroom-shaped picrolite example and a probably imported carnelian biconical type), and various discoid and biconical beads. Only seven picrolite objects (pendants and beads) were found, and no unworked pebbles of that material were discovered.

Bone objects were not well preserved; most are points and needles of varying thickness (some pierced), with one or two bone and antler beads. Dentalium shell was also used for beads and pen-

TABLE 1. Stone Artifacts at Kalavasos-Ayious*

Objects	Percentage
Axes, adzes, and chisels	25.4
Flaked tools (scrapers?)	2.2
Pestles	9.4
Vessels	11.0
Grinders	10.8
Querns and rubbers	16.8
Hammerstones	7.7
Stones with depressions	4.1
Pendants	1.6
Beads	3.3
Worked ochre pebbles	1.9
Miscellaneous	5.8

*Expressed as percentages of all stone objects found on the site.

dants. Ceramic sherds were fashioned into discs, and one small ceramic pendant perhaps imitates a fish.

Thirty-seven figurines and fragments were found (figs. 5–7), all ceramic except for one limestone piece. Only two small, crudely shaped figures with splayed bases and incised details are complete and another fragmentary example belongs to the same type. Although most of the rest are extremely fragmentary, it is clear that they represent a fair variety

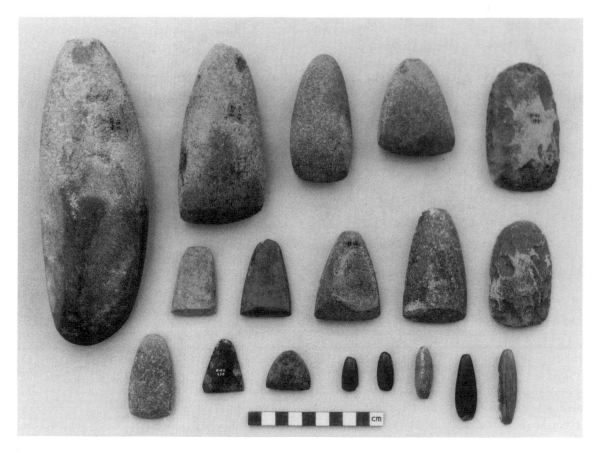

Fig. 4. Kalavasos-Ayious: stone axes, adzes, flaked tools, and chisels. Photograph by A. South.

of sizes and types; where the sex is apparent it is always female. Some belong to a simple type with the body, head, and limbs all in the same plane, while some large limb fragments may belong to three dimensional types. Most are solid, but one fragment appears to include part of the legs of a very large seated figure, and six smaller fragments probably also came from hollow figurines. The few surviving heads are tilted back and show the eyes and nose in a stylized, emphatic manner; one has holes presumably for the attachment of hair. Many of the fragments are unpainted, but several have painted red decoration of lines and lattices.

The great majority of the figurine fragments were found in the northwest area of the site, the largest number in the pit and tunnel complex (Pit 25); several were found in various nearby large pits. The fragments were found mainly in fills that accumulated after the original use of the pits, and there is probably no functional connection between the figurines and the pits in which they were found. The concentration of figurines in this part of the site may be due simply to the fact that discarded figurine fragments were derived from nearby structures or areas. The remarkably fragmentary nature of the material (while the fragments themselves are in quite good condition) might suggest deliberate breakage, but there is no positive evidence of that. The situation of the Ayious figurines contrasts strongly with the careful treatment and probable religious function of the Kissonerga-Mosphilia cache (Peltenburg *et al.* 1988), yet it may logically be another aspect of the same behavior pattern. Perhaps figurines could not be disrespectfully disposed of in the Ayious manner unless they were "deactivated," deliberately or accidentally. Although the state of the Ayious figurines is uninspiring, it is clear that a considerable number and variety of ceramic figures were used, and presumably manufactured, in that part of the island.

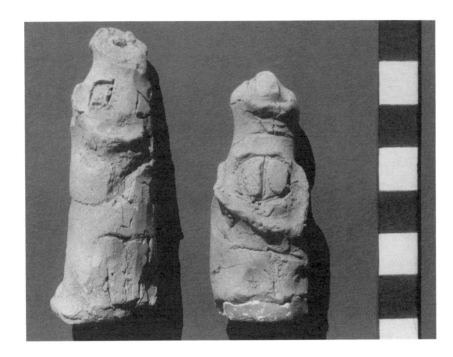

Fig. 5. Kalavasos-Ayious:
ceramic figurines K-Ay 285
and 284. Photograph by
A. South.

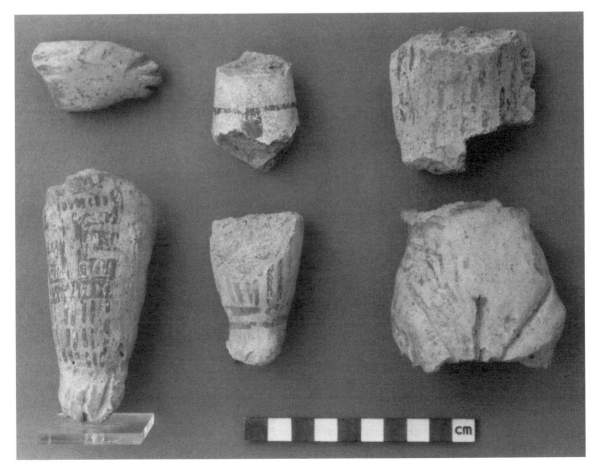

Fig. 6. Kalavasos-Ayious: ceramic figurine fragments. Photograph by A. South.

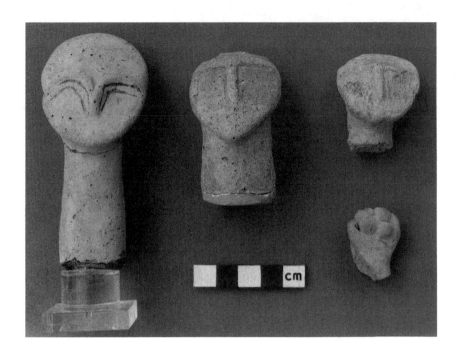

Fig. 7. Kalavasos-Ayious:
ceramic figurine fragments.
Photograph by A. South.

INTERPRETATION OF THE SITE AT AYIOUS

It is most likely that the Ayious site represents a settlement of lightly built huts, most traces of which have been lost through erosion and plowing. Some of the pits may have been dug originally for the extraction of raw material (possibly for building), but in their excavated form they are interpreted as hearths, storage facilities, and possibly as occasional domestic work areas. There is little to recommend the deeper pits as the lower parts of long-term pit-dwellings, nor is there significant evidence that they served a specialized industrial or manufacturing purpose. The reasons for the cutting of the tunnels in the northwest area remain unknown; while the tunnels do provide a sheltered means of communication between Pits 25 and 27 and Feature 111, movement along them would have been difficult; it also seems unlikely that they were places of refuge, being themselves inherently dangerous and liable to collapse. The fill of the tunnels contained comparatively few artifacts, and was not indicative of any special purpose.

Analyses of the artifacts and organic remains derived from the Ayious excavations have failed to provide conclusive evidence concerning the nature of the site, although several possible pointers have been isolated. Study of the animal bones revealed little indication of significant spatial variability in the distribution of faunal remains on the site; deer form the predominant species (70.1 per cent) and caprines, pig, dog, and fox occur in much smaller numbers (Croft in Todd and Croft, in press). Analysis of the chipped stone industry revealed equally little evidence of variability (Betts in Todd and Croft, in press). In both cases, however, the lack of variation could be ascribed to the comparative paucity of data, which may in turn have obscured meaningful patterning. The predominance of burins and the small number of sickle blades at Ayious provide a contrast to the industries of the Chalcolithic sites in western Cyprus, but the evidence of the burins does not help to determine the nature of the site since the burins' purpose is unclear. The ceramics excavated in the various features provide valuable evidence for chronological seriation but little information on the purpose of individual features. No clear evidence was found for ceramic manufacture on the site. The botanical remains also proved of little value in determining the pits' purpose. Despite extensive flotation of deposits, the botanical yield at Ayious was generally meager. Domesticated barley and emmer wheat are represented, as are mallow, oats, lentils, and small seeded wild grasses. No intrasite variation was detected, and even comparison with the botani-

cal remains from the Tenta excavations did not reveal significant evidence of change (Hansen in Todd and Croft, in press).

Based on the evidence of four credible radiocarbon dates (BM-1832R 5040 ± 110 BP; BM-1833R 5000 ± 170; BM-1834R 5030 ±120; BM-1836R 4700 ±310),[4] the archaeological deposits at Ayious date to several centuries before the middle of the fourth millennium B.C., in the gap suggested by Peltenburg between the Sotira and Erimi groups of sites. The site postdates the Ceramic Neolithic settlements such as Sotira-Teppes, Ayios Epiktitos-Vrysi, Philia-Drakos A, and the poorly represented Ceramic Neolithic phase at Kalavasos-Tenta; it is a little earlier than Kissonerga-Mylouthkia and probably the earliest phase at Erimi-Pamboules. It is approximately contemporary with the Chalcolithic component of Maa-Palaeokastro and it predates the main part of the Erimi settlement and sites such as Lemba-Lakkous and Kissonerga-Mosphilia. Such a chronological position is borne out by Baird's analysis of the ceramics, which demonstrates connections with Sotira-Teppes, Ayios Epiktitos-Vrysi, Kissonerga-Mylouthkia, and Maa-Palaeokastro, among other sites (Baird in Todd and Croft, in press).

Scattered parallels exist within Cyprus for the various types of subterranean or semisubterranean features at Ayious. The closest parallels are found at Kalavasos-Kokkinoyia and Pamboules (which may represent a southward continuation of the Ayious site), although no tunnels were found there. The tunnels at Ayious are, however, very similar to features found (in a probably earlier context) at Philia-Drakos A west of Nicosia, in association with above-ground settlement architecture (Watkins 1969). The numerous artifacts, many in unused condition, found in the Philia features differentiate their fill from the material within the tunnels at Ayious, which was water-laid and which contained comparatively few artifacts. The purpose of the features of Philia is unknown, and comparison does not help to determine the reasons for the cutting of the tunnels at Ayious.

The lack of extant evidence of standing structures, in conjunction with a large area honeycombed by pits, is paralleled at Kissonerga-Mylouthkia (Peltenburg 1982a: 56–66), and it is clearly significant that no solid architectural remains were found at either site. However, the pit typology at the two sites varies considerably. At least some of the Mylouthkia pits seem to have been dumps since they lack the evidence of activity surfaces found in the larger pits at Ayious. Artifactual parallels (ceramics, human figurines, etc.) also indicate connections between the Kalavasos and Kissonerga sites, but the two are by no means identical. Other parallels for the Ayious features exist at Maa-Palaeokastro (within the area of the Late Bronze Age settlement) (Thomas in Karageorghis and Demas 1988, chapter V, part 1) and in the earliest phase at Erimi-Pamboules (Dikaios 1936), but the available information does not suggest a detailed comparison with Ayious. While ceramic parallels exist between Ayious and Ayios Epiktitos-Vrysi on the north coast (Peltenburg 1982b), the large hollows at the latter site do not offer a close comparison to the Ayious features.

EXCAVATIONS AT KALAVASOS-TENTA

Excavations in various areas on the lower slopes of Kalavasos-Tenta revealed strata dating to the Ceramic Neolithic and Early Chalcolithic phases, predominantly to the latter (Todd 1987: 166–72). No architectural remains were found in any of those levels, but the areas of excavation were limited, and the possibility of architecture at Tenta in the post-Aceramic Neolithic phase must remain open.

In the excavation in Squares K/L 6/7 at Tenta a series of pits was encountered, mostly cut into the natural terrace calcarenites; they were ca. 0.60 m to ca. 2.00 m in diameter and ca. 0.20 m to ca. 0.55 m in depth. Ceramics and other artifacts were found in the fill of some of the pits, and ashy deposits indicate that several of the smaller pits had been used as hearths. No pits resembling the largest ones at Ayious were found. Several surfaces that could be interpreted as floor levels were found in one pit (Square K 7 B, Deposits 3.1–3.3). No evidence was found for Neolithic/Chalcolithic structures of any type in that part of the site. It is uncertain how the lower flanks of Tenta were used in the post-Aceramic Neolithic phase.

Based on the ceramic analyses, Baird has suggested that the bulk of the Tenta ceramic material dates later than Ayious Phase 1 and earlier than Ayious Phase 2 (Baird in Todd and Croft, in press). He infers from his ceramic seriation a relatively complex settlement pattern, and suggests that there might be a gap in the occupation of

Ayious between Phases 1 and 2, during which Tenta was occupied. The available evidence supports the idea of occupation or utilization of both sides of the valley in the Tenta-Ayious area in the Early Chalcolithic, probably with short occupations in different places.

FIELD SURVEY

The field survey of the Vasilikos valley was designed to provide information about sites of all periods from which the settlement system might be reconstructed (see Todd 1989 for the most recent report). While it was hoped at first that complete coverage of the valley could be achieved, the initial reconnaissance survey soon indicated that the density of sites was such that some form of sampling procedure had to be adopted. It was also apparent that certain types of small sites were missing. A system based on 100 m wide transects was, therefore, established with a distance of 400 m separating the south side of one transect from the north side of the next transect to the south. The transects were aligned east-west across the valley and its side drainages, crosscutting the major environmental zones. Nineteen transects were surveyed, beginning at the coast and stretching as far north as the Kalavasos Dam and the copper mines. The areas surveyed ranged in length from less than 1.5 km to more than 4.5 km. Twenty percent of the valley was covered by the transects, and additional areas of side drainages were selected to ensure that these were not underrepresented in the overall results. A total coverage of at least 30 percent was thus achieved. Despite the lack of total coverage of the valley, the picture provided by the survey should be essentially accurate and fairly comprehensive.

Information pertinent to the Chalcolithic occupation of the valley consists mainly of ceramics. The typology of the earliest Chalcolithic phase is well known, mainly from the Ayious excavations; but the later Chalcolithic phases present much more uncertainty because remains of that period have not yet been excavated in the valley. Some parallels may be expected with the Late Chalcolithic and initial Early Bronze Age material published by Dikaios from sites in the north and northwestern parts of the island (Dikaios 1962: 141–76); but, as Peltenburg points out, the nature of Dikaios' ceramic seriation does not inspire confidence (Peltenburg 1982a: 92–93), and it cannot

be used as a firm guide to what might be anticipated in the Vasilikos valley. Parallels also exist with the ceramics recently excavated in the Lemba/Kissonerga area by Peltenburg. However, the marked regional variation within Cyprus has become more apparent in recent years in various prehistoric phases, and the extent to which the Vasilikos valley Chalcolithic ceramics differ from those of other regions remains to be established. Regional variation aside, Peltenburg has recognized Red and Black Stroke Burnished sherds of Paphos type and other Late Chalcolithic wares among the Vasilikos valley material; and it is likely that the ceramic typology formulated as a result of the excavations at Lemba-Lakkous (Peltenburg 1985), Kissonerga-Mylouthkia (Peltenburg 1982a), and Kissonerga-Mosphilia (Peltenburg 1989) for western Cyprus will most closely resemble the Vasilikos valley sequence.

The Late Chalcolithic in the valley is clearly marked in ceramic terms by predominantly monochrome wares as in the west and elsewhere, but the nature of Middle Chalcolithic ceramics remains to be established. Comparison with the Mosphilia ceramics also suggests that a continued and extensive use of Red-on-White ware may be expected, but this remains to be confirmed. In the Vasilikos valley sherds of a thick and heavy monochrome burnished ware, often somewhat purple to brown, have been found on a number of sites. No complete profiles have been found, but an open bowl shape seems to predominate. The general resemblance of the ware to the Neolithic to Early Chalcolithic types suggests an early date, whereas the monochrome surface foreshadows the monochrome wares of the Late Chalcolithic. A chronologically intermediate date is possible.

The nature of the end of the Late Chalcolithic occupation of both the sites in the west and those the Vasilikos valley also seems problematic. Peltenburg notes that there is very little Philia-type ceramic material in the west, and that at Kissonerga-Mosphilia the occupation following the Chalcolithic dates to the Middle Cypriot period (Peltenburg 1982a: 99). No Philia types have yet been recognized in the Vasilikos valley, and no pottery can be ascribed with certainty to the Early Bronze Age.

Until very recently, when the main part of the field survey was completed, emphasis was placed on fieldwork rather than artifactual analyses because of the rapid alteration or destruction of the landscape through Land Consolidation and other

agencies. Terracing, consolidation of plots, construction of new access roads, and laying of irrigation pipes have all become very frequent since the completion of the Kalavasos Dam in 1985, and disturbance of archaeological sites (or at least of areas where there are surface sherds) has been widespread. It was thus essential to gather the field data as quickly as possible before they were destroyed. Much of the ceramic material recovered from the surface of the various sites surveyed, therefore, still awaits detailed examination and recording; allocation of sites to the Chalcolithic period or to a specific phase of that period rests on brief initial examination of the sherds and must be confirmed by future, more detailed inspection. Large quantities of Late Chalcolithic monochrome wares (together with earlier Chalcolithic painted sherds) have only been found at Kalavasos-Pamboules (Dikaios' Kalavasos Site B); at other sites only a few have been recognized. The date of much of the Pamboules material was only recognized comparatively recently, and there has not been sufficient time to reexamine sherds from other sites to look for the less diagnostic parallels. A further problem encountered in the dating of some earlier Chalcolithic sherds is the sometimes very abraded condition of the material, and, at worst, sherds can only be generally labeled "Neolithic/Chalcolithic."

If consideration is limited to sherds that can be assigned to a definite phase of the Chalcolithic, only six sites can be ascribed to the Early Chalcolithic (Kalavasos-Ayious [13],[5] Kafkalia VI [124], Pamboules [60], Spilios [70], Tenta [71], and Mari-Moutsounin/Mandra tou Rirou [88]). The most northerly site is Spilios,[6] on the west side of the valley north of Kalavasos village and only a short distance south of the Kalavasos mines. The other five sites are all clustered close to—and most are adjacent to and overlooking—the point at which the east–west route followed by the old Nicosia–Limassol road crossed the Vasilikos river. Early Chalcolithic sherds have been found on the heights on all four "corners" overlooking that junction, and the distribution pattern can scarcely be considered coincidental. It may also be significant that no Early Chalcolithic material was found near the coast, although occupation during the Aceramic and Ceramic Neolithic and the Late Chalcolithic phases is attested at Mari-Mesovouni [87], south of Mari village.

If fine monochrome wares such as Red-and-Black Lustrous indicate Late Chalcolithic utiliza-

tion of a site, five sites in the Vasilikos valley area can be attributed to this phase: Asgata-Neron tou Phani [109], Kalavasos-Arkhangelos [8], Melisotriba East [114], Pamboules [60], and probably Tokhni-Latomaes [99]. Asgata-Neron tou Phani marks the present northern limit (on the west side of the valley west of Spilios), and Pamboules marks the southern limit.

There remains the problem of the chronological placement of the heavy monochrome burnished sherds mentioned above. The sites on which they occur are more numerous than those of either the Early or Late Chalcolithic phases, and only at Melisotriba East and perhaps Tokhni-Latomaes do they occur in conjunction with indubitably Late Chalcolithic fine monochrome sherds. That may indicate that the heavy monochrome sherds predate the Late Chalcolithic, and even a Neolithic date cannot be ruled out. The heavy monochrome wares occur on sites as far north as Mazeri [57] on the east side of the valley and Spilios on the west. Toward the south they are probably represented at Mari-Mesovouni [87], although the poor condition of the ceramics from that site does not facilitate identification. A striking feature of the distribution of sherds of that type is their occurrence on the tops of major hills south of Kalavasos on the east side of the valley (e.g., at Ipsopamboulos [21], Kambanaris [28], and Tokhni-Latomaes [99]); but it may be premature to speculate on political conditions based on such evidence. The distribution of Early Chalcolithic, Late Chalcolithic and heavy monochrome wares is shown with differing symbols in fig. 8.

CONCLUSIONS AND FUTURE RESEARCH

The excavations at Kalavasos-Tenta and Ayious and the field survey of the Vasilikos valley from the mines to the coast, have considerably clarified certain facets of the Chalcolithic period; others remain to be addressed by future fieldwork. It presently seems that the Chalcolithic occupation began as early in the valley as it did in the west, and perhaps in similar form. Solid-standing architectural remains are lacking at Kalavasos-Ayious and at Kissonerga-Mylouthkia in the earliest Chalcolithic phase; at both sites the excavated features comprise a variety of pits, the nature of which varies from site to site. That villages of substantial huts with stone foundations developed soon thereafter is shown by the excavations at Kissonerga-Mosphilia,

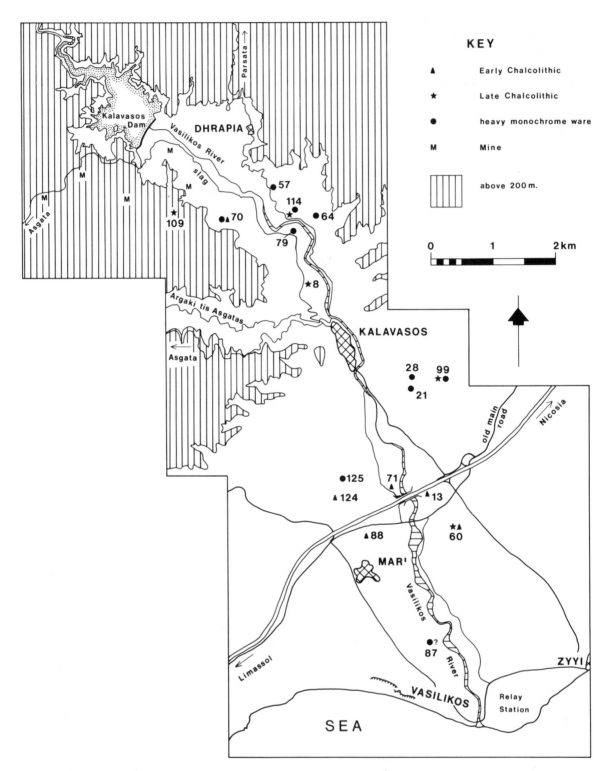

Fig. 8. Location of Chalcolithic sites in the Vasilikos valley. Drawn by I. A. Todd.
Key to sites: **8**. Arkhangelos; **13**. Ayious; **21**. Ipsopamboulos; **28**. Kambanaris; **57**. Mazeri; **60**. Pamboules; **64**. Potima II; **70**. Spilios; **71**. Tenta; **79**. Yirtomylos; **87**. Mari-Mesovouni; **88**. Mari-Moutsounin/Mandra tou Rirou; **99**. Tokhni-Latomaes; **109**. Asgata-Neron tou Phani; **114**. Melisotriba East; **124**. Kafkalia VI; **125**. Argakia East.

but further excavation will be required in the Vasilikos valley to show whether the same development occurred there. While the Middle Chalcolithic phase is now represented at Kissonerga-Mosphilia, it is less clear in the Kalavasos area. The Late Chalcolithic is, however, attested on a number of sites in the latter area, although occupation does not seem to have been particularly dense. The quantities of Late Chalcolithic sherds on the surface of the Pamboules locality are far greater than on any other site in the valley known so far, and it has also become apparent that Kokkinoyia and Pamboules represent two separate but adjacent sites, the former mainly utilized in the Ceramic Neolithic phase while the latter was used in the earlier (including Middle?) and Late Chalcolithic phases. The nature of the transition to the Bronze Age anywhere in the valley has not yet been determined.

The first major task for future fieldwork pertaining to the Chalcolithic settlement of the Kalavasos area should be to establish whether there was a full architectural development sequence, at least through the Late Chalcolithic, as there was in the Lemba/Kissonerga region. Excavations at Pamboules should help to determine that, since at least the Early and Late Chalcolithic phases seem well represented there. However, no evidence of architecture has yet been found at Pamboules other than the "houses" published by Dikaios, and no substantial stone walls or wall footings have come to light despite the additional disturbance of parts of the site in recent years.

The second major task is to determine the nature of events at the end of the Late Chalcolithic and whether there is any evidence in the valley for settlement in the succeeding Early Bronze Age. Excavations at Pamboules might help here, too; but clear Early Bronze Age sherds are totally lacking on the site. Philia-type pottery has not been found in the Vasilikos valley, but it seems possible that the Late Chalcolithic-type wares may have continued at least into the Early Bronze Age (Herscher 1980: 18), thus masking a transition marked by clear ceramic change in some other parts of the island. Excavation of a major Middle Bronze Age settlement in the Kalavasos area might also indicate that some of the Red Polished pottery types are of greater antiquity than is currently thought.

Accomplishment of those two tasks will be a priority upon completion of the present excavations at the Late Bronze Age site of Ayios Dhimitrios. The past 12 years of fieldwork have greatly clarified the nature of the prehistoric settlement of the Vasilikos valley, but solution of these important Chalcolithic problems will occupy many further seasons.

ACKNOWLEDGMENTS

I am most grateful to V. Karageorghis, then Director of the Department of Antiquities, for his initial suggestion of Kalavasos as a possible area for fieldwork. My thanks are also due to E. J. Peltenburg for his examination of selected sherds from the Vasilikos valley sites and for his comments concerning similarities with wares found in the west.

NOTES

[1] No full report was ever published about the Tenta excavations, but the site is mentioned briefly by Dikaios in his Khirokitia volume (1953) and in the *Swedish Cyprus Expedition* Vol. IV Part 1A.

[2] The summer season of excavation in 1979 was directed by A. Kingsnorth and all operations thereafter were supervised by P. Croft.

[3] The soft blue-gray stone usually referred to as "antigorite" in previous V.V.P. publications is here termed "picrolite" to facilitate comparison with other studies in this issue.

[4] The dates were initially published in Todd 1982: 9; the revised dates published here were provided by S.G.E. Bowman of the British Museum (personal communication, 26 April 1988).

[5] Numbers in brackets refer to the official V.V.P. site numbers, which will be used in the final publication of the survey.

[6] Localities cited without the prefixed village name lie in the village lands of Kalavasos.

BIBLIOGRAPHY

Dikaios, P.
1936 The Excavations at Erimi, 1933–1935. *Report of the Department of Antiquities of Cyprus*: 1–81.
1953 *Khirokitia*. London: Oxford University.
1962 The Stone Age. Pp. 1–204 in *The Swedish Cyprus Expedition IV.1A*. Lund: Swedish Cyprus Expedition.

Herscher, E.
1980 Southern Cyprus and the Disappearing Early Bronze Age. *Report of the Department of Antiquities of Cyprus*: 17–21.

Karageorghis, V., and Demas, M.
1988 *Excavations at Maa-Palaeokastro 1979–1986*. Nicosia: Nicolaou.

Kromholz, S.
1981 A Preliminary Report on the Earlier Prehistoric Ceramics of the Vasilikos Valley. Pp. 17–55 in *Studies in Cypriote Archaeology*, eds. J. C. Biers and D. Soren. Los Angeles: UCLA Institute of Archaeology.

Peltenburg, E. J.
1982a *Recent Developments in the Later Prehistory of Cyprus*. Studies in Mediterranean Archaeology, Pocket-book 16. Göteborg: Åström.
1982b *Vrysi: A Subterranean Settlement in Cyprus*, Warminster: Aris and Phillips.
1985 *Lemba Archaeological Project Vol. I: Excavations at Lemba Lakkous, 1976–1983*, Studies in Mediterranean Archaeology 70:1. Göteborg: Åström.
1989 Lemba Archaeological Project Cyprus, 1987. *Levant* 21: 195–97.

Peltenburg, E. J., *et al.*
1988 Kissonerga-Mosphilia 1987: Ritual Deposit, Unit 1015. *Report of the Department of Antiquities of Cyprus*: 43–52.

South, A. K.
1985 Figurines and Other Objects from Kalavasos-Ayious. *Levant* 17, 65–79.
1988 Kalavasos-*Ayios Dhimitrios* 1987: An Important Ceramic Group from Building X. *Report of the Department of Antiquities of Cyprus*. Part 1: 223–28.

Stanley Price, N. P.
1979 *Early Prehistoric Settlement in Cyprus 6500–3000 B.C.* BAR International Series 65. Oxford: British Archaeological Reports.

Todd, I. A.
1977 Vasilikos Valley Project: First Preliminary Report, 1976. *Report of the Department of Antiquities of Cyprus*, 5–32.
1979 Vasilikos Valley Project: Third Preliminary Report, 1978. *Journal of Field Archaeology* 6: 265–300.
1982 Radiocarbon Dates for Kalavasos-Tenta and Kalavasos-Ayious. *Report of the Department of Antiquities of Cyprus*: 8–11.
1986 *Vasilikos Valley Project 1: The Bronze Age Cemetery in Kalavasos Village*. Studies in Mediterranean Archaeology, ed. I. A. Todd. Göteborg: Åström.
1987 *Vasilikos Valley Project 6: Excavations at Kalavasos-Tenta* I. Studies in Mediterranean Archaeology 76:1. Göteborg: Åström.
1989 The 1988 Field Survey in the Vasilikos Valley. *Report of the Department of Antiquities of Cyprus*: 41–50.

Todd, I. A., and Croft, P.
In Press *Vasilikos Valley Project 8: Excavations at Kalavasos-Ayious*. Göteborg: Åström.

Watkins, T.
1969 The First Village Settlements. *Archaeologia Viva* 3: 29–38.

Kissonerga-Mosphilia: A Major Chalcolithic Site in Cyprus

EDGAR PELTENBURG
Department of Archaeology
University of Edinburgh
19 George Square
Edinburgh, U.K. EH8 9JZ

Calibrated radiometric dates have shown that the Chalcolithic period in Cyprus lasted from about 3800 to 2300 B.C., much longer than Dikaios (1962) and others thought was the case. Although copper was first exploited then, a dynamic new art style was created, and transmaritime exchanges were initiated, no work has been carried out on a major site of the period since Dikaios' 1933–1935 sounding at Erimi. To remedy this obvious shortfall, the Lemba Archaeological Project has conducted excavations since 1983 at Kissonerga-Mosphilia, the largest prehistoric site in western Cyprus. This article is a descriptive account of some preliminary results that, when analysis of retrieved material is complete, will add significantly to our understanding of the late fifth to third millennia B.C. in the eastern Mediterranean basin.

INTRODUCTION

In studies on the evolution of complex societies, much attention has been devoted to the view that population growth itself inevitably led to cultural change, which in turn triggered profound transformations in the organization of egalitarian and ranked societies. More emphasis is currently given to the interactions among several variables, especially sociopolitical mechanisms, to explain that evolution (see, e.g., Earle 1984; Upham 1990). A major research theme of the prehistory of Cyprus is the explanation of causes for the persistence of small-scale societies, long after adjacent regions—Egypt, the Levant, Anatolia, and Crete—had crossed the threshold to "complexity." As Upham and others have shown (Upham 1990), "middle range" political systems had powerful mechanisms to defend equality, yet many of the systems possessed settlement-size hierarchies. It is the contention here that it was in the largest of those that pressures for change resulting in the breakdown of kin-based control systems were keenest.

Prior to the development of pristine civilization in Mesopotamia there occurred sites that were far larger than their neighbors and yet they lacked features typical of complex societies. These and other precocious Near Eastern sites include Çatal Hüyük, Abu Hureyra, ᶜAin Ghazal (see Redman 1978; Rollefson *et al.* 1985; Moore 1988: 3–12) and, in Cyprus, Khirokitia (Le Brun *et al.* 1987: 282–316). All were densely crowded with dwellings and hence social relations in those outsized centers probably differed over time from those in smaller, more ephemeral communities. Direct evidence for this differentiation is clear from the finer quality of artifacts, for example, from the large sites. We may also infer differences on the basis of economic patterns. Thus, larger agricultural settlements need more land to support inhabitants and that leads to increasing distances to cultivated plots (Gamble 1982: 161–71). The resulting increase in labor costs are likely to foster changes in the economy of garden agriculture settlements where pack and draft animals were unknown, and economy cannot be divorced from other aspects of society. While in general the communities discussed here may have remained small-scale societies, the exceptionally large population centers merit special attention in considering trajectories toward complexity, since inherent stimuli leading to change in the preexisting social and economic structures are more likely to have emerged there.

Similar site hierarchies also existed in Chalcolithic Cyprus, *ca.* 3800–2300 B.C. While most surveyed sites of the period hardly attain 3 ha, a few

17

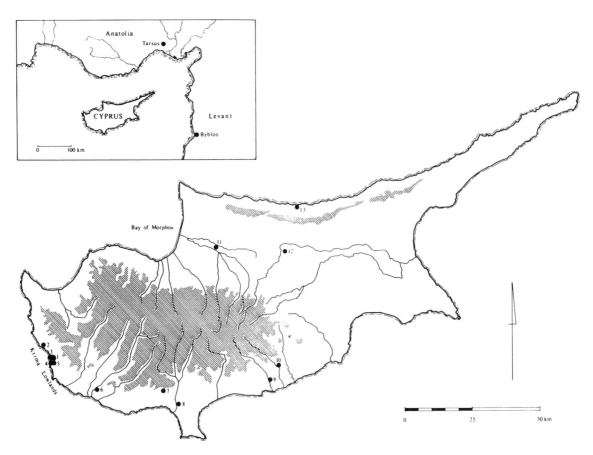

Fig. 1. Location map of some Neolithic, Chalcolithic, and Early Bronze Age sites in Cyprus and on the adjacent mainland. 1. Kissonerga-Mosphilia; 2. Maa-Palaeokastro; 3. Kissonerga-Mylouthkia; 4. Khlorakas-Palloura; 5. Lemba-Lakkous; 6. Souskiou-Vathyrkakas; 7. Sotira-Teppes; 8. Erimi; 9. Kalavassos-Ayious; 10. Khirokitia-Vouni; 12. Nicosia-Ayia Paraskevi; 13. Philia-Vasiliko; 13. Ayios Epiktitos-Vrysi.

extend over much larger areas. For instance, Erimi-Pamboula is 15 ha and Kissonerga-Mosphilia 12 ha (Swiny 1989: 16). Erimi has yielded a wealth of material (Dikaios 1936; Bolger 1988), which may be contrasted with the smaller amount of data recovered from excavations of comparable size at other Chalcolithic sites. The contrasts may also be expressed in terms of population if one accepts Renfrew's (1972: 251) figure of 200 inhabitants per hectare in lowland Mediterranean agricultural sites. That figure, however, must be treated with caution, at least in the Cypriot context. Lemba (see fig. 1 for the location of this and other Cypriot sites mentioned here) had dispersed buildings and hence a low occupation density. Of a total exposure of 612 m^2 in Area II, only a little over 250 m^2 comprised roofed dwellings (Peltenburg *et al.* 1985a: 327, fig. 6:6). As much as 40 percent might have

been occupied, for an estimated population of 240. However, even that may be an inflated number, since only part of the site was occupied contemporaneously. Kissonerga on the other hand was densely inhabited, especially in the Late Chalcolithic period; and on the above criteria, with a load factor of about 40 percent occupation, the population may have been nearly one thousand. These crude estimates suggest that there are appreciable population differences among Chalcolithic settlements. The estimates also have implications for social organization, since cross-cultural comparisons indicate that although communities exceeding 500 might still be considered villages, they nonetheless require authoritative officials (Trigger 1978: 156).

In addition to spatial, demographic, and probably social parameters, Erimi and Kissonerga are distinguished by their longevity. Most pre-Bronze

Age Cypriot sites are single-period settlements, and no other prehistoric site in the west has such a long sequence of occupation as Kissonerga. Size and duration could, of course, be interdependent if each occupation phase is accretive onto rather than superimposed over earlier deposits. Stratigraphic evidence from the site, however, reveals a great deal of superimposition; hence, settlement drift alone cannot account for its large size.

In spite of the exceptional character of these outsized sites, Erimi was only briefly sounded in the 1930s and no other work was carried out on a major Chalcolithic site in the ensuing decades. When Kissonerga was threatened by agriculture, the Lemba Archaeological Project undertook excavations there as part of its multisite excavation and survey program, to decode the qualitative differences that both caused and sustained the unusual status of exceptionally large Mediterranean settlements.[1]

THE SITE OF KISSONERGA-MOSPHILIA

Kissonerga is located on gently sloping terrain north of the Skotinis River, about 1 km from the coast in the southwestern corner of Cyprus (fig. 1). It is part of a cluster of several Ktima Lowland sites that belong to the same period, and so this region was relatively well populated during the Chalcolithic. Kissonerga, however, is much larger than the other sites by a factor of two or four. Mylouthkia is about 6 ha, and Lemba and Khlorakas about 3 ha each. This size hierarchy remains to be characterized since there is evidence from Mylouthkia, which comprises dispersed pits, that not all sites were equally densely populated or contemporaneously occupied.

The site was recently deeply terraced to provide flat, extended plots for agricultural development. As a result of that land consolidation, parallel strips of later deposits at the inner, upslope margins of the terraces are missing. The severe disturbance of the site is further exacerbated by plowing, so all late deposits are poorly preserved. Visible on the terraces and in terrace faces prior to excavation were circular stone buildings, walls up to ten courses high, floors with carbonized deposits, stamped and pebbled flooring, burnt, square-sectioned pits, and deep hollows. Finds were prolific, especially in the ashy fields nearest the Skotinis River where excavations have been concentrated (see Peltenburg *et al.*

1984: 59, fig. 2). Most of the site is now planted with banana trees.

Presentation in this article of material according to period without an initial description by levels, strata or floors needs comment since it cuts across accepted convention in Cypriot archaeology. To take but one example, at Sotira-Teppes, Dikaios (1961: 205–9) went to great lengths to establish the existence of levels across the whole site and through them to determine building phases. Groups of associated levels thus comprise periods. In favorable circumstances, as when radically different building materials are used sequentially or when paved roads link discrete building quarters, it may be possible to discern periods on the basis of stratigraphy alone, but for most prehistoric settlements that is a forlorn exercise. Decayed building materials, which constitute the matrix in which human activity is encapsulated, are seldom regularly differentiated by color or texture in succeeding phases. Nor is there often a uniform, neat build-up of decay between structures, as was the case at Ayios Epiktitos-Vrysi (Peltenburg 1982a). Recycling and erosion destroy such certainties in stratigraphic paradigms, even if one assumes regular and constant rebuilding of all structural units. In settlements comprised of dispersed buildings and graves, intervening deposits are the key to relationships between structures, but unless paved, those essential links are usually destroyed by human interference, and especially by erosion. The latter is a major postdepositional constraint at Kissonerga since precipitation in Cyprus frequently descends in torrents that annually degrade the stratigraphy of its typically sloped and shallowly stratified sites.

To overcome the characteristic discontinuities and to ascertain the chronology of Kissonerga, it has been necessary to isolate vertical sets of occupation depositions, to apply a matrix form of analysis and sometimes to extrapolate from the ceramic record. This procedure allows a fine-grained, intraperiod division of occupational episodes that need not be of concern for this article except to note that virtually every period consists of multiple activity phases. Five "periods" can thus be discerned by the above criteria in a coarse temporal division of occupation at Kissonerga.

Radiocarbon dates and artifactual correlations indicate that, quite exceptionally for Cyprus, occupation extended from the Late Neolithic period to the start of the Bronze Age, from about 4500 to

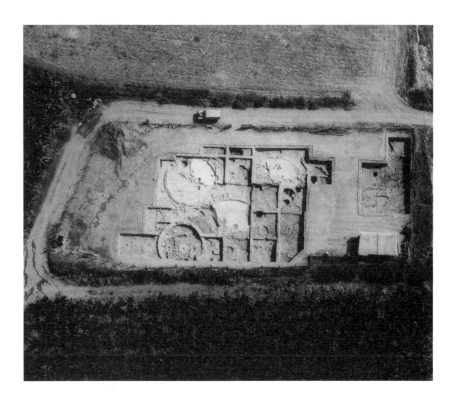

Fig. 2. Aerial view of excavations at Kissonerga-Mosphilia 1986 (Courtesy RAF Akrotiri).

2300 B.C. That occupation probably was not continuous in the main area of our excavations (fig. 2), but interruptions there do not necessarily imply that the site as a whole was subject to cycles of habitation and complete abandonment. To test the representative nature of evidence from the main exposure, monitor trenches were placed in terraces to the east. Although limited in scope, they demonstrate the existence of other types of activities and probable intermediate phases of settlement. While intrasite drift means that Kissonerga could have been continually inhabited, much more extensive excavation is required to resolve whether that was actually so. Detailed as it is, therefore, the project's record cannot yet answer with certainty questions of continuity and variety of occupation. In spite of such critical shortcomings, the evidence from Kissonerga is the most comprehensive from a Chalcolithic site in Cyprus, revealing many of the formative changes between the Neolithic/Chalcolithic and the Chalcolithic/Bronze Age periods, innovating achievements of the Erimi culture, and foreign contacts at a site of unprecedented longevity. A successor was established later in the Bronze Age on the south side of the Skotinis River (Philip 1983).

PERIOD 1

Evidence for the earliest settlement at Kissonerga survives as unabraded Combed and Red-on-White pottery, occasionally in sealed deposits (e.g., Peltenburg *et al.* 1979: pl. 9D; 1980: 8–10, figs. 2. 1, 2, 4, 8; 3. 15, 16). The former continues into the Early Chalcolithic at Ayios Epiktitos-Vrysi, Erimi, Kalavassos-Ayious, Maa-Palaeokastro, and Kissonerga-Mylouthkia, although in much smaller quantities than at Kissonerga-Mosphilia (for those sites, see Peltenburg 1990). The latter belongs to the Late Neolithic Broad Line Style (Peltenburg 1982b: 44–46), which can be differentiated from the patterned styles that occur at sites just mentioned, as well as later ones. Hence it seems likely that the first occupation of Kissonerga took place in the Late Neolithic period. Structures of some kind are indirectly attested by lumps of pisé associated with the pottery, but *in situ* deposits are needed to characterize the nature and extent of settlement here in the later fifth millennium B.C. These are the first excavated Late Neolithic deposits in the west of the island and, as in Cyprus in general, they show no cultural connections with the much earlier Aceramic Neolithic culture, which also reached the west (Fox 1988).

PERIOD 2

Trial trenches below Period 3 deposits at the seaward edge of the main excavation area disclosed a number of pits cut into wash lenses. The pits varied in type, but all contained exclusively Early Chalcolithic pottery like that from Kissonerga-Mylouthkia, Maa-Palaeokastro, Kalavassos-Ayious, and Ayios Epiktitos-Vrysi Late Phase (Bolger 1988: 293). The pits were cut from levels at the base and at the top of the inwash, decisive evidence that erosion took place during the period. It seems that a break in scarp existed at the western edge of the site and that during the earlier fourth millennium B.C. active erosion gradually swept deposits from the upper terrace into the declivity. If that reconstruction of events is correct, the inhabitants either did not attempt, or were unsuccessful in designing, countermeasures. There may have been no pressing need to do so, of course, if they only used the site during the summer when there was minimal rainfall.

Evidence for other Early Chalcolithic activities at Kissonerga was located in monitor trenches about 100 m east. They were densely pitted extramural areas. Among the pits were specially constructed burial slots that consist of oblong cuts for the reception of single inhumations covered by stone slabs, in the manner well known at nearby Lemba (Peltenburg et al. 1985a: 241–45). One, Grave 554, deserves special comment since below and at right angles to the covering slabs lay another slab roughly carved in human form (fig. 3). Both the position of the stone over the body and its coarsely-worked shape are highly unusual. Also remarkable was the inclusion of malachite in a bivalve shell at the feet of the inhumation. Very few Early Chalcolithic burials are known, so it is not possible to state if the funerary rites seen here were normal. The malachite is one of the first instances of the use of copper on Cyprus. It could have been procured from a local copper source; analytical results are pending. In Mesopotamian and Egyptian burials where there are similar instances of colorful minerals in shells, they are usually interpreted as cosmetics and toilet articles (see Peltenburg et al. 1989: 29–30 for fuller discussion).[2]

It is clear even from the fragmentary data that Kissonerga was used for funerary and daily life purposes during the Early Chalcolithic period. As at other contemporaneous sites (cf. Todd 1981: 57–68), erosion proceeded unchecked and hence little

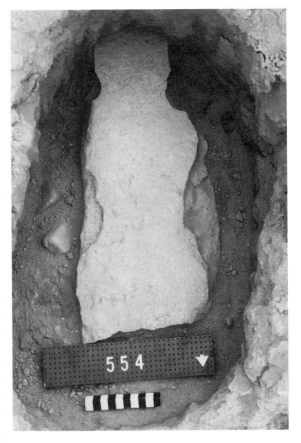

Fig. 3. Pit Grave 554, Period 2; the anthropomorphic slab rests over the single inhumation.

is left on the old, deflated ground surface. Stone-based structures at prehistoric sites in similar topographies survive moderately well, so it seems reasonable to suggest that structures at that time were more prone to erosion, were probably built of less weather-resistant materials, and may not have been maintained for permanent occupation. The evolution of building materials at Lemba and Erimi, from pisé and wood to more durable walls with stone foundations, also points to the existence of less permanent structures (see Peltenburg et al. 1985a: 314–28, with references). Early Chalcolithic Kissonerga thus probably once comprised a settlement with upstanding buildings.

PERIOD 3 (fig. 4)

At some stage during the Middle Chalcolithic a contiguous group of some of the largest buildings of prehistoric Cyprus, divided by a paved track

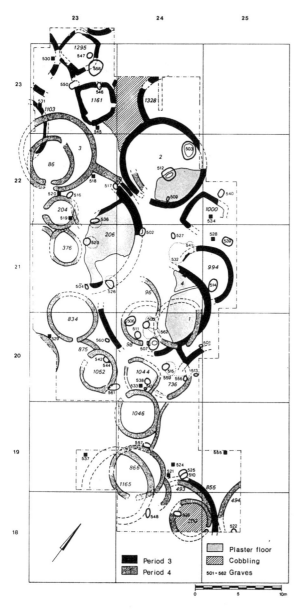

Fig. 4. General plan (1989) of Periods 3 and 4.

site of Lemba, the same Black Topped pottery is found well preserved in Period 1 deposits and it is succeeded by Red-on-White in Period 2 (Peltenburg *et al.* 1985a: 12–15). The Lemba sequence therefore suggests that intervening occupation exists elsewhere at Kissonerga, between excavated remains of Period 2, which lacks Black Topped pottery, and Period 3. Whether that occupation fills the gap between Periods 2 and 3 depends on the chronological span of Black Topped pottery, but that chronology is not yet known. In any case, it appears that the excavated sample of Kissonerga is not entirely representative of developments on the site as a whole.

The second factor, stratigraphy, concerns the relationship of small, rectilinear and curvilinear structures to the large circular buildings at the north of the excavation area. They are separated by a north–south paved track or road, at least 15 m long. The road, which was constructed at the time of the large buildings, blocked an entrance to small Building 1161, hence the latter and adjacent insubstantial structures went out of use some time before the installation of the spacious circular buildings. There are thus two Middle Chalcolithic phases at Kissonerga.

Cross-dating suggests that the scanty traces of the early Period 3 occupation are contemporary with Lemba Period 1 and the earlier levels at Erimi. However, none of those sites explains the origins of the imposing new buildings subsequently established at Kissonerga. With internal areas of 77 m^2 or more, they are the largest in prehistoric Cyprus and they required sophisticated engineering skills. They were carefully situated not to interfere with neighbors and they were abandoned before many alterations could be carried out. There was thus a concerted and relatively short-lived move into that part of the site.

The outsized circular buildings possess many features that distinguish them from most other Chalcolithic buildings: diameters in excess of 8.5 m; accurately positioned, low wall foundations incorporating calcarenite blocks; and hard, lime-plastered floors for a prestigious room to the east of the entrance (fig. 5). The room was separated from the rest of the interior by radial partition walls (now robbed) and in one case at least—Building 206—it had red painted floors and walls. Where they survive in tolerably good shape, central hearths were rectangular, an unusual form in Late Neolithic and Chalcolithic Cyprus.

from relatively insubstantial huts, was founded on the terrace, which had been denuded of Early Chalcolithic occupation. An interval of unknown length occurred between Periods 2 and 3 as they are represented in the main area of excavation. Two types of evidence bear on the issue of discontinuity: the representative nature of the sample and the stratigraphy.

In Period 3, Black Topped pottery occurs in highly fragmentary form together with high proportions of Red-on-White pottery. At the nearby

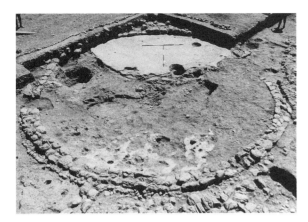

Fig. 5. Building 2, Period 3, with 2 m scales in the paved eastern room.

Some of the round structures retained restorable vessels on their floors, showing that impoverished compositions of Period 2 Red-on-White were replaced by imaginatively articulated designs of the Close Line Style. Many bear linear patterns such as latticed squares dependent from rim and base, or curvilinear designs that introduce tension and motion into an otherwise static repertoire (see Bolger, this issue pp. 81–93). Storage vessels, the first *pithoi* in Cyprus, were kept in the buildings and some were also boldly painted, unlike their plain, utilitarian successors. Other pottery may have possessed applied decoration since one Red-on-White figurine (Peltenburg 1987: 223, fig. 2) is clearly broken away from a larger object. In contrast, the small earlier buildings nearby only possessed plain pottery. So, there is evidence for significant changes in ceramic as well as architectural products during Period 3.

The rectilinear structures vary in size and fittings. Thus the interior of one, Building 1161 (4.5 × 5 m), was mainly occupied by an oven placed in such a way that when the building's door was opened, it would have struck the oven. The latter may have been a secondary feature in a building riddled with animal disturbance. An adjacent example was also poorly kept, unlike the impressive circular structures. It had a conventional circular platform hearth, which occurs both in preceding Late Neolithic and succeeding Late Chalcolithic habitations. The dissimilarities between the small, rectilinear structures indicate that they were not all made for the same purpose, nor were they all found to one side of the road. A fragmentary example was

located among the large circular buildings; but, unlike others of its type, it was neatly constructed, like the adjacent buildings. That some were overtly utilitarian and required less labor to fashion is clear, and one at least would seem to be a dwelling. So striking are the architectural contrasts that social and functional differences may be inferred within Middle Chalcolithic Kissonerga. That diversity means that it is difficult to assess the architectural "norm" for the period, although structures elsewhere indicate that examples like Building 206 are outsized and that Kissonerga possesses a group of exceptional, sophisticated structures.

Other noteworthy features of Period 3 are several kinds of pits. One is for single inhumations, although there are so few of these that some of the dead must have been buried elsewhere. Small pits were designed to receive infants, some of whom wore necklaces of a few beads and pendants. Assuming that pit size corresponds to size of the deceased, an exceptional adult grave was cut through Building 2. There was no body in its disturbed shaft, and the capstone had been thrown back into the pit so that it no longer rested as normal on the ledge above. That was not the action of grave robbers since two splendid Red-on-White flasks and a fine stone bowl were set along the ledge, presumably as post-capping offerings (Peltenburg *et al.* 1985b: 55, fig. 2). That the only possible adult burial of the period should be disturbed may mean that it was an unconventional grave and that adults normally were buried outside the area of excavation.

Other pits ultimately were used to receive domestic rubbish. One was filled largely with the stone lids of pottery *pithoi*, neatly carved and polished mushroom-shaped limestones with diameters up to 30 cm.

Hemispherical pits dug outside buildings for getting rid of burnt materials contained fire-cracked stones and ash, unlikely debris from the clean hearths inside the circular buildings. The numerous stones could conceivably be pot-boilers from vats set over the hearths or from other, outdoor, activities. There is little in the pits to indicate other than domestic discards, but two neatly cut pits, 1015 and 1225, are decidedly extraordinary.[3]

Hoards, Public Ceremony, and Discontinuity

Below the floor of Building 994, Chalcolithic people cut a 1 × 1.5 × 0.36 m pit, Unit 1015, and

deposited in it a startling array of burnt and broken objects. Its contents may be divided into two groups: heat-fractured stones, ground stone tools, some stained with red ochre, organic remains, and some sherds that filled most of the pit; and against its south wall, a stack of pottery vessels with, in and around the lowest, a total of 41 figurines and other objects (see Goring, this issue pp. 153–61, fig. 1). Within the stack, the upper painted bowl was upright and intact, part of its rim projecting at the floor level of the building. Beside and below it were two inverted bowl halves. At the bottom was another upright bowl packed with stone and pottery figurines, a large triton shell, a four-legged model stool, a pierced terracotta cone, pestles, pounders, rubbing stones, a polisher, a flint blade, and pebbles. Wedged upright around its base or laid on their sides were more figurines. Nowhere in the deposit was there evidence for a burial, so this is evidently the rarest of Chalcolithic assemblages, a nonmortuary hoard in which highly unusual objects were taken out of circulation, not stored temporarily.

Of the ten stone figures, six were inside, four outside the lowest bowl. The anthropomorphic ones resemble the popular cruciforms only to the extent that their arms are outstretched. Blue-green picrolite, the stone *par excellence* for Chalcolithic cruciform pendant figures, is completely lacking in the assemblage, so personal adornments were apparently excluded. The preferred stone for figures of this deposit was a type of limestone. At the simplest, it was carved to produce plain, schematic figures, symmetrically balanced like a "gingerbread man." More complex types are still not very elaborate, but they do indicate the sex of the figures. One is rendered standing with flat breasts, wide hips that extend in a "bustle" around the back, and short legs with feet demarcated by an incision. Less easily identified images include an elongated pebble with a stem-like terminal set obliquely to the body. Viewed from the side it appears like a recumbent animal with its haunches perfunctorily indicated. From above, however, it could be interpreted as a reclining human figure with its legs divided by a single groove as in other representations (cf. Swiny and Swiny 1983: 56–59). All are unsuitable as pendants, ideal as hand held objects.

The pottery figures are much more varied than the stone ones. Six were placed inside, three outside the bowl. All except one are female, an uneven proportion of sexual types that recurs in one of the

Souskiou tombs (cf. Christou 1989). The single male figure is in fact a cylindrical vessel with a boldly modeled face below the rim. Its conical eyes and pouting, serrated lips are encircled by red bands with a pendant (labret?) dangling below the lips. It is uncertain if there were enormous ears and arms since the broken stubs may also be restored as two vertical handles, like the handles of a *depas*. One of the females, a matronly figure with arms raised to the shoulders, is also hollow and presumably served as a vessel (see Goring, this issue pp. 153–61, fig. 5). One leg is placed slightly in front of the other to achieve stability. The figure has small breasts, a ridge-like fold along the stomach and another around the hips and back. Elaborate painted designs suggest that it was heavily tatooed or wore trousers. Head and neck are missing. The unusual position of the arms corresponds in general to that of a seated male in the Pierides collection in Larnaca (Karageorghis 1985: 46–47). Its provenance, from Souskiou or the Balkans, is disputed and so the undoubted Cypriot Chalcolithic context of the Kissonerga parallel strengthens the case for a Cypriot origin for the Pierides male.

Of the remaining painted figures, one is a mutilated vessel; one is a standing cylinder; two are small and worn with wide, flat bases; and three, though fragmentary, are so similar that they can be restored as tall females with cylindrical necks and bodies and outstretched arms. Unlike all the others, these are seated on four-legged circular stools and are in the act of giving birth (see Goring, this issue pp. 153–61, figs. 2, 3). Here, then, is explicit evidence that concepts of fertility, indeed parturition and life itself, motivated the creation of the figures.

All the pottery and most of the stone figures were in a fragmentary condition when they were deposited in the pit. That this was not solely due to normal wear is indicated by the fresh breaks (see Goring, this issue, pp. 153–61), the position of some of the breaks, and by the state of the lowest bowl. Quite unlike any other known Chalcolithic bowl, this one depicts a building with entrance, detachable door, bracket and pivot in which the door rotated, central hearth, and floor ridges (fig. 6). Its walls are painted with bizarre designs including squares arranged as steps with strokes set obliquely at their corners, other squares set on series of tangential bands, a line with attached blobs and a vertical with zigzag fringes like a pole with streamers. None of the elaborate interior decoration was visible at the time of discovery. It, together with

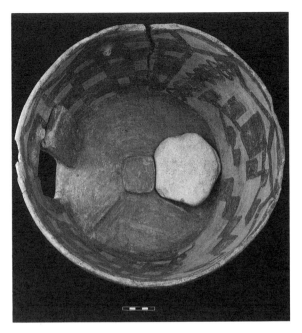

Fig. 6. Red-on-White pottery vessel in the shape of a building with detachable door, central hearth, radial floor dividers, and stone platform. This comes from Period 3.

the red-framed doorway, was coated with an un-fired buff slip of uniform thickness that concealed the patterns. The slip also covered the broken stubs of nine protomes that had been deliberately detached from their position above the entrance. Other projections, such as the wall bracket, door tenon, and internal features had also been snapped away. The whole building model therefore had been intentionally defaced and its presumably symbolic internal decoration hidden. That corresponds to the mutilated state of many other objects in the deposit. Either before or during the fire rites that accompanied the deposit, the participants in the ritual made a concerted effort to desanctify, or "kill" many figurative components of the hoard.

Excavation has shown that the model is no mere fantasy but one based on a specific building type. The vast majority of Chalcolithic structures are circular and many retain the door pivot on the inside of the entrance exactly as portrayed in fig. 6. What they normally lack are square hearths and the low radial floor ridges of the model. Those have been found in only three contemporary structures at Kissonerga (see Peltenburg 1989: 111, fig. 15.1d for an example). In Period 3 the large circular buildings have radial walls instead of ridges, and those define elaborately paved floors that are al-

ways situated in the east quadrant of the building. It could also be argued that the Lady of Lemba (Peltenburg *et al.* 1985a: frontispiece and fig. 11) comes from such a special room and that there is thus some evidence that those eastern rooms played an important role in settlements. Whatever that function, it is at least clear that the bowl is a realistic building model of a type of structure that is atypical within Late Neolithic-Late Chalcolithic architectural traditions.

The deposits were discovered beneath Building 994, the last structure belonging to Period 3 within our exposure of the settlement. There followed a stage when that area was given over to quarrying, burials, and—to the south—possible building. Later, construction of buildings resumed on a more general pattern. In all the first post-Period 3 units, the pottery is radically different from earlier finds; it is characterized by dominant proportions of the new Red and Black Stroke Burnished ware. Building types have also changed, though the circular plan remains ubiquitous. In at least one instance a Period 4 building was placed directly on the wall stubs of a Period 3 building, but that is no guarantee of continuity. The marked alterations in pottery and architectural styles suggest an occupation interval of unknown duration, perhaps as long as a few centuries, after Period 3.

These considerations of relative chronology demonstrate that Unit 1015 occurred at a critical juncture within the history of Kissonerga. According to available evidence the hoard was buried some little time before the inhabitants abandoned at least that part of the settlement, if not the whole of it. In that sense we may speak of the hoard with its attendant rites as a closure ceremony, the public deposition and "deconsecration" of important symbolic items before the community vacated the area. That it was a peaceful episode is suggested by the fact that there was no violent destruction either in the out-sized buildings or in the relatively empty Building 994. Yet the final burial of so many overtly symbolic objects, surely a communal rather than a domestic act, must have been traumatic because of its rarity and because it effectively brought to an end those practices previously connected with the objects. There is no evidence for continued production of those types of objects later.

The conclusion that Units 1015 and 1225, the latter comprised of a nest of bowls surrounded by numerous heat-cracked stones in a pit, are the result of a closure or departure ceremony is at odds

with most interpretations of hoards. Such hoards normally are regarded as caches hidden in times of trouble and not recovered in antiquity, or as foundation deposits. But there are no signs of danger and both of the units discussed here are associated with an extramural group of firepits that lie well beyond the later Building 994. That its builders and occupants were nonetheless aware of the underlying deposits is evident from the manner in which the wall base touches but does not break the nested pots of Unit 1225 and the way in which part of the rim of the uppermost bowl in Unit 1015 projected through the floor of the building. The delicate rim must have been treated with care since it is in excellent condition. In this case, stratigraphic proximity at least implies respect for earlier deposits. The deposits therefore may well have involved the closure of earlier buildings together with the foundation of a new structure. The one need not preclude the other. Unfortunately, little survives of the new Building 994 to indicate its function.

It is clear from these aspects of Units 1015 and 1225 that rare items were deliberately deposited. Such ritual activity has been conspicuously absent from the nonfunerary archaeological record of prehistoric Cyprus and it requires reassessment of the islanders' socioreligious organization. The goods were intentionally and permanently taken out of circulation, not merely stored for subsequent retrieval. Given the timing and formalities of the deposits, there are implications for the nature of settlement drift that is such a pervasive characteristic of Cypriot prehistory.

This is the earliest hoard of figurines and building model from Cyprus. Although general parallels for such deposits may be found in other regions, such as Syro-Palestine, Greece, and the Balkans, there is no convincing argument for a foreign inspiration for the figurines, model, or deposition custom. Such arguments are unconvincing because of chronological difficulties, major stylistic differences, and the absence of evidence for significant long distance trade in late fourth millennium B.C. Cyprus. All components of the hoards are local products. The style of the figurines can be traced back to the formative Early Chalcolithic period, a time when many changes occurred in Cyprus without foreign involvement. It might also be argued that the unique character of those deposits implies an intrusive custom; but current studies are based on only minimum exposures of settlements and cemeteries of the Chalcolithic period, which lasted some 1500 years. The origins of the practice are to be found in the social and religious developments of fourth millennium B.C. Cyprus.

Clay building models are a cross-cultural phenomenon found in the Balkans, the Aegean, Egypt, and the Near East in prehistoric and later contexts (Peltenburg 1988a). They have been interpreted in various ways, but in terms of style the closest analogy to the Kissonerga model is the "Sacred Enclosure," from a tomb in the Early Bronze Age cemetery of Vounous in Cyprus (Dikaios 1940: pls. 7–8). Like the Kissonerga model, it has a hardly-modified open bowl shape, internal fixtures, and a clearly articulated entrance. Both are decorated and each has 19 associated figures. It seems reasonable to conclude that the whole concept of the Vounous bowl has an enormously lengthy and unsuspected pedigree, within the Chalcolithic period at least. This is important for considerations of continuity and disruption through the crises that mark the advent of the Bronze Age in Cyprus. But it is equally important to note the differences in detail for they epitomize the changes in the ideological, social, and economic domains of the two periods. The Vounous bowl is populated by figures with folded arms—one holding an infant—by penned bulls, and by snakes. None of that exists in Chalcolithic representations. The form has thus persisted yet the content has changed dramatically.

Period 3 with its road, differentiated and elaborate structures, finely painted pottery, varied array of coroplastic and other art forms, including the largest picrolite cruciform figurine from Cyprus (fig. 7), and occasional imports such as flint and obsidian, has evidence for a thriving population. That it was not unique to Kissonerga is evident from remarkable contemporary finds in Building 1 at Lemba, much of the Souskiou cemetery, and the later levels at Erimi (see Vagnetti 1980; Peltenburg et al. 1985a: 67–70, 77–78). The flourishing character of that period may be epitomized by the amount of specialized labor needed to construct some of the enormous buildings at Kissonerga. They may also provide insights into the reasons for observed changes insofar as they contrast so markedly in size and sophistication with nearby habitations. In other words, labor was explicitly concentrated on certain buildings that possessed special pottery and storage containers. This may well be a reflection of increased social divisions leading to the production of more "luxury" goods.

In addition to its sharply gradated house sizes, Kissonerga 3 has also yielded evidence for public ritual. Units 1015 and 1225 were deposited in an

Fig. 7. Fragment of the largest picrolite cruciform figurine from Cyprus, Period 3; surviving height, 16.3 cm.

center, the burial of all those quasiutilitarian objects at a time of movement away from the area is to be linked with abandonment procedures and may shed light on why relatively large Cypriot population aggregates did not develop more obviously stratified and centralized organizations.

Dwelling size differences, the likelihood of special structures and leaders of ritual, and the advent of large intramural storage containers and differential burial rites are indicative of emerging asymmetrical social relationships in Kissonerga 3. Had the process continued, such a large center probably would have developed hierarchical political units and eventual urbanization, as happened in neighboring lands. That did not occur in Chalcolithic Cyprus. One form of resistance to the loss of autonomy was settlement shift, and perhaps social fissioning, an abiding aspect of prehistoric Cypriot "sedentary" communities. Clearly there were stresses in the evolving dynamics of power negotiations within social networks of prestate societies in Cyprus. Two features commonly linked with the appearance of complex societies were also largely lacking in the island prior to the Late Chalcolithic period. These are long distance trade and surplus production. The selective control of those activities are here regarded as symptoms of the appropriation of power by emerging elites. In spite of the richness of Kissonerga 3, there are very few exotica, and metal remains extremely rare. There is also no evidence, in terms of storage, that comestibles were centrally distributed or controlled. Low population density on the island as a whole may also have been a contributing factor to the retention of communal society. Relative sparsity meant that additional territory was available for occupation by disaffected groups, and that the opportunity for competition among interacting peer groups was limited. Why such low population densities persisted for millennia on an isle of plenty is a question common to many island demographies, but Lunt's observation of high infant mortality rates at Lemba (in Peltenburg *et al.* 1985a: 245–49) and Kissonerga (Lunt, personal communication) may supply a crucial explanation for Cyprus. It may also help to explain why such unprecedented emphasis was given to the overt depiction of birth in the figurine repertory (see Goring, this issue, pp. 153–61).

PERIOD 4 (fig. 4)

As stated, there may have been a hiatus before the main area saw further settlement in the form of

open space and hence they are likely to have concerned the community. The objects also are likely to have come from a single, special place since, had they come from individual households with similar wants and needs, there probably would have been a repetition of types rather than the remarkable stylistic heterogeneity of old and new figures. Public ritual and ceremony enhance the importance of participants and the status of the centers in which they occur. The ceremonies are integral in maintaining, defining, and modifying the structure of society. Therefore the social importance of these deposits ought not to be underestimated. While their scale attests to Kissonerga as a ceremonial

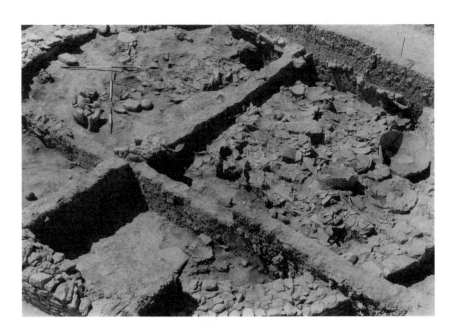

Fig. 8. Building 3, Period 4, with masses of storage vessels lying in destruction debris on the floor.

a quarry dug for poor quality marl and *havara* and for some graves. Thereafter, dispersed small buildings were constructed, gradually filling in the entire area preserved at this level. Three or four phases can be discerned with—in a final phase to be dated to the mid-third millennium B.C.—numerous small structures placed beside a major establishment, Building 3. The settlement plan is quite different from that of Period 3, but it closely resembles nearby Lemba 3, in which a large structure is also associated with several smaller ones. Again, as at Lemba, several of the smaller units are reserved for special functions. Thus one building, 1052, has an oven that occupies a significant proportion of the interior space; another, Building 1046, has three spacious, compartmentalized basins and could not have been used for ordinary residence. The settlement seems to consist of a major all-purpose building with several subsidiary dwellings and ancillary structures devoted to specific functions. At Lemba the major building was associated with a group of tombs uniquely supplied with libation holes (Peltenburg *et al.* 1985a: 114–18, fig. 41, pl. 28.1), at Kissonerga with a remarkable concentration of storage vessels.

The pots were found in Building 3, which was destroyed in a fire that caused roof timbers to come crashing onto the floor. Among the trapped objects were some 40 pithoi and 20 smaller vessels (fig. 8). They occupied fully half the internal floor area. Measurement of pithoi body diameters, moreover,

reveals that there would not be enough space for all those jars had they stood on the floor. Since there was no evidence for a loft, the problem of spatial congestion is best overcome by assuming that many were stacked. Sherd concentrations indicate that the jars were densest near the central hearth. The lighter concentration near the wall corresponds with two rows of jar stands. In other words, there was a permanent complement of 11 pithoi near the wall and the remainder were stacked temporarily between them and the hearth. Since access to all but the jars nearest the entrance would have been impractical, the building could not have operated as an effective dispensary of stored commodities at the time of its destruction. Indeed, if this reconstruction of a stacked assemblage of jars is correct, the jars were probably empty since it is unlikely that such friable, handmade pots could have supported stacked vessels which, when full, would have been quite heavy.

There is negative evidence that the jars may have been empty. In a Mediterranean horticultural community like Kissonerga, one would expect that contents belonged to the standard polyculture of cereals, oil, and wine. Flotation of Building 3 burnt deposits, however, yielded only a few pistachio seeds. Cereals, if present, were not there in the form of seeds. The olive was also domesticated in Cyprus at that time; but had the vessels contained olive oil, burning would have been far more intense than was the case. Wine also seems unlikely since

these were large-volume jars and without lids wine quickly would have become rancid. It seems reasonable to assume exceptional, depleted, or no contents. Rather than opt for idiosyncratic contents, it might be more appropriate to conclude that Building 3, which had normal domestic furnishings such as the circular platform hearth, was converted into a central repository of pithoi at certain times in the agricultural cycle. Presumably it was burnt down unexpectedly, since the body of a child was found trapped by fallen masonry.

Building 3 clearly served as a focus of communal activity. Its 11 permanent storage jars alone give some idea of its exceptional status. The significance of this concentration can be put into perspective in another way by comparing it with Myrtos in Crete, a contemporary settlement that yielded a total of 44 similarly-sized pithoi, little more than the full complement from this building. Warren, the excavator of Myrtos, argued that the pithoi represent a surplus of oil amassed for exchange, an important step in the evolution of palatial redistributive economies (Warren 1972: 145–46). While the exact size of the Kissonerga Period 4 settlement is unknown, the concentration of so much storage capacity in Building 3, a major dwelling, not a specialized or public structure, is strong evidence for the impressive wealth and degree of control exercised by its occupants over productive labor. The material disparities between Building 3 and other dwellings suggest that, as in Period 3, unequal concentrations of energy expenditure were typical of prestate Chalcolithic Cyprus. In a broader context, this evidence points to the growth of large container, intramural storage in both Crete and Cyprus by the mid-third millennium B.C.

The sequence of levels at Building 3 is also important for an understanding of developments toward the end of the Chalcolithic period. After the building's destruction, pits and other features cut into the debris contained evidence for the production of luxury materials. For example, wasters were left behind by a shell carver. Among his intended finished products were dentalium beads and spurred, annular pendants, the latter well known from Philia contexts in the central part of the island, where they are sometimes referred to as fish amulets (cf. Dikaios 1962: 175, fig. 84.18–22; Hennessy et al. 1988: fig. 25). At Kissonerga, however, they have only been found together with Late Chalcolithic pottery and not Red Polished (Philia) pottery as elsewhere, thereby raising the issue of the

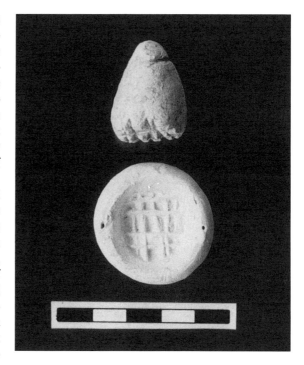

Fig. 9. Limestone conical stamp seal with impression, Period 4.

origins of this new type of jewelry. Copper ore from the same level suggests an association with copper extraction process, at least on a limited scale. It may not have come from the prolific Troodos copper belt since there are small, local sources available (Zwicker 1988: 427–28). Another innovation was a conical stamp seal (fig. 9), the earliest securely dated example from Cyprus. Similar poorly dated examples are known from other sites (e.g., Peltenburg et al. 1985a: pl. 47.11), so it is evidence for the beginning of a new custom, not an isolated experiment. On the mainland, such seals are often used for the administration of property in stratified societies. If it was adopted for the same reasons in Cyprus, it provides supporting evidence for the trappings of control systems seen in the immediately underlying Building 3. Its close association with high-value objects like copper and shell pendants may indicate the growing convergence of power and "wealth" in Late Chalcolithic society.

Sunk into the prolific residues of Building 3 was the third element of the sequence, a small, fine structure, Building 86. In spite of its size it ranks as one of the best constructed prehistoric buildings of Cyprus (Peltenburg et al. 1985b: 57, pl. 2A). Its

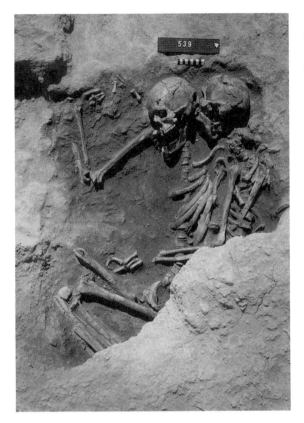

Fig. 10. Double inhumation Grave 539, Period 4. The lower parts of the bodies extend out of sight beneath what remains of the roof of the chamber.

neat southern facade was flattened, its entrance jambs carefully thickened and its masonry pecked flat in rustic technique on its inner face. *In situ* wall collapse provides evidence for a stone wall almost 2 m high, by far the tallest recorded Chalcolithic elevation. Thus there is continuity in the occurrence of high quality materials at this location. Building 86 had two phases before it collapsed. Over it were basins, pits, and disturbed wash containing material of Period 5, the clearest sequence in Cyprus for the transition from the Chalcolithic to the Early Bronze Age. Pre-Philia material at Kissonerga demonstrates either that artifacts previously regarded as diagnostic of the Bronze Age were current in the preceding Late Chalcolithic or that innovations made in a newly emergent Philia group in the Morphou Bay area were adopted by existing communities.

Indicators of greater social differentiation in Kissonerga 4 are also evident in mortuary practices. Chamber graves with funerary furniture now ap-

pear alongside the traditional pit graves that normally lack offerings. With their appearance there occurs a shift from single to multiple interments (fig. 10). That is not to be interpreted as simply a shift to more elaborate graves, but one that entails new attitudes toward access to certain tombs and perhaps a greater emphasis on distinctive social relations. The multiple burial tradition may already have been reserved for special social groups, since it is first found in Cyprus in selected Middle Chalcolithic graves. Almost all the evidence comes from Souskiou (Christou 1989: 82–94) where multiple interments were inhumed in shaft graves, and hence the particular novelty at Kissonerga is the chamber. Since the soft marl of the site is unsuitable for well-constructed chambers, the tomb type was probably introduced. It was to become the standard tomb type throughout the rest of antiquity in Cyprus.

Grave 505 is a bilobate example of the Late Chalcolithic chamber tomb (see Peltenburg *et al.* 1985b: 58–61, where it is referred to as Grave 5). Its 1.6 m deep shaft was sealed below the hearth of Building 98. At the base of the shaft a triangular platform was bisected by a rickle of stones that proved to be an extension of a stone-built pier dividing the burial area into two chambers. There were at least two interlocked adults in the 1 × 2 m Chamber 1, each provided with a spouted pottery flask. Dentalium shells and other objects in the shaft may have belonged to those interments or to earlier graves through which this one was cut. A single, flexed inhumation was placed against the back wall of the similarly sized Chamber 2 and a bowl was placed on the edge of the platform leading to the chamber. It seems to have been the custom to provide the dead in Late Chalcolithic chamber tombs with a single vessel and sometimes other goods, including necklaces of small stone and faience disc beads. The latter are the earliest examples of a synthetic material from the Mediterranean region and they arrived as part of developing exchanges with the Levantine mainland. Their advent soon after in the Aegean to the west (Foster 1979: 34, 56–59) is hardly likely to have been fortuitous.

PERIOD 5

The upper culture-bearing deposits are disturbed by plowing and extensive terracing. The stratigraphic distinction between Periods 4 and 5 therefore is fraught with difficulties, since, for example,

late sherdage often may be plowed into underlying levels.[4]

Certain novel burials exemplify these problems of stratigraphy. They include two urn graves in Period 4 levels but probably cut down from higher up (e.g., Peltenburg *et al.* 1985b: 58–59, pl. 3A). A tightly crouched child lay in one urn, its feet at the base of the jar. The vessel does not strictly conform to Late Chalcolithic shapes or finishes and it has analogies in transitional and Early Cypriot contexts (e.g., Dikaios 1962: 171, fig. 83.9; Stewart 1962: fig. 109). The custom of urn burial is intrusive and while there may have been indigenous reasons for its appearance, one cannot overlook that this was a time of foreign contact with the Levant and with EB I/II Anatolia where it was the most common burial type (Wheeler 1974). Grave 529 is another burial that belongs to this or the preceding period. With the inhumed child was a miniature dentalium shell necklace, annular shell pendant of the type manufactured on the site, and a copper spiral ring with expanded terminal (Peltenburg 1988b: 234–35, fig. 3). The combination of traits often regarded as distinctive of the Chalcolithic (shallow pit burial, dentalia) and the Early Bronze Age (annular pendant, spiral ring) in a single burial provides conclusive evidence that there was no sharp break between the two periods.

Other distinctive features undoubtedly belonging to Period 5 are terracotta spindle whorls and two classes of pottery. The whorls are no longer made from flat, pierced sherds. Instead, they are fashioned into decorated biconical and ring shapes from the new, finely levigated clays used for Red Polished (Philia) pottery; they are almost indistinguishable from types found at Philia-Vasiliko (cf. Dikaios 1962: 175, fig. 84.13–17). The pottery survives principally as sherds from flasks with rod handles and cutaway spouts. Part of a small jar has an incised herringbone design on its shoulder and it corresponds in shape and decoration with jars from Philia tombs in the center of the island (Peltenburg *et al.* 1984: 62, fig. 58; cf. Hennessy, Eriksson, and Kehrberg 1988: 60, fig. 15.11). The other class of pottery is Black Slip-and-Combed, known previously from Philia sites in the north and center of the island and EB II Tarsus.[5] It has a dark core with organic filler. Its decoration is effected by scraping away a dark slip (when reduced) to reveal an underlying red surface. One carefully executed example has rows of dots rather than the usual banded decoration. Their arrival with Red Polished (Philia) in the west indicates that these vessels are not the result of occasional interregional exchanges, but rather part of a new, intrusive ceramic package.

Philia traits at Kissonerga are of considerable interest for the momentous transition to the Early Bronze Age; but because the Philia group of sites around the Bay of Morphou remains ill-defined in chronological terms, a number of interpretations are possible. Before evaluating alternatives, it should be noted that, contrary to J. R. Stewart (1962: 287–89) and Herscher (1981) the western instances confirm that Philia cultural traits were widespread and pervasive and that the west was not isolated from the profound changes that affected the rest of Cyprus in the mid-third millennium B.C. Of the likely explanations for the Kissonerga data, two commend themselves for assessment: model 1 (M_1), in which there is such pronounced regional variation that Kissonerga 4 and Philia are contemporary; and diachronic model 2 (M_2), in which Kissonerga 4 provides a *terminus post quem* for Philia throughout Cyprus.

Synchronous, Regional Variation. M_1 assumes that the Philia group already existed in central Cyprus during Kissonerga 4 (fig. 11). According to the Kissonerga 4 radiometric dates (Peltenburg, in press) Philia should therefore start before 2400/2300 B.C. That corresponds with conventional dates for Tarsus II, which possesses Philia-type material. If the Tarsus Black Slip-and-Combed pottery proves to come from Philia sites in Cyprus, its occurrence in the earlier part of EB II Tarsus means that Philia started well before the mid-third millennium B.C. The fact that Red Polished (Philia) pottery only appears in Period 5, after the spiral ring and annular pendant, suggests three stages of interaction between the west and central parts of Cyprus: contact, followed by influence, concluding with radical structural changes in traditional Erimi culture societies.

Unfortunately, the poor preservation of Period 5 deposits does not allow for detailed assessments of those changes; but scholars ought not to underestimate them in view of the completely different techniques and clay sources used to produce the local Red Polished (Philia) pottery and spindle whorls. These are not solely matters of fashion: they imply a radical departure from traditional modes of production. According to this model, Grave 529 probably belongs to Stage 2.

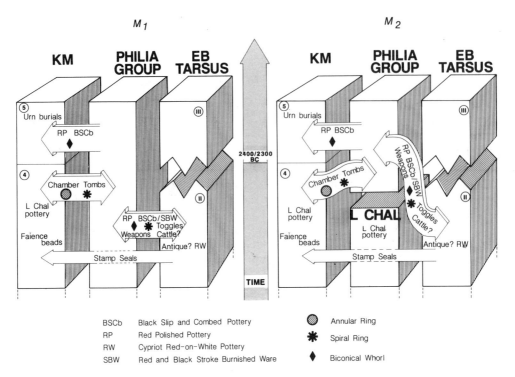

Fig. 11. Early (M₁) and late (M₂) models for the role of the Philia group of sites in changing cultural patterns in Cyprus during the transitional phase to the Early Bronze Age. "KM" is Kissonerga-Mosphilia.

Diachronic Evolution. Alternative M₂ stipulates that Philia in central Cyprus is contemporary only with Period 5 (and later), and that important changes in Period 4 were generated entirely within the late Erimi culture. The changes could not be a consequence of interaction Stages 1 and 2 as defined above. The Period 4 increased complexity includes more social differentiation (building and burial hierarchies) and the appearance of foreign prestige items (e.g., faience beads) and customs (e.g., stamp seals). This interpretation requires that exceedingly rapid changes took place in the Morphou Bay area subsequently and that the newly evolved culture spread speedily throughout the island, perhaps as a sudden migratory movement. The destruction of Lemba 3 and the disappearance of the Erimi culture further suggest that this was catastrophic as far as the native population was concerned.

Kissonerga dates indicate that the destruction of Lemba 3 occurred after 2400/2300 B.C., about the time of the destruction of EB II Tarsus. Many have argued that the culture of the Anatolian refugees prospered in Cyprus while new cultures developed in their homeland.[6] That explanation allowed

scholars to explain the similarities between pre-2400 B.C. Tarsus and post-2400 B.C. Cyprus, and it requires a sharply curved arrow between Tarsus and Philia in M₂ of fig. 11. But if, as proposed above, Black Slip-and-Combed pottery at Tarsus came from Philia sites in Cyprus, M₂ is faulty. The existence of chamber tombs, annular spurred pendants, and spiral rings in Kissonerga 4 and Philia sites strengthens the case for contemporaneity and regional variation. While the two models have little explanatory value for culture change, the adoption of M₁ allows us to consider change in a clearer temporal framework. Research may now be aimed to refine M₁, to investigate the origin of the Philia culture and to document its formative interaction with more conservative Erimi culture groups.

Kissonerga is one of a very few sites in Cyprus to span the transition to the Early Bronze Age. Most Late Chalcolithic sites ceased before or during that critical time. Kissonerga's long history, size, and importance may have conferred an exceptional degree of stability that enabled it to survive such upheavals. But no community exists in isolation and the abandonment and destruction of so many associated villages must have been a determining

factor in its demise in the final quarter of the third millennium B.C.

CONCLUSION

Kissonerga provides valuable information on several perennial problems of Cypriot prehistory. In terms of cultural homeostasis and change, this includes environmental conditions during the Neolithic/Chalcolithic transition, and chronological and cultural data for the momentous upheavals at the start of the Bronze Age. The desultory use of copper is a surprising feature throughout most of its existence, given the importance of the metal in contemporary societies outside the island and ready availability on the island. Such neglect is revealing of the isolated status of Cyprus prior to the Late Chalcolithic when evidence for transmaritime exchanges becomes obvious and increased use of metal begins to affect traditional stone adze working (Elliott 1985: 167). Checks on growth toward complexity have been inferred from the recurrence of single period sites, in other words from mobile economies. Although there are no tells in Cyprus, Kissonerga demonstrates the existence of long-term site occupation on the island. In the two periods where settlement evidence is good, there are pronounced spatial disparities in architecture and other material goods, but no evidence for public institutions. Unequal control of energy, or social practices, was thus not an evolutionary tendency of those ostensibly "middle range" societies, but an established feature, well before the Bronze Age.[7]

ACKNOWLEDGMENTS

Major sponsors of the Lemba Archaeological Project include the British Academy, the British School of Archaeology at Jerusalem, the National Geographic Society and the National Museums of Scotland.

NOTES

[1]Results of six seasons of excavations at Kissonerga, from 1983 to 1989, have so far mainly appeared in preliminary reports (see Peltenburg et al. 1985b; 1989, with references). The aim of this contribution is to present a selection of the principal discoveries mentioned in scattered reports, and which appear to distinguish Kissonerga as a major prehistoric settlement of Cyprus. Another season of investigation and much postexcavation work still need to be carried out, hence inferences from these discoveries are kept to a minimum here pending final analyses. Although a firm chronology exists for the penultimate period of occupation (see Peltenburg, in press), further radiocarbon dates are awaited to provide a more secure framework for earlier periods.

[2]Copper, perhaps as malachite, is available in the vicinity of the site, at Khlorakas for example (Zwicker 1988: 427-28).

[3]The material from these and associated pits is currently being prepared for publication in the Lemba Archaeological Project series (see Peltenburg et al. 1985a). For some preliminary accounts and illustrations, see Goring, this issue, pp. 153-61 and Peltenburg 1988a; 1989).

[4]We have been rigorous in excluding any suspect material, but not all data have been processed and so final analysis may necessitate revisions of assessments made here.

[5]For this important ware, see the discussions in Dikaios 1962: 201 and Stewart 1962: 225. At the conference on Cypriot ceramics in Philadelphia in 1989, I examined relevant Tarsus material (stored at Bryn Mawr) through the kindness of D. Bolger. Although analytical confirmation is required, Tarsus Streak Burnished fabric and finish are visually so like Cypriot Black Slip-and-Combed that they may be regarded as the same diagnostic ware. This reassessment has important repercussions on the nature of the transition to the Bronze Age in Cyprus (see below).

[6]E.g., Gjerstad 1980. Although his interpretation would seem to be a conflation of M_1 and M_2, it cannot work for chronological reasons and because of the absence of Red Polished (Philia) pottery at Ambelikou prior to the topmost disturbed pits (see Peltenburg, in press).

[7]Knapp (1990) has misdated the Kissonerga evidence and appropriated it to support his contention that incipient stages of complexity were associated with the secondary products revolution in the Bronze Age. Most of the cited evidence for innovations, specialist production, and expansion of capital factors that he attributes to the Philia culture (Knapp 1990: 157, Table 5) in fact belongs to Kissonerga Period 3, which is late fourth millennium B.C. and hence well before Philia and evidence for cattle in Cyprus.

BIBLIOGRAPHY

Bolger, D.
 1988 *Erimi-Pamboula. A Chalcolithic Settlement in Cyprus.* BAR International Series 443. Oxford: British Archaeological Reports.
Christou, D.
 1989 The Chalcolithic Cemetery 1 at Souskiou-Vathyrkakas. Pp. 82–94 in *Early Society in Cyprus*, ed. E. Peltenburg. Edinburgh: Edinburgh University.
Dikaios, P.
 1936 The Excavations at Erimi 1933–1935. *Report of the Department of Antiquities of Cyprus*: 1–81.
 1940 The Excavations at Vounous-Bellapais in Cyprus, 1931–2. *Archaeologica* 88: 1–174.
 1961 *Sotira.* Philadelphia: University of Pennsylvania.
 1962 The Stone Age. Pp. 1–204 in *Swedish Cyprus Expedition* IV.1A. Lund: Swedish Cyprus Expedition.
Earle, T., ed.
 1984 On The Evolution of Complex Societies. Essays in Honor of Harry Hoijer 1982. *Other Realities* 6. Malibu: Undena.
Elliott, C.
 1985 The Ground Stone Industry. Pp. 161–95 in *Lemba Archaeological Project I. Excavations at Lemba Lakkous, 1976–1983*, by E. J. Peltenburg et al. Studies in Mediterranean Archaeology 70: 1. Göteborg: Åström.
Foster, K.
 1979 *Aegean Faience of the Bronze Age.* New Haven: Yale.
Fox, W. A.
 1988 Kholetria-Ortos: A Khirokitia Culture Settlement in Paphos District. *Report of the Department of Antiquities of Cyprus*: 29–42.
Gamble, C.
 1982 Animal Husbandry, Population and Urbanisation. Pp. 161–71 in *An Island Polity. The Archaeology of Exploitation in Melos*, eds. C. Renfrew and M. Wagstaff. Cambridge: Cambridge University.
Gjerstad, E.
 1980 The Origin and Chronology of the Early Bronze Age in Cyprus. *Report of the Department of Antiquities of Cyprus*: 1–16.
Hennessy, J.; Eriksson, K. O.; and Kehrberg, I. C.
 1988 *Ayia Paraskevi and Vasilia. Excavations by J. R. B. Stewart.* Studies in Mediterranean Archaeology 82. Göteborg: Åström.
Herscher, E.
 1981 Southern Cyprus and the Disappearing Early Bronze Age. *Report of the Department of Antiquities of Cyprus*: 17–21.

Karageorghis, V.
 1985 *Ancient Cypriote Art in the Pierides Foundation Museum.* Larnaca: Pierides Foundation.
Knapp, A. B.
 1990 Production, Location and Integration in Bronze Age Cyprus. *Current Anthropology* 31: 147–76.
Le Brun, A.; Cluzan, S.; Davis, S.; Hansen, J.; and Renault-Miskovsky, J.
 1987 Le néolithique précèramique de Chypre. *L'Anthropologie* 91: 283–316.
Moore, A. M. T.
 1988 The Prehistory of Syria. *Bulletin of the American Schools of Oriental Research* 270: 3–12.
Peltenburg, E. J.
 1982a *Vrysi, a Subterranean Settlement in Cyprus. Excavations at Prehistoric Ayios Epiktitos Vrysi 1969–73.* Warminster: Aris and Phillips.
 1982b *Recent Developments in the Later Prehistory of Cyprus.* Studies in Mediterranean Archaeology, Pocket-book 16. Göteborg: Åström.
 1987 Lemba Archaeological Project, Cyprus, 1985. *Levant* 19: 221–24.
 1988a A Cypriot Model for Prehistoric Ritual. *Antiquity* 62, 235: 289–93.
 1988b Lemba Archaeological Project, Cyprus, 1986. *Levant* 20: 231–35.
 1989 The Beginnings of Religion in Cyprus. Pp. 108–26 in *Early Society in Cyprus*, ed. E. Peltenburg. Edinburgh: Edinburgh University.
 1990 Chalcolithic Cyprus. Pp. 5–22 in *Cyprus before the Bronze Age: Art of the Chalcolithic Period*, eds. V. Karageorghis, E. J. Peltenburg, and P. Flourenzos. Malibu: Getty Museum.
 In press Toward Definition of the Late Chalcolithic in Cyprus: The Monochrome Pottery Debate. In *Cypriot Ceramics: Reading the Prehistoric Record*, eds. J. Barlow, D. Bolger, and B. Kling. Philadelphia: University of Pennsylvania.
Peltenburg, E. J., et al.
 1979 Lemba Archaeological Project, Cyprus, 1976–77: Preliminary Report. *Levant* 11: 9–45.
 1980 Lemba Archaeological Project, Cyprus, 1978: Preliminary Report. *Levant* 12: 1–21.
 1984 Lemba Archaeological Project, Cyprus, 1982: Preliminary Report. *Levant* 16: 55–65.
 1985a *Lemba Archaeological Project I. Excavations at Lemba Lakkous, 1976–1983.* Studies in Mediterranean Archaeology 70:1. Göteborg: Åström.
 1985b Lemba Archaeological Project, Cyprus, 1983: Preliminary Report. *Levant* 17: 53–64.

1989 Excavations at Kissonerga-Mosphilia 1988. *Report of the Department of Antiquities of Cyprus*: 29–40.

Philip, G.
1983 Kissonerga-Skalia Ceramics. Pp. 46–53 in The Prehistory of West Cyprus: Ktima Lowlands Investigations 1979–82, by E. Peltenburg *et al*. *Report of the Department of Antiquities of Cyprus*.

Redman, C.
1978 *The Rise of Civilization*. San Francisco: Freeman.

Renfrew, C.
1972 *The Emergence of Civilisation*. London: Methuen.

Rollefson, G., *et al*.
1985 Excavation at the Pre-Pottery B (PPNB) Neolithic Village of ꝗAin Ghazel (Jordan) 1983. *Mitteilungen der Deutschen Orient Gesellschaft* 117: 69–116.

Stewart, J. R.
1962 *The Early Cypriote Bronze Age*. Pp. 205–391 in *Swedish Cyprus Expedition* IV.1A. Lund: Swedish Cyprus Expedition.

Swiny, S.
1989 From Round House to Duplex: A Reassessment of Prehistoric Cypriot Bronze Age Society. Pp. 14–31 in *Early Society in Cyprus*, ed. E. Peltenburg. Edinburgh: Edinburgh University.

Swiny, H., and Swiny, S.
1983 An Anthropomorphic Figure from the Sotira Area. *Report of the Department of Antiquities of Cyprus*: 56–59.

Todd, I. A.
1981 Current Research in the Vasilikos Valley. Pp. 57–68 in *Chalcolithic Cyprus and Western Asia*, ed. J. Reade. British Museum Occasional Publications 26. London: British Museum.

Trigger, B.
1978 *Time and Traditions*. Edinburgh: Edinburgh University.

Upham, S., ed.
1990 *The Evolution of Political Systems. Sociopolitics in Small-Scale Sedentary Societies*. Cambridge: Cambridge University.

Vagnetti, L.
1980 Figurines and Minor Objects from a Chalcolithic Cemetery at Souskiou-Vathyrkakas (Cyprus). *Studi Micenei ed Egeo-Anatolici* 21: 17–72.

Warren, P.
1972 *Myrtos: An Early Bronze Age Site in Crete*. London: Thames and Hudson.

Wheeler, T. S.
1974 Early Bronze Age Burial Customs in Western Anatolia. *American Journal of Archaeology* 78: 415–25.

Zwicker, U.
1988 Investigations of Material from Maa-Palaeokastro and Copper Ores from the Surrounding Area. Pp. 427–31 in *Excavations at Maa-Palaeokastro 1979–1986*, eds. V. Karageorghis and M. Demas. Nicosia: Department of Antiquities of Cyprus.

Metals and Metallurgy in the Chalcolithic Period

Noël H. Gale
Nuffield College, Oxford
Oxford, England

The corpus of Chalcolithic metals excavated in Cyprus is discussed against the background of Chalcolithic metallurgy principally in the Levant, Anatolia, Bulgaria, and northern Greece. Metallurgy in Chalcolithic Cyprus seems rather primitive and provincial, surprisingly so in view of the large resources of copper ores in Cyprus. New trace element chemical analyses, and some metallographic evidence, are presented of Chalcolithic metal objects from Cyprus and of Cypriot native copper, together with a lead isotope analysis for the one object for which a sufficient sample was available. New analyses are also given for Early Cypriot objects from Vounous and Lapithos. The metallographic investigation of the Chalcolithic Cypriot artifacts indicates cold working and annealing. The known Chalcolithic copper objects probably are not made from Cypriot native copper, nor was the beginning of metallurgy in Cyprus connected with the increasing exploitation of picrolite. The one Chalcolithic Cypriot artifact for which a lead isotope analysis exists was not made of copper from Cyprus. The question arises whether any of the Chalcolithic metal objects from excavations on Cyprus were made of Cypriot copper.

INTRODUCTION

The beginnings of metallurgy in Cyprus can be viewed from at least two standpoints. One is that of the archaeometallurgist interested in the broad history of the development of metallurgy and mining in the eastern Mediterranean and the Aegean. The other is that of the scholar of prehistory, who needs to go beyond the bare fact and description of a technological development in an attempt to assess its importance within the culture system as a whole (see Lechtman 1980; Peltenburg 1982). This is the more so since the evolution of complex societies is now seen not so much as simply an outcome of population growth, but as stemming from the interaction among several variables (see Earle 1984), of which metallurgy may be one. The student of Cypriot prehistory needs to relate the advent of simple metalwork in Cyprus shortly after 4000 B.C. to the evolution of communities within Cyprus and the possible influence of diffusion, Cypriot invention, local innovation within Cyprus, transmaritime contacts, and imports. Some of that will necessitate an examination of metallurgical developments in relatively nearby regions.

Knowledge of the relative and absolute chronology of the regions involved is important; Table 1 gives the chronology adopted here. The table is based largely on the recent work of J. E. Coleman (unpublished), which is in turn dependent both on ceramic evidence and on C-14 dates calibrated according to the tables published by Klein *et al.* (1982). All dates in this article rest upon such calibrated radiocarbon dates.

EARLY METALLURGY IN THE NEIGHBORHOOD OF CYPRUS

This brief introduction will be limited to a comparison of metallurgy in Chalcolithic Cyprus with metallurgy that predated or was roughly contemporaneous with it in the Aegean, the Balkans, Anatolia, and Palestine.

The Aegean Area (fig. 1)

The first use of metal in final Neolithic Sitagroi (Renfrew 1972: 309–11; McGeehan-Liritzis and Gale 1988: 199–225), in the form of beads and small copper objects, comes from the end of Phase II, contemporary with Karanovo IV/V and dating to about 4800 B.C.

Support for this early appearance of metal is given by small objects of copper (Daux 1968: 1070) found in Middle Neolithic levels at nearby Dikili

TABLE 1. Relative and Absolute Chronology for Cyprus, Anatolia, the Balkans, Greece, and Thrace

CALIBRATED C-14 DATES B.C.	Cyprus	E. Macedonia and Thrace	Bulgarian Thrace	Central and North Balkans	N.W. Greece	E. Aegean	Anatolia
	Middle Cypriot				Middle Bronze Age	Poliochni bruno	Troy V
2000 —							Troy IV
	Early Cypriot	Sitagroi Vb		Cotofeni-Kostolac			Troy III
2500 —		Sitagroi Va	Cotofeni		Early Bronze Age	Poliochni gallo, rosso, verde	Troy II
	Chalcolithic	Sitagroi IV	Ezero, Karanovo VII	???		Poliochni azurro Emborio IV, V	Troy I
3000 —					— ? —		
3500 —		Break?		Tiszapolgar		Poliochni nero Emborio VI–VII	Kum Tepe IB
	Late Ceramic Neolithic	— ? —	Gumelnitza, Karanovo VI			— ? —	— ? —
4000 —		Sitagroi III Dikili Tash 'LN'			Late Neolithic	Emborio IX–X	Kum Tepe IA
	Early Ceramic Neolithic	—	Maritsa, Karanovo V	Vinca B₂-D		— ? —	— ? —
4500 —		Sitagroi II	Karanovo IV				Chalcolithic
5000 —	Gap?	Sitagroi I Dikili Tash 'MN'	Veselinovo, Karanovo III	Vinca A-B₁			
			Karanovo II	Starcevo (Anza II, III)	Middle Neolithic		Neolithic
5500 —	Aceramic Neolithic		Karanovo I	(Anza I)	Early Neolithic III		

Tash, particularly a copper needle (Deshayes 1970: 799–808). The date for these earliest metals at Dikili Tash is about 5000 B.C. (Delibrias, Guillier, and Labeyrie 1974: Table 2). Alleged copper slag of the same date has also been reported from Dikili Tash (Seferiades 1983: 635–76).

The first appearance of metals in northern Greece, at Sitagroi and Dikili Tash, dates therefore to about 5000 to 4800 B.C., and is nearly as early as elsewhere in southeastern Europe. To those should be added, for southern Greece, the copper pin from Level II of the Kitsos Cave near Lavrion (Lambert 1970: 703–35; 1973: 502–15), which has been dated by radiocarbon analysis to about the mid-fifth millennium B.C. (Delibrias, Guillier, and Labeyrie 1974: 54–55).

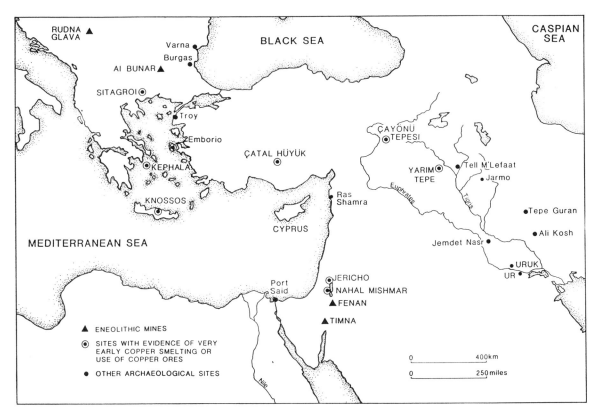

Fig. 1. Map of the Middle and Near East and the eastern Mediterranean, showing sites mentioned in the text.

Figure 2 shows the location, and Table 2 summarizes, the other finds from southeastern Europe thought to date between 5300 B.C. and 4500 B.C. (see also Gale *et al.*, in press). In most cases there is little evidence that those objects represent anything beyond the "trinket" metallurgy stage of hammered native copper. However, the high iron content of the copper sheet from Usoe II, from about 5000 B.C., suggests that it was made from smelted copper, while the claimed fragment of copper slag from Anza IV in Yugoslavia also suggests the beginning of copper smelting by 5000 B.C. in the Balkans.

Later at Sitagroi, in Phase III dated to approximately 4500 B.C., there are not only the graphite-painted wares and terracotta figurines typical of the Karanova VI Gulmenitsa culture, but also copper awls and pins and crucibles and copper slags (Renfrew 1973: 473–81; McGeehan-Liritzis and Gale 1988).

Even in Phase III at Sitagroi, however, the developments in copper metallurgy were relatively primitive and insignificant in comparison with the emergence of the great Copper Age cultures of

Eneolithic southeastern Europe, in present day Yugoslavia (Jovanovic 1989) and Bulgaria (Todorova 1986). There the trinket stage of copper metallurgy was reached by 5000 B.C., while by the beginning of Karanovo VI, not later than about 4300 B.C., there existed a series of heavy copper shaft hole axes and large chisels, and the typical double spiral headed pins, which are well illustrated in works by Cernych (1978a) and Todorova (1981; 1986).

Todorova and her colleagues have shown that many of those mid-fifth millennium axes were cast in bivalve molds; they are some of the earliest such molds yet known and testify to an advanced stage of metallurgy.

The same time also sees the earliest known shaft mining for copper at Rudna Glava in Yugoslavia (Jovanovich 1980a; 1980b)—which dates at least as early as 4300 B.C.—and the open cast trench mining at Ai Bunar in Bulgaria (Cernych 1978a; 1978b: 203–17; 1982: 5–15). Figure 3 shows the location of those mines and of Eneolithic sites around Stara Zagora and Ai Bunar. Indeed the beginning of the extraction of copper ores at Ai

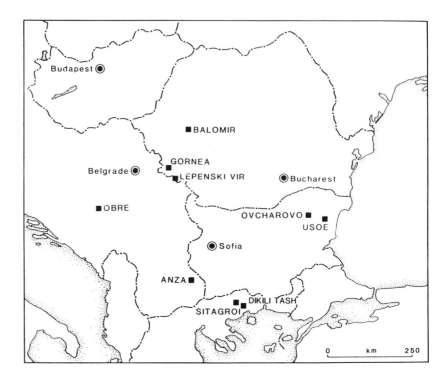

Fig. 2. Sites in southeast Europe with evidence of metallurgy in the period 5300 B.C. to 4500 B.C. ■ = sites with copper objects, copper ore, or copper slag, in Late Neolithic contexts.

TABLE 2. Copper Objects and Copper Ores from Levels ca. 5500 B.C.–4500 B.C.

Site	Object	Reference
Oycharovo I Eastern Bulgaria	Fragment of copper in the lowest (Early Neolithic) level of the tell	Todorova 1975
Usoe II Cave Dwelling VII, Eastern Bulgaria	Oxidized pieces of copper sheet, possibly a copper bead. Analyses in Moscow show the copper sheet to contain 10% iron	Todorova 1981
Balomir Transylvania, Romania	Double-pointed awl, from a Late Cris tell	Vlassa 1969: 504, fig. 6
Iernut Transylvania, Romania	Shapeless copper lump in a Cris culture level	Vlassa 1967
Gornea Iron Gates, Romania	Fish-hook in Gomea Ib horizon	Lazarovici 1970
Szarvas 23 Ko. Bekes, Hungary	Two thin flakes of copper associated with late Koros pottery	Makkay 1982
Obre I Bosnia, Yugoslavia	A fragment of copper from a Site IB/IC transition level	Sterud and Sterud 1974: 258
Lepenski Yir IIIA Iron Gates, Yugoslavia	Azurite and malachite beads from the latest phase of level IIIA Starkevo	Srejovik 1969: 173
Zmajevak Sumadja, Yugoslavia	Fragment of malachite found next to a Starcevo pot	Glumac, in Chapman 1981: 131
Anza IV Yugoslavia	Fragment of copper slag?? about 500 B.C.	Chapman and Tylecote 1983

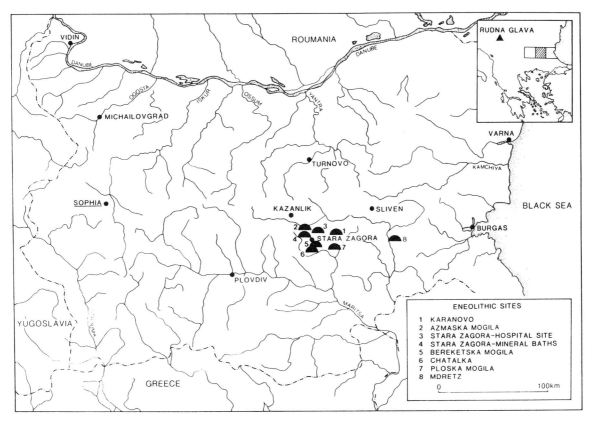

Fig. 3. The locations of Eneolithic sites and the fifth millennium copper mine of Ai Bunar around Stara Zagora in modern Bulgaria.

Bunar may well date even earlier, since copper ores from Ai Bunar were found at nearby sites in stratified levels, together with Karanovo V pottery dating perhaps as early as 4600 B.C. Another Eneolithic copper mine in Bulgaria is at Prochorovo, which had pottery of both the Karanovo V and VI periods (see Cernych 1978a; Gale *et al.*, in press).

In Anatolia well-known evidence from Çayonu Tepesi indicates that trinket metallurgy, involving the hammering of native copper, was in progress by 7000 B.C. (Muhly 1989, with references). However that appearance seems to have been transient (Brewer 1870), and it was not until 2500 years later that the first real evidence is found for copper metallurgy on a large scale, involving the practice of extractive metallurgy. A well known fifth-millennium example is the metal hoard from Late Chalcolithic Level 34 at Beycesultan (Stronach 1959: 47–50, fig. 6, pl. IIIA), usually put at about 4300 B.C. although Muhly (1985: 109–41) has cited

C-14 dates that would date it to about 3500 B.C. The hoard contains a dagger, chisels, needles, and awls, all of copper, and a silver ring. Note, however, that the use of copper at that time in Anatolia is on a significantly more restricted scale than in fifth millennium Bulgaria.

Much more advanced are the metal objects excavated fairly recently by Palmieri from Period VIA at Arslantepe, which C-14 dates to about 3200 B.C. (Alessio *et al.*, quoted by Palmieri 1983: 658). They comprise nine swords, twelve spearheads, and a quadruple spiral plaque, all of arsenical copper (Palmieri 1983: 394–407, figs. 58–62). Three of the swords have hilts with fine silver inlay (see also Caneva and Palmieri 1983).

The southern Levant (see fig. 4) also produced some contemporaneous artifacts. The major and most elaborate assemblage of Chalcolithic metal artifacts and industrial remains have been found almost wholly in preurban Palestine, located as it

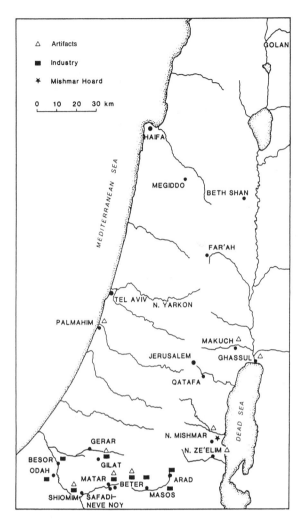

Fig. 4. Chalcolithic sites with metal remains.

was between the two major foci of Near Eastern civilization, Egypt and Mesopotamia. In that region the Chalcolithic period dates roughly between 4500 and 3200 B.C. It is striking that, although hundreds of Chalcolithic sites have been identified in Palestine, from the Golan Heights to the southern Negev, those with metal related artifacts are confined to the southern area, between the northern Negev and the Yarkon river line.[1]

Levy and Shalev (1989) have shown that in that period in the southern Levant two types of copper industries worked in parallel. One produced utilitarian tools of simple shape, ranging from small awls to quite large axes, adzes, and chisels (Shalev and Northover 1987: 357–71, pls. 14.3, 4). The other industry produced prestige cultic objects of

complex shape, such as the standard head that Levy and Shalev illustrate from Shiqmim (1989: fig. 2). That standard head has close parallels in some of those present in the Nahal Mishmar Hoard (Bar-Adon 1980), which supports the thesis that the contents of that hoard are not exotic, but are typical of the southern Levantine Chalcolithic culture (see also Moorey 1988: 171–89).

Taking together all but one of the Chalcolithic sites, there are roughly twice as many utilitarian as prestige copper objects. By far the largest number of Chalcolithic metals (416 objects) was found at the Cave of the Treasure in the Nahal Mishmar near the Dead Sea (there were only 65 objects from all other sites); that site contains 25 times more cultic objects than utilitarian. The Nahal Mishmar Hoard was dated by C-14 between 3500 and 3800 B.C. (see Weinstein 1984: 297–366). The astonishing range of metallurgical expertise—apparently mostly in arsenical copper—represented in the hoard is brought out well by the illustrations published by Bar-Adon (1980). The hoard accounts for about 90 percent of the Chalcolithic Levantine metal objects currently known. Thus, when considering Chalcolithic Cypriot metals, it is necessary to bear in mind the restrictions of the surviving material record so well illustrated by that hoard; poverty of existing evidence is not necessarily evidence for poverty of production.

The source of none of the copper used in Chalcolithic Palestine has yet been established; the most promising approach undoubtedly lies in lead isotope analyses. With the recognition that the objects seem to form part of a local metallurgical tradition, there is less pressure to seek the source of the copper far to the north or northeast in Turkey. That is especially true when we recall that copper mining in that period has been established both for Fenan in Jordan (Hauptmann 1989) and for Timna in the Arabah in the Sinai (Rothenberg 1978; 1982). Though the low arsenic content of ores from both deposits is compatible with the low arsenic content of Chalcolithic Levantine tools, it is difficult to believe that the Chalcolithic Levantine cultic objects are made of copper from those ore sources (deliberate alloying of copper with arsenic can surely be discounted for that period) since those cultic objects are claimed to have relatively high contents of arsenic (Potaszkin and Bar-Avey 1980; Key 1980). Repeat chemical analyses of the objects are definitely desirable. However, chemical analysis alone will not determine the source of the copper

Fig. 5. Chalcolithic sites with metals, other archaeological sites, and localities where native copper has been reported, in Cyprus.

used; for that we must rely on lead isotope analyses, which are now a priority for the Nahal Mishmar Hoard.

CHALCOLITHIC CYPRUS

Copper mining and metallurgy in the areas surrounding Cyprus were both contemporary with and somewhat earlier than the Chalcolithic period in Cyprus itself. In contrast to Palestine, which has none, Cyprus was, of course, well endowed with copper ores. Yet according to present evidence Chalcolithic Cyprus was comparatively rather primitive in copper metallurgy.

Only five Chalcolithic sites show evidence of metals; all are in the southwestern part of the island (see fig. 5): Erimi-Pamboula, Souskiou-Vathyrkakas, Lemba-Lakkous, Kissonerga-Mylouthkia and Kissonerga-Mosphilia. The finds come chiefly from the excavations by Dikaios, Peltenburg, and members of the Cypriot Department of Antiquities. Table 3 summarizes the extant objects connected with metallurgy from Chalcolithic sites in Cyprus. At present only eleven metal objects are known from clear Chalcolithic contexts; all are copper based.

Kissonerga-Mylouthkia

The earliest metal object yet excavated in Cyprus is probably the hook from Kissonerga-Mylouthkia (fig. 6), dating probably to about 3500 B.C.

Kissonerga-Mylouthkia (Peltenburg, this issue, with references) does not now comprise a prehistoric site with buildings, but rather is a heavily eroded coastal tract with occupation debris only in isolated hollows. Erosion has covered the hollows with about one meter of soil, recently cut into by tracks and quarrying. The copper hook was found beneath a lime paving near the lip of Pit F8; the pit was 0.3 m deep by 1.6 m wide at the exposed face. The hook was found 0.1 m in from the exposed face without signs of disturbance or intrusion. Carbon-14 dates from other pits gave a consistent set of calibrated dates ranging from 3490 to 3650 B.C.

In Pit F29, another apparently undisturbed pit about 0.5 m deep, excavators found a small plaque (fig. 6) near the center of the fill, some 0.03 m from the exposed surface; the fill itself comprised a few stones and uniform, crumbly brown pisé-like soil. Slater's analyses in Glasgow seem to show the presence of about 7.8 per cent of zinc in the plaque,

TABLE 3. Catalogue of Known Chalcolithic Metals
and Ores from Cypriot Sites

Site	Object	Date	Reference
Kissonerga-Mylouthkia	Hook	3500 B.C.	Peltenburg 1982
Erimi	Chisel	3200 B.C.	Dikaios 1936
Erimi 7	Hook	3200 B.C.	Bolger 1985
Lemba 134	Chisel	2500 B.C.	Peltenburg 1982
Lemba 209	Blade?	2500 B.C.	Peltenburg 1982
Souskiou	Spiral bead	2500 B.C.	Christou 1989
Kissonerga-Mosphilia 457	Axe	2500 B.C.	
Kissonerga-Mosphilia 416	Awl	2500 B.C.	Peltenburg 1985
Kissonerga-Mosphilia 694	Chisel	2500 B.C.	
Kissonerga-Mosphilia 986	Chisel	2500 B.C.	
Kissonerga-Mosphilia 1182	Ear ring?	2200 B.C.?	Peltenburg 1988
Kissonerga-Mosphilia 701	?	2500 B.C.	
Kissonerga-Mosphilia 2109	Ore in Shell	3500 B.C.	
Kissonerga-Mosphilia 633	Copper Ore	2500 B.C.	

which makes it difficult to accept it as a Chalcolithic object. It is perhaps more reasonably connected with later Roman activity in the area. Peltenburg (1982) has expressed caution about the stratigraphic position of both objects, although he is inclined to believe that both are contemporary with the site; it seems more likely, however, that only the hook dates to about 3500 B.C.

Erimi-Pamboula

The first Chalcolithic metal object found in Cyprus was the tip of a chisel, excavated at Erimi-Pamboula at a depth of 2.2–2.4 m by Dikaios (1936: 50, fig. 13h) and dating to about 3200 B.C. Two more copper-based objects were recently found by D. Bolger in the basement of the Nicosia Museum, among the Erimi finds.[2] They were never published by Dikaios; nor were some other important objects from Erimi.

The first of those objects (No. 7) is a hook (fig. 7), 2.9 cm long, 0.1–0.15 cm thick, and 0.1–0.2 cm wide. The other is a fragment, perhaps of a knife, 2.3 cm long, 1.4 cm wide, and 0.2–0.25 cm thick. In an excavation day book of 1933,[3] Dikaios makes a fairly clear reference to the discovery of the hook at a depth of 0.4–0.6 m in a clearly Chalcolithic context. The provenience of the fragment is much more dubious, since the museum has no record of

find number, level, or trench and it is not mentioned in the day book.

Souskiou-Vathyrkakas

In Tomb 3 at Souskiou-Vathyrkakas was found a spiral twisted spacer, mentioned by Tylecote (1977) and recently illustrated by Christou (1989). It probably dates to about 3000 B.C.

Lemba-Lakkous

Two copper based objects excavated at Lemba-Lakkous (Peltenburg 1982: 42) are a chisel and a corroded trapezoidal piece of metal (fig. 8).

Both were well stratified, having been deposited at the end of the first or during the second phase of occupation in Building 3. Carbon-14 dates from nearby phases, linked by ceramics to that from which the metals came, give a date of about 2500 B.C.

Kissonerga-Mosphilia (see Peltenburg, this issue, pp. 17–35)

Most Chalcolithic copper based objects in Cyprus, five in all, have come from Peltenburg's excavations at Kissonerga-Mosphilia (see Peltenburg, this issue, with references) discussed in order below.

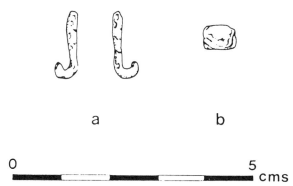

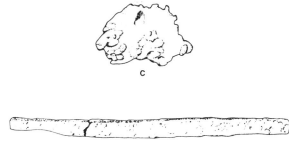

Fig. 6. Chalcolithic copper hook (a) and plaque (b) from Kissonerga-Mylouthkia.

Fig. 8. Chalcolithic chisel (d) and trapezoidal piece of metal (c) from Lemba-Lakkous.

Fig. 7. Chalcolithic hook from Erimi (no. 7) (Photograph by Diane Bolger).

An extremely interesting green-blue malachite ore in a bivalve shell was found in Grave 554 from Period 2, dating to about 3500 B.C. Similar examples of colored minerals in shells occur in Egyptian and Mesopotamian burials, where they are often interpreted as cosmetics. That could also be the case here. It is impossible to conclude, from this evidence alone, that the very early use of a copper mineral in Cyprus[4] has anything to do with copper metallurgy,[5] or that the inhabitants of Kissonerga-Mosphilia even connected the mineral with the metal copper.

Small Find 1182 from the same site is a spiral metal hair ring 1.7 cm in diameter, 0.2 cm thick. It cannot yet be better dated than either Mosphilia Period 4 or 5, Late Chalcolithic or Transitional Early Bronze Age (Philia Stage). Similar rings occur in Cyprus at Philia-Vasiliko and Nicosia-Ayia Paraskevi (see Gjerstad et al. 1972: figs. 84:10–12, 101:4–5). Perhaps significantly, there are Anatolian parallels at EB II Tarsus (Goldman 1956).

All the other metal objects from Mosphilia date to Period 4 and are Late Chalcolithic, about 2500 B.C. Small Find No. 416 is an awl with a bone handle (Peltenburg 1985: 62, fig. 4). Similar square sectioned awls are known from later, Early Cypriot, contexts (Stewart, in Gjerstad et al. 1972: 248, fig. 100:28), though it is not until later that intact bone handles are recorded, for instance from Lapithos (Dikaios 1961: pl. 26.4). However the Mosphilia find is such a simple object that one need not doubt its Late Chalcolithic context.

One of the most substantial Late Chalcolithic copper based objects from Mosphilia is Small Find No. 457 (fig. 9), the butt of an axe or adze from compacted deposits immediately over the tumble of building 86 (Peltenburg 1985: 62). At the butt end it is 3.6 cm wide; it is 3.3 cm long and 0.3 cm

Fig. 9. Chalcolithic axe butt (KM457) from Kissonerga-Mosphilia (photograph by E. Peltenburg).

Fig. 10. Chalcolithic chisel (KM986) from Kissonerga-Mosphilia (photograph by E. Peltenburg).

thick, somewhat larger than most other early examples from Cyprus (cf. Dikaios in Gjerstad *et al.* 1972: fig. 84; Stewart in Gjerstad *et al.* 1972: 249).

Also substantial is Small Find No. 986 (fig. 10), a hitherto unpublished, square sectioned, late Chalcolithic chisel, 11.2 cm long and 0.8 cm wide. It is a little larger than the similar square sectioned chisel from Lemba-Lakkous (see fig. 8); both are different from the rectangular-sectioned chisel excavated by Dikaios at Erimi.

The last of the five copper metal objects from Kissonerga-Mosphilia is another unpublished copper chisel, Small Find No. 694, from Unit 246, 9.8 cm long and having a square section of 1.1×1.1 cm.

Some other objects from Late Chalcolithic Mosphilia also may be connected with metals. One is

Small Find No. 701 from Unit 238, which dates to Period 4. It may be either a completely corroded lump of copper or a piece of oxidized copper ore. Another is Small Find No. 633 from Unit 150, of Period 4, a lump of what is definitely copper ore. Figure 11 shows a polished section, as seen under the optical microscope, showing that it contains oxidized copper ore. Figure 12 shows that in other regions it contains the most common Cypriot copper mineral, chalcopyrite, $FeCuS_2$.

COMPARATIVE CHALCOLITHIC METALLURGY

This brief survey of Chalcolithic metals in Cyprus and the nearby regions points up the relative poverty of early metallurgy in Cyprus. Dating to the period 3500 to 3200 B.C. in Cyprus are only two small hooks and a chisel tip plus malachite in a shell; dating to about 2500 B.C. are only eight more copper based objects, which include as moderately substantial objects only three chisels and one axe/adze. Only in somewhat later times is there evidence of really substantial use of copper, and even then it is limited to northern sites such as Vounous, Vasilia, and Lapithos.

In contrast, already in early fourth millennium Anatolia there are more substantial arsenical copper objects at the single site of Beycesultan than have been found in the whole of Chalcolithic Cyprus. By 3200 B.C. at Arslantepe there are numbers of substantial swords and spearheads of arsenical copper. Mid-fifth millennium copper mining existed at Rudna Glava and Ai Bunar, and by about 4300 B.C. in Bulgaria there was an abundance of heavy axes and chisels. Relatively extensive Chalcolithic copper mining and extractive metallurgy began in Fenan and Timna at the latest by the middle of the fourth millennium B.C.; the substantial arsenical copper objects found at Nahal Mishmar and other Levantine sites date to the early or mid-fourth millennium B.C.

In the face of such evidence—and one could add to this the metals from the Eneolithic cemetery at Byblos—the few small objects from Cyprus seem to suggest that the Chalcolithic copper industry in Cyprus is primitive and provincial indeed. By itself the comparison seems to argue against seeing the beginnings of copper metallurgy in Cyprus in terms of foreign influence or colonization, or the direct importation of copper metal or objects, unless Chalcolithic Cyprus was so insignificant for its

neighbors that it was unable to command any-thing but unwanted trifles from their metallurgical industries.

SCIENTIFIC EVIDENCE

Scientific evidence may increase our knowledge about Chalcolithic Cypriot metallurgy beyond what we can glean from descriptions of excavated objects. Clearly chemical analyses can at least reveal the type of copper used, whether it was almost pure copper or an alloy of copper with arsenic or tin. The use of tin, ores of which do not occur in Cyprus, would immediately indicate that foreign metals were being imported to Cyprus. Comparative metallographic studies plus trace element chemical analyses of Chalcolithic copper-based objects and naturally occurring native copper metal might establish whether the Chalcolithic objects were made of native copper, or if their manufacture involved the extraction of copper from its ores by smelting. Lead isotope analyses would prove whether or not the Chalcolithic metal objects were made from copper ores occurring in Cyprus.

CHEMICAL ANALYSES

Chemical analyses of Chalcolithic Cypriot copper objects were made using neutron activation analysis.[6] Previous analyses existed only for the Erimi chisel, performed by Brun for Dikaios (1936), and for two objects from Lemba and two from Kissonerga-Mylouthkia, done by Slater (Peltenburg 1982). Preliminary optical emission spectrographic analyses were carried out by Zwicker (unpublished) on the Erimi hook and plaque.

Table 4 shows the new analyses of the five Chalcolithic Cypriot metal objects available to us so far. It also includes an analysis by Slater, and analyses made in Oxford of four copper ore samples from Chalcolithic Cypriot levels. The table shows that the chisel from Erimi and the later chisel from Lemba are made of arsenical copper, but arsenic contents at that level do not necessarily point to a deliberate alloying process. The arsenic may easily be the result of smelting arsenical copper ores, as is the case for the Early Cycladic arsenical copper objects (Stos-Gale 1989). There is no tin bronze. Only two objects have any measurable tin content at all: the Lemba blade fragment, at 0.23 percent, and the Erimi chisel, at 0.07 percent. The amount of tin in the Erimi chisel is a factor of two lower

Fig. 11. Polished section of copper ore (KM633) found in a Chalcolithic level at Kissonerga-Mosphilia, showing oxidized copper ore (photomicrograph by U. Zwicker).

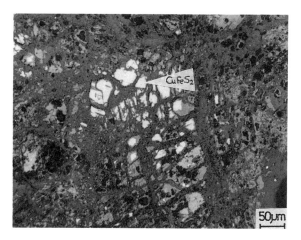

Fig. 12. Polished section of another area of KM 633, showing the presence of the copper ore chalcopyrite, $CuFeS_2$ (photomicrograph by U. Zwicker).

than the analysis by Brun, who also overestimated the iron content. The analyses in Oxford were checked by the analysis of Swiss standards circulated in an interlaboratory comparative study and also by the analysis of copper standards supplied by the U.S. National Bureau of Standards.

The oxidized ores from stratified levels at Kissonerga-Mosphilia contain no tin or arsenic, but they do have high percentages of copper. Thus rich copper ores were certainly known at that Chalcolithic site, but in what amount or whether they were smelted to extract metallic copper cannot be known from this evidence alone.

TABLE 4. Chemical Analyses, by Instrumental Neutron Activation Analysis (INAA), of Chalcolithic Metals and Ores from Cyprus

Sample	Type	Date	Percent		Parts per million													Percent
			Sn	As	Sb	Au	Ag	Se	Te	Fe	Zn	Co	Cr	Ni	Sc	Gu	Cu	
Erimi	Chisel	3200 B.C.	0.07	1.12	1084	8.2	244	33	<66	771	<80	4.9	<19	735	1.9	n.d.	98.8	
Erimi 7	Hook	3200 B.C.	<0.02	0.066	642	3.2	230	122	<29	151	<28	6.7	<6	<60	0.8	n.d.	99.2	
Kissonerga-Mylouthkia	Hook	3500 B.C.			(270)	(7.8)	(720)			(930)		(3.5)	(45)					
Lemba 134	Chisel	2500 B.C.	<0.04	0.75	4889	0.7	5400	<23	<100	<100	705	5	<33	<280	1.0	n.d.	98.9	
Lemba 209	Blade?	2500 B.C.	0.23	0.003	200	5.0	44	133	<13	621	<14	8	7	<31	0.3	n.d.	99.4	
Kissonerga-Mosphilia 457	Axe	2500 B.C.	<0.01	0.002	3.6	3.4	9.5	139	9.3	<200	<17	32	<3	<40	0.4	n.d.	99.6	
Kissonerga-Mosphilia 2109	Ore	3500 B.C.	<0.03	0.002	20.3	<0.05	<5	<11	<32	9986	582	11.4	92	<118	7.4	n.d.	28.9	
	(Shell)																	
Kissonerga-Mosphilia 633	Ore	2500 B.C.	<0.01	0.0008	30	0.17	<2	<5	<14	80,000	438	355	844	490	8.0	14	1.0	
CY1230 I																		
Kissonerga-Mosphilia 633	Ore	2500 B.C.	<0.01	0.0016	36	0.45	<2	9	<19	50,000	726	357	215	688	5.0	14	14.5	
CY1230 II																		
Kissonerga-Mosphilia 633	Ore	2500 B.C.	<0.01	0.0012	36	0.33	<3	<10	<22	28,000	465	170	420	213	3.0	14	23.5	
CY1230 IIA																		

TABLE 5. Chemical Analyses, by INAA, of Early Cypriot Copper Based Objects from Vounous, Cyprus

		Percent		Parts per million							
Tomb and Object Number		Sn	As	Sb	Au	Ag	Se	Fe	Zn	Co	Date
T111.51	Knife	<0.01	3.20	28	69.6	539	42	1603	<100	234	EC IC
T111.52	Dagger	0.016	1.34	138	7.1	76	42	9653	100	39	EC IC
T111.53	Dagger	<0.01	0.49	4	13.3	559	27	<100	<100	4	EC IC
T161.43	Dagger	<0.01	0.12	41	15.9	193	202	1436	247	9	EC IB
T161.44	Knife	11.2	0.51	500	31.6	638	35	1099	323	41	EC IB
T161.45	Axe	0.067	0.49	204	19.0	91	141	3616	<100	37	EC IB
T161.46	Dagger, rat tanged	<0.01	3.00	39	38.9	41	94	<100	20	29	EC IB
T161.48	Axe	0.065	0.49	206	20.5	88	143	3888	<100	37	EC IB
T15.73	Dagger, rat tanged	<0.01	0.31	134	0.29	9	294	4180	195	14	EC III
T15.80	Dagger	<0.01	0.85	80	0.26	28	180	<100	<100	<0.5	EC III

TABLE 6. Trace Element Analyses of Early Cypriot Copper Based Objects from Lapithos

		Percent		Parts per million						
Number	Object	Sn	As	Sb	Au	Ag	Se	Fe	Zn	Co
53	Pin	14.2	0.166	24	0.42	25	48	552	214	18
72c	Pin	15.5	0.433	69	4.57	4232	20	943	294	14
74	Sword	0.24	1.40	71	5.38	72	83	3710	179	7
99	Pin	0.65	0.129	30	11.50	1598	195	n.d.	n.d.	22

The analyses of the Chalcolithic objects can be compared with the new analyses (Table 5) of the composition of Early Cypriot I objects from Vounous dating only a little later, to about 2500–2400 B.C. The objects from Vounous are nearly all of arsenical copper and all contain some arsenic, in contrast to the Chalcolithic objects, of which over half contain no arsenic. An EC IB knife from Tomb 161 at Vounous is, surprisingly, of tin bronze with 0.5 percent arsenic. If that piece really does date to EC IB, it is the earliest tin bronze yet known from Cyprus. It would date to about 2400 B.C., but its content of tin, arsenic, gold, and silver are all very similar to those of EB II tin bronze objects from Troy, which presumably date a few hundred years earlier.

Table 6 presents some new analyses of EC III objects from Lapithos, dating presumably to about 2000 B.C. They all contain tin and arsenic, two being tin bronzes. It is certain, therefore, that tin, perhaps as tin bronze, was being imported into Cyprus at least as early as EC III, if the dating of the objects from Lapithos Tomb 313A is correct.

NATIVE COPPER

It has been conjectured that Chalcolithic Cypriot copper artifacts might have been made of native copper occurring naturally in Cyprus. Peltenburg (1982: 53–56) noted that the appearance of copper objects in Chalcolithic Cyprus coincided temporally with a sharp rise in picrolite production (Peltenburg 1982),[7] and that picrolite certainly and native copper notionally were dispersed beyond the mineralization zone by river transport. He postulated a connection: Chalcolithic people, having become interested in collecting attractive bluish-colored picrolite, also might have noticed and collected native copper. Although his argument is a little weak, since native copper is rarely blue but ranges mostly from copper-red through brown to black, it is nevertheless a hypothesis worthy of further study.

TABLE 7. Trace Element Analyses, by INAA, of Native Copper from Various Localities in Cyprus

Sample No.	Mine	Parts per million												
		Sn	As	Sb	Au	Ag	Se	Te	Fe	Zn	Co	Cr	Ni	Sc
Cy 500A	Peristerka	<40	2.0	<0.2	0.06	0.6			<45	2	1.0	<1		
CY 500B	Peristerka	<40	5.1	0.3	0.02	1.0			<45	<4	0.7	<1		
CY 49	Peristerka	<40	5.0	0.7	0.08	3.0			<45	<6	1.8	<1		
CY 1419A	Limni	<116	2.25	2.22	0.15	4.9	16	<11	<160	<14	3.3	2.4	<33	1.0
CY 1147	Kokkinorotsos	<40	1.5	0.3	0.02	38			828	<2	1.1	15		
CY 51A	Troodos	<40	2.3	0.2	0.04	26			712	<3	<0.1	78		

It has been argued that it is difficult to identify with certainty by metallographic means whether or not a copper artifact is made of native copper (Maddin, Wheeler, and Muhly 1980).

Can the trace element chemical analyses of Chalcolithic Cypriot objects be used instead to determine whether they were made of native copper occurring naturally on Cyprus? Some authors have expressed skepticism also about this approach (e.g., Tylecote 1976: 1), but their question seems to be because they were inclined to compare the trace element composition of archaeological objects with analyses of native copper drawn from all over the world. For the present study, however, attention should, of course, be confined to analyses of native copper from Cyprus itself.[8]

Native copper occurs rarely in Cyprus; according to Bear (1963) it has been recorded chiefly from the chromite mines at Troodos and from mines at Peristerka, Mavrovouni, and Limni, with very minor occurrences at Sha, Kalavasos, and Monagroulli (see fig. 5).

Quite large nuggets of native copper have recently been found in the chromite mines, but those mines were not accessible to Chalcolithic people, nor can native copper from that source have been eroded out and transported by rivers. The much more common form in which native copper occurs in Cyprus is as mossy, dendritic, platy, or filiform encrustations on another ore such as limonite. Examples of that form from the Limni mine are of particular interest as a possible source of copper for western Cyprus. Other examples available for analysis came from the Kambia mine area, specifically from Peristerka.[9]

The trace element analyses of Cypriot native copper (Table 7) show that it is extremely pure, with impurities occurring only at the parts per

million (ppm) or sub-ppm level. It contains no detectable tin and only a few ppm of arsenic. This high purity is characteristic of 99 percent of native copper from all over the world (Patterson 1971).

Silver (Ag), iron (Fe), and chromium (Cr) are all low in the Cypriot native coppers, except that the two native coppers from the chromite $[Cr_2FeO_4]$ mines of Kokkinorotsos and Troodos have noticeably higher contents of all three elements. It would be possible to distinguish a Chalcolithic object made from native copper from the chromite mines on that basis alone.

Figure 13 compares the analyses of the objects and Cypriot native copper for the elements tin (Sn), arsenic (As), antimony (Sb), silver (Ag), cobalt (Co), zinc (Zn), and gold (Au). The concentration scales cover four orders of magnitude, a range of 10,000 to 1. The contents of Sn, As, Sb, Ag, and Au in the Chalcolithic objects are all very much higher than in Cypriot native copper. Figure 14 shows the differentiation between the Chalcolithic objects and the native copper in a more striking way through multivariate statistical analysis (see Manly 1986). Stepwise discriminant analysis[10] shows a clear grouping of the native coppers, well away from the Chalcolithic metal objects.

We can be sure that none of the analyzed Chalcolithic objects was made of native copper from the four Cypriot sources analyzed. Those sources of native copper are geographically widely dispersed through Cyprus; moreover, the ores from the Limni and Peristerka mines come from the Cretaceous horizon common to all the oxidized and sulphidic copper ores, while those from the two chromite mines come from a considerably older geological horizon (fig. 15). It is highly unlikely that there was ever a source of native copper on Cyprus impure enough to match the Chalcolithic objects.

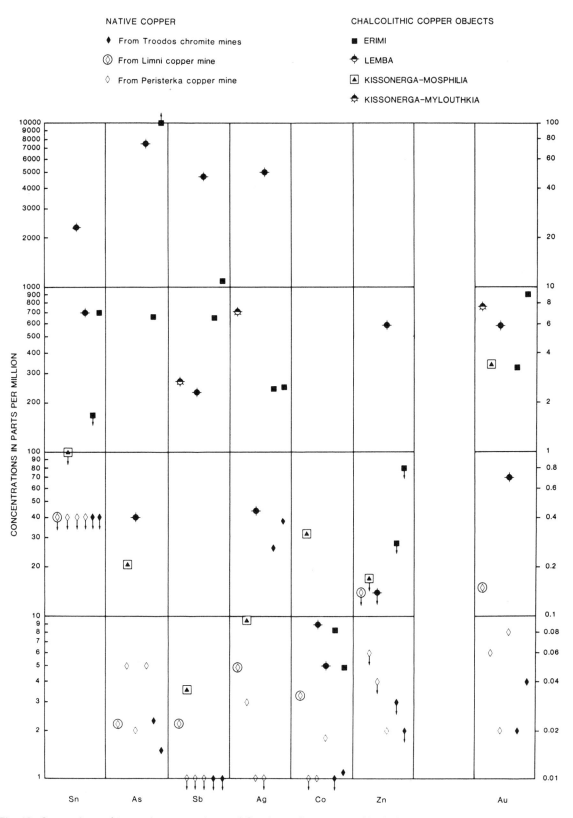

Fig. 13. Comparison of trace element analyses of Cypriot native copper with similar analyses of Chalcolithic Cypriot copper based objects.

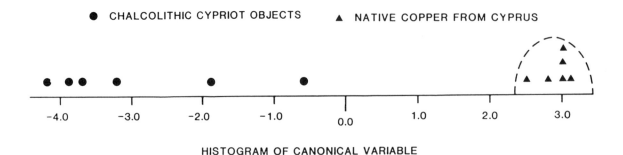

STEPWISE DISCRIMINANT ANALYSIS FOR Ag, Au, Sb, As, Sn, Zn, Co

● CHALCOLITHIC CYPRIOT OBJECTS ▲ NATIVE COPPER FROM CYPRUS

HISTOGRAM OF CANONICAL VARIABLE

Fig. 14. Stepwise discriminant analysis of trace element analyses of Cypriot native copper and Chalcolithic Cypriot copper based objects, showing that the Chalcolithic objects do not fall into the core group for native copper.

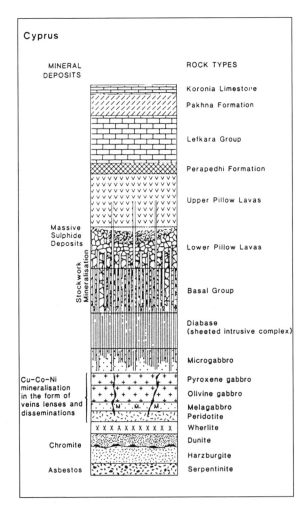

Fig. 15. A schematic geological column for Cyprus, showing that the chromite occurrences (including the native copper found within the chromite deposits) are geologically older than the massive sulphide deposits (also containing rare native copper occurrences) occurring in the pillow lavas.

METALLOGRAPHIC ANALYSIS

Metallographic analyses have been made by Tylecote (1977) for the Souskiou spiral, by Northover in Oxford for the Erimi hook, and by Zwicker in Erlangen both for the Erimi hook and the Erimi plaque. The Erimi plaque, though found by Bolger in the Erimi material in Nicosia, was not mentioned in Dikaios' day book. Coupled with this, Zwicker's semiquantitative optical emission spectroscopic analysis showed a high amount—+++++, in the conventional representation for this type of analysis—of tin (erroneously recorded by Balthazar 1990: 92–93); his metallographic section (shown in fig. 16) is typical for a high tin bronze. It seems most unlikely that the plaque is of Chalcolithic date.

Metallography can measure the hardness of a copper-based metal, and etched and unetched sections can provide information as to whether the metal was hot- or cold-worked or deformed (Scott 1987).

Figure 17 shows the etched metallographic section, magnification x100, of the Erimi hook. The hardness was measured as 109HV5. In the unetched section, thin stringers of copper sulphide (Cu_2S) were seen. The etched section shows a fully recrystallized equiaxed grain structure with annealing twins; the grains are slightly distorted but slip traces were not etched. From the metallographic evidence it can be deduced that the hook was cold-worked and annealed, that the total reduction in the section etched was about 80 percent, and that the final cold reduction was about 20 per cent.

For the Souskiou spiral Tylecote (1977) measured a hardness of 54HVI. He observed that the

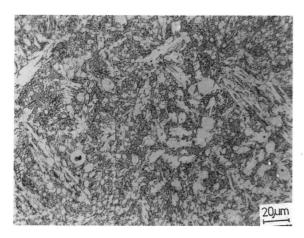

Fig. 16. Metallographic section of the plaque found by D. Bolger in the Nicosia Museum with the Erimi material excavated by Dikaios; the structure is typical for a high tin bronze (Photomicrograph by U. Zwicker).

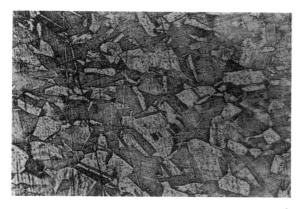

Fig. 17. Etched metallographic section of Erimi hook no. 7, mentioned in Dikaios' day book and found in the Nicosia Museum by D. Bolger among the Erimi material (Photomicrograph by N. H. Gale).

center of the strip is fully recrystallized with straight twins and that at the edges there are some bent twins but no slip lines. He deduced that it had been worked and then annealed, with subsequent reworking, particularly on the surface.

It is clear that both the cold-working and annealing of copper were known and practiced in Chalcolithic Cyprus, unless all of the studied objects were imported.

LEAD ISOTOPE ANALYSIS

Lead isotope analysis is the only method currently available for determining whether the Chalco-

lithic metals were made from Cypriot copper ores.[11] This method depends on the natural variability in the isotopic composition of lead, that is, the variability of the ratios between the numbers of the atoms of lead of the different masses 208, 207, 206, and 204. Without going into details, each of several different copper mines, which always contain traces of lead, has a characteristic lead isotope composition that covers a small range. That composition depends to the first order on the geological age of the copper deposit. The isotopic composition of the small amounts of lead occurring in ancient copper artifacts—lead that comes from the copper ores from which the copper metal was smelted— can be compared with the lead isotope compositions characteristic of the various copper mines.

To discover the isotopic composition for the Cypriot copper deposits the ore deposits were sampled (see fig. 18) and the isotopic field was established (fig. 19). If a Chalcolithic copper object, or a copper ore found in a Chalcolithic level, has an isotopic composition falling within that field, it is consistent with having been made of copper from a Cypriot copper deposit. If the lead isotope composition falls outside the field, it cannot have been made from Cypriot copper.

For lead isotope analysis of Chalcolithic objects adequate samples so far are available only for the copper axe (KM 457) and copper ore (KM 633) found at Kissonerga-Mosphilia. Figure 20 also shows the lead isotope analyses of four EC I arsenical copper objects from Vounous; all of these EC I objects are consistent with having been made using copper smelted from Cypriot copper ores. Also consistent with the lead isotope field of Cypriot copper ores is the Chalcolithic copper ore (KM 633) from Kissonerga-Mosphilia, which indicates that oxidized Cypriot copper ores were certainly known at that site, though whether they were recognized as a source of copper is uncertain.

The biggest surprise is that the copper axe butt from Kissonerga-Mosphilia was not made of copper smelted from Cypriot copper ores; its lead isotope composition falls below the Cypriot field. Sporadic, small occurrences of oxidized copper minerals do occur near Kissonerga and Lemba; since they occur outside the main belt of copper deposits, they might conceivably have different lead isotope compositions, which might match the axe. However our preliminary analyses of such copper ores from Akoursos-Mavrokolymbos, Khlorakas, and elsewhere[12] show that the axe was not made from those Cypriot copper ores either. One could

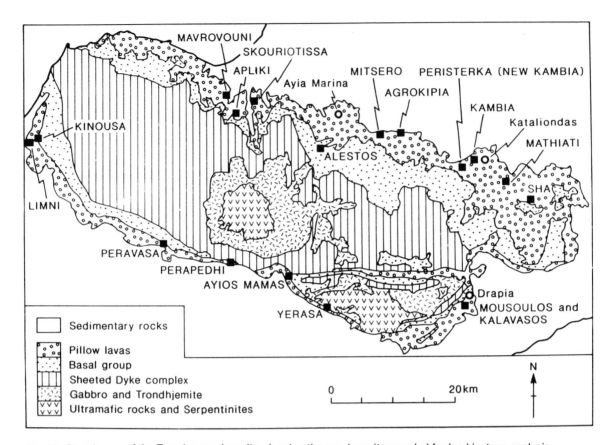

Fig. 18. Sketch map of the Troodos ore deposits, showing the ore deposits sampled for lead isotope analysis.

speculate that it might have come from Anatolia. Until recently archaeologists have tended, when writing about Anatolian copper ore deposits, to concentrate on the very large copper deposits at Ergani Maden as the possible source of much ancient copper.

Figure 21 compares the lead isotope composition of the axe butt with the field for Ergani Maden. This lead isotope diagram proves that Ergani was not the source of copper for the axe under discussion.

The work of the German team led by Wagner (see Wagner, Oztunali, and Eibner 1989) and of the Turkish team led by Yener (Yener *et al.* 1989) has directed attention to many other copper sources in Turkey. Lead isotope analyses for some of those have been made by both groups.

The only Turkish copper ore deposit with a published lead isotope composition close to that of the Kissonerga axe is that of Dogançilar (Site TG133 in Pernicka *et al.* 1984: 557–58) in the Troad. It may or may not be significant that two daggers

from Vounous Tomb 15 of EC IIIB date and two daggers from Vasilia Tomb 1 of the Philia culture also have a lead isotope composition compatible with their copper having come from the Dogançilar copper ore deposit. The copper deposits so far analyzed from the Taurus Mountains by Yener *et al.* (in press) do not match the Kissonerga object or the daggers from Vounous and Vasilia.

It thus appears that the Kissonerga axe itself, or the copper from which it was made, was imported to Cyprus, perhaps from northwestern Anatolia. But unless good samples for lead isotope analysis from the other Chalcolithic Cypriot objects can be found, it cannot be determined whether all are of foreign copper.

CONCLUSIONS

It has been shown that the Chalcolithic metallurgy of Cyprus is somewhat primitive and provincial when viewed from the standpoint of metallurgy in the surrounding mainland regions. Some Cypriot

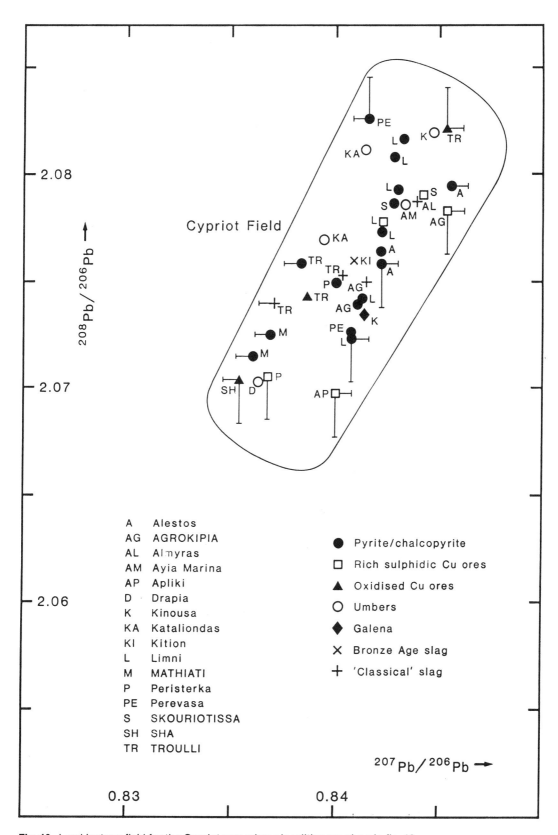

Fig. 19. Lead isotope field for the Cypriot ores whose localities are given in fig. 18.

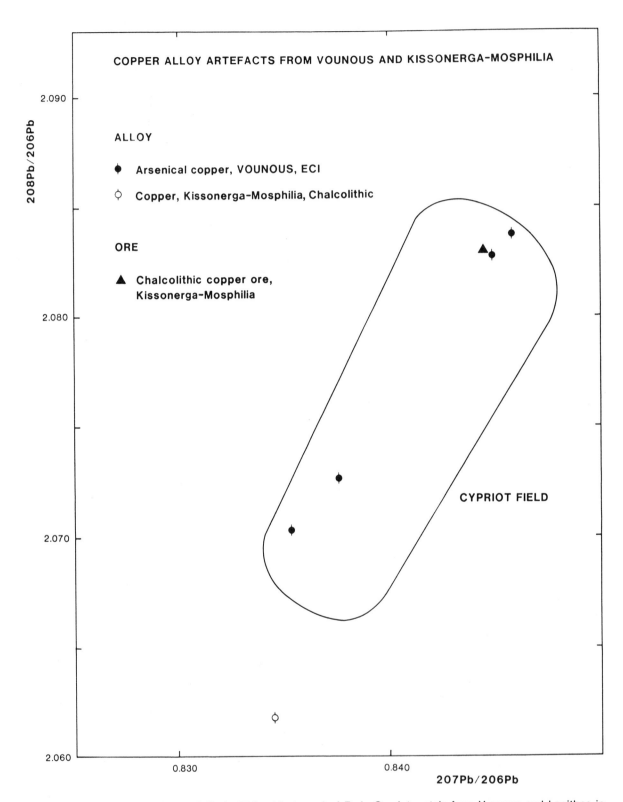

Fig. 20. Lead isotope analyses of Chalcolithic objects and of Early Cypriot metals from Vounous and Lapithos in relation to the Cypriot lead isotope field.

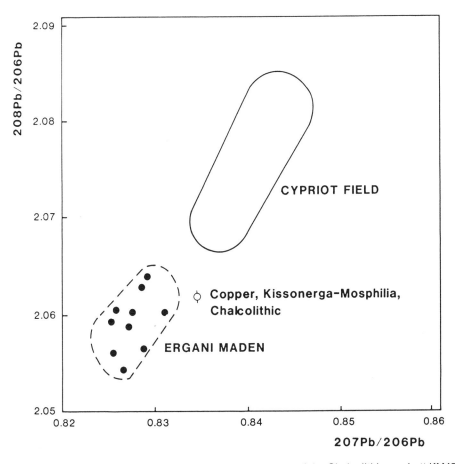

Fig. 21. Comparison of the lead isotope composition of the Chalcolithic axe butt KM457 with the field characteristic of the large copper deposit at Ergani Maden in Turkey.

oxidized ore was certainly acquired by the Chalcolithic people, though at present it is not known whether they extracted copper metal from it or regarded it merely as a pigment. It seems clear that the six analyzed Chalcolithic objects cannot have been made from Cypriot native copper, but were probably of metal smelted from copper ores. This greatly weakens earlier suggestions that the beginning of the use of metals in Cyprus did involve the use of native copper found in the same river beds that supplied picrolite. That contradicts the hypothesis that the advent of metallurgy in Cyprus was directly related to the search for picrolite, both copper and picrolite having been transported from their source regions by rivers. At least the one Chalcolithic axe was made from non-Cypriot copper metal that may have come from northwestern Anatolia. Further, some typological parallels may link the hair ring, No. 1182 from Kissonerga-Mosphilia, with Anatolia. Metallographic investigations show that those who made the few Chalcolithic artifacts thus far investigated were acquainted with cold-working and annealing. Whether that represents talents of the Chalcolithic Cypriot people or of foreigners, however, cannot be guessed without more information from lead isotope analyses of the other Chalcolithic Cypriot metal objects, which would point to the geographical origin of the copper metal used in their manufacture. At present it is not known if the foreign origin of axe No. 457 from Kissonerga-Mosphilia is atypical; nor do we know whether the eleven Chalcolithic objects so far excavated in Cyprus represent any use of Cypriot copper ores at all.

ACKNOWLEDGMENTS

This paper could not have been written without the generosity in supplying information and materials of numerous colleagues, in particular V. Karageorghis, E. Peltenburg, U. Zwicker, D. Bolger, C-G. Styrenius, E. Slater, G. Constantinou, A. Panayiotis, and N. M. Charalambides, to all of whom I offer my warm gratitude. The financial support of the Leverhulme Trust, the Science and Engineering Research Council, the Getty Museum, and the Leventis Foundation are gratefully acknowledged.

NOTES

[1]Levy and Shalev (1989: 352–72) present a discussion of Levantine metalwork and its social perspectives.

[2]I thank D. Bolger for permission to mention these finds.

[3]These were recently found by V. Karageorghis in the Museum files and made available for study to D. Bolger.

[4]The malachite could well have been found near Kissonerga, since that copper mineral does occur locally at Chlorakas and Akoursas (U. Zwicker, personal communication).

[5]In Eneolithic sites around the fifth millennium copper mine of Ai Bunar in Bulgaria, green and blue malachite and azurite occur in stratified contexts, as do large copper tools. However lead isotope analyses show that, although the copper ores do come from Ai Bunar, the analyzed copper artifacts are not made of copper from that deposit (Gale *et al.*, in press).

[6]The use of instrumental neutron activation analysis for the determination of trace elements in copper is discussed by Stos-Gale 1991.

[7]Picrolite was used for a substantial repertoire of pendants, beads, figurines, vessels, etc.; e.g., Vagnetti 1980.

[8]In this regard the average analyses presented by Rapp (1982: 33–40) for native copper allegedly from Cyprus are not admissible, since the analyzed native coppers came from American museum collections and had but an uncertain attribution to Cyprus.

[9]G. Constantinou gave U. Zwicker samples from the Limni copper mine and from the Troodos chromite mines; they and N. M. Charalambides gave us samples from those sources and the Kambia copper mines area.

[10]The program 7m from the BMDP set of multivariate statistical programs described by Dixon 1990.

[11]Reviews of this method are presented in Gale 1989; Gale and Stos-Gale 1988.

[12]U. Zwicker kindly provided these ores.

BIBLIOGRAPHY

Balthazar, J. W.
 In press *Copper and Bronzeworking in Early through Middle Bronze Age Cyprus.* Studies in Mediterranean Archaeology Pocketbook. Götheborg: Åström.
Bar-Adon, P.
 1980 *The Cave of the Treasure.* Jerusalem: Israel Exploration Society.
Bear, L. M.
 1963 *The Mineral Resources and Mining Industry of Cyprus.* Nicosia: Cyprus Geological Survey.
Brewer, E. C.
 1870 *A Dictionary of Phrase and Fable.* London: Cassell.
Caneva, C., and Palmieri, A. M.
 1983 Metalwork at Arslantepe in Late Chalcolithic and Early Bronze I: The Evidence from Metal Analyses. *Origini* 12: 637–54.

Černych, E. N.
 1978a *Gornoe delo i Metallurgia v Drevneishei Boulgarii.* Sofia: Boulgarski Akademii Nauk.
 1978b Aibunar—a Balkan Copper Mine of the Fourth Millennium B.C. *Proceedings of the Prehistoric Society* 44: 203–17.
 1982 Die altesten Bergleute und Metallurgen Europas. *Das Altertum* 28, 1: 5–15.
Christou, D.
 1989 The Chalcolithic Cemetery 1 at Souskiou-Vathyrkakas. Pp. 82–94 in *Early Society in Cyprus,* ed. E. J. Peltenburg. Edinburgh: Edinburgh University.
Daux, G.
 1968 Chronique des fouilles et découvertes archéologiques en Grèce en 1967. *Bulletin de Correspondance Hellénique* 92: 711–1136.
Delibrias, G.; Guillier, M. T.; and Labeyrie, J.
 1974 Natural Radiocarbon Measurements VIII. *Radiocarbon* 16: 15–94.

Deshayes, J.
 1970 Dikili Tash. *Bulletin de Correspondance Hel-
 lénique* 94: 799–808.
Dikaios, P.
 1936 The Excavations at Erimi, 1933–1935. *Report
 of the Department of Antiquities of Cyprus*:
 1–81.
 1961 *A Guide to the Cyprus Museum*. Nicosia:
 Department of Antiquities of Cyprus.
 1962 The Stone Age. Pp. 1–204 in *Swedish Cyprus
 Expedition IV-1A*. Lund: Swedish-Cyprus
 Expedition.
Dixon, W. J.
 1990 *BMDP Statistical Software Manual*. Berke-
 ley: University of California.
Earle, T.
 1984 On the Evolution of Complex Societies. Es-
 says in Honor of Harry Hoijer 1982. *Other
 Realities* 6.
Frangipane, M., and Palmieri, A. M.
 1983 Perspectives on Protourbanization in Eastern
 Anatolia: Arsentepe (Malatya). An Interim
 Report on 1975–83 Campaigns. *Origini* 12:
 287–454.
Gale, N. H.
 1989 Lead Isotope Studies Applied to Archaeology:
 a Brief Review. Pp. 469–502 in *Archaeometry*,
 ed. Y. Maniatis. Amsterdam: Elsevier.
Gale, N. H., and Stos-Gale, Z. A.
 1988 Bronze Age Archaeology of the Mediterra-
 nean: The Impact of Lead Isotope Studies.
 Pp. 159–98 in *Archaeological Chemistry* IV, ed.
 R. O. Allen. Washington: American Chemical
 Society.
Gale, N. H.; Stos-Gale, Z. A.; Dimitrov, M.; and
 Todorov, T.
 In press Recent Studies of Eneolithic Copper Ores and
 Artefacts in Bulgaria. In *Proceedings of the
 1989 Colloquium La Découverte du Metal*,
 ed. C. Eluère. Paris: Picard.
Gjerstad, E. *et al.*
 1972 *The Swedish Cyprus Expedition* IV.1A. Lund:
 Swedish Cyprus Expedition.
Goldman, H.
 1956 *Excavations at Gözlü Kule, Tarsus II. From
 the Neolithic through the Bronze Age*. Prince-
 ton: Princeton University.
Hauptmann, A.
 1989 The Earliest Periods of Copper Metallurgy in
 Feinan, Jordan. Pp. 119–35 in *Old World
 Metallurgy*, Der Anschnitt Beiheft 7, eds. A.
 Hauptmann, E. Pernicka, and G. A. Wagner.
 Bochum: Deutsches Bergbau-Museums.
Jovanovic, B.
 1980a The Origins of Copper Mining in Europe.
 Scientific American 242, 5: 152–67.

 1980b Primary Copper mining and the Production
 of Copper. Pp. 31–40 in *Scientific Studies in
 Early Mining and Extractive Metallurgy*, ed.
 P. T. Craddock. London: British Museum.
 1989 Die Rolle des Kupfers in der Ökonomie der
 frühäneolithischen Gruppen des Balkans.
 Pp. 13–19 in *Old World Metallurgy*, Der An-
 schnitt Beiheft 7, eds. A. Hauptmann, E. Per-
 nicka, and G. A. Wagner. Bochum: Deutschen
 Bergbau-Museums.
Key, C. A.
 1980 The Trace Element Composition of the Cop-
 per and Copper Alloys of the Nahal Mishmar
 Hoard. Pp. 238–43 in *The Cave of the Trea-
 sure*, by P. Bar-Adon. Jerusalem: Israel Ex-
 ploration Society.
Klein, J.; Lerman, J. C.; Damon, P. E.; and Ralph, E. K.
 1982 Calibration of Radiocarbon Dates. *Radio-
 carbon* 24: 103–50.
Lambert, N.
 1970 Grotte de Kitsos (Laurion). *Bulletin de Cor-
 respondance Hellénique* 95: 703–35.
 1973 Les industries de la grotte néolithique de
 Kitsos. Pp. 502–15 in *Actes du VIIIᵉ Con-
 grés Internationale des Sciences Préhistoire
 et Protohistorique*, Vol. 2. Belgrade: Univer-
 sity of Belgrade.
Lechtman, H.
 1980 The Central Andes, Metallurgy without Iron.
 Pp. 267–334 in *The Coming of the Age of
 Iron*, eds. T. A. Wertime and J. D. Muhly.
 New Haven: Yale.
Levy, T. E., and Shalev, S.
 1989 Prehistoric Metalworking in the Southern
 Levant: Archaeometallurgical and Social Per-
 spectives. *World Archaeology* 20, 3: 352–72.
McGeehan-Liritzis, V., and Gale, N. H.
 1988 Chemical and Lead Isotope Analyses of
 Greek Late Neolithic and Early Bronze Age
 Metals. *Archaeometry* 30: 199–255.
Maddin, R.; Wheeler, T. S.; and Muhly, J. D.
 1980 Distinguishing Artifacts Made of Native
 Copper. *Journal of Archaeological Science* 7:
 211–25.
Manly, B. F. J.
 1986 *Multivariate Statistical Methods*. London:
 Chapman and Hall.
Moorey, P. R. S.
 1988 The Chalcolithic Hoard from Nahal Mishmar,
 Israel, in Context. *World Archaeology* 20,
 2: 171–89.
Muhly, J. D.
 1985 Beyond Topology: Aegean Metallurgy in its
 Historical Context. Pp. 109–41 in *Contribu-
 tions to Aegean Archaeology: Studies in*

Honor of William A. McDonald, eds. N. C. Wilkie and W. D. E. Coulson. Minneapolis: University of Minnesota.

1989 Çayonu Tepesi and the Beginnings of Metallurgy in the Ancient World. Pp. 1–12 in *Old World Archaeometallurgy*, Der Anschnitt Beiheft 7, eds. A. Hauptmann, E. Pernicka, and G. A. Wagner. Bochum: Deutsches Bergbau-Museums.

Patterson, C. C.
1971 Native Copper, Silver, and Gold Accessible to Early Metallurgists. *American Antiquity* 36: 286–321.

Peltenburg, E. J.
1982 Early Copperwork in Cyprus and the Exploitation of Picrolite. Evidence from the Lemba Archaeological Project. Pp. 41–62 in *Early Metallurgy in Cyprus 4000–500 B.C.*, eds. J. D. Muhly, R. Maddin, and V. Karageorghis. Larnaea: Pierides Foundation.
1985 Lemba Archaeological Project, Cyprus, 1983: Preliminary Report. *Levant* 17: 53–64.

Penicka, E.; Seeliger, T. C.; Wagner, G. A.; Begemann, F.; Schmitt-Strecker, S.; Eibner, C.; Oztunali, O.; and Baranyi, I.
1984 Archäometallurgische Untersuchungen in Nordwestanatolien. *Jahrbuch des Romisch-Germanischen Zentralmuseums Mainz*: 533–99.

Potaszkin, R., and Bar-Avi, K.
1980 A Material Investigation of Metal Objects from the Nahal Mishmar Hoard. Pp. 235–37 in *The Cave of the Treasure*, by P. Bar-Adon. Jerusalem: Israel Exploration Society.

Rapp, G.
1982 Native Copper and the Beginning of Smelting: Chemical Studies. Pp. 33–40 in *Early Metallurgy in Cyprus, 4000–500 B.C.*, eds. J. D. Muhly, R. Maddin, and V. Karageorghis. Larnaea: Pierides Foundation.

Renfrew, A. C.
1972 *The Emergence of Civilisation*. London: Methuen.
1973 Sitagroi and the Independent Invention of Metallurgy in Europe. Pp. 473–81 in *Actes du VIIIᵉ Congrés des Sciences Préhistoire et Protohistorique*. Belgrade: University of Belgrade.

Rothenberg, B.
1978 Excavations at Timna Site 39: A Chalcolithic Copper Smelting Site and Furnace and Its Metallurgy. Pp. 1–15 in *Chalcolithic Copper Smelting: Excavations and Experiments: Archaeometallurgy I*, ed. B. Rothenberg. London: Institute of Archaeo-Metallurgical Studies.

1982 Copper Smelting Furnaces in the Arabah. Pp. 123–50 in *Furnaces and Smelting Technology in Antiquity*, British Museum Occasional Paper 48, eds. P. T. Craddock and M. J. Hughes. London: British Museum.

Scott, D.
1987 *Metallography of Ancient Metal Artifacts*. London: Institute of Archaeology.

Seferiades, M.
1983 Dikili Tash: introduction à la préhistoire de la Macedoine oriental. *Bulletin de Correspondance Hellénique* 107: 635–77.

Shalev, S., and Northover, P.
1987 Chalcolithic Metal and Metalworking from Shiqmim. Pp. 357–71 in *Shiqmim I*, ed. T. E. Levy. BAR International Series 356(i). Oxford: British Archaeological Reports.

Stewart, J.
1962 The Early Cypriot Bronze Age. Pp. 205–401 in *The Swedish Cyprus Expedition* IV.1A. Lund: Swedish Cyprus Expedition.

Stos-Gale, Z. A.
1989 Cycladic Copper Metallurgy. Pp. 279–90 in *Old World Archaeometallurgy*, Der Anschnitt Beiheft 7, eds. A. Hauptmann, E. Pernicka, and G. A. Wagner. Bochum: Deutsches Bergbau-Museums.
In press Neutron Activation Analysis of Bronze Age Copper Based Alloys. In *Proceedings of the Symposium on Neutron Activation and ICP/DCP Analysis in Archaeology*, ed. M. J. Hughes. London: British Museum.

Stronach, D.
1959 An Early Metal Hoard from Beycesultan. Pp. 47–50 in Excavations at Beycesultan II. The Chalcolithic Sounding, by S. Lloyd, J. Mellaart, and D. Stronach. *Anatolian Studies* 9.

Todorova, H.
1981 *Die kupferzeitliche Äxte und Beile in Bulgarien: Praehistorische Bronzefunde IX,14.* Munich: Beck.
1986 *Kamiena Miednata Epocha v Boulgarii.* Sofia: Nauka: Izkustvo.

Tylecote, R. F.
1976 *A History of Metallurgy*. London: The Metals Society.
1977 A Report on Metallurgical Work Carried Out on Material Collected in Cyprus in 1973. *Reports of the Department of Antiquities of Cyprus*: 317–27.

Vagnetti, L.
1980 Figurines and Minor Objects from a Chalcolithic Cemetery at Souskiou-Vathyrkakas (Cyprus). *Studi Micenei ed Egeo Anatolici* 21: 17–72.

Wagner, G. A.; Oztunali, O.; and Eibner, C.
 1989 Early Copper in Anatolia: Archaeometallur-
 gical Evidence. Pp. 299–306 in *Old World
 Archaeometallurgy*, Der Anschnitt Beiheft 7,
 eds. A. Hauptmann, E. Pernicka, and G. A. Wag-
 ner. Bochum: Deutsches Bergbau-Museums.
Weinstein, J.
 1984 Radiocarbon Dating in the Southern Levant.
 Radiocarbon 26: 297–366.

Yener, K. A.; Ozbal, H.; Minzoni-Deroche, A.; and
Aksoy, B.
 1989 Bolkardag: Archaeometallurgical Surveys in
 the Taurus Mountains, Turkey. *National Geo-
 graphic Research* 5: 477–94.
Yener, K. A.; Sayre, E. V.; Ozbal, H.; Joel, E. C.; Barnes,
 I. L.; and Brill, R. H.
In Press The Central Taurus Mountains: Lead Isotope
 Studies. *Journal of Archaeological Science.*

Man and Beast in Chalcolithic Cyprus

PAUL CROFT
Archaeological Centre
Lemba, Paphos
Cyprus

The range of animals exploited during the Cypriot Chalcolithic shows continuity from the preceding Aceramic and Ceramic Neolithic periods. For the most part, caprines and pigs were probably herded, domestic animals, but feral populations also may have been hunted. It is highly unlikely that fallow deer, also of great economic importance in Early Prehistoric Cyprus, were ever domesticated. The anachronistic importance of deer hunting in Cyprus is discussed in its ecological and economic context. Trends inferred from faunal remains are interpreted as representing increasingly intensive exploitation of animals during the Chalcolithic.

INTRODUCTION

The unusual significance of deer as a subsistence resource in the earlier Holocene of Cyprus was noted by Zeuner (1958) and has for several decades attracted considerable comment and speculation. Recent zooarchaeological research (Carter 1989; Croft 1985; 1989; Croft, in press; Davis 1984; Legge 1982; Watson and Stanley Price 1977) has added greatly to our knowledge of human subsistence in Early Prehistoric (E.P.[1]; i.e., Neolithic and Chalcolithic) Cyprus and has shown that for 5000 years or so, roughly between 7000 b.c. and 2000 b.c.,[2] considerable reliance on the exploitation of fallow deer (*Dama mesopotamica*) was a standard, probably invariable, feature of the subsistence economies of village settlements. Heavy reliance on deer seems to have persisted later still in some places (Croft 1988b).

The longevity and obvious importance of the man–deer relationship in Cyprus represents a situation that is unique in the Holocene archaeological record of the Near East; subsistence economies in which deer played a prominent role are otherwise confined to the Pleistocene (Bar Yosef 1981: fig. 11; Edwards 1989: fig. 3).

In addition to deer, only pigs and caprines attained any degree of prominence as a meat source in subsistence economies throughout the E.P. in Cyprus; cattle were entirely absent. This attests a high degree of uniformity in the nature of subsistence within the period, and even into the Chalco-

lithic. Thus, to assess the interaction of man and beast in Chalcolithic Cyprus it is necessary to review the evidence for the origins and development of those heavily deer-oriented economies before the Chalcolithic period.

The larger mammals consumed by the inhabitants of early village settlements in Cyprus, beginning in the Aceramic Neolithic, include sheep, goat, and pig, which were all domesticated animals at the time on the nearby mainland. The Neolithic fauna of Cyprus also includes the fallow deer, which rapidly assumed a level of economic importance unparalleled elsewhere during the Holocene. Although the fallow deer is not generally considered ever to have been domesticated in the past, its importance as a subsistence resource in Cyprus has prompted suggestions, notably by Zeuner (1958: 133) and more recently by Jarman (1982: 166), that it must (in some sense at least) have been a domestic animal. It is argued below, however, that although subjected to controlled exploitation, the fallow deer was a free-living, hunted animal. Among the smaller mammals, which were less likely to have been eaten, dog, fox, and cat are present from the Aceramic Neolithic (Croft 1988a; Davis 1987: 305). This array of unquestionably man-associated animals represents a complete break with the preceding Pleistocene fauna (Boekschoten and Sondaar 1972; Davis 1985: 26). It is conceivable that pig and fallow deer could have colonized by swimming, but that could hardly account for the presence of caprines and the carnivores in

Cyprus. The most probable explanation is that all of those animals were deliberately imported by man (Watson and Stanley Price 1977: 247).

The Ecology of Pre-Chalcolithic Cyprus

Since direct evidence is sparse, consideration of the ecology of early Holocene Cyprus must necessarily rely heavily on extrapolation from evidence obtained from the nearby mainland. In brief, it seems that the northeast Mediterranean region was somewhat moister than it is at present (Bottema and Van Zeist 1981: 130; Van Zeist and Woldring 1980: 120). A period of high precipitation and humidity from 8000 to 6000 b.c. presented most favorable conditions for tree growth (Bottema and Van Zeist 1981: 118; Van Zeist and Bottema 1982: 282). At that time the vegetation of Cyprus would have differed radically from the largely anthropogenic vegetation of today. In place of the degraded communities of the more recent past, Cyprus would have supported a generally less xerophilous vegetation that included a greater number and variety of trees, particularly deciduous species. In the shade of those trees, the annual growth of herbs and grasses would have been more profuse and diverse and the understory vegetation would have remained green for longer into the hot dry season than do the herbs and grasses of the present (Jones *et al.* 1958: 45).

Whether or not the Pleistocene fauna became extinct prior to the first human presence on Cyprus (Simmons 1988), it does seem that it disappeared prior to the animal introductions made by Aceramic Neolithic settlers. It follows, therefore, that the pre-Neolithic vegetation of Cyprus would have developed, for a time at least, in the complete absence of mammalian herbivores. Pygmy hippopotami and elephants would have had little, if any, influence on the vegetation that confronted the Neolithic colonists of Cyprus and their animal imports.

It appears, then, that whether colonization occurred as early as 7500 b.c. (Todd 1987: 184) or as late as ca. 6000 b.c. (Le Brun *et al.* 1987: 283–84), there would have been at least some centuries, and possibly up to two millennia, during which natural woodland vegetation was able to develop in the complete absence of any browsing pressure. Browse-resistant plants would therefore have possessed no competitive advantage, and the vegetation that developed would have been highly palatable to herbivores and liable to damage following their

introduction. That vulnerability is confirmed by pollen evidence from Aceramic Neolithic Khirokitia, which indicates that the local woodland vegetation had already become degraded by an early stage in the life of the settlement (Renault-Miskovsky 1987).

The sparse distribution of Aceramic sites in Cyprus suggests that the human population did not multiply sufficiently during that period for its area of distribution to extend even throughout the lowland zone, let alone into the uplands. However, introduced ungulates, particularly free-living deer, would have colonized the entire habitable range far more rapidly, and it is highly probable that deer at least would have become established islandwide within a few human generations of the initial introduction. If, for the sake of argument, the assumptions are made that there was only one successful liberation of fallow deer in E.P. Cyprus, that it took place about half-way along the north coast in the vicinity of Troulli, and that the rate of dispersion of the deer was 0.8 km per year (Chapman and Chapman 1980: 129), then it is clear that deer could have colonized the entire island in about a century and a half. At the same rate of dispersion, liberation at Cape Andreas at the tip of the Karpass Peninsula, the most easterly point of the island, would have resulted in the most protracted colonization process, but even that would have taken less than three centuries.

It will be clear from the foregoing that the ecological circumstances of the earliest human settlement in Cyprus probably differed very considerably from those on the contemporary mainland, from which Cyprus was colonized, but from which it seems to have remained effectively isolated for the succeeding several millennia.

THE ANIMALS

Deer

The earliest discussion of the origin and status of the fallow deer of Cyprus was that of Zeuner (1958), who thought that they were probably indigenous to the island. Zeuner believed that by the Late Bronze Age the fallow deer was domesticated in Cyprus, and the abundance of deer remains in the Late Bronze Age sanctuary at Myrtou-Pigadhes led him to suggest a religious context for that domestication. He did, however, discuss the alternative view that the fallow deer was not indigenous

and that its presence in the Neolithic period indicates that it must have been imported at an early date. In Zeuner's opinion importation "would imply not only cultural relations, but a certain amount of 'domestication'... for religious purposes only or for meat supply also" (Zeuner 1958: 133).

It is now generally accepted that the deer were imported from Syria-Palestine (Chapman and Chapman 1980: 121; Davis 1987: 307; Halstead 1977: 267; Jarman 1982: 66; Karageorghis 1982: 25; Morris 1985: 189; Watson and Stanley Price 1977: 248), although not necessarily as domestic animals. That constitutes one element in the broader argument for an easterly rather than a northerly origin for the Aceramic culture of Cyprus (Stanley Price 1977: 84).

Ducos (1965: 4) was unable to determine whether or not the fallow deer of Cyprus were domesticated, since he lacked sufficient data to produce age frequency curves for the various sites. Such data are now available, but unfortunately they do not answer the question either. Ducos' assumption that mortality patterns that indicate other than random culling indicate that the species involved was domestic (Ducos 1968: xiv) is no longer accepted. The ungulates of Neolithic and Chalcolithic Cyprus appear normally to have been culled in a nonrandom fashion, which does reflect resource management; but resource management is not necessarily synonymous with domestication (Jarman 1982: 51).

Ducos (1965: 4-5) avoided the term "domestication" but suggested that the fallow deer of Cyprus were probably tamed or "semidomestic" at the inception of the Ceramic Neolithic. He bases that claim largely on the great economic importance of deer during the later part of the E.P. as represented by the sites of Sotira-Teppes and Erimi-Pamboula, compared with its lesser importance at Aceramic Neolithic Khirokitia. Since that time various others (e.g., Schwartz 1974: 103) have also suggested that the sheer quantity of deer remains in E.P. Cyprus indicates that deer were domesticated. That interpretation is not necessarily accurate; the abundance of the deer logically suggests only that deer were of considerable economic importance, not that they had to have been domesticated.

As the following section of this article will show, reliance on deer hunting increased subsequent to the Aceramic period in Cyprus, even though the importance of deer at Khirokitia may have been atypically low for the period because of the inadequacy of hunting to support an unusually large population there. Increased reliance on deer may

be explained in terms of ecological and economic factors, and does not require a major change of the sort Ducos (1965) envisaged in the nature of the relationship between man and deer.

Individual fallow deer are easily tamed (Clutton-Brock 1981: 182) and herds of untamed fallow deer are easy to keep in large, enclosed areas such as deer parks (Zeuner 1963: 434). On this basis it has been suggested that their status in Europe in recent centuries amounts to that of a semidomesticate (Ducos 1965: 4), and that view has undoubtedly influenced the interpretation that Jarman (1976: 42-43; 1982: 66) placed upon the Cypriot evidence:

> The introduction [to Cyprus] of deer in sufficient numbers to act as a breeding stock for the substantial population for which there is archaeological evidence clearly argues for a high degree of control over the animals and for their sophisticated management. Furthermore, it is surely perverse to suggest that man imported small numbers of sheep and goats, which he herded and husbanded while depending primarily on fallow deer which he also imported, but then released and hunted. It seems overwhelmingly more like[ly] that the deer were the objects of the same measures of husbandry as the other imported herbivores, and that they were herded, behaviorally domestic animals until their decline in economic importance some millennia after their first introduction to the island (Jarman 1982: 66).

Is the suggestion that Neolithic man released and hunted the fallow deer in Cyprus really so perverse? On the contrary, it is arguably perfectly natural that incoming humanity, encountering a landscape devoid of huntable creatures, should wish to stock it with useful free-living animals such as deer. Following an apparent decline in numbers of the species in the Natufian period, the remains of fallow deer, while regularly present, are not generally abundant on Levantine sites during the Holocene (Bar Yosef 1981: fig. 11; Davis 1982; Edwards 1989, fig. 3; Legge 1982: 83). Fallow deer made a relatively small contribution to subsistence, and were clearly a hunted rather than a domestic animal. It follows, then, that it would have been as hunted animals that they were introduced by the early colonists of Cyprus. Moreover, it is hardly likely that those who first liberated the fallow deer into that unbrowsed, and therefore highly palatable, insular environment could have foreseen how what was traditionally a minor resource on the mainland was to become the basis of a highly

successful insular adaptation that would sustain successive human generations over several millennia.

Fallow deer are primarily grazers, but commonly browse trees and shrubs. Neither very open conditions, lacking in cover and shelter, nor densely wooded conditions suit them but they are able to thrive in a wide diversity of habitat types between those two extremes, ranging from fairly open grassland and scrub to moderately dense woodland (Chapman and Chapman 1975: 173–74). The broad ecological tolerance and the adaptability of fallow deer underlie its rapid rise to prominence in the subsistence economies of E.P. Cyprus.

The introduction of the fallow deer may have been part of a wider policy of stocking the Cypriot landscape with huntable wild animals. The fox, common on contemporary mainland sites, is also known from the Aceramic period at both Tenta and Khirokitia, and seems to be one such animal, doubtless desirable for its pelt. The presence of a small cat at both of those Cypriot sites may be explained in the same way, unless it was already domesticated at that early date.

In fact, very few deer would have been needed to establish a breeding population (Chapman and Chapman 1975: 185; 1980: 74); as few as a score probably would have been more than adequate. The transportation of such small numbers of animals from the mainland need not have posed a problem to seamen who were, after all, clearly capable of transporting a breeding population of humans (see Clutton-Brock 1981: fig. 18.6). Furthermore, there is no reason why the ability to capture, immobilize, and transport deer should be taken to imply either "a high degree of control over the animals," in the general sense at least, or their sophisticated management as inferred by Jarman (1982: 66).

The notoriously intractable temperament of the fallow deer (Chapman and Chapman 1975: 156; Dansie 1984: 169; Fletcher 1978: 356; Tomlinson 1988: 93) renders it improbable that they were ever closely controlled in E. P. Cyprus. To this behavioral argument against their having been domesticated may be added the economic argument that the more labor-intensive strategy of carnivorous pastoralism does not provide access to additional products that are not available to the hunter. Furthermore, a herded animal will not normally convert vegetation to meat any more efficiently than a hunted one, and may indeed be less efficient (Ingold 1980: 87). In the absence of large carnivores—and

unless human groups behaved as competing predators—the protection of deer herds by the exercise of close control over them would seem unnecessary.

The deer of Cyprus are unlikely to have utilized terrain above about 1000 m (Chapman and Chapman 1975: 173–74); but land at that elevation is restricted to the core area of the Troodos Massif, so the great majority of the surface area of the island may be considered potential deer range. However, Cyprus is not a large landmass, and the facts that fallow deer do not undertake seasonal mass migrations over considerable distances and that they are easily exploited by sedentary people (Chaplin 1975: 42) indicate that a relationship of the type described by Jarman (1982: 52) as herd following is most unlikely to have existed in the E.P. Cypriot situation. A man-deer relationship of the sort that Jarman categorizes as controlled predation is therefore regarded as having occurred throughout the E.P. period.

Sheep, Goats, and Pigs

Unlike the fallow deer, the other animals that were of primary economic significance in E.P. Cyprus were also important in mainland western Asia. Sheep and goat herding was a regular feature of subsistence economies in the Levant from the mid-eighth millennium b.c. (Bar Yosef 1981: fig. 11; Edwards 1989: fig. 3; Moore 1982: 16) and beyond (Reed 1983: 525–26; Stampfli 1983: 443). It is exemplified at Jericho, where domestic sheep and goat accounted for about half of the 745 bones and teeth of the larger mammals during the PPNB (Clutton-Brock 1979: table 1; 1981: 56, 60). The Jericho pigs, represented by about a third as many items, are considered probably also to have been domestic (Clutton-Brock 1979: 146; 1981: 72). Beyond the Levant, domestic sheep and goats of broadly comparable date are reported from a variety of sites in western Asia, including Jarmo in northeastern Iraq (Reed 1983: 525–26; Stampfli 1983: 443). Domestic pigs are also known from the upper levels of Jarmo, beginning about the mid-seventh millennium b.c. (Stampfli 1983: 443) and from the Balkans, although the latter probably were independently domesticated (Bokonyi 1974: 208).

Thus it is most likely that the caprines and pigs in the earliest village settlements on Cyprus were introduced as domestic stock. The caprines of E.P. Cyprus display no appreciable differences from

their western Asiatic wild ancestors, but there is some evidence that the pigs may have been slightly smaller by the Cypriot Aceramic (Davis 1984: 156, fig. 98).

Even recent, improved forms of those farmyard animals, genetically far more remote from their wild forebears than the early domesticates, possess considerable potential for feralization (Davidson 1989: 61). Thus it is quite possible that free-living populations of those animals became established in Cyprus from an early date and were exploited in some way. Feral goats and pigs are reported to have existed formerly (Storrs and O'Brien 1930: 297), and the existence to this day of the moufflon or *agrino* bears witness to the feralization of primitive domestic sheep on the island (Boekschoten and Sondaar 1972: 333; Groves 1989: 49).

It is possible, therefore, that a typical Neolithic/ Chalcolithic faunal assemblage from Cyprus includes the bones not only of hunted deer and herded pigs and caprines, but also of morphologically indistinguishable (or at least closely similar) feral pigs and caprines. This situation poses severe, and presently unsolvable, problems for detailed economic interpretation. Accordingly, the interpretations presented here are based on the working assumption that most, if not all, caprines and pigs were domesticates.

SUBSISTENCE ECONOMY IN PRE-CHALCOLITHIC CYPRUS

Excavations at the Aceramic Neolithic settlements of Kalavasos-Tenta and Khirokitia-Vounoi— 6 km apart in the south coastal hinterland—and at Cape Andreas-Kastros, on the tip of the Karpass Peninsula, have furnished evidence for the animal economies of this period (Croft, in press a; Davis 1984; 1987). All three faunal assemblages consist overwhelmingly of deer, pigs, and caprines (mainly sheep in the south central region and goats at Cape Andreas), all of which are abundantly represented. Fox and cats, represented at both Tenta and Khirokitia, may have been exploited for their pelts, although the cat already may have assumed its familiar role of village-dwelling scavenger and exterminator of vermin. Dogs were not reported from these sites but are known from Aceramic Cape Andreas-Kastros (Davis 1987: 305).

The faunal assemblage at Neolithic Dhali-Agridhi was dominated by deer, but caprines and pigs were also prominent (Carter 1989: Croft 1989; Schwartz 1974). However, since the site possessed components of both the Aceramic and Ceramic Neolithic periods (Lehavy 1989) and the faunal remains could not be chronologically subdivided, they will not be further discussed in the current article.

The faunal assemblages from Tenta, Khirokitia, and Cape Andreas are all amenable to chronological subdivision, and fairly distinct trends in animal exploitation may be observed within the Aceramic period. While the animal economies were based on the same three taxa, the diversity attests a high degree of flexibility in economic behavior within the period, no doubt in response to demographic, environmental, and social factors, which varied locally.

At Khirokitia a decrease in the importance of deer and pigs over time is offset by a pronounced increase in the relative abundance of caprine remains; at Cape Andreas exactly the reverse is true (Davis 1987: fig. 21). Trends in animal exploitation at Tenta are less pronounced; as at Khirokitia, reliance on deer decreases over time, but to a far lesser extent, while both caprines and pigs become somewhat more significant.

The implications of those trends in terms of changes in the relative contribution to overall meat supply may be estimated on the basis of counts of identified faunal remains available for both Tenta (Croft, in press) and Khirokitia (Davis 1984: Table 2). Those estimates are explained and presented in Table 1.

Additionally, extrapolation from the graphic representation of Davis' data for Cape Andreas permits the estimate that during Period II the relative contribution of deer, pigs, and caprines to overall meat supply was relatively similar—deer 32 percent, pig 38 percent, and caprines 30 percent. By Period VI, however, the importance of both deer (41 percent) and pig (52 percent) as meat providers had increased significantly, while that of caprines had plummeted to 7 percent.

Assuming that the deer were free-living, hunted animals, and that the caprines and pigs were (at least mostly) domestic, the faunal trends at Khirokitia indicate a pronounced shift in emphasis away from hunting and toward the exploitation of domestic stock; at Tenta the trend is toward a moderate shift in the same direction, while Cape Andreas shows a moderate shift away from husbandry and toward hunting. Nonetheless, all three sites retained

TABLE 1. Remains of Deer, Pigs, and Caprines from
Aceramic Kalavasos-Tenta and Khirokitia-Vounoi

| Site/Period | Deer | | Pigs[a] | | Caprines | | |
	no.	%	no.	%	no.	%	Total
Kalavasos-Tenta							
Period 4	206	56.4	83	22.7	76	20.8	365
Meat supply fraction[b]		63.2		30.0		6.9	
Period 3	30	39.0	30	39.0	17	22.1	77
Meat supply fraction		42.7		50.2		7.1	
Period 2	140	42.3	106	32.0	85	25.7	331
Meat supply fraction		48.3		43.0		8.6	
Khirokitia-Vounoi							
Period D		?	51	?	28	?	21
Meat supply fraction		56.6		36.6		6.9	
Level III	110	33.8	68	20.9	147	45.2	325
Meat supply fraction		47.2		34.3		18.5	
Level II	103	22.8	85	18.8	263	58.3	451
Meat supply fraction		36.7		35.7		27.6	
Level I	67	8.5	79	10.1	639	81.4	785
Meat supply fraction		19.3		26.7		54.0	

[a] Figures for Tenta are based on identified postcranial fragments that could be confidently attributed to period. The Tenta pig figures exclude metapodia II and V and accessory phalanges, since those elements have no analogues in the deer or caprine skeleton. Furthermore, only half of the pig metapodia III and IV are included since the anatomical analogue of those paired elements in the ruminant skeleton is a single cannon bone. Figures for Khirokitia are based on a selection of skeletal elements and have been taken (or, in the case of Period D, extrapolated) from Davis (1984: 149; 1987: fig. 21).

[b] In estimating contributions to meat supply, if the meat yield of a hypothetical "average caprine," the smallest animal under consideration, is taken to be a unit, then the yields from the average deer (3.4 units) and pig (4.0 units) may be expressed in terms of this. The case for the use of these particular values has been fully presented elsewhere (Croft 1988a), and it is sufficient to outline here the assumptions that have gone into the calculation of these meat yield factors:

	Deer	Pig	Caprines
Average adult weight (kg)	96	90	34
Edible portion	60%	75%	50%
Edible weight (kg)	57.6	67.5	17.0
Ratio of edible weights	3.4	4.0	1.0

In applying the meat yield factors, each fragment count is multiplied by the appropriate factor, and the product of each calculation is expressed as a percentage of the sum of the products.

a strong hunting (and presumably gathering) component throughout. Such economies generally are associated with low population densities, as may be inferred from the small number of known sites of this Aceramic Neolithic period.

The shift toward greater reliance on domestic stock at Tenta and Khirokitia may be viewed as a shift toward greater labor intensiveness in animal exploitation. Since both settlements outgrew their original boundaries (Le Brun 1981: 464–65; Todd

1987: 29), it is likely that population growth also led to this increased emphasis on food production. However, a greater degree of intensification is apparent at Khirokitia than at Tenta, possibly reflecting the larger size of the former and the differing potential of its environs (Cluzan 1987; Wagstaff 1978).

At the coastal site of Cape Andreas marine resources were important, as evidenced by finds of shells, fish remains, and bone fishhooks. Terrestrial

mammals may have been of lesser importance there than at inland sites like Khirokitia and Tenta. Yet there, too, evidence that deer increased somewhat in economic significance over time suggests a degree of economic deintensification, which may reflect a declining population. Certainly the excavation revealed no particular evidence for settlement expansion.

It seems clear that the Aceramic colonists of Cyprus stocked their newly-occupied, faunally impoverished landscape with a variety of animals, both domestic and wild, which they perceived as useful. In the sense that the perpetrators of such a policy of animal introductions could not have predicted its consequences, it may indeed be apposite to adopt a zoologist's viewpoint that prehistoric man "inadvertently instigated a zoological experiment" (Davis 1984: 148). Even if those prehistoric experimenters could have predicted the success with which the fallow deer would adapt to Cyprus, they could hardly have foreseen that a comparatively minor resource in their former western Asiatic homeland would rapidly become an economic resource of the first importance and would remain so for several millennia.

The exposure of the pristine vegetation of Cyprus to a variety of exotic herbivores must have resulted in the profound modification of that vegetation, and in consequent broader environmental ramifications, such as soil erosion and increased aridification. It is thus entirely predictable that a series of rapid adjustments should take place early in the postcolonization period within the overall context of a three-way interdependent relationship among man, animals, and environment. Early generations of human colonists would have to find new patterns of cultural behavior that would be both viable and satisfactory in an unfamiliar environment, which was itself undergoing rapid change. Both social behavior and subsistence practice are prone to rapid modification in a community confronted by such a challenge. Furthermore, the social and economic forms encountered among contemporary, perhaps rather isolated, pioneer communities are liable to be unusually diverse, although intercommunal contact may partially mitigate diversity. Social barriers can be as effective as geographical isolation in separating communities from one another (Hughes 1973). Even if the obvious defensive works at Tenta and Khirokitia were not constructed in response to a direct threat of attack by neighboring communities, it is difficult to view them as

other than physical manifestations of an ideology of separateness. It is thus against a backdrop of environmental, demographic, and social instability that the apparently rapid pace of economic change at Tenta, Khirokitia, and Cape Andreas must be viewed and intersite differences in the nature of that change evaluated.

While the economic significance of deer varied both spatially and temporally within the Aceramic Neolithic, deer were always important. The patchy evidence we have from several sites suggests that they were even more so during the Ceramic Neolithic.

In a subsample of the faunal remains recovered from the Ceramic Neolithic settlement of Philia-Drakos Site "A" near Morphou, 252 postcranial fragments included 71 percent deer, 17 percent pig, and 11 percent caprines.[3] The high percentage of deer remains supports the thesis that animal economies were unambiguously deer-dominated. The figure of 76 percent quoted by Ducos (1965: 4) for Ceramic Neolithic Sotira-Teppes offers similar support, but his total represents only 19 deer bones.

The Ceramic Neolithic subterranean village of Ayios Epiktitos-Vrysi, on the north coast of Cyprus, produced deer remains only marginally more abundant than those of caprines. The bones of the three main taxa (excluding teeth) included 46 percent deer, 43 percent caprines, and 11 percent pig (Legge 1982: Table 5). That has prompted the suggestion that the subsistence pattern at Vrysi represented a departure from the general pattern for the Ceramic Neolithic and Early Chalcolithic, in which the importance of deer hunting far exceeded that of caprine herding (Peltenburg 1978: 64; 1982a: 99). However, since one deer probably yielded, on average, more than three times as much meat as caprine, the Vrysi bone evidence is consistent with deer hunting having been by far the predominant source of meat.

Man and Beast in Chalcolithic Cyprus

It has been shown above that animal economies in which deer hunting was anachronistically prominent characterize the Cypriot Neolithic. Hunting moved from merely prominent to predominant during the later part of the period—the Ceramic Neolithic. The following section of this article shows that hunting continued to predominate into the early Chalcolithic period, after which it declined somewhat in importance.

Knowledge of the relationship of man and beast in Chalcolithic Cyprus is based primarily on data from the three settlements of Lemba-Lakkous, Kissonerga-Mosphilia, and Kissonerga-Mylouthkia in the Kitma coastal lowlands in the west of the island. Other, lesser, bodies of faunal data are available from Kalavasos-Ayious and Erimi-Pamboula, both in the south coastal hinterland, and these will be discussed first. The range of animals represented and counts of identified mammalian bones are given in Table 2, and an assessment of the relative importance of the main food animals is presented in Table 3.

Because the bone sample from Kalavasos-Ayious (Croft, in press b) was exceptionally fragmentary and very poorly preserved, the sample may be biased in favor of the larger, more durable bones of deer (70 percent) and against those of pigs (9 percent) and caprines (14 percent). However, even if their importance has been inflated, it seems likely that deer were overwhelmingly the most important food animal in the subsistence economy at Ayious.

Little is known of the faunal remains from Erimi-Pamboula, which was excavated in the 1930s. King (1953: 432) observed that deer were common on the site, occurring in all levels of Dikaios' excavations; Ducos (1965: 4) gives the number 164 (71.9 percent) for the deer remains he examined. Another, very small, bone sample acquired from the site more recently also consisted mostly of deer remains (Croft 1981). Three mid-third millennium b.c. radiocarbon dates came from the upper levels of the site (Peltenburg 1982b: 113), but to judge from the 5.5 m depth of the Erimi stratigraphy, the lower levels are probably contemporary with Kalavasos-Ayious and Kissonerga-Mylouthkia, which are dated some centuries earlier. The meager evidence for the animal economy of Erimi, therefore, suggests that it probably was as heavily deer-dependent as the two earlier Chalcolithic sites.

The Ktima Lowlands Chalcolithic sites of Kissonerga-Mylouthkia, Kissonerga-Mosphilia, and Lemba-Lakkous constitute a localized cluster of chronologically overlapping settlements. Excavations on all three sites have yielded faunal remains, providing evidence for the nature of subsistence in three individual settlements and a unique opportunity to examine economic development at the regional level. The outline of economic change in the Ktima Lowlands presented here is a preliminary one, and additional animal bones from both

Mylouthkia and Mosphilia await analysis. It is probable that Mosphilia has already yielded more animal remains than any other archaeological site, of whatever period, in Cyprus—almost 5000 identifiable specimens—and it is estimated that the final count will be two to three times that number.

The following outline presents changes in the regional animal economy, both in terms of the relative abundance of the remains of various animals and in terms of their estimated significance as suppliers of meat. These estimates are based on the bone counts in Table 3, calculated by the method outlined in the notes to Table 1.

The animal economy of Early Chalcolithic Mylouthkia during the first third of the third millennium b.c. was very heavily deer-oriented. At Mylouthkia, as at the other Ktima Lowlands Chalcolithic sites, the caprines consisted overwhelmingly of goats.

Somewhat later, during Period 1 at Lemba, which represents the earlier phase of the Middle Chalcolithic at that site, the animal economy appears almost identical to that deduced for Early Chalcolithic Mylouthkia. Although those figures well may have been influenced to some extent by preservational bias, it seems apparent that deer were food animals of considerable importance in both instances. The consistency of the two sets of results prompts the suggestion that they characterize a pattern of faunal exploitation during the earliest centuries of substantive human settlement in the Ktima Lowlands. The heavy predominance of deer among faunal remains from Kalavasos-Ayious and Erimi-Pamboula (above) suggests that such a pattern was also current in other regions of Cyprus.

By the later phase of the Middle Chalcolithic at Lemba (Period 2) deer had declined somewhat in significance relative to the importance of other food animals. The continuation of those trends, at least for deer and pigs, is evidenced by the figures for Lemba, Period 3 (Late Chalcolithic). Indeed the decline in the importance of deer as a food source was even sharper between Periods 2 and 3 than between Periods 1 and 2, as was the concomitant increase in the importance of pigs.

Analysis of faunal remains from the ongoing excavations at Mosphilia is still in progress, but preliminary indications for the Middle to Late Chalcolithic are similar to the situation at Lemba. The patterns for the Late Chalcolithic period at the

TABLE 2. Identified Mammalian Bone Fragments from Chalcolithic Cyprus

		Deer	Pig	Caprine	Dog	Fox	Cat	Cetacean	Total
Kalavasos-Ayious	no.	611	81	125	43	11			871
	%	70.1	9.3	14.4	4.9	1.3			
Kissonerga-Mylouthkia	no.	831	390	222	10	74	3		1530
	%	54.3	25.5	14.5	0.7	4.8	0.2		
Erimi-Pamboula	no.	184	+	+			+		256[a]
	%	71.9							
Lemba-Lakkous	no.	546	437	295	3	27	1		1309[b]
	%	41.7	33.4	22.5	0.2	2.1	0.1		
Kissonerga-Mosphilia	no.	1777	2080	859	6	82	6	1	4811[c]
	%	36.9	43.2	17.9	0.1	1.7	0.1	–	

[a] Based on Croft 1981; Ducos 1965; King 1953. Information for the other sites is drawn entirely from examination of the material. + = taxon present but in unknown proportions.

[b] Total excludes two fragments of cattle bone and one fragment of equid bone, both from unreliable contexts.

[c] Total excludes 15 fragments of cattle bone, all from unreliable contexts.

TABLE 3. Relative Importance of Deer, Pig, and Caprines from Chalcolithic Cyprus[a]

Site/Period	Deer no.	Deer %	Pigs[a] no.	Pigs[a] %	Caprines no.	Caprines %	Total
Early Chalcolithic							
Kalavasos-Ayious	545	78.1	48	6.9	105	15.0	698
Meat supply fraction		86.2		8.9		4.9	
Kissonerga-Mylouthkia	723	63.7	211.5	18.6	200	17.6	1134.5
Meat supply fraction		70.2		24.1		5.7	
Early-Middle Chalcolithic							
Lemba-Lakkous Period 1	47	63.9	12.5	17.0	14	19.0	73.5
Meat supply fraction		71.4		22.3		6.3	
Middle Chalcolithic							
Lemba-Lakkous, Period 2	99	47.6	42	20.2	67	32.3	208
Meat supply fraction		58.9		29.4		11.7	
Kissonerga-Mosphilia, Period 3	97	51.3	65	34.4	27	14.3	189
Meat supply fraction		53.5		42.2		4.4	
Late Chalcolithic							
Kissonerga-Mosphilia, Period 4	1272	44.4	1063	37.1	528	18.4	2863
Meat supply fraction		47.5		46.7		5.8	
Lemba-Lakkous, Period 3	127	35.9	129	36.4	98	27.7	354
Meat supply fraction		41.3		49.1		9.4	

[a] Based on numbers of identified postcranial fragments. The way in which the pig bones have been counted and the way in which the fraction of meat supply has been estimated are explained in the footnotes to Table 1.

TABLE 4. A Comparison of the Age Stages at Which
Deer, Pigs, and Caprines Were Killed at the Chalcolithic Sites of the Ktima Lowlands[a]

	Deer				Pig				Caprines			
	I	J	S	A[b]	I	J	S	A	I	J	S	A
Mylouthkia	11	1	17	71	29	2	20	49	4	8	20	68
Lemba, Periods 2–3	5	20	28	47	61	0	23	16	6	29	6	59
Mosphilia	7	25	8	60	33	23	27	17	14	19	9	58

[a] Percents, based on epiphysial fusion data
[b] I = Infant J = Juvenile S = Subadult A = Adult

two sites are very similar and the Middle Chalcolithic patterns accord reasonably well.

The conclusions to be drawn from the foregoing attempt at a diachronic view of the regional animal economy of the Ktima Lowlands during the third millennium b.c. are that a marked decline occurred in the importance of deer for meat, while the importance of pigs increased twofold. By the end of the millennium as represented by Period 3 at Lemba, pigs became the major meat producers; the same appears to have been the case in Period 4 at Mosphilia. Assuming that deer were hunted animals and that at least the great majority of other creatures were domesticates, it would seem that herding, particularly of pigs, gradually increased in importance as hunting declined through the third millennium b.c.

As with the Aceramic Neolithic settlements of Kalavasos-Tenta and Khirokitia in the south coastal hinterland, the shift toward greater reliance on domestic stock during the Chalcolithic of the Ktima Lowlands suggests a shift toward greater labor-intensiveness in animal exploitation. The fact that both Tenta and Khirokitia demonstrably outgrew their early boundaries constitutes good evidence for population expansion, and thus provides a motive for the investment of greater effort in subsistence. That population expansion occurred in western Cyprus during the third millennium b.c. may be adduced from ceramic evidence. More than 30 Chalcolithic sites have been located in the Ktima Lowlands-Paphos Plateau region as a whole (Baird 1984; 1985; 1987; Hadjisavvas 1977; Peltenburg 1979: 72–79; Sheen 1981) but only three—Mosphilia, Mylouthkia, and Miliou—have yielded the

Glossy Burnished pottery characteristic of the Early Chalcolithic (Peltenburg 1983: 11; 1989: 195).

Economic intensification, inferred from the shift toward greater reliance on herding and reduced reliance on hunting, is also suggested by a second line of evidence. Data regarding the stage of life at which the animals were culled during the E.P. in the Kitma Lowlands, presented in Table 4, suggest that both deer and pig were, on average, culled at a younger age in the later third millennium b.c. than previously.

Although the growth rate of the fallow deer is in constant decline from the outset, it is still rapid until the third year of life. By the fourth year, it has become rather slow, and it is very slow (males) or possibly nonexistent (females) thereafter. Therefore, the younger the average age of a deer population the more productive (of biomass) it will be. Efficient exploitation would probably focus on culling in the juvenile stage, when the deer attain a substantial portion (possibly some 50 to 70 percent) of adult body weight (see also the work of Koike and Ohtaishi [1987] on deer hunting in Jomon, Japan).

The study of the animal remains from the Chalcolithic settlements of the Ktima Lowlands has demonstrated that deer persisted as an important resource for the entire third millennium b.c. Moreover, faunal evidence from Maa-Palaeokastro (Croft 1988b), a late second millennium B.C. settlement on the northern margin of the lowlands, shows that deer retained a high degree of economic significance for another thousand years in the locality. The longevity of the man–deer relationship in the area certainly suggests a conservationist policy

toward deer exploitation, but that may not tell the whole story. Although uncontrolled, indiscriminate hunting may lead to the extinction of an animal population, that is not invariably the case. If the animals exist over a wide area, so that pockets of habitat exist that are inaccessible to hunters, the animals may continue to flourish (Bailey *et al.* 1983: 77).

In the Ktima Lowlands, age-biased mortality patterns established from deer remains from a range of Chalcolithic settlements and phases represent selective (nonrandom) culling, and seem to reflect the various stages of an evolving system of game management. Increasing intensification of deer hunting has been inferred from the apparent trend toward younger culling. However, since at least some of the deer culled may have been replaced by immigration from beyond the hunted area, one cannot infer that the longevity of the man–deer relationship in the region was entirely attributable to an effective conservationist approach to deer exploitation.

Ceramic evidence points to an increase in the human population of the Ktima Lowlands–Paphos Plateau region during the Chalcolithic period. It seems probable that the population density in the region may have been sufficiently low during the Early Chalcolithic that unhunted areas existed. As settlement density increased over time, however, such pockets of unhunted deer would have become reduced and eventually would have disappeared. Hunters would have gained smaller returns from the prevailing hunting strategy, which would have provided an incentive to modify that strategy for greater efficiency of exploitation. It is proposed that the changes in deer culling policy that have been inferred between the Early Chalcolithic (Mylouthkia) and later stages in the third millennium b.c. represent just such an improvement in the productive efficiency of deer exploitation.

It is clear from the prominence of deer in the Maa-Palaeokastro faunal sample that even as late as the later second millennium B.C., deer had not been hunted to extinction in the Ktima Lowlands area. However, it is probable that as the human population expanded during the third millennium b.c. and deer were exploited more fully, the importance of hunting to the subsistence economy gradually lessened. Whether there would have been an absolute decline in the deer population as a result of hunting remains a moot point, although that is certainly possible. The size of the deer population would have declined with respect to that of the human population as the latter increased; however many deer there were, the number of deer per hunter undoubtedly would have declined over time. A reduction in the availability of what was traditionally the main meat animal must certainly have underlain the modifications in the mode of exploitation of deer.

The culling of pigs prior to subadulthood increased over time (Table 4), and an intensification in pig exploitation may therefore be indicated. In fact, it is exceptionally difficult to interpret this trend with any degree of confidence due to the possible presence of morphologically indistinguishable hunted, free-living pigs as well as domestic stock.

The attitudes of the people of Mylouthkia to the culling of both feral and domestic pigs, if both were exploited, may well have diverged considerably. Evidence from Mylouthkia for crop agriculture (Colledge 1980; 1981) suggests that the feral pigs would have been unwelcome visitors in fields or gardens. Although a useful source of meat, these destructive animals might have been viewed largely as pests to be exterminated on sight, irrespective of age or sex. It seems likely that the population of feral pigs around such early sites as Mylouthkia in time became depleted. As feral pig became scarcer, the mortality pattern that may be inferred from the pig remains should increasingly represent culling of domestic pigs alone. Taken as a whole, the pig culling pattern at Mylouthkia might represent some combination of two separate strategies applied to domestic and feral populations, while that at Lemba (Periods 2, 3) and Mosphilia may more purely reflect the former. Thus the increased emphasis on the slaughter of very young pigs may have run hand in hand with increasing reliance on husbanded rather than feral pigs.

A reduction over time in the availability of deer and feral caprines may also have had repercussions for the conduct and importance of pig keeping. Concurrently with those trends during the third millennium b.c. in the Ktima Lowlands, pig meat increased in overall importance in human diet. At Mylouthkia and the earliest period of occupation at Lemba, pig is estimated to have accounted for about one-quarter of meat consumed, while in the latest period at Lemba and at Mosphilia during Period 4, the figure approaches one-half.

Examination of the detailed morphology of the caprine skeletal remains from the Ktima Lowlands sites indicates that the vast majority of caprines present in the third millennium b.c. were goats. On the basis of a wide range of elements believed identifiable to the genus level, sheep appear to represent only 4 percent of the caprine material at Mylouthkia; and although slightly more common later at Lemba (9 percent) and Mosphilia (12 percent), they still were only a small percent of caprines.

With apparently only one exception, goat horn-cores from E.P. Cypriot sites are of the robust "scimitar" type, displaying no hint of the helical twist characteristic of the more developed varieties of domestic goat (Zeuner 1955; Clutton-Brock 1981: 61). They tend to have the lozenge- or almond-shaped cross-section generally associated with an early stage of domestication rather than the quadrangular section typical of the western Asiatic wild goat (*Capra aeqaqrus*) (Bokonyi 1973: 173–74; Hole, Flannery, and Neely 1969: 271–72, fig. 115; Reed 1960: 130). The one exception, a specimen from Mosphilia, shows a slight degree of twisting, but it probably is not of great significance (Ducos and Helmer 1981: 523).

A study of deer and caprine skeletal remains (Croft 1988a) suggests that sexual size dimorphism is in general more pronounced among the caprines of E.P. Cyprus than among the deer, permitting a variety of caprine skeletal elements to be sexed with a high degree of confidence. That study concluded that a pronounced sexual imbalance existed among the fused caprine bones from Tenta; roughly nine of ten represented females for both sheep and goats. Such an imbalance would be expected only if the Tenta caprines were husbanded animals exploited primarily or solely for meat; the great majority of males would have been superfluous for herd maintenance and therefore would have been slaughtered at a young age.

The relatively slight preponderance of females over males at the three Chalcolithic sites of the Ktima Lowlands (as seen in the fused skeletal elements) presents a radically different picture. Numbers of males per female are 0.79 at Mylouthkia, 0.73 at Lemba, and 0.95 at Mosphilia, clearly denoting a different system of caprine exploitation than at Tenta. Such a large proportion of male caprines would be inefficient for either meat or milk production, and while a balanced sex ratio is characteristic of wool production (Payne 1973:

figs. 1–3), the heavy predominance of goats in the Ktima Lowlands caprine population invalidates that interpretation.

It thus appears that productive efficiency was not the sole guiding principle behind the exploitation of goats in the Ktima Lowlands during the third millennium b.c. In all three bone samples discussed here, a far larger proportion of males appears to have been allowed to survive into adulthood than would be expected if the animals were being herded for meat. Three plausible explanations may be suggested, but the available evidence does not permit us to evaluate the relative merit of each.

The first is that the Chalcolithic goat-herders of the Ktima Lowlands indulged an "expensive" dietary preference for the flesh of well-grown male goats.

A second explanation suggests that although uneconomic in terms purely of meat production, the maintenance of a large proportion of well-grown males was perceived as desirable. It is conceivable that mature male goats, with their massive, graceful, backward-sweeping horns advertised the wealth and status of their owner. Alternatively, those impressive animals may have symbolized certain social values or aspirations, possibly connected with fertility. Even today, horns remain a powerful symbol in rural Cyprus to ward off the evil eye (*to mati*), particularly from animal pens, and also to characterize the *keratas* or cuckold (see Morris *et al.* 1979: 120–46).

Finally, perhaps the assumption that the goats of the Kitma Lowlands consisted overwhelmingly of domestic stock is erroneous; the age–sex patterning within the caprine sample to a large extent may instead represent predation on feral herds. In support of this suggestion, the 41–47 percent representation of males among the sexable fused elements of caprines from the three Ktima Lowland sites compares far more closely with their 37–53 percent representation among hunted deer from six E.P. sites (Croft 1988a: Table 3.4) than it does with the ten percent figure for the representation of males among domestic caprines from Tenta.

The mortality patterns presented in Table 4 suggest that caprines, like deer and pig, may have been culled younger as time went on. Certainly, while preadult culling at the two later sites tended to occur mostly prior to the end of the juvenile stage, it seems to have been concentrated during the succeeding (subadult) stage at Mylouthkia. Thus, even

if a similar proportion of caprines survived to adulthood on the later sites, the average age at death seems still to have decreased.

CONCLUSIONS

The anachronistic importance of deer is the most conspicuous aspect of the subsistence economies of village settlements during the Neolithic and Chalcolithic periods of Cyprus. Indeed, it has sometimes been suggested that the importance of deer was such that they must have been domesticated. It is argued here, however, that for man to have herded deer would have involved greater effort than hunting without yielding additional returns and it is consequently concluded that the deer would have been a free-living, hunted animal throughout the period under discussion (roughly 7000–2000 b.c.).

The extent to which animal economies were oriented toward deer hunting reached a peak during the Ceramic Neolithic, and a very high level of dependence upon deer endured through the earlier part of the Chalcolithic. Subsequent decline in overall economic significance of deer hunting during the Middle and Late Chalcolithic in the Ktima Lowlands may have been due to the decreasing capacity of the hunting strategy to support an expanding human population. It is apparent that the trend was accompanied by an increase in the relative importance of pigs. Pig herding probably ex-

panded, although the possibility should not be overlooked that some of the pig remains from those Chalcolithic settlements represent hunted feral animals. Concurrently with the changes in the relative contributions of deer and pig to subsistence, there may also have been a shift toward younger culling, indicating intensification in their exploitation. Despite the steady decline in their contribution to subsistence during the Chalcolithic, even by the end of that period deer hunting was still providing almost a half of all meat consumed.

Caprines, mostly goats in the Ktima Lowlands, were never major sources of meat, but are represented at a fairly constant, if low, level throughout the Chalcolithic. The balanced representation of the sexes among mature bones would indicate a grossly inefficient mode of exploitation if maximization of the meat yield had been the primary objective. This suggests either that other considerations were uppermost in the herdsman's mind, or that the caprines were (at least mainly) hunted animals, although an equal sex ratio would not seem to represent a particularly efficient pattern of hunting either. Even so, the mortality patterns of the Ktima Lowlands caprines hint that they, like the deer and pig, may have been culled younger over time. That would accord with the proposed general trend towards an increasingly intensive exploitation of beast by man in Chalcolithic Cyprus.

NOTES

[1] Following Stanley Price (1979: xi), the term Early Prehistoric (E.P.) is used here as a more concise way of indicating that portion of Cypriot prehistory that encompasses what are conventionally referred to as the Aceramic (Early) and Ceramic (Late) Neolithic and the Chalcolithic periods.

[2] b.c. (lower case) is used throughout to denote radiocarbon years before Christ, while B.C. indicates calendar years.

[3] I examined some of the faunal remains from Philia-Drakos "A" with the kind permission of A. J. Legge, to whom the material had been given for study.

BIBLIOGRAPHY

Bailey, G.; Carter, P.; Gamble, C.; and Higgs, H.
 1983 Epirus Revisited: Seasonality and Inter-site Variation in the Upper Palaeolithic of Northwest Greece. Pp. 64–78 in *Hunter-gatherer Economy in Prehistory*, ed. G. Bailey. Cambridge: Cambridge University.

Baird, D.
 1984 Survey in the Dhrousha Area of Western Cyprus. Appendix II. Pp. 63–65 in Lemba Archaeological Project, Cyprus, 1982: Preliminary Report, by E. J. Peltenburg. *Levant* 16: 55–65.

1985 Survey in Peyia Village Territory, Paphos 1983. *Report of the Department of Antiquities of Cyprus*: 340–49.

1987 Survey in the Stavros tis Psokas 1985. Pp. 15–18 in Excavations at Kissonerga-Mosphilia 1986, by E. J. Peltenburg. *Report of the Department of Antiquities of Cyprus*: 1–18.

Bannerman, M. M., and Blaxter, K. L., eds.
1969 *The Husbanding of Red Deer*. Aberdeen: Rowett Research Institute/Highland and Islands Development Board.

Bar Yosef, O.
1981 The Epipalaeolithic Complexes in the Southern Levant. Pp. 389–408 in *Préhistoire du Levant. Chronologie et organisation de l'espace depuis les origines jusqu'au VIe millénaire*, eds. J. Cauvin, and P. Sanlaville. Colloques International du Centre National de la Recherche Scientifique 598. Paris: Centre National de la Recherche Scientifique.

Boekschoten, G. J., and Sondaar, P. Y.
1972 On the Fossil Mammalia of Cyprus. *Proceedings of the Koninlijke Nederlandse Akademie van Wetenschappen*. Series B. 75: 306–38.

Bokonyi, S.
1974 *History of Domestic Mammals in Central and Eastern Europe*. Budapest: Akademiai Kiado.

Bottema, S., and Van Zeist, W.
1981 Palynological Evidence for the Climatic History of the Near East, 50,000–6,000 B.P. Pp. 111–32 in *Préhistoire du Levant. Chronologie et organisation de l'espace depuis les origines jusqu'au VIe millénaire*, eds. J. Cauvin and P. Sanlaville. Colloques International du Centre National de la Recherche Scientifique 598. Paris: Centre National de la Recherche Scientifique.

Carter, P. L.
1989 Fauna from the 1976 Season. Pp. 244–58 in *American Expedition to Idalion Cyprus 1973–1980*, eds. L. E. Stager and A. Walker. Oriental Institute Communications 24. Chicago: University of Chicago.

Chaplin, R. E.
1975 The Ecology and Behaviour of Deer in Relation to Their Impact on the Environment of Prehistoric Britain. Pp. 40–42 in *The Effect of Man on the Landscape: The Highland Zone*, eds. J. G. Evans, S. Limbrey, and H. Cleere. Council for British Archaeology Research Report 11.

Chapman, N. G., and Chapman, D. I.
1975 *Fallow Deer*. Lavenham (Suffolk): Terence Dalton.
1980 The Distribution of Fallow Deer: A Worldwide Review. *Mammal Review* 10: 61–138.

Clutton-Brock, J.
1979 The Mammalian Remains from the Jericho Tell. *Proceedings of the Prehistoric Society* 45: 135–57.
1981 *Domestic Animals From Early Times*. London: Heineman/British Museum (Natural History).

Cluzan, S.
1987 La potentiel agricole de Khirokitia. Pp. 312–13 in Le Néolithique Préceramique de Chypre, by A. Le Brun, S. Cluzan, S. J. M. Davis, J. Hansen, and J. Renault-Miskovsky. *L'anthropologie* 91: 283–316.

Colledge, S.
1980 Plant Species from Kissonerga Mylouthkia Feature 16.3. Appendix I. Pp. 18–20 in Lemba Archaeological Project, Cyprus 1978: Preliminary Report, by E. J. Peltenburg. *Levant* 12: 1–21.
1981 Kissonerga Mylouthkia 1979: Palaeobotanical Report. Appendix 4. p. 47 in Lemba Archaeological Project, Cyprus, 1979: Preliminary Report, by E. J. Peltenburg. *Levant* 13: 28–50.

Croft, P. W.
1981 Notes on the Animal Bones from the 1980 Excavation at Erimi Pamboula. Appendix a, Pp. 40–41 in Erimi Revisited, by H. Heywood, S. Swiny, D. Whittingham, and P. Croft. *Report of the Department of Antiquities of Cyprus*: 24–42.
1985 The Mammalian Fauna. Pp. 98–100, 202–8, 295–96 in *Lemba Archaeological Project 1: Excavations at Lemba Lakkous 1976–1983*, by E. J. Peltenburg. Studies in Mediterranean Archaeology 70.1. Göteborg: Åström.
1988a An Osteological Study of Neolithic and Chalcolithic Cyprus. Unpublished Ph.D. Thesis, University of Cambridge.
1988b Animal Remains from Maa-Palaeokastro. Appendix 9. Pp. 449–57 in *Excavations at Maa-Palaeokastro 1979–1986*, by V. Karageorghis and M. Demas. Nicosia: Department of Antiquities of Cyprus.
1989 A Reconsideration of Fauna from the 1972 Season. Pp. 259–74 in *American Expedition to Idalion Cyprus 1973–1980*, eds. L. E. Stager and A. Walker. Oriental Institute Communications 24. Chicago: University of Chicago.
In press a Mammalian Faunal Remains from Aceramic Kalavasos-Tenta. In I. A. Todd, *Vasilikos Valley Project 7: Excavations at Kalavasos-Tenta II*. Studies in Mediterranean Archaeology 71:7. Göteborg: Åström.
In press b Mammalian Faunal Remains from Kalavasos-Avious. In I. A. Todd and P. W. Croft. *Vasilikos Valley Project 8: Excavations at*

Kalavasos-Avious. Studies in Mediterranean Archaeology 71:8. Göteborg: Åström.

Dansie, O.
1984 The Case for Catching Deer: Part 2. *Deer* 6: 169.

Davidson, I.
1989 Escaped Domestic Animals and the Introduction of Agriculture to Spain. Pp. 59–71 in *The Walking Larder: Patterns of Domestication, Pastoralism, and Predation,* ed. J. Clutton-Brock. London: Unwin Hyman.

Davis, S. J. M.
1982 Climatic Change and the Advent of Domestication: the Succession of Ruminant Artiodactyls in the Late Pleistocene-Holocene in the Israel Region. *Paléorient* 8/2: 5–15.
1984 Khirokitia and its Mammal Remains a Neolithic Noah's Ark. Pps. 147–62 in *Fouilles récentes a Khirokitia (Chypre) 1977–1981,* by A. Le Brun. Paris: Editions Recherche sur les Civilizations.
1985 Tiny Elephants and Giant Mice. *New Scientist* 1437: 25–27.
1987 La faune. Pp. 305–9 in Le Néolithique Préceramique de Chypre, by A. Le Brun, S. Cluzen, S. J. M. Davis, J. Hansen, and J. Renault-Miskovsky. *L'anthropologie* 91: 283–316.

Dorst, J.
1964 L'introduction d'especes animales et leur impact sur l'environnement tropical. Pp. 245–52 in *The Ecology of Man in the Tropical Environment,* ed. H. F. L. Elliott. IUCN Publications, New Series 4 (Proceedings and Papers of the 9th Technical Meetings, Nairobi, September 1963). Morges, Switzerland.

Ducos, P.
1965 Le daim a Chypre aux époques préhistoriques. *Report of the Department of Antiquities, Cyprus:* 1–8.
1968 *L'origine des animaux domestiques en Palestine.* Publications de l'institut de préhistoire de l'université de Bordeaux, Memoire 6. Bordeaux: University of Bordeaux.

Ducos, P., and Helmer, D.
1981 Le point actuel sur l'apparition de la domestication dans le Levant. Pp. 523–28 in *Préhistoire du Levant. Chronologie et organisation de l'espace depuis les origines jusqu'au VIe millénaire,* eds. J. Cauvin and P. Sanlaville. Colloques International du Centre National de la Recherche Scientifique 598. Paris: Centre National de la Recherche Scientifique.

Edwards, P.
1989 Revising the Broad Spectrum Revolution: And Its Role in the Origins of Southwest Asian Food Production. *Antiquity* 63: 225–46.

Fletcher, T. J.
1978 The Breeding of Deer for Maximum Yield. *Deer* 4: 353–58.

Groves, C. P.
1989 Feral Mammals of the Mediterranean Islands: Documents of Early Domestication. Pp. 46–58 in *The Walking Larder: Patterns of Domestication, Pastoralism, and Predation,* ed. J. Clutton-Brock. London: Unwin Hyman.

Hadjisavvas, S.
1977 The Archaeological Survey of Paphos. A Preliminary Report. *Report of the Department of Antiquities of Cyprus:* 222–31.

Halstead, P.
1977 A Preliminary Report on the Faunal Remains From Late Bronze Age Kouklia, Paphos. *Report of the Department of Antiquities of Cyprus:* 261–75.

Howard, W. E.
1965 Interaction of Behaviour, Ecology and Genetics of Introduced Mammals. Pp. 461–84 in *The Genetics of Colonizing Species,* eds. H. G. Baker and G. L. Stebbins. New York: Academic.
1967 Ecological Changes in New Zealand Due to Introduced Mammals. Pp. 219–40 in *Towards a New Relationship of Man and Nature in Temperate Zones. Part 3. Changes Due to Introduced Species.* IUCN Publications New Series 9. (Proceedings and Papers of the 10th Technical Meeting, Lucerne, Switzerland, 1966). Morges, Switzerland.

Hughes, I.
1973 Stone Age Trade in the New Guinea Inland. Pp. 97–126 in *The Pacific in Transition,* ed. H. Brookfield. London.

Ingold, T.
1980 *Hunters, Pastoralists and Ranchers: Reindeer Economies and Their Transformations.* Cambridge: Cambridge University.

Jarman, M. R.
1976 Animal Husbandry—The Early Stages. Pp. 22–50 in *Origine de l'elevage et de la domestication.* Colloque XX of the 9th Congress of the Union Internationale des Sciences Préhistoriques et Protohistoriques, ed. E. S. Higgs. Nice.
1982 Palaeoeconomic Perspectives. Pp. 49–71 in *Early European Agriculture: Its Foundations and Development,* eds. M. R. Jarman, G. N. Bailey, and H. N. Jarman. Cambridge: Cambridge University.

Jones, D. K.; Merton, L. F. H.; Poore, M. E. D.; and Harris, D. R.
1958 *Report on Pasture Research, Survey and Development in Cyprus.* Government of Cyprus.

Karageorghis, V.
 1982 *Cyprus from the Stone Age to the Romans.*
 London: Thames and Hudson.
King, J. E.
 1953 Mammal Bones from Khirokitia and Erimi.
 Appendix 3, Pp. 431–37 in *Khirokitia*, by
 P. Dikaios. Monographs of the Department
 of Antiquities of the Government of Cyprus
 1. Oxford: Oxford University.
Koike, H., and Ohtaishi, N.
 1987 Estimation of Prehistoric Hunting Rates
 Based on the Age Composition of Sika Deer
 (*Cervus nippon*). *Journal of Archaeological
 Science* 14: 251–69.
Le Brun, A.
 1981 Remarques sur l'utilisation de l'espace a Khiro-
 kitia et au Cap Andreas-Kastros (Chypre).
 Pp. 457–66 in *Préhistoire du Levant. Chrono-
 logie et organisation de l'espace depuis les
 origines jusqu'au VI^e millénaire*, eds. J. Cau-
 vin and P. Sanlaville. Colloques International
 du Centre National de la Recherche Scien-
 tifique 598. Paris: Centre National de la Re-
 cherche Scientifique.
Le Brun, A.; Cluzan, S.; Davis, S. J. M.; Hansen, J.; and
 Renault-Miskovsky, J.
 1987 Le Neolitique Préceramique de Chypre. *L'an-
 thropologie* 91: 283–316.
Legge, A. J.
 1982 The Vertebrate Fauna. Pp. 76–87, 401–14 in
 *Vrysi. A Subterranean Settlement in Cyprus.
 Excavations at Prehistoric Ayios Epiktitos-
 Vrysi 1969–73*, by E. J. Peltenburg. Warmin-
 ster: Aris and Phillips.
Lehavy, Y.
 1989 Dhali-Agridhi: The Neolithic by the River.
 Pp. 203–43 in *American Expedition to Idalion
 Cyprus 1973–1980*, eds. L. E. Stager and
 A. Walker. Oriental Institute Communica-
 tions 24. Chicago: University of Chicago.
Moore, A. M. T.
 1982 A Four-Stage Sequence for the Levantine
 Neolithic, ca. 8,500–3750 B.C. *Bulletin of the
 American Schools of Oriental Research* 246:
 1–34.
Morris, D.
 1985 *The Art of Ancient Cyprus.* Oxford: Phaidon.
Morris, D.; Collett, P.; Marsh, P.; and O'Shaugh-
 nessy, M.
 1979 *Gestures: Their Origins and Distribution.*
 London: Cape.
Payne, S.
 1973 Kill-off Patterns in Sheep and Goats: The
 Mandibles from Asvan Kale. *Anatolian Stud-
 ies* 23: 281–303.

Peltenburg, E. J.
 1978 The Sotira Culture: Regional Diversity and
 Cultural Unity in Late Neolithic Cyprus. *Le-
 vant* 10: 55–74.
 1979 The Prehistory of West Cyprus: Ktima Low-
 lands Investigations 1976–78. *Report of the
 Department of Antiquities of Cyprus*: 69–99.
 1982a *Vrysi. A Subterranean Settlement in Cyprus.
 Excavations at Prehistoric Ayios Epiktitos-
 Vrysi 1969–73.* Warminster: Aris and Phillips.
 1982b *Recent Developments in the Later Prehistory
 of Cyprus.* Studies in Mediterranean Archae-
 ology Pocket-book 16. Göteborg: Åström.
 1983 The Prehistory of West Cyprus: Ktima Low-
 lands Investigations 1979–82. Pp. 9–18 in The
 Prehistory of West Cyprus: Ktima Lowlands
 Investigations 1979–82, by E. J. Peltenburg,
 P. W. Croft, J. D. Stewart, J. Woodhead,
 C. Elliott, and G. Philip. *Report of the De-
 partment of Antiquities of Cyprus*: 9–55.
 1989 Lemba Archaeological Project, Cyprus, 1987.
 Levant 21: 195–97.
Reed, C. A.
 1983 Archeozoological Studies in the Near East: A
 Short History (1960–1980). Pp. 511–36 in
 *Prehistoric Archaeology Along the Zagros
 Flanks*, eds. L. S. Braidwood, R. J. Braid-
 wood, B. Howe, C. A. Reed, and P. J. Wat-
 son. University of Chicago Oriental Institute
 Publications 105. Chicago: University of
 Chicago.
Renault-Miskovsky, J.
 1987 Etude palynologique preliminaire. Pp. 303–5
 in Le Neolithique Préceramique de Chypre,
 by A. Le Brun, S. Cluzan, S. J. M. Davis,
 J. Hansen, and J. Renault-Miskovsky. *L'an-
 thropologie* 91: 283–316.
Rowley-Conway, P.
 1986 Between Cave Painters and Crop Planters:
 Aspects of the Temperate European Meso-
 lithic. Pp. 17–32 in *Hunters in Transition:
 Mesolithic Societies of Temperate Eurasia
 and Their Transition to Farming*, ed. M. Zve-
 lebil. Cambridge: Cambridge University.
Schwartz, J. H.
 1974 The Paleo-osteology of Cyprus. Pp. 119–21
 in *American Expedition to Idalion, Cyprus.
 First Preliminary Report: Seasons of 1971
 and 1972*, eds. L. E. Stager, A. Walker, and
 G. E. Wright. *Bulletin of the American
 Schools of Oriental Research Supplement* 18.
 Cambridge, MA: American Schools of Ori-
 ental Research.
Sheen, A.
 1981 Stavros tis Psokas Survey 1979. Appendix 1.
 Pp. 39–42 in Lemba Archeological Project

Cyprus, 1989: Preliminary Report, by E. J. Peltenburg. *Levant* 13: 28–50.

Simmons, A. H.
1988 Test Excavations at Akrotiri-Aeto-kremnos (Site E), an Early Prehistoric Occupation in Cyprus: Preliminary Report. *Report of the Department of Antiquities of Cyprus*: 15–24.

Stampfli, H. R.
1983 The Fauna of Jarmo with Notes on Animal Bones from Matarrah, the ꜥAmuq and Karim Shahir. Pp. 431–83 in *Prehistoric Archaeology Along the Zagros Flanks*, eds. L. S. Braidwood, R. J. Braidwood, B. Howe, C. A. Reed, and P. J. Watson, University of Chicago Oriental Institute Publications 105. Chicago: University of Chicago.

Stanley Price, N. P.
1977 Khirokitia and the Initial Settlement of Cyprus. *Levant* 9: 66–89.
1979 *Early Prehistoric Settlement in Cyprus 6500–3000 B.C.* BAR International Series S65. Oxford: British Archaeological Reports.

Storrs, R., and O'Brien, B. J.
1930 *The Handbook of Cyprus*. 9th ed. London: Christophers.

Todd, I. A.
1987 *Vasilikos Valley Project 6: Excavations at Kalavasos-Tenta I*. Studies in Mediterranean Archaeology 71: 6. Göteborg: Åström.

Tomlinson, D.
1988 Finishing Touch in the Park. *Country Life*. February 25th: 92–95.

Uerpmann, H.-P.
1981 The Major Faunal Areas of the Middle East During the Late Pleistocene and Early Holocene. Pp. 99–106 in *Préhistoire du Levant. Chronologie et organisation de l'espace depuis les origines jusqu'au VIᵉ millénaire*, eds.

J. Cauvin and P. Sanlaville. Colloques International du Centre National de la Recherche Scientifique 598. Paris: Centre National de la Recherche Scientifique.

Van Zeist, W., and Bottema, S.
1982 Vegetational History of the Eastern Mediterranean and the Near East during the Last 20,000 Years. Pp. 277–323 in *Palaeoclimates, Palaeoenvironements and Human Communities in the Eastern Mediterranean Region in Later Prehistory*, eds. J. L. Bintliff and W. Van Zeist. BAR International Series S133. Oxford: British Archaeological Reports.

Van Zeist, W., and Woldring, H.
1980 Holocene Vegetation and Climate of Northwestern Syria. *Palaeohistoria* 22: 111–25.

Vos, A. de; Manville, R. H.; and Van Gelder, R. G.
1956 Introduced Mammals and Their Influence on Native Biota. *Zoologica* (New York) 41: 163–96.

Wagstaff, J. M.
1978 Geographical Contribution to the Vasilikos Valley Project, 1977. Pp. 187–89 in Vasilikos Valley Project: Second Preliminary Report, 1977, by I. A. Todd, *Journal of Field Archaeology* 5: 161–95.

Watson, J. P. N., and Stanley Price, N. P.
1977 The Vertebrate Fauna from the 1972 Sounding at Khirokitia. *Report of the Department of Antiquities of Cyprus*: 232–60.

Zeuner, F. E.
1958 Animal Remains from a Late Bronze Age Sanctuary on Cyprus, and the Problem of the Domestication of Fallow Deer. *Journal of the Palaeontological Society of India* 3: 131–35.
1963 *A History of Domesticated Animals*. London: Hutchinson.

The Evolution of the Chalcolithic Painted Style

Diane L. Bolger
Frankfurt, Germany

Structural analysis of painted design on pottery has been used by anthropologists to measure degrees of intersite interaction. In this article, design structures of Red-on-White pottery from three sites of the Chalcolithic period in Cyprus—Lemba-Lakkous, Kissonerga-Mosphilia, and Erimi-Pamboula—are compared and contrasted. The analysis is confined to three major morphological types of the Middle Chalcolithic period: the flask, the spouted bowl, and the hemibowl. Comparative results suggest that stylistic links between Mosphilia and Erimi are stronger than between either site and Lemba. This evidence contradicts standard explanations of distance as the most critical factor in intersite interaction and encourages archaeologists to seek other explanations for the phenomenon during the Chalcolithic period.

INTRODUCTION

Recent approaches in anthropology and archaeology have sought to use pottery evidence not only to measure diachronic change, but also to document and interpret spatial variability (Rice 1987: 249–52). The studies have generated new methods of stylistic analysis based on criteria that are more objective than those of the past because they have been more carefully defined. They normally address questions of stylistic variation at one or more of the following levels: the technical level, concerned with the tools and materials used as well as with the techniques employed in the execution of painted design; the structural level, modeled on linguistic paradigms and involving analysis of painted designs into their smallest components ("elements") and the discovery of rules ("syntax") according to which elements combine to form larger structural units; and the symbolic level, attempting to elucidate the ways in which painted designs are used to signify and transmit cultural meaning.

Consideration of the analyses conducted to date on Chalcolithic pottery in Cyprus, and in particular on the principal patterned ware of the period, Red-on-White (RW), shows that little work has been carried out at any of the levels just outlined (see Baird, in press b; Peltenburg 1982; Bolger 1988a: 35–72). At the symbolic level, it is unlikely that we will ever be in a position to do so. The linear character of the style and the fragmentary nature of the evidence make interpretation at that abstract level difficult if not impossible to achieve.

Technically, little knowledge of the composition of RW paint is available, including such fundamental distinctions as whether what we call "paint" should sometimes be more properly termed "slip" (that is, a clay solution rather than a mineral pigment such as hematite mixed with a binding agent). Macroscopic examination favors the latter, but more objective, scientific criteria are needed. X-ray diffraction analysis of painted sherds from Kissonerga-Mosphilia, currently underway at Glasgow University, may serve as an important first step in this direction. A second area of investigation that could enhance our understanding of RW technique would be experimentation with native plant types to distinguish the types of brushes used to apply the painted motifs; and with stone, bone, and pottery tools to understand burnishing techniques. At present, however, our technical knowledge of decorative processes such as painting and burnishing is quite limited.

During the Middle Chalcolithic (ca. 3500–3000 B.C.), which may be regarded as the floruit of the RW style, brush strokes on RW vessels tend to be narrow and closely-spaced, prompting the label "Close Line Style" to characterize the painted designs of that phase of the pre-Bronze Age sequence (Peltenburg 1982). During earlier phases (Late Neolithic and, to a lesser degree, Early Chalcolithic)

the style is distinguished by thicker and more loosely-knit motifs; consequently, it has been referred to as the "Broad Line Style" (Peltenburg 1982). Recognition of the gradual transition of RW from Broad Line to Close Line composition currently serves as the only guide to the differentiation of stages in the evolution of the painted style. It has proved useful in the field for the relative dating of sherd deposits which, due to their fragmentary state, provide stylistic evidence primarily at the design-element level. It is perhaps a less useful analytical tool in cases of larger, well-preserved fragments or whole vessels, where it is possible to assess not only individual motifs, but their configurations relative to shape of the vessel and to the structural fields comprising the interior and exterior surfaces. Dikaios included in his Erimi report a general commentary on the structure of design of RW pottery there, but the limited scope of the sounding and a lack of comparative material from around the island prevented him from developing those ideas in greater depth (Dikaios 1936: 31). Nevertheless, his careful and methodical recording of the finds permits comparison of his results with evidence from more recently excavated sites. This article will consider some of the structural aspects of Middle Chalcolithic RW. First, however, it will be useful to establish some of the primary technical and structural aspects of the earlier phases of the painted style, beginning with the origins of RW ware during the Late Neolithic period.

THE EARLIEST RW:
LATE NEOLITHIC PERIOD

Not long after painted pottery first appeared in Cyprus, it was accompanied by Combed Ware (Cb), a monochrome pottery type with reserve decoration (most often, sets of curvilinear bands) produced by scraping the painted surface with one or more of a variety of single or multiple-pronged tools. According to Dikaios, the combed style provided the initial impetus for emergence of the painted style: by reversing positive and negative elements, the pottery created a new technique that in Dikaios' words "freed him from the monotony of the combed style" (Dikaios 1961: 179). Although evidence from more recent excavations has demonstrated that Combed Ware was not antecedent to early RW, there is no doubt of the close relationship between the two during the Late Neolithic period. Their association

can be readily observed on Painted-and-Combed (PCb) vessels (fig. 1.6–7), on which positive bands or panels have been combed with multiple-pronged tools; on "bilingual" bowls from Sotira and elsewhere which display combed or painted-and-combed interiors and RW exteriors (fig. 1.5); and on bowls from Ayios Epiktitos-Vrysi in the north, decorated with both combed wavy bands and positive ripple patterns (fig. 1.8; see Peltenburg 1975: 17–45). In the south, the influence of the monochrome tradition is attested by the restricted range of RW motifs (straight bands, zigzag bands, rings, and curvilinear bands only). On open vessels such as shallow bowls, those elements are arranged in patterns that appear to be closely related to the reserve designs of some Combed Ware vessels (fig. 1.3–4; cf. fig. 1.1 and Dikaios 1961: pl. 59). Closed vessels in RW, however, contain decorative elements that occasionally diverge from their reserve counterparts, suggesting that vessel morphology played a significant role in the early development of RW design. Several globular and ovoid jugs, for example, have design fields divided vertically or horizontally (fig. 1.1–2). Static and dynamic composition are both attested, and in both cases symmetry is an important compositional feature, although its potential visual impact is mitigated by uneven line thicknesses and irregular spacing of repeated elements.

In the north of the island, vivid and robust designs are characteristic of the painted style. At sites such as Vrysi (fig. 1.9–10), the painted pottery tradition seems to have been more popular than it was in the south; moreover, there is ample evidence of diachronic change (Peltenburg 1982: 18–36). During the early phase at Vrysi, sets of wavy bands in ripple patterns predominate, as do sets of open circles or rings; motifs are carelessly executed. During the middle phase, linear motifs such as chevrons become popular, as do dot borders and lattice patterns used as filler motifs. Groups of wavy bands continue to be popular and persist into the late phase. At the end of that phase, however, radical changes occur. Thinner-lined lattice motifs first appear, together with reserve bars or "slits" (fig. 1.9). New shapes, such as the platter and the holemouth jar, indicate that changes in the ceramic repertoire were far-reaching. In terms of composition, the most significant development of Late Phase ceramics is the division of the design field into small, compartmentalized units (Peltenburg 1982: 32). Evidence for the ultimate phase, limited

Fig. 1. Pottery of the Late Neolithic period: Sotira-Teppes (1–4); Kalavasos-Tenta (5–7); Ayios Epiktitos-Vrysi (8–10).

though it is, suggests a new stage of the painted style marked by a reduction in the number of design elements; greater complexity of design composition; new tools and techniques to achieve more gracile, closely-spaced linear motifs; and the application of the latter to a new range of morphological types. Many of the new features are paralleled elsewhere on the island in contexts datable to the Early Chalcolithic period.

THE EMERGENCE OF AN ISLAND-WIDE STYLE: EARLY CHALCOLITHIC RW

Perhaps the closest links with Vrysi can be observed at Kalavasos-Ayious on the south coast (fig. 2.1–3). Kromholz' preliminary study of the ceramics (1981: 17–53) and Baird's final report on RW at the site (Baird in press a) point to similarities between RW pottery from Ayious (especially Phase 1A) and sites of the Late Neolithic period. Proportions of RW during that phase, as well as the intricacy of painted compositions, closely replicate patterns recorded at middle-phase Vrysi and the earlier part of Vrysi late phase. During Phase 1B at Ayious, RW diminishes. Compositions are linear and more subdued, and there is a tendency to leave large portions of the vessel surface unpainted. That is particularly apparent on bowls with plain or rim band exteriors and interior patterning comprised of simple rectilinear elements. During Phase 2, many 1B characteristics, such as the platter shape and the spaciousness of design composition, continue. There are also innovations, such as the incorporation of curvilinear elements and the first appearance of thin-lined lattice motifs. The latter are applied with a multiple brush and occur most

Fig. 2. Red-on-White pottery of the Early Chalcolithic period: Kalavasos-Ayious (1–3); Maa-Palaeokastro (4–6); Kissonerga-Mosphilia (7–11).

frequently on interiors of open vessels. On closed shapes, painted designs adhere more faithfully to tradition, consisting almost entirely of reserve bands as in Ayious 1.

RW from the end of the late phase at Vrysi bears close similarities to that of Ayious 1B and 2. Morphological features such as the diagnostic platter shape—not a Neolithic type—and decorative features such as thin-lined multibrush lattice tech-

niques suggest that the transition from Neolithic to Chalcolithic was effected during the final phase of occupation. The emergence of a positive painted style at Ayious and Vrysi in which lattice motifs played a central role demonstrates the increasing independence of the Early Chalcolithic painted style from previous decorative canons. At Ayious it is perhaps indicative of the influence of the north in those developments; at the very least, it suggests

greater degrees of contact and communication be-
tween northern and southern sectors than had pre-
viously been the case.

Investigations by the Lemba Archaeological Proj-
ect at sites in the Ktima Lowlands north of Paphos
are contributing a great deal to current understand-
ing of Early Chalcolithic pottery styles in the west
of Cyprus. Although not all of the excavations
have been completed, a clear picture is beginning
to emerge. A small scale excavation at Maa-
Paleokastro, undertaken in 1986 by G. Thomas
under the auspices of the Cyprus Department of
Antiquities (V. Karageorghis director), yielded pot-
tery that on morphological grounds appears to
belong to an early stage of the Early Chalcolithic
(fig. 2.4–6; Thomas 1988; Bolger 1988b). In par-
ticular, a bridge-spouted hemibowl is strongly remi-
niscent of Late Neolithic types; and platters with
straight sides and flaring rims are common. Despite
the small sample size and the severely abraded
surfaces of the sherds, several features evince links
with Ayious. The pieces include platters whose
exteriors were monochrome or unpainted and
whose interiors were decorated with thick, broadly-
spaced bands (fig. 2.5); and pointed-based flasks
with reserve slit and window motifs (fig. 2.4, 6).
The same elements recur at other Early Chalcolithic
contexts in the west, such as Kissonerga-Mosphilia
Period 1, where flasks with reserve rectilinear mo-
tifs and platters with lattice or plain banded in-
teriors occur (fig. 2.7–10); and at Kissonerga-
Mylouthkia, where RW sherdage, though rare, ex-
hibits a similarly restricted range of motifs and
shapes (see Bolger 1989; Peltenburg 1982: 85–87).
Period 1 at Lemba-Lakkous probably dates to
Early Chalcolithic as well. There RW is extremely
rare, accounting for little more than 1.5 per cent of
the total sherdage (Stewart 1985: 65). In Area I,
rim bands, lattice motifs, and parallel lines are the
only elements recorded. In Area II, zigzag bands
and fringed or dotted bands also occur; those
elements are recorded elsewhere in Middle Chal-
colithic contexts, supporting the excavator's sup-
position that Period 1 in Area II is chronologically
later than Period 1 in Area I (Peltenburg 1985: 316).

The evidence from the west still remains to be
assessed in greater detail. However, on present
analysis, Early Chalcolithic RW in the region corre-
sponds closely with its counterparts elsewhere on
the island. Pottery types at Chalcolithic Maa indi-
cate that the site appears to be roughly contem-
porary with Ayious Phase 1 and Vrysi Late;

Mosphilia 1 and Mylouthkia with Ayious 2 and
the latest part of Late Phase Vrysi; and Lemba
Period 1 (Area I) overlapping in part with Ayious 2
and directly anticipating the earliest levels at Erimi
(see Baird, in press a; Bolger 1988b). The close
connections at all of the above sites with regard to
decorative elements and their structural associa-
tions argue in favor of a high level of intersite
contact during the period and the emergence of an
island-wide style characterized by new morphologi-
cal types (platters and flasks); close association
between closed shapes, notably the flask, and re-
serve design elements such as slits and windows;
high frequency of platter and other open shapes
with plain slipped or monochrome exteriors and
simply-patterned interiors; and introduction of a
positive style comprised of closely spaced, thin-
lined motifs executed with a multiple brush. Few
of those characteristics persist into the succeeding,
Middle Chalcolithic period.

FROM UNIFORMITY TO COMPLEXITY:
MIDDLE CHALCOLITHIC RW

The results of recent excavations, together with
evidence from Erimi and a number of other sites
investigated earlier in the century, demonstrate in-
creased levels of prosperity, stability, and social
complexity during the second half of the fourth
millennium (see Peltenburg 1982; Peltenburg, in
press). In ceramic terms, the developments are
marked by a greater diversity of morphological
types, including new shapes such as deep bowls
with spouts or lugs, a variety of hemibowls with
flanged or flattened bases, and large-scale storage
jars—the first pithoi in Cyprus. The platter, diag-
nostic of the Early Chalcolithic period, declines in
popularity, while the flask becomes more popular.
Novel shapes, such as a spouted flask from the
cemetery at Souskiou (Maier and Karageorghis
1984: fig. 2) and an anthropomorphic tumbler from
Mosphilia (Peltenburg 1988: fig. 1, lower right)
suggest the occasional manufacture of special ves-
sels for ceremonial purposes; both signify impor-
tant developments in the relationship between
society and the supernatural at that time.

Painted decoration likewise undergoes great trans-
formations. The reserve style, so popular during
the Early Chalcolithic period, becomes extremely
rare; positive designs are the order of the day. On
open vessels, motifs occur on exterior surfaces with
much greater frequency. Moreover, painted designs

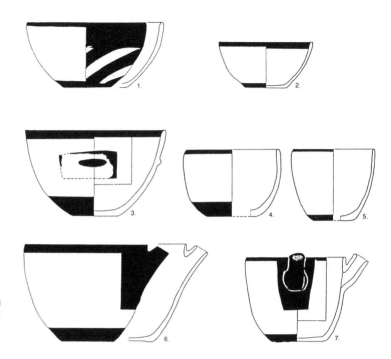

Fig. 3. Red-on-White vessels from Lemba-Lakkous: hemibowls (1–2); deep bowls (3–5); spouted bowls (6–7).

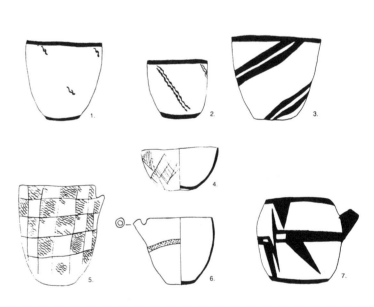

Fig. 4. Red-on-White vessels from Erimi-Pamboula: hemibowl (4); deep bowls (1–3, 5); spouted bowls (6–7).

become more complex, as is evident from expanded motif repertoires of RW ware—a total of 26 at Mosphilia,[1] 25 at Lemba (Stewart 1985: 65), and 29 at Erimi (Bolger 1988a: 188). Comparison of those elements indicates many common examples, a phenomenon that is often interpreted as a sign of strong intersite communication. However, similarities in occurrence and frequency of design elements

cannot by themselves be used as proof of stylistic uniformity. To infer similarities in style, researchers must also consider the structure of design elements. Several ethnographic studies have demonstrated the relative ease with which individual elements in pottery styles are exchanged locally and interregionally (Rice 1987: 252–54; Shepard 1980: 264–67; Hole 1984: 326–47; Plog 1983: 125–42). Design

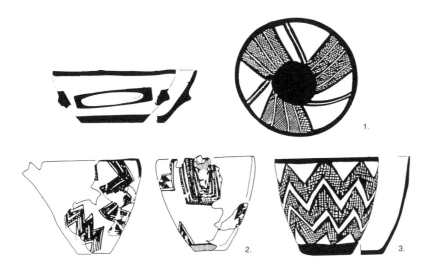

Fig. 5. Red-on-White vessels from Kissonerga-Mosphilia: hemibowl (1); deep bowl (3); spouted bowl (2).

TABLE 1. Motifs on Hemibowls from Erimi, Lemba, and Mosphilia*

		Site	
	Erimi	*Lemba*	*Mosphilia*
Field 1	a) (no. 441)	(no. 1154)	(no. 1205)
	Blank	Rim band	Rim band
	b) (no. 471)	(no. 1328)	(no. 1206)
	Blank	Rim band	Rim band
	c) —	(no. 168)	(no. 1207)
		Rim band	Rim band
	d) —	—	(no. 1253)
			Rim band
Field 2	a) Lattice triangular Thin filler	Blank	Blank
	b) Thin lattice filler	Rectangular panel over lug	Blank
	c) —	Two diagonal "drip" lines	Rectangular panel over lug
	d) —	—	Rectangular panel over lug
Field 3	a) Blank	Base band	Base band
	b) Blank	Base band	Base band
	c) —	Base band	Base band
	d) —	Base band	Base band
Field 4	a) Blank	Rim band	Rim band, solid base, radiating lattice bands
	b) Blank	Rim band	Rim band, lattice-filled rectangular pendant from rim and projects from base
	c) —	Upper half monochrome, lower half radiating bands	Monochrome
	d) —	—	Rim band, monochrome base, alternating groups of lattice bands

*Erimi (a) no. 441, (b) no. 471; Lemba (a) no. 1154, (b) no. 1328, (c) no. 168; Mosphilia (a) no. 1205, (b) no. 1206, (c) no. 1207, (d) no. 1253.

structures, on the other hand, are much less prone to casual exchange since they are more complex and difficult to comprehend. Consequently, they serve as more accurate indicators of the characteristic styles of ceramic assemblages and provide a firmer basis for intersite comparison.

To compare design structures of Middle Chalcolithic RW assemblages, one must begin by considering vessel morphology, since "design structure" is defined as the patterns of motif occurrence on particular areas of the vessel surface. Those zones, or "fields" of decoration, can be isolated by dividing the vessel into its constituent structural components (rim, body, base, etc.). Design fields for three common Middle Chalcolithic types—hemibowl, deep bowl, and spouted bowl—will be considered in this article.

Each shape has four fields, with the hemibowl and deep bowl divisible into exterior rim, exterior body, exterior base, and interior; the spouted bowl is divisible into exterior rim, exterior body, exterior base, and spout.

Evidence from Erimi, Lemba, and Mosphilia will be utilized, since those settlement sites have yielded significant numbers of whole vessels. Admittedly, the number is not great, and sherdage from the sites suggests that RW design was more varied than the whole vessels alone appear to indicate. For present purposes, however, the disadvantage of a smaller body of comparative material is outweighed by the opportunity to isolate several key aspects of the Middle Chalcolithic painted style on the basis of complete rather than fragmentary evidence.

Shape 1: Hemibowl (figs. 3.1–3; 4.4; 5.1)

Nine examples are included in the present analysis—two from Erimi, three from Lemba, and four from Mosphilia. The vessels and their associated motifs are listed in Table 1 according to site and decorative field. Field 1-a, for example, stands for the exterior rim area of vessel "a" (Erimi no. 441); Field 2-a, the exterior body of no. 441; Field 3-a, the exterior body just above the base of no. 441; and Field 4-a, the interior of no. 441. Designs are registered according to field, with "blank" signifying a slipped, unpainted surface; "monochrome" signifies a red, unpatterned surface. The information provided in Table 1 has been synthesized into a more usable form in Table 2.

Structural elements on hemibowls at the sites reveal close associations between those from Lemba

TABLE 2. Motifs on Hemibowls from Erimi, Lemba, and Mosphilia: Synthesis of Data*

	Site		
	Erimi	Lemba	Mosphilia
Structural Elements (%)			
Field 1	0	100	100
2	0	33	50
3	0	100	100
4	0	66	75
Design Elements			
Field 1	0	0	0
2	100	33	0
3	0	0	0
4	0	33	75
Design Elements (occurrence)			
Field 1	—	—	—
2	Lattice	Parallel lines	—
3	—	—	—
4	—	Parallel bands	Parallel bands, lattice bands, other lattice designs

*% of structural elements in Fields 1–4; % of design elements in Fields 1–4; types of design elements in Fields 1–4.

and Mosphilia. All of the examples contained rim bands in Field 1 and base bands in Field 3. Moreover, comparable frequencies of structural elements occurred in Field 2 (specifically, solid rectangles over horizontal lugs) and Field 4 (internal rim bands). In contrast, Erimi hemibowls did not contain structural elements in any of their four fields.

The link between Lemba and Mosphilia is further evidenced by a comparison of design element location. Data on design elements from Fields 2 and 4 (Table 2) indicate that all Erimi hemibowls have painted designs on their exteriors; at Lemba only one such example was recorded and at Mosphilia, none. By the same token, there was no example at Erimi of a hemibowl with interior decoration, while at Lemba and Mosphilia hemibowls often contained painted patterns on their interiors.

A comparison of motif types on hemibowls fails to demonstrate close associations among any of those sites. A bowl from Lemba (fig. 3.1) with radiating bands on its interior is reminiscent of a bowl from Mosphilia (fig. 5.1), the latter containing lattice rather than monochrome spirals. Otherwise, however, Lemba hemibowls have blank interiors,

TABLE 3. Motifs on Deep bowls from Erimi, Lemba, and Mosphilia*

			Site	
		Erimi	*Lemba*	*Mosphilia*
Field 1	a)	(no. 403)	(no. 1325)	(no. 1251)
		Rim band	Rim band	Rim bands w/row of squiggles
	b)	(no. 413)	(no. 1326)	(no. 1256)
		Rim band	Rim band	Rim band
	c)	(no. 414)	(no. 1152)	(no. 1346)
	d)	Rim band	Rim band	Rim band
		(no. 190)	(*LAP* I fig. 58.5)	(no. 1347)
		Start of field	Rim band	Rim band
		2 motifs		
Field 2	a)	Pairs of diagonal bands	Blank	Zigzag lattice bands
	b)	Pairs of wavy strokes	Blank	Zigzag lattice bands
	c)	Pairs of diagonal wavy bands	Blank	Lattice checkerboard
	d)	Checkerboard w/wavy lines	Monochrome	Rows of zigzag lattice bands
Field 3	a)	End of field	Base band	Base band
		2 motifs		
	b)	Base band	Base band	Base band
	c)	Base band	Base band	Base band
	d)	Blank	Base band	Base band
Field 4	a)	Blank	Blank	Monochrome
	b)	Blank	Blank	Blank
	c)	Monochrome	Monochrome	Monochrome
	d)	Blank	Monochrome	Monochrome

*Erimi (a) no. 403, (b) no. 413, (c) no. 414, (d) no. 190; Lemba (a) no. 1325, (b) no. 1326, (c) no. 1152, (d) unnumbered in publication, *LAP* I fig. 58.5; Mosphilia (a) no. 1251, (b) no. 1256, (c) no. 1346, (d) no. 1347.

with the occasional exception of an internal rim band (a structural element).[2] Mosphilia hemibowls display far more elaborate designs, incorporating radiating bands, lattice bands, and complex lattice rectangles into bold, dynamic compositions.

Shape 2: Deep Bowl (figs. 3.4–5; 4.1–3, 5; 5.3)

The process used to analyze hemibowls was next applied to deep bowls. Twelve were considered—four each from Erimi, Lemba, and Mosphilia. Painted motifs on those vessels have been registered by site and field (Table 3). Data concerning the frequency and occurrence of design and structural elements are summarized in Table 4.

With regard to the structure of design on deep bowls, there are correspondences among all three sites. Most of the examples considered in this article have rim bands and base bands on their exteriors.

There were no structural elements in Field 2 at any site, and only one vessel contained a structural element in Field 4, a rim band on a bowl from Lemba (fig. 3.3). Design element percentages reveal a different pattern, however. Significant is the high frequency rate of design elements in Field 2 at Erimi and Mosphilia, and the complete lack of Field 2 designs on Lemba examples. At Lemba, Field 2 is consistently left blank, again evidence for a plain or "minimalist" style already observed on hemibowls from the site.

Comparison of design elements at Erimi and Mosphilia indicates that connections between them were not as close as the evidence of structural elements suggests. Deep bowls at Erimi favor wavy strokes or diagonal bands as basic motifs, whereas at Mosphilia lattice motifs (lattice-filled checks, lattice zigzag bands, etc.) predominate. At both sites, static and dynamic compositions occur.

TABLE 4. Motifs on Deep Bowls from Erimi,
Lemba, and Mosphilia: Synthesis of Data*

| | *Site* | | |
	Erimi	Lemba	Mosphilia
Structural Elements (%)			
Field 1	75	100	75
2	0	0	0
3	50	100	100
4	0	0	0
Design Elements (%)			
Field 1	25	0	25
2	100	0	100
3	25	0	0
4	0	0	0
Design Elements (occurrence)			
Field 1	Checkerboard w/wavy lines	—	Rim bands w/row of squiggles
2	Parallel bands, wavy bands, checkerboard w/wavy lines	—	Lattice checkerboard, zigzag lattice bands
3	Checkerboard w/wavy lines	—	—
4	—	—	—

*% of structural elements in Fields 1–4; percent of design elements in Fields 1–4; types of design elements in Fields 1–4.

Shape 3: Spouted Bowls (figs. 3.6–7; 4.6–7; 5.2)

Seven examples of this type were considered, two each from Lemba and Erimi, and three from Mosphilia. Motifs associated with the vessels are listed by site on a field-by-field basis (Table 5). Table 6 lists percentages of structural elements and design elements and specifies design element types.

Structural elements appear to have been very popular on spouted bowls at Lemba: both examples have rim bands, base bands, and rectangular painted panels in Field 2 where the spout is attached. At Erimi and Mosphilia, on the other hand, structural elements do not occur in Field 2 and only about 50 percent of the time in Fields 1 and 3.

Design element percentages corroborate that picture. At Lemba, design elements fail to occur in Field 2; the latter is simply left blank. At Erimi, however, all spouted bowls have design elements in Field 2. The best preserved example (fig. 4.7) combines a horizontal band joined to a solid tapered

band, the latter projecting diagonally toward the base. This combination of static and dynamic elements appears on deep bowls at Erimi as well (see fig. 4). At Mosphilia, two out of three spouted bowls display design elements in Field 2, but compositions are far more dynamic than those at Erimi (e.g., fig. 5.2). Once again, lattice motifs dominate, this time with zigzag lattice bands and complex lattice-filled rectangles serving as the primary design elements.

CONCLUSIONS

In attempting to distill basic patterns from the variety of motif occurrences and design structures, it should be stressed that the present results are by no means conclusive and should ultimately be tested and expanded by incorporating analyses of relevant sherd material. Nevertheless, a number of preliminary inferences can be made on the basis of the group of RW vessels considered here.

Painted decoration on RW bowls at Lemba was composed primarily of structural elements; design elements were rare by comparison. Rim bands, base bands, and solid panels reinforcing other structural features of the vessel were the main elements used. The evidence suggests a distinctive painted tradition at Lemba in which large portions of the vessel surface were left unpainted—a bold, "minimalist" style that has not been documented elsewhere with the same degree of force. This structure-oriented style can be observed to a lesser degree on hemibowls at nearby Mosphilia, where structural elements are regularly joined by dynamic design compositions based on lattice motifs. The occurrence of painted decoration on hemibowl interiors, occasionally at Lemba and frequently at Mosphilia, may signify the persistence into the Middle Chalcolithic period of earlier painted traditions.[3]

Stylistic links between Erimi and Mosphilia appear to be stronger than between Lemba and either of those sites. Apart from the differential placement of design elements on hemibowls (at Erimi they occurred most frequently in Field 2 and at Mosphilia in Field 4), RW vessels share many design-structure traits. Most noteworthy are the high frequencies of design elements on body exteriors (Field 2) of deep bowls and spouted bowls. Field 2 on corresponding examples at Lemba was left blank. The close structural links between Erimi and Mosphilia contradict the standard explanation of distance as the most decisive factor in intersite

TABLE 5. Motifs on Spouted Bowls from Erimi, Lemba, and Mosphilia*

		Site		
		Erimi	Lemba	Mosphilia
Field 1	a)	(no. 193)	(no. 374)	(no. 400)
		Rim band	Rim band	Rim band
	b)	(no. 399)	(no. 1155)	(no. 1498)
		Blank	Rim band	Monochrome
	c)	—	—	(no. 2284)
				Rim band
Field 2	a)	Horizontal band; reserve motifs; diagonal triangular band	Rectangular panel around spout	Zigzag lattice bands; rectangular lattice bands around spout
	b)	Horizontal lattice band	Rectangular panel around spout	Monochrome
	c)	—	—	Lattice-filled rectangles
Field 3	a)	Base band	Base band	End of Field 2 motifs
	b)	Blank	Base band	Base band
	c)	—	—	Base band
Field 4	a)	Monochrome	Monochrome	Lattice decoration
	b)	Blank	Monochrome	Rim band at spout end
	c)	—	—	Rim band at spout end

*Erimi (a) no. 193, (b) no. 399; Lemba (a) no. 374, (b) no. 1155; Mosphilia (a) no. 400, (b) no. 1498, (c) no. 2284.

interaction and encourage us to seek other explanations for the phenomenon during the Chalcolithic period.

The similarities of Erimi and Mosphilia RW do not appear to extend to the level of motif occurrence and design configuration, however. At Mosphilia the popularity of the lattice motif is attested both by the present corpus of vessels and by statistics from the general sherdage. Lattice bands in spiral arrangements on hemibowl interiors, in diagonal zigzag arrangements on spouted bowls, and as filler motifs in rectangles projecting alternately from rim and base on deep bowls and spouted bowls, are typical examples of a bold, dynamic style peculiar to the site. Static compositions do occur at Mosphilia, but not nearly as often as they do at Erimi. Moreover, Erimi RW sometimes combines static and dynamic elements on a single vessel (figs. 4.5, 4.7, for example), a phenomenon not observed at Mosphilia. Purely dynamic compositions do occur at Erimi (fig. 4.2–3), but the thinness of brushstrokes and the tendency toward open compositions fail to achieve the often striking effects of their Mosphilia counterparts. Unlike Mosphilia with its ubiquitous lattice designs, no single motif type dominates RW composition at Erimi. The

TABLE 6. Motifs on Spouted Bowls from Erimi, Lemba, and Mosphilia: Synthesis of Data*

		Site	
	Erimi	Lemba	Mosphilia
Structural Elements (%)			
Field 1	50	100	66
2	—	100	—
3	50	100	66
4	—	—	66
Design Elements (%)			
Field 1	—	—	—
2	100	—	66
3	—	—	—
4	—	—	33
Design Elements (occurrence)			
Field 1	—	—	—
2	Parallel bands; lattice bands; reserve motifs	—	Lattice bands
3	—	—	Lattice bands
4	—	—	Lattice bands

*% of structural elements in Fields 1–4; % of design elements in Fields 1–4; types of design elements in Fields 1–4.

recurrence of short wavy-line motifs on deep bowls (fig. 4.1, 4.5) may indicate the popularity of that element in certain contexts, but in general the evidence points to a far greater degree of eclecticism in the choice of design elements.

The differences in the painted style at Erimi and Mosphilia outweigh their similarities. On this basis, the island-wide uniformity of RW during the Early Chalcolithic does not appear to continue to the same degree during the Middle Chalcolithic. Nor does there appear to be a return to the type of regional variation in style noted for RW designs of the Late Neolithic period; rather, the evidence suggests the advent of localized centers of stylistic production, perhaps the result of increased levels of craft specialization. Other classes of evidence point to accelerated growth and affluence during the second half of the fourth millennium, and it is at that time that the painted style reaches its apex, in terms of both popularity and complexity. One wonders, then, what developments occurred to account for the sudden decline of the painted style during the Late Chalcolithic period, when RW all but disappeared and the long-standing tradition of painted pottery was supplanted by a monochrome tradition that persisted until the beginning of the Early Cypriot Bronze Age.

NOTES

[1] Analysis of RW design on sherdage from Kissonerga-Mosphilia is currently being undertaken by L. Maguire.

[2] The published sherdage from Lemba appears to support this picture; see Peltenburg 1985: figs. 59–61 for published examples.

[3] Further analysis of Early Chalcolithic RW is needed from sites in the west, however, before its relationship to Middle Chalcolithic RW can be properly assessed; for preliminary analyses, see Peltenburg 1982; Bolger 1988b; 1989.

BIBLIOGRAPHY

Baird, D.
In press a Ceramics. In *Excavations at Kalavasos-Ayious*. Studies in Mediterranean Archaeology 71: 8 by Ian Todd. Göteborg: Åström.
In press b Independent Variables: A Flexible Classification of Late Neolithic and Chalcolithic Pottery. In *Cypriot Ceramics: Reading the Prehistoric Record*, eds. J. Barlow, D. Bolger, and B. Kling. Philadelphia: University of Pennsylvania.

Bolger, D.
1988a *Erimi Pamboula: A Chalcolithic Settlement in Cyprus*. BAR International Series 443. Oxford: British Archaeological Reports.
1988b Chalcolithic Maa: The Pottery. Pp. 290–300 in *Excavations at Maa-Paleokastro 1979–86*, by V. Karageorghis and M. Demas. Nicosia: Department of Antiquities of Cyprus.
1989 Wares of the Early Chalcolithic Period: A Preliminary Assessment. Pp. 35–36 in Excavations at Kissonerga-Mosphilia 1988, by E. J. Peltenburg and Project Members. *Re-port of the Department of Antiquities of Cyprus*: 29–40.

Dikaios, P.
1936 The Excavations at Erimi, 1933–35. *Report of the Department of Antiquities of Cyprus*: 1–81.
1961 *Sotira*. Philadelphia: University of Pennsylvania.

Hole, F.
1984 Analysis of Structure and Design in Prehistoric Ceramics. *World Archaeology* 15.3: 326–47.

Kromholz, S.
1981 A Preliminary Report on the Earlier Prehistoric Ceramics of the Vasilikos Valley. Pp. 17–53 in *Studies in Cypriot Archaeology*, eds. J. C. Biers and D. Soren. UCLA Institute of Archaeology Monograph 18. Los Angeles: University of California at Los Angeles.

Maier, F. G., and Karageorghis, V.
1984 *Paphos: History and Archaeology*. Nicosia: Leventis.

Peltenburg, E. J.

1975 Ayios Epiktitos-Vrysi, Cyprus: Preliminary Results of the 1969–73 Excavations of a Neolithic Coastal Settlement. *Proceedings of the Prehistoric Society* 41: 17–45.

1978 The Sotira Culture: Regional Diversity and Cultural Unity in Late Neolithic Cyprus. *Levant* 10: 55–74.

1982 *Recent Developments in the Later Prehistory of Cyprus*. Studies in Mediterranean Archaeology, Pocketbook 16. Göteborg: Åström.

1985 *Lemba Archaeological Project. Vol. 1, Excavations at Lemba-Lakkous 1976–83*. Studies in Mediterranean Archaeology 70:1. Göteborg: Åström.

1988 A Cypriot Model for Prehistoric Ritual. *Antiquity* 62, 235: 289–93.

In press The Chalcolithic Period of the History of Cyprus. In *Makarios History of Cyprus I*. Nicosia: Makarios Foundation.

Plog, S.

1983 Analysis of Style in Artifacts. *Annual Review of Anthropology* 12: 125–42.

Rice, P.

1987 *Pottery Analysis: A Sourcebook*. Chicago: University of Chicago.

Shepard, A. O.

1980 *Ceramics for the Archaeologist*. Carnegie Institute of Washington Publication 609. Ann Arbor: Braun-Brumfield.

Stewart, J. D.

1985 Area I Ceramics. Pp. 59–69 in *Lemba Archaeological Project I: Excavations at Lemba-Lakkous 1976–83*, by E. J. Peltenburg. Studies in Mediterranean Archaeology 70:1. Göteborg: Åström.

Thomas, G.

1988 The Maa Chalcolithic Excavations. Pp. 267–89 in *Excavations at Maa-Paleokastro 1979–86*, by V. Karageorghis and M. Demas. Nicosia: Department of Antiquities of Cyprus.

Rock Sources of Ground Stone Tools of the Chalcolithic Period in Cyprus

CAROLYN ELLIOTT
Lemba Archaeological Project
Paphos, Cyprus

Correct rock terminology applicable to Cyprus is defined and probable rock sources exploited in the Chalcolithic period are outlined. Igneous rocks for axes, adzes, and other tools demanding a hard rock include diabase, basalt, pyroxene andesite, microgabbro, and gabbro. Sedimentary rocks for rubbing stones, querns, rubbers, pestles, and pounders include varieties of limestone, chalk, and sandstone. Lemba and Mosphilia most likely drew on local beaches and riverbeds, especially the Potima beach and the Mavrokolymbos riverbed. Kalavassos-Ayious and Pamboules had a rich potential rock source in the Vasilikos riverbed, and Erimi could have drawn on the Kouris riverbed. The choice of rock differed according to availability— bowls, rubbers, and querns in the Lemba area are of sedimentary rocks; in the highland zone to the north diabase and gabbro were used at sites such as Trimithousa. That site and Phasli are noted for the occurrence of a quartzitic sandstone for a specific type of grinder-pounder.

INTRODUCTION

Before discussing the rock sources exploited by the Chalcolithic inhabitants of Cyprus, this article presents a brief account of the rock terminology developed and used at the Lemba Archaeological Project. Until now there has been a lack of correlation between the rock names appearing in archaeological publications and those used by the Cyprus Geological Survey in its literature and on geological maps of the island. In the past, archaeologists frequently have used rock names such as andesite and dolerite and meaningless terms such as black rock and white rock, which do not appear on geological maps of Cyprus.

Andesite refers to an igneous rock that is fine to medium grained and of a particular chemical composition, with a high silica content (\approx56 percent); it can be either a lava or a hypabyssal intrusive "dyke." Cypriot lavas may include andesitic compositions; but they are extremely weathered, soft, and unsuitable for tool manufacture.

Dolerite is a hypabyssal rock, fine to medium grained, occurring as dykes or sills, and having a basaltic composition, i.e., a silica content much lower than andesite (<50 percent).

IGNEOUS ROCKS

The fine to medium grained igneous rocks used for tool manufacture in Chalcolithic Cyprus are black, or dark gray to greenish gray; they are extremely hard. They must therefore be searched for beyond the areas of lava outcrop and into what the Cyprus Geological Survey calls the Sheeted Intrusive or Sheeted Diabase Complex (Geological Map of Cyprus 1979).

The Sheeted Diabase Complex consists of 100 percent dykes intruded vertically side by side or through each other in varying widths from 1 cm to 5 m. In composition they vary from basaltic to andesitic to dacitic, a progression marked by increasing silica content. Basaltic compositions can be almost black with lighter colors characterizing the more silica-rich rocks. Extremely thin dykes and the borders of thicker dykes cool very fast and as a result are very fine grained. The interiors of thicker dykes cool more slowly and are therefore coarser grained, with individual minerals visible to the naked eye.

All of those rocks are extremely tough and most survive the wear and tear of river transport. They are found as subrounded pebbles, cobbles, and

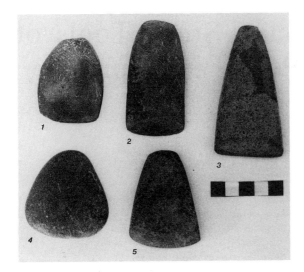

Fig. 1. **1.** Basalt adze Lemba, reg. no. LL285; **2.** diabase adze Lemba, reg. no. LL1200; **3.** pyroxene andesite adze Lemba, reg. no. LL909; **4.** basalt adze roughout Lemba, reg. no. LL561a; **5.** basalt adze Lemba, reg. no. LL67.

Fig. 3. **1–2.** Chert pounders Lemba, reg. no. LL554, Lemba, reg. no. LL553; **3.** serpentinite pounder Lemba, reg. no. LL979; **4.** chert pounder Lemba, reg. no. LL394.

Fig. 2. **1–3.** Microgabbro hammerstone/grinders Lemba, reg. no. LL23, Lemba, reg. no. LL164, Lemba, reg. no. LL1264; **4.** mica sandstone hammerstone/grinder Lemba, reg. no. LL1210.

boulders along the riverbeds and streams draining the Diabase country; and as smooth, rounded pebbles and cobbles along most beaches.

As used by the Lemba Archaeological Project, subdivisions of the rocks are determined according to grain size and color, but the ultimate source of all of them is the Sheeted Diabase Complex. The subdivisions of rock types can be briefly summarized as follows:

Basalt: black, extremely fine grained, minerals not visible with the naked eye. Basalt was chosen mainly for small thin tools such as adzes (fig. 1:1, 4–5), chisels, flaked tools, and polishers (Elliott 1985: 73–77, 165–70, 181).

Pyroxene andesite: greenish gray to light green-gray, with a few large crystals of pyroxene. Other minerals are not visible to the naked eye. This rock was chosen for fine axes and adzes (fig. 1:3), usually of superior quality (Elliott 1985: 73, 161, 165).

Diabase: dark gray to light gray, fine grained, minerals visible with the naked eye. Diabase was commonly chosen for large axes, adzes (fig. 1:2), chisels, flaked tools, hammerstone/grinders, pestles, and pounders (Elliott 1985: 71–82, 161–80).

Microgabbro: dark gray to light gray, medium grained. Grain size is larger than diabase, U2 mm. This rock was used for axes, hammerstone/grinders (fig. 2:1–3), and pestles (Elliott 1985: 161, 172, 175).

Other igneous rocks in our classification, such as *gabbro, olivine gabbro, foliated* or *layered gabbro, serpentinite* and *harzburgite* have direct correlation with outcrops shown on the geological map of Cyprus. Gabbro was used for large axes, hammerstone/grinders, pestles, and the rare macehead. Serpentinite was used for small pebble polishers and an occasional hammerstone/grinder, and serpentinized harzburgite occurs rarely for a hammerstone/grinder.

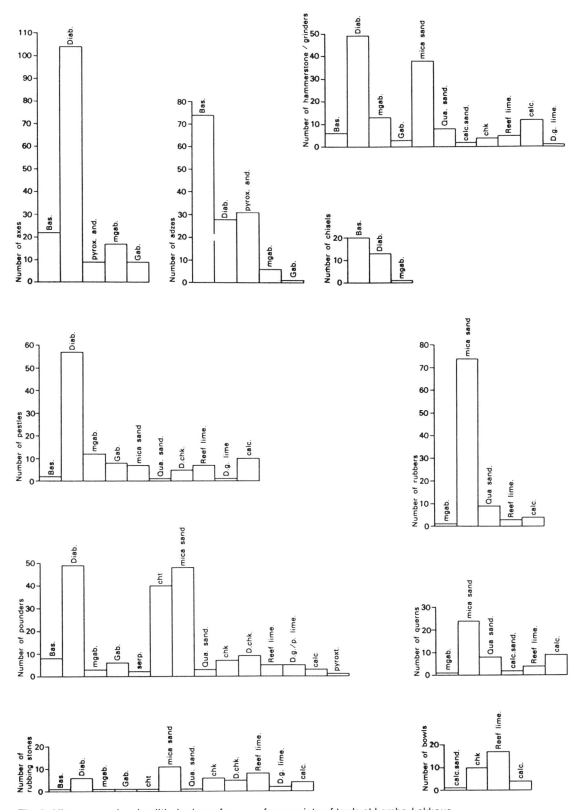

Fig. 4. Histograms showing lithologic preferences for a variety of tools at Lemba-Lakkous.

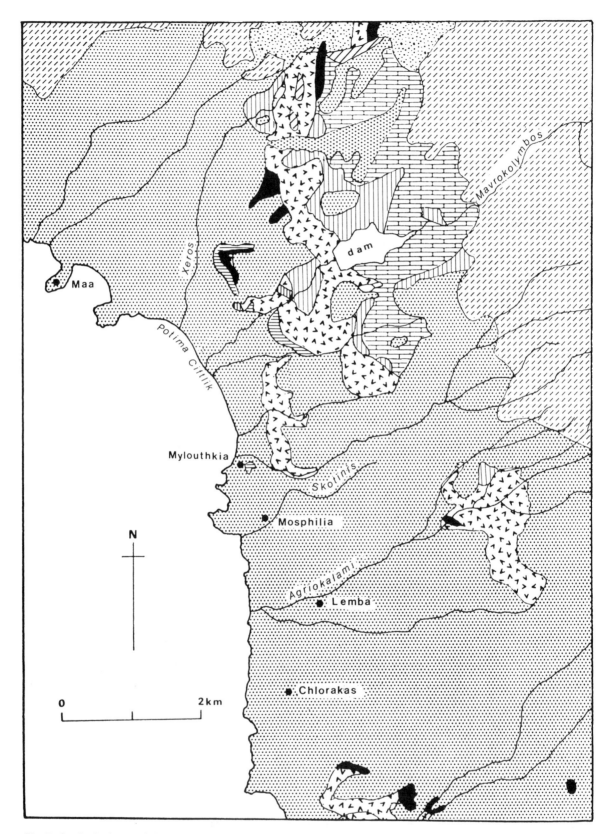

Fig. 5. Geological map of the Lemba area; based on H. Lapierre 1971.

SEDIMENTARY ROCKS

Regarding the sedimentary rocks, the term "limestone" is often used in Cypriot archaeological literature. Objects of what some archaeologists might call "limestone" in fact comprise diverse carbonate rocks. A more precise classification for a meaningful sourcing study has thus been adopted:

Dense gray limestone and *crystalline limestone* derived from the Mamonia Complex, used rarely for hammerstone/grinders and pounders (Elliott 1985: 81, 172–73, 178).

Chalk, dense chalk, and *silicified chalk* derived from the much younger Lefkara Formation, used for bowls, hammerstone/grinders, pestles, pounders and rubbing stones (Elliott 1985: 78–83, 172–80).

Dense reef limestone, bioclastic limestone, chalky reef limestone, all from the reef facies of the Lefkara and Pakhna formations, used for bowls, hammerstone/grinders, pestles, pounders, and rub-

bers (Elliott 1985: 78–82, 86, 89, 172–79, 183–84, 188).

Light yellow, *calcareous sandstone* and *porous calcarenite* derived from the youngest geological formations—the raised beach deposits along the Paphos lowlands—used for pestles, rubbing stones, and cupped stones (Elliott 1985: 80–83, 88, 175–76, 180, 186–87).

Mica sandstone, quartz sandstone, and red-colored *chert,* from the Mamonia Complex. The sandstones were used especially for rubbers and querns, as well as for hammerstone/grinders (fig. 2:4), pounders, and rubbing stones (Elliott 1985: 78, 81–83, 85–87, 172–73, 178–80, 183–85). Chert was chosen mainly for globular pounders (fig. 3) and pecking stones.

Figure 4 shows the rock percentages for various tool classes at Lemba-Lakkous in the Paphos District. The Chalcolithic inhabitants in the west of the island had several sources for such rocks. The sites of Kissonerga-Mosphilia, Lemba-Lakkous,

Fig. 5 (continued)

	LITHOLOGY	FORMATIONS	PERIODS
	Calcarenites	Marine terrace deposits	Pleistocene
	Gypsum, marls, marly limestone, calcarenites, chalks, chalks with cherts	Pakhna formation and Lefkara group	Miocene-Upper Cretaceous
	Blocks of rocks of Mamonia group in clays	Moni "mélange"	Pre-Eocene
	Bentonitic clays, tuffaceous sandstone	Moni clays and Parekklisha sandstone	Maestrichtian-Campanian
	Reef limestone, pelagic limestone, brecciated limestone	Petra tou Romiou formation	Upper Triassic
	Thin-bedded cherts, quartz sandstone, limestone	Mamonia formation cherts unit	Jurassic-Triassic
	Sandstone with fossil plant remains	Sandstone with fossil plant remains unit	Upper Triassic

IGNEOUS ROCKS

	Serpentinites	Serpentinites	
	Microgabbro ophitic, diabase dykes	"Diabase"	
	Basaltic, andesitic pillow lavas, trachyandesites-trachytes	Mamonia lavas	

Fig. 6. Pebbles from Lemba beach suitable for hammerstone/grinders: **1.** Dense pink limestone; **2-3.** diabase; **4.** mica sandstone; **5.** calcareous sandstone; **6.** dense gray limestone.

Fig. 7. Pebbles from the beach between Mylouthkia and the Cynthiana Beach Hotel: **1-2, 5-6.** Diabase; **3.** basalt; **4.** microgabbro.

Chlorakas-Palloura (Peltenburg 1979: 79), Peyia-Viklarin (Baird 1985: 64), and Maa-Palaeokastro (Thomas 1988: 279–82) must have derived their raw materials from the nearby stream beds and beaches (fig. 5). The Agriokalami stream, north of Lemba, is, however, a poor supplier, containing only small sedimentary pebbles, chert, and some serpentinite—the latter brought down from the ser-

pentinite outcrop south of Tala village (Lapierre 1971). Today the Agriokalami is overgrown in many places and supports lush reed growth.

Closer to Lemba, the calcarenite bedrock breaks to form boulders suitable for querns, large basins, and mortars, as well as building-stone. The Agriokalami empties into the sea on the sandy beach below the site and is bordered by calcarenite outcrops. On that beach, waterworn, rounded pebbles could have been collected for a limited range of tools such as hammerstone/grinders, pestles, and pounders (fig. 6). Dense gray and red limestone, mica sandstone, and calcarenite are present. Igneous rocks are rare here, however, with only an occasional diabase pebble noted.

The Skotinis stream, along the south side of Kissonerga-Mosphilia, also contains sedimentary rocks to the exclusion of igneous varieties. The stream bed is now no more than a channel, having been altered by modern terracing.

The beach between the locality of Mylouthkia and the Cynthiana Beach Hotel comprises large, rounded boulders of calcarenite suitable for querns, rubbers, bowls, and mortars: it also has chert pebbles for globular pounders, and a few diabase and microgabbro pebbles for small tools such as adzes (fig. 7).

The Xeros river to the north contains angular to subrounded cobbles and pebbles of dense gray limestone, reef limestone, and red and gray chert (fig. 8). Mica sandstone is present and would have been suitable for rubbers. Igneous material is rare, comprising diabase and microgabbro pebbles of unsuitable shapes and poor weathered quality.

So where does one find the elusive igneous rocks for all the numerous axes, adzes, and other tools? The small beach now commonly known as "Five Rocks," below the transitional Neolithic–Chalcolithic site of Kissonerga-Mylouthkia, is a source for small basalt and diabase pebbles (figs. 9, 10) suitable for small tools such as adzes and chisels (Elliott 1983b: fig. 2). Very little shaping would have been necessary and often sharpening of the blade end alone would have sufficed to provide an efficient wood-working tool. On that beach there are also gabbro, pyroxenite, red jasper, chert, calcarenite, and other sedimentary pebbles. Serpentinite is present in suitable sizes and shapes for small polishers like those found at the sites of Lemba, over 2 km away—a present-day walk of 35 minutes (Elliott 1985: 181)—and Mosphilia, 1 km away—a 12-minute walk. Concretions on the

Fig. 8. Pebbles from the Xeros riverbed unsuitable for tools: **1.** Dense gray limestone; **2.** siltstone; **3.** chert; **4.** reef limestone, suitable for bowl.

Fig. 9. Pebbles from "Five Rocks" beach near Mylouthkia. **1–2, 4.** Microgabbro; **3.** basalt; **4–5.** diabase.

Fig. 10. Diabase and microgabbro pebbles from "Five Rocks" beach near Mylouthkia.

beach suggest the human form (fig. 11) and recall the concretion found in a ritual deposit at Mosphilia (Peltenburg *et al.* 1988: pl. 5:9).

One of the main sources of raw material must have been the 1.5 km-long beach known as Potima (fig. 12), north of Mosphilia 1.5 km away, 20 minutes walk, from that site and 3.5 km, 45 minutes walk, from Lemba. That pebble and boulder beach comprises waterworn, rounded shapes of basalt, diabase (fig. 13:1–3), and small amounts of gabbro suitable for axes, adzes, pestles, and hammerstone/grinders. Serpentinite is present, usable for polishers (fig. 13:4–6), chert for globular pounders (fig. 14:2) and pecking stones, every variety necessary

for ideally shaped hammerstone/grinders—especially mica sandstone and calcarenite—and diabase and silicified chalk suitable for elongated pounders. The stream that enters the sea at the southern end of the beach contains sedimentary boulders and pebbles and some serpentinite, the latter originating in the serpentinite outcrops to the east (Lapierre

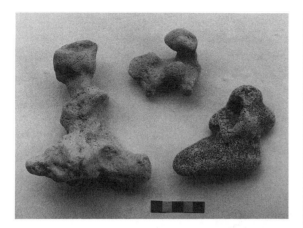

Fig. 11. Concretions from "Five Rocks" beach near My-
louthkia.

Fig. 12. Beach at Potima Ciftlik.

1971). The use of igneous rocks for bowls is ex-
tremely rare—only one cup of such material was
found at Lemba (Elliott 1985: 190) and there are a
few, mainly fragmentary, examples from Mos-
philia. The Potima beach could have provided the
necessary raw materials for such vessels. The pebble
beach north of Maa, now known as Coralia, con-
tains similar material but less of it. In none of those
cases is the walking time from the rock sources to
any of the sites mentioned a long or arduous one.
Today the terrain is easily traversable—the main
obstacle being the Agriokalami stream bed—down
gentle enough slopes to the flatter coastal zone.
There is, of course, no evidence for tool manufac-
ture on the beaches, and none has been detected in
the riverbeds or on the adjacent outcrops. No manu-
facturing debris has been found on the sites them-
selves, though discarded objects broken during
manufacture are recorded at Mylouthkia.

The presence of lavas on the geological map in
the area of the Mavrokolymbos riverbed, the major
river in the area, is deceptive as regards their suita-
bility for a tool source (Lapierre 1971). The lavas
are sheared and altered and the diabase and micro-
gabbro dykes are also shattered and weathered.
The same is true for the Mamonia lavas a few
kilometers northeast of Lemba near Tala village
and for the lavas south of Chlorakas. The Mavro-
kolymbos lavas are also too close to the river mouth
to have been carried down and worn into suitably
rounded shapes.

The serpentinites in the Mavrokolymbos are a
distinctive feature of the landscape and occur in
the riverbed as large boulders, cobbles, and pebbles.
The riverbed is also a splendid supplier of large
and small blocks of mica sandstone and quartz
sandstone (fig. 15), rock types used for large saddle
querns in particular, as well as rubbers and other
abrasive artifacts.

It has been postulated here that quartz sandstone
was used for grinding blocks on which to shape
and sharpen artifacts; and the riverbed here must
have been an important source for all sites in the
area.

Diabase and microgabbro were never used for
querns at Lemba or Mosphilia and only extremely
rarely for rubbers. This scarcity contrasts with the

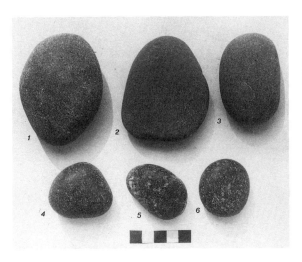

Fig. 15. Mavrokolymbos riverbed with large quartz and mica sandstone boulders.

Fig. 13. Pebbles from Potima beach. **1–3.** Diabase; **4–6.** serpentinite.

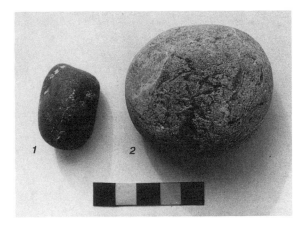

Fig. 14. Pebbles from Potima beach. **1.** Red jasper; **2.** chert.

early Chalcolithic site of Kalavassos-Ayious, overlooking the Vasilikos river valley. There diabase bowls, as well as querns and rubbers, appear in some quantity (South 1985: fig. 6), and their presence directly reflects the ready availability of diabase in the Vasilikos riverbed. That river also contains large boulders and pebbles of microgabbro and gabbro, serpentinite, and serpentinized harzburgite, as well as other rocks covering the entire size range required for Chalcolithic tool selection. The Vasilikos would have been the source for Kalavassos-Pamboules (Dikaios' Kalavassos Site

B), where again diabase rubbers, pestles, pounders, and hammerstone/grinders are common and sedimentary examples are less frequent (Dikaios 1962: 136, fig. 65:1–23).

The site of Erimi, close to the Kouris river, had easy access to large diabase, microgabbro, and gabbro boulders, and pebbles brought down by the river from the Troodos Mountains. Serpentinite, serpentinized harzburgite, and a wide range of sedimentary rocks also occur. The Kouris riverbed includes foliated and layered gabbro and it must be from such a source that the gabbro used for large axes and bottle-shaped pestles found at Lemba and Mosphilia was collected. Certainly, from the point of view of easy access to the widest variety of rock types, Erimi—near the Kouris river—and any Chalcolithic site near the Dhiarizos river valley were ideally situated, especially for gabbro, as both rivers rise in the Plutonic Complex on top of Troodos. It is not possible to determine to which settlements rock gatherers belonged, how far they traveled, or how the material or even the finished products were exchanged. Further west, the Ezousas and Xeropotamos rivers are an excellent source of diabase and microgabbro as they both rise in the Diabase. In the Xeropotamos, diabase pebbles are of shapes suitable for axes and adzes.

Souskiou, the major site near the Dhiarizos river, had easy access to diabase and gabbro boulders and pebbles high up on the old river and beach terraces as well as in the present riverbed. Those river and old beach deposits also would have served the Chalcolithic sites in the Kouklia area (Maier

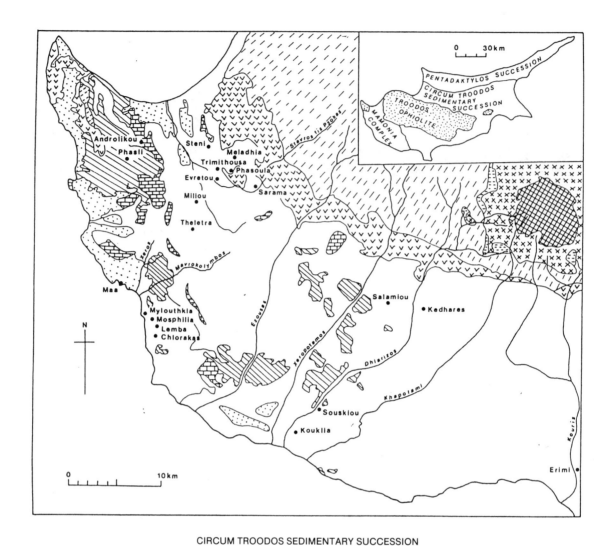

CIRCUM TROODOS SEDIMENTARY SUCCESSION

LITHOLOGY	FORMATIONS	PERIODS
Calcarenite, sand, gravel	Terrace deposits	Pleistocene
Reefs, bioherms and biostroms	Terra	Lower Miocene

TROODOS OPHIOLITE

Pillowed flows of basalts with dykes and sills Metabasalts	Upper and Lower Pillow Lavas Basal Group	Volcanic Complex
Diabasic, basaltic and ultramafic dykes	The Diabase	Sheeted Diabase Complex
Granophyre, tonalite, quartz diorite	The Plagiogranite	
Gabbro, olivine gabbro, and melagabbro (dominantly layered)	The Gabbro	Plutonic Complex
Serpentinized harzburgite with minor serpentinized dunite	The Serpentinite	

MAMONIA COMPLEX

Radiolarian cherts, quartzitic sandstones, limestone, basaltic, andesitic pillow lavas, trachyandesites, serpentinite

Fig. 16. Simplified geological map of southwest Cyprus; based on Geological Map of Cyprus. Nicosia 1979.

1981: 104; Maier and von Wartburg 1985: 105; Rupp 1981: 263, fig. 4).

Sites surveyed by the Cyprus Department of Antiquities and subsequently by the Lemba Archaeological Project in the highland country north of Paphos include Meladhia, Philousa, Evretou (Sheen 1981: 42; Site 18; fig. 2), Trimithousa, Sarama (Baird 1987: 15; Site 4; fig. 5). Miliou (Peltenburg 1981: 36–38), and Phasli (fig. 16). Finds from the previous surveys have been summarized by Stanley Price (1979: 145–46). Sites near the Stavros tis Psokas river, like Trimithousa, Philousa, and Evretou, would have exploited that riverbed for diabase, microgabbro, and gabbro. Diabase and gabbro were commonly used for a wide range of tools including rubbers, querns, and pestles (Elliott 1983a: 35–46). As with the Kalavassos sites, the common use of igneous rocks for querns and rubbers echoes the local availability of the material and again contrasts with their almost total absence at Lemba and Mosphilia for artifacts of those types.

The pillow lavas that crop out on the road from Philousa down to Trimithousa are severely weathered and could not have been the rock source for tools at those sites. Again it is clear that waterworn, rounded pebbles were collected from the riverbed and adjacent slopes. Old river debris in fields sloping gently to the river west of Evretou include diabase and gabbro as well as abundant quartz sandstone and mica sandstone. East of Evretou the sandstone blocks on slopes above the north bank are of suitable size for querns. The new Evretou dam has now considerably altered the topography in that area.

Phasli, a highland site in the Mamonia Complex, has a type of silicified quartzitic sandstone used specifically for grinder/pounders. That rock variety does not appear at the sites of Lemba and Mosphilia; it is a regional variant of the Phasli area. It has been noted so far only at the site of Trimithousa, where similar quartzitic sandstone grinder/pounders were seen at the site in 1982 and 1983 (Elliott 1983a: 44). Phasli and the site of Androlikou could have drawn on the Ayios Ioannis and smaller stream beds for other rock types.

To conclude, the evidence from the Chalcolithic ground stone industry can show a degree of regionalism, with a varying exploitation of rock types from site to site as well as differences in tool frequency and quality, as illustrated in the Paphos District, even within what on the map may seem to be a limited area. That regionalism directly reflects the very different terrain and environment that demanded different responses and adaptations to the landscape and its resources.

ACKNOWLEDGMENTS

I am grateful to C. Xenophontos, geologist at the Lemba Archaeological Project, for rock identifications, and to E. J. Peltenburg for permission to publish tools from Lemba-Lakkous.

BIBLIOGRAPHY

Baird, D.
 1985 Survey in the Drousha Area of Western Cyprus. Pp. 63–65 in Lemba Archaeological Project, Cyprus 1982, Preliminary Report, by E. J. Peltenburg. *Levant* 16: 55–65.
 1987 Survey in the Stavros tis Psokas 1985. Pp. 15–18 in Excavations at Kissonerga-Mosphilia 1986, by E. J. Peltenburg and Project Members. *Report of the Department of Antiquities of Cyprus*: 1–18.

Dikaios, P.
 1962 The Stone Age in Cyprus. Pp. 1–204 in *The Swedish Cyprus Expedition* IV.1A. Lund: Swedish Cyprus Expedition.

Elliott, C.
 1983a Ground Stone Tools from Trimithousa-Kilistra. Pp. 35–46 in The Prehistory of West Cyprus: Ktima Lowlands Investigations 1979–82, by E. J. Peltenburg et al. *Report of the Department of Antiquities of Cyprus*: 9–55.
 1983b Kissonerga-Mylouthkia: An Outline of the Ground Stone Industry. *Levant* 15: 11–37.
 1985 The Ground Stone Industry. Pp. 70–93, 161–95, 271–75 in *Lemba Archaeological Project I. Excavations at Lemba-Lakkous 1976–83*, by E. J. Peltenburg et al. Studies in Mediterranean Archaeology 70:1. Göteborg: Åström.

Geological Survey Department of Cyprus
 1979 Geological Map of Cyprus. Nicosia: Geological Survey Department.

Lapierre, H.
 1971 Geological Map of the Polis-Paphos Area. Nicosia: Geological Survey Department, Cyprus.

Maier, F. G.
 1981 Excavations at Kouklia (Palaepaphos). Elev-
 enth Preliminary Report. Seasons 1979 and
 1980. *Report of the Department of Antiquities
 of Cyprus*: 101–5.
Maier, F. G., and von Wartburg, M. L.
 1985 Excavations at Kouklia (Palaepaphos). Thir-
 teenth Preliminary Report. Seasons 1983 and
 1984. *Report of the Department of Antiquities
 of Cyprus*: 100–125.
Peltenburg, E. J.
 1979 The Prehistory of West Cyprus: Ktima
 Lowlands Investigations 1976–1978. *Report
 of the Department of Antiquities of Cyprus*:
 69–99.
 1981 Survey. Pp. 35–38 in Lemba Archaeological
 Project, Cyprus 1979: Preliminary Report, by
 E. J. Peltenburg *et al. Levant* 13: 28–50.
Peltenburg, E. J.; Bolger, D.; Goring, E.; and Elliott, C.
 1988 Kissonerga-Mosphilia 1987: Ritual Deposit,
 Unit 1015. *Report of the Department of Anti-
 quities of Cyprus*: 43–52.

Rupp, D. W.
 1981 Canadian Palaepaphos Survey Project. Pre-
 liminary Report of the 1979 Season. *Report
 of the Department of Antiquities of Cyprus*:
 251–68.
Sheen, A.
 1981 Appendix I. Stavros tis Psokas Survey 1979.
 Pp. 39–42 in Lemba Archaeological Project,
 Cyprus 1979: Preliminary Report, by E. J.
 Peltenburg. *Levant* 13: 28–50.
South, A.
 1985 Figurines and Other Objects from Kalavassos-
 Ayious. *Levant* 17: 65–79.
Stanley Price, N.
 1979 *Early Prehistoric Settlement in Cyprus*. BAR
 International Series 65. Oxford: British Ar-
 chaeological Reports.
Thomas, G.
 1988 The Maa Chalcolithic Excavations. Pp. 267–
 89 in *Excavations at Maa-Palaeokastro*, by
 V. Karageorghis and M. Demas. Nicosia: De-
 partment of Antiquities of Cyprus.

Local Exchange in Prehistoric Cyprus: An Initial Assessment of Picrolite

EDGAR PELTENBURG
Department of Archaeology
University of Edinburgh
19 George Square
Edinburgh, U.K. EH8 9JZ

Evidence for pre-Bronze Age Cypriot contacts is exceedingly rare. Picrolite, a soft, attractive rock, was used throughout the period, and preliminary analysis (Xenophontos 1991: 127–38) suggests that it was derived as water-worn pebbles from the Karyotis and Kouris rivers. Examination of its use in the Chalcolithic period reveals marked inter- and intrasite inequalities. A reciprocal exchange network, associated with social divisions and perhaps marriage alliances, is postulated. The material was primarily exchanged in raw form, and nonspecialists produced items locally. Although Erimi may have grown large because of its advantageous location beside the major source, there is still no evidence that this led to the formation of hierarchical society based on the control of the prized resource. The limited evidence rather suggests that the picrolite network sustained existing sociopolitical structures.

INTRODUCTION

Evidence for foreign and local contacts in Cyprus before the Bronze Age is so sparse that the island's insular and regional isolation may be not only symptomatic of, but also a cause of the conservatism of its cultures. The dearth of unambiguous archaeological indicators for internal contacts suggests the existence of autonomous communities, but that leaves unanswered the question of the means of social integration that formed relatively homogeneous cultures throughout the island. The island's internal topography also promoted isolation, as Ross (1845, in Christodoulou 1959: 97) confirmed when he described the sequestered lives of more recent villagers: "The men [from Akanthou] sometimes, but seldom, cross the [Kyrenia] mountains into the [Central Lowlands] and even as far as the 12-hours away market of Nicosia. . . . But women are born and die here without having seen more of the world than their village." Ross was writing in 1845, when pack animals for travel were common. Communication was undoubtedly more difficult prior to the arrival of transport, roads, and bridges. It is nonetheless the contention of this article, that the motives for con-

tact between villages in prehistoric times were strong, that intercommunity exchange may be assumed to have existed since it is pervasive in most societies (Bender 1985), and that the seeming self-sufficiency of Neolithic and Chalcolithic villages in Cyprus is more apparent than real.

There are compelling general reasons for assuming the existence of local contacts within small-scale, agricultural societies. Plog (1980: 138) notes three of these:

● *Temporal variation in resource availability.* Rainfall maldistribution is an intractable, recurrent problem in Cyprus, causing drought and local shortages in essential foodstuffs (Christodoulou 1959: 28–30). For economic prehistorians like Runnels and van Andel (1988), foodstuffs are regular components of trade, but in the case of localized contacts in Cyprus, that is unlikely to have been a major risk-avoidance strategy. More important was an information network that could be utilized in times of need.

● *The maintenance of political alliances.* Although some settlements were enclosed by walls and ditches in the Neolithic period (Karageorghis 1982: 21–22, 28–30), there are no obvious weapons in the tool kits. Nevertheless, conflicts are likely to have arisen

because of the proximity of many Late Neolithic and Chalcolithic communities. Institutions no doubt existed for the conduct of relations between groups.

● *Marriage networks.* A number of studies conclude that villages with populations under 500 need to practice exogamy. Thus, in his analysis of the Tsembaga, Rappaport (1967: 102) found that it was difficult for a population of about 425 to survive without exogamy. Wobst (1974), using life model tables, similarly concluded that it was necessary for populations of 145 to 475 to take part in extended marriage networks. Most Cypriot prehistoric sites are of the order of 3 to 5 ha, and thus well below the 500 population threshold. In those cases the need for exogamy probably promoted intervillage and interregional relations for mate selection. Little is known of the dynamics of site clusters, a Cypriot phenomenon, but it is doubtful that they raised regional population densities to thresholds that obviated the need for extended marriage networks.

The case for resource heterogeneity as a stimulant to the formation of exchange systems is powerful (e.g., Ericson 1977, and for Cyprus, Stanley Price 1979a: 70–71), but pre-Bronze Age Cypriot settlements are largely confined to similar ecozones and it may be inappropriate to project back later adaptive strategies. Contrasting site locations of later periods fostered the establishment of fairs and markets as nodal points for the exchange of produce. Christodoulou (1959: 102) remarks that such events were "associated with shrines, monasteries, churches or icons. They are pilgrimages, occasions for merrymaking, but also places of a large volume of trade." Strabo's description of the fair at Palaepaphos confirms the antiquity of such gatherings from all over the island and their connection with religious ceremony by Roman times at least (*Geographia*, 14.6.3). The system depended on upland settlements to provide complementary foodstuffs, but extension into the hill zone was subject to fluctuating sociopolitical trends and the first significant settlement inroads occurred only in the Iron Age (e.g., Rupp *et al.* 1986). Earlier, the Central Massif and Chalk Plateau were largely unoccupied and the few higher altitude villages were usually on valley sides, which, apart from fruit, today produce similar crops to those of lower altitude villages.

For Runnels and van Andel (1988), "cash crops" and hence specialized production for accumulation of wealth through trade, were as old as subsistence farming; but agriculture for profit has yet to be demonstrated in small-scale prehistoric societies. Widespread subsistence homogeneity as well as a varied comestible base in Cyprus is suggested by the similarity of fauna and flora from northern and western sites (see Kyllo 1982 for the north, Colledge 1980 for the west of the island). Possible exceptions include salt and fish. Stanley Price (1979a: 70) draws attention to the limited availability of the former in the Salt Lake beside the Bay of Larnaca. While that was certainly a major source, smaller quantities can be obtained in coastal rock pools around the island. Desse and Desse-Berset (1984) suggest that specialist fishermen kept their tackle along beachheads, but the absence of evidence for any deep sea fish at Khirokitia and other Neolithic and Chalcolithic sites indicates only limited inshore maritime contact and hence reduced opportunity for contact. Much more significant for the issue of contact are the consistently high proportions of fallow deer in faunal assemblages. Croft (this issue, pp. 63–80) shows that herds were most likely managed. Collection of shed antlers also indicates that the deer were not just randomly hunted, but regularly followed, their habits closely observed. Although fallow deer territories need not be extensive, contact with other groups is likely to have occurred to allocate rights to lands and resources.

In spite of the geographical ubiquity of many basic natural resources in Cyprus, full economic autonomy remains unlikely, not least because of acute rainfall variability. Extensive exploitation of fallow deer, moreover, required mechanisms to avoid or resolve conflicts over access to wandering herds.

Indisputable material evidence for contact remains tenuous, largely due to the close juxtaposition of diverse ecological zones in Cyprus. Secondary deposits of various stones and minerals, well beyond their "natural" locations, were also produced by rivers. In addition to salt and picrolite (see below), Stanley Price (1979a: 70) lists igneous rocks, flint, copper, umbers, and marine shells as materials whose acquisition would have required distant travel in some areas. Gabbros, pyroxene andesite, and quartzitic sandstone were also exploited by prehistoric communities, but it is not yet known how widely dispersed all the sources are (see Elliott 1981: 16–17; 1983: 33; Bolger 1988: 82; Lehavy 1989: 208). Flint and chert requires much more study (Betts 1987); but, like umbers, they are fairly common. The location of copper outcrops in the Ktima Lowlands, well away from the famous copper belt encircling the Troodos Mountains

(Zwicker 1988: 427–28), means that potential sources are much closer to metal-yielding sites than has generally been realized. However, the island origin of the few known copper artifacts is disputed (Stos-Gale, Gale, and Zwicker 1986: 135). So many sites are within easy reach of the sea that, with the possible exceptions of a few inland sites like Kritou Marrottou, Kannaviou (Fox 1988: 21–22), and Dhali (Lehavy 1989: 211), access to marine shells may not have necessitated contact or travel beyond village territories.

To this list may be added pottery, obsidian, carnelian, calcite, "marble," and ivory. Identification of the last three, from Kalavassos-Ayious (Todd 1986), still requires confirmation. Real marble is not native to Cyprus. Nor are obsidian and carnelian, but it is uncertain whether such materials were traded or brought by colonists during the Aceramic Neolithic period. The extended range of C-14 dates for Aceramic sites increasingly supports the argument for obsidian exchange, perhaps in a down-the-line network through Troulli.[1] The paucity of obsidian and carnelian at later sites raises the problem of whether they were imported then or simply collected from Aceramic locations. Although pottery usually is assumed to be locally manufactured in small-scale societies, cross-cultural studies increasingly demonstrate that even coarse wares traveled considerable distances (e.g., Plog 1980; Peacock 1988). Frankel (1974: 47–51) links the creation of regional Middle Cypriot styles to copper exchange and the movement of people rather than to direct trading of pots. A similar investigation of interaction between regional styles, supported by petrographic analysis, is warranted for the periods under discussion here. Classes such as white clay wares at Sotira (Stanley Price 1979b: 69) and western Red and Black Stroke Burnished Ware in the east (Peltenburg, in press) are plausible intrusives. Recent discoveries at Kissonerga-Mosphilia have provided evidence that exotic items occasionally reached Cyprus during the Chalcolithic. They include flints (Betts 1987), chlorite, and faience (Peltenburg 1990: 155). These rarities serve to indicate the gradual breakdown of Cypriot insularity during the third millennium B.C.

THE SOURCES OF PICROLITE

Taken together, current archaeological evidence articulates suspected intercommunity ties poorly, but research aimed at monitoring them and assessing their role in communal integration is still lack-ing. The deficiency is not so much the absence of nonlocal materials as the absence of characterization studies. Picrolite may lend itself to this type of analysis because it was used widely for ornaments throughout the pre-Bronze Age (fig. 1) and it comes from only a few sources. Vagnetti (1980: 38), Karageorghis (1982: 36), and South (1985: 68), for example, believe that this attractive blue and green rock was extracted from western locations or that figurines were manufactured there. Stanley Price (1979a: 70) regards it as more likely coming from the central mountains, which prompted the exploration of the Troodos Massif; and Peltenburg (1982b) holds that its extraction as water-worn pebbles from central rivers may have led to the "discovery" and use of copper. Elliott (1981: 17, n. 7) and Peltenburg (1982b) suggest that, in addition to the Kouris river, the Dhiarrizos may also have picrolite or serpentinite, but the suitability of material from the valley is doubtful. Hancock and Fox (in press) conclude that the Kouris river was the most likely source for 41 analyzed archaeological samples. Bolger (1988: 128–29) is the only scholar to have assessed the social implications of picrolite acquisition. In her reappraisal of the Erimi settlement, she argues that the occupants of the site extracted picrolite from the adjacent Kouris river, and that the exploitation of that resource became a mainstay of the economy. The exceptional size and longevity of Erimi may thus be based upon its location beside a natural resource that its inhabitants exploited to enhance prestige or to accumulate wealth and power through trade.

Xenophontos (this issue, pp. 127–38) gives an account of picrolite sources surveyed by him and the author, and presents problems of identification and initial analytical conclusions. His preliminary x-ray diffraction analyses demonstrate that the geochemistry of ten artifacts from sites as far apart as Vasilia, Erimi, and Miliou (fig. 2) is consistent with the Troodos sources. The headwaters of the Kouris and Karyotis rivers, the only verified picrolite carriers, lie in those mountains, and since riverine pebbles are found on archaeological sites, it is suggested that picrolite was acquired from those rivers rather than from *in situ* seams that would have required laborious quarrying.[2]

Picrolite is a nonessential, nonutilitarian, "valuable" material, and hence its widespread distribution probably was significant in sociopolitical contacts among villages. In theory, therefore, it should provide considerable insights into the integration of regions, but in practice it is difficult to

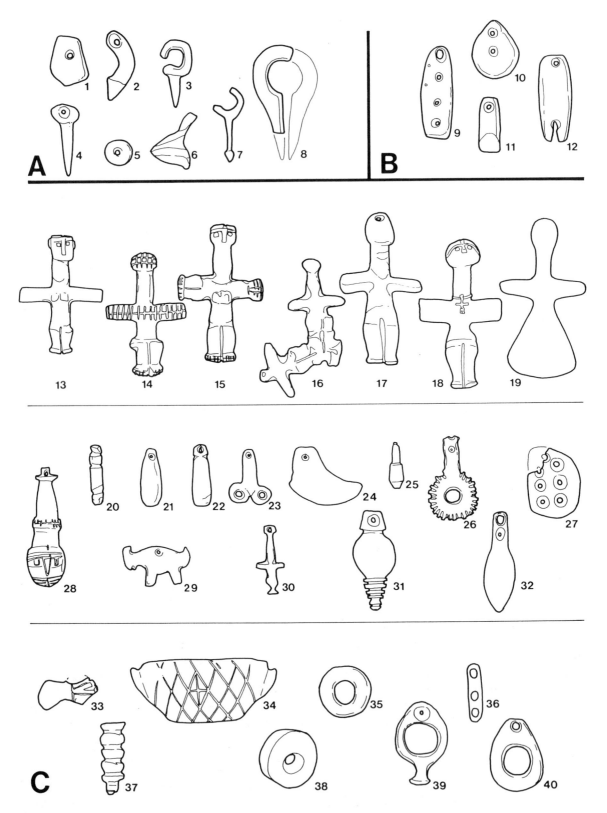

Fig. 1. Typical picrolite artifacts in eighth to sixth millennium (A), fifth millennium B.C. (B), fourth to third millennium B.C., (C) Cyprus.

make sound inferences. General reasons are the usual limits imposed by the biases of archaeological recovery, variation of symbolic and ideological meaning of the objects, applicability of cross-cultural analogies and interpretation of distribution maps based on the final resting place of the objects rather than the direct evidence of transactions (cf. Welinder 1988; see also below). In addition, a number of limitations are particular to this data set.

Material Identification. Not all blue rock is picrolite and not all picrolite is blue. It was first correctly and consistently identified in the archaeological literature by Manglis (in Dikaios 1953: 441), the geologist whom Dikaios consulted; but scholars frequently continued to refer to it as "steatite" (e.g., Pantazis 1980). In spite of Xenophontos' arguments (1982), other terms for the same material, such as antigorite and serpentinite, continue to appear in the literature.[3] Although confusion in terms persists, most archaeologists acknowledge that they are usually referring to visually identical material. Xenophontos confirms that all the examples studied are picrolite. The remainder, visually identical artifacts, most likely will also prove to be the same, and they are so treated here regardless of conflicting nomenclatures (listed under "comments" in Tables 1–5).

Sample Magnitude. Some 700 provenanced artifacts relating to ca. 6000 years of prehistory have been recorded. More provenanced examples are known and a larger corpus is desirable to interpret distribution patterns more satisfactorily than is possible at present. Since most of the artifacts

belong to the Chalcolithic, that period is the most promising for study.

Contexts. The number of samples suitable for distribution analysis is limited, since such an analysis must exclude the many picrolite objects looted from settlements and cemeteries. In diachronic studies, it is also necessary to treat cautiously those from multiperiod sites, even when recovered by controlled survey.

Fakes. The material is easily carved and fakes are known. Material without verified provenance and properly controlled recovery is excluded.[4]

Differential Retrieval. Fewer Chalcolithic sites have been systematically explored in the east, center, and north of the island than in the south and west. This geographical bias is much less acute in the Aceramic and Late Neolithic periods, but in the Chalcolithic it remains a significant problem.

USES OF PICROLITE
IN PREHISTORIC CYPRUS

Picrolite use and distribution have only been considered indirectly, usually in typological treatments of the striking cruciform pendant figurines (fig. 1c.13–19) of the Chalcolithic period (e.g., Vagnetti 1974; 1975; 1980; Karageorghis 1977: 27–30; Morris 1985: 122–32). Those studies lack a contextual approach that is essential for an evaluation of the procurement system.

Picrolite has great potential for colorful personal ornaments and it may have been so used already by

Fig. 1: 1–6. Khirokitia (Dikaios 1953: pls. 141–42:1014, 293, 1282, 1006, 758, 1037).
 7. Kalavassos-Tenta (Todd 1977: pl. 11:8).
 8. Khirokitia (Dikaios 1953: pl. 142:1110).
 9. Ayios Epiktitos-Vrysi (Peltenburg 1982a: 362, fig. 62:485).
 10–12. Sotira-Teppes (Dikaios 1961: pl. 102:86, 417, 121).
 13. Lemba-Lakkous (Peltenburg *et al.* 1985: fig. 80:1).
 14–16. Souskiou-Vathyrkakas (Vagnetti 1980: pls. 3:6, 12, 4:10).
 17. Kythrea (Vagnetti 1974: pl. 5:4).
 18. Yalias (Vagnetti 1974: pl. 5:1).
 19. Unprovenanced (Vagnetti 1979: pl. 12:1).
 20–27. Lemba-Lakkous (Peltenburg *et al.* 1985: fig. 83:1, 8, 9, 15–19).
 28–30. Souskiou-Vathyrkakas (Vagnetti 1980: pls. 11:42, 12:65, 13:66).
 31. Kissonerga-Mosphilia No. 2015.
 32. Nicosia-Ayia Paraskevi (Stewart 1962: 262, fig. 105:7).
 33. Lemba-Lakkous (Peltenburg *et al.* 1985: fig. 83:20).
 34. Souskiou-Vathyrkakas (Vagnetti 1980: pl. 19:107).
 35–36. Nicosia-Ayia Paraskevi (Stewart 1962: 262, fig. 105:2, 6).
 37–38. Souskiou-Vathyrkakas (Vagnetti 1980: pl. 18:102, 105).
 39–40. Nicosia-Ayia Paraskevi (Stewart 1962: 262, fig. 105:8, 11).

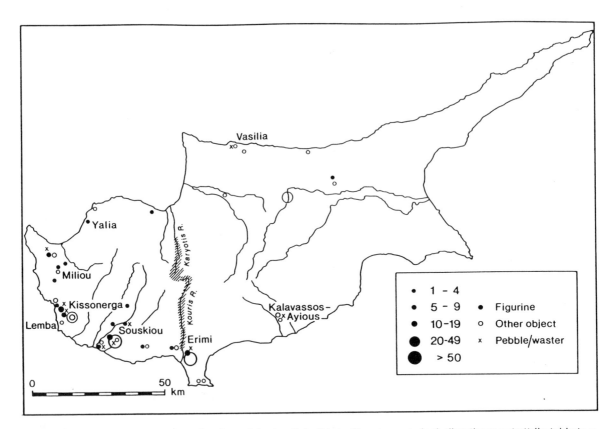

Fig. 2. Distribution of Chalcolithic picrolites of the fourth to third millennium B.C., including those not attributable to a specific millennium. Kouris and Karyotis River drainages are shaded.

the first visitors or colonists of Cyprus in the ninth to eighth millennium B.C. (fig. 3a; Appendix, Table 1). If the beads from Akrotiri prove to be from ninth to eighth millennium B.C. *in situ* deposits, it would seem likely that the occupants traveled around the bay to the west of the peninsula and foraged along the lower reaches of the Kouris River where picrolite is plentiful.

The use of picrolite is well attested subsequently in Aceramic Neolithic settlements, where carvers developed a highly distinctive repertoire of pendants, "dress pins," beads, rings, and small vessels (fig. 1a). Identification of some of the pieces as amulets and dress pins is speculative; some could equally well have been labrets, noserings, or earrings. In Upper Egypt, for example, shapes like the dress pins (fig. 1a.8) are referred to as hair rings (Williams 1983: pl. 109). Unfortunately, information on associations between picrolite adornments and their wearers is poor.[5] In his publication of Khirokitia, Dikaios (1953) and most other fieldworkers of his generation (e.g., Gjerstad *et al.*

1934), was more concerned with chronology and typology than with individual contexts of the finds. That disinterest in extramural activities is particularly unfortunate since 84 percent of recorded picrolites were recovered from such locations in the early excavations of Khirokitia. Assuming that the picrolites have not eroded from buildings on the steeply sloped site (only seven come from intramural deposits), they may be part of general habitation refuse. In his more recent investigations at Khirokitia, Le Brun (1989: 79–80) has postulated that a similar distribution of figurines can be explained in terms of loss of significance and their disposal once they had fulfilled their purpose. In other words, rather than regard such wasteful discard practices as profligate rejection of imported valuables, it may be that picrolites were used for restricted purposes, to be dispensed with, after life crises rites for example. They were not normally kept as funerary offerings.

In the Late Neolithic, picrolites were less common and their shapes much less elaborate (fig. 1b).

Fig. 3. Distribution of picrolite in the ninth to sixth millennium B.C. (a); fifth millennium B.C. (b); fourth millennium B.C. (c); and third millennium B.C. (d). See Figure 2 for symbols.

Pebbles were only slightly altered to form beads and elongated pendants. While such typological impoverishment cannot explain the ever-diminishing chronological gap in the occupation record of Neolithic Cyprus (Held 1989), the dates associated with some examples are noteworthy. If the Dhali beads (Appendix, Table 2) belong, at the latest, to the mid-fifth millennium B.C. (Lehavy 1989: 211), it would indicate that communities engaged in alternative economic strategies between the Aceramic and Late Neolithic periods maintained access to supplies. Such a scenario might help explain the firmer evidence from Ayios Epiktitos-Vrysi, where picrolite occurs in the earliest levels (fig. 1b.9). Since the relevant pendants or raw material had to come from distant sources across the Kyrenia Mountains (fig. 3b), the first attested occupants of Ayios Epiktitos were either natives or colonists who quickly established relations with those natives who had knowledge of the sources. In either case, the evidence strengthens the case for continuity of

occupation in the Neolithic of Cyprus, rather than abandonment as advocated by several scholars (e.g., Stanley Price 1977: 37; Cherry 1981: 60–61; Karageorghis 1982: 27).

The absence of picrolite jewelry from the Sotira cemetery suggests that such pieces were used only as personal ornaments for the living—not funerary offerings—during the Late Neolithic. Of the picrolites recovered from the settlement area, 66 percent comes from houses, a notable contrast with Aceramic era discard practices. Most were found in below-floor deposits, which may comprise general habitation fills rather than special foundations.[6]

The Zenith of Picrolite Use in the Chalcolithic Period

The dramatic increase in number of picrolites during the succeeding Chalcolithic period is matched by a substantial extension in morphology and the onset of their use in burials (figs. 2; 3c, d; Appendix,

Tables 3–5). This leap, from 50 in the fifth millennium B.C. to 445 in the fourth to the third, is an underestimate: it does not take into account the many unprovenanced objects attributable to the Chalcolithic period on stylistic grounds. New carving techniques were developed for the production of beads, inlays, whorls, vessels, a much enlarged repertoire of pendants, and—for the first time—figurines. The revolution, evident already in Early Chalcolithic Kalavassos-Ayious and Kissonerga-Mylouthkia, was one of a number of changes in behavioral patterns. More rock types were exploited and, as is evident at Kalavassos-Ayious in the south of the island, it was not solely due to population increase in the west where a greater range of rocks is available. Intensified demand in a whole range of rock types thus led to the increased exploitation of picrolite.

Intensification by itself does little to explain the unprecedented growth of the picrolite network. Enhanced exploitation and distribution served socially determined needs, and they are most obviously visible in the major product, the cruciform pendant figurine (fig. 1c.13–19). Morris (1985) argues persuasively that they are birth charms, while others (e.g., Karageorghis 1977) believe they represent fertility deities. The more important point for this discussion is that the highly stylized shape was widely accepted, and is the first unequivocal symbol in Cyprus. Production, distribution, and consumption of picrolite during the Chalcolithic therefore were integral to the formation and maintenance of social customs involving birth, and hence probably also marriage.

The spectacular evidence of the Souskiou cemeteries has led to the unwarranted general assumption that picrolite pendants and figurines were made solely for funerary purposes (e.g., Karageorghis 1977: 28; Vagnetti 1980: 53–54). Rather, they were used for both the living and the dead: the holes of many perforated pendants are often nearly worn through (fig. 1c.22, 32) or have already broken and the pendants have been repierced (fig. 1c.26, 32). Furthermore, the absence of picrolites in burials at Karavas and Erimi (Dikaios 1936: 11, 74) indicates that only some of the population was entitled to be buried with such pieces. Thus picrolite was a prestige item.

Evidence from Lemba and Kissonerga in the west of the island repeats and amplifies the pattern recovered at Erimi and Karavas. Of 56 graves at Lemba only five or six possess picrolites, and only

one of those contained a figurine (Peltenburg *et al.* 1985). At Kissonerga, four of 67 graves have picrolites and again only one has figurines (unpublished data). In total, only 18 percent of all picrolites recovered from Lemba occur in graves and only 6 percent at the far richer site of Kissonerga. According to the evidence from Karavas, Erimi, Lemba, and Kissonerga, therefore, the site of Souskiou is anomalous in yielding so much picrolite from mortuary contexts. A number of more obvious possible reasons may be proposed for that anomaly, none of them satisfactory:

●*Souskiou is anomalous because the material comes from cemeteries, not intramural graves as at the other sites.*

Lemba Area I also has a cemetery and its burials had no durable grave-goods (Niklasson 1985: 43–53, 323, fig. 6.4). Also, many graves that now appear to be intrasettlement were located in areas where there were no buildings. If a cemetery is defined as a burial area set aside from other pursuits for some, rather than all time, the distinction between it and a settlement is not always easy.

●*Since most Souskiou picrolites were found in clandestine operations, they could have been collected from the settlement.*

In the first excavation at the site, Iliffe and Mitford (1952) investigated three tombs that produced picrolite and none was reported from the settlement. Subsequent rescue work was undertaken in response to tomb looting, evidence for which was clearly visible in the spoil dumps beside emptied shaft graves (Maier 1974; Christou 1989). Those rescue operations also yielded picrolites in abundance and none from the settlement.

●*Picrolites from general habitation contexts are derived from burials since graves in densely occupied settlements are frequently disturbed.*

This argument does not confront their absence from undisturbed graves. A few graves were undoubtedly reused for other purposes, but not many, and the argument requires more human bone from general habitation deposits than actually occurs.

One may conclude that some ancient special circumstance attends the deliberate concentration of picrolite at Souskiou and that it is not a result of retrieval bias. A possible reason for the anomaly may be the role of Souskiou along a boundary. The site is situated at the east end of the populous Ktima Lowlands. Further east, the terrain becomes difficult, and hills extend right to the sea, rendering coastline routes to the Kouris picrolite source

virtually impassable. The site lies above the Dhiarizzos, a perennial river that provides access to the mountains to the north, but the mountains are devoid of Chalcolithic sites. Souskiou, therefore, occupies a strategic position in terms of communication arteries and site distributions. Elaborating on Polanyi's concept of "ports of trade" and their location at interfaces, Bradley (1985) draws attention to the location of metalwork hoards on the edges of culture zones in Europe, especially in the vicinity of rivers. Such specialized sites may have served as "neutral places where balanced transactions took place" (Bradley 1985: 699). Souskiou's most notable feature is its rich cemeteries with their picrolites, mother-of-pearl (Vagnetti 1980: 44, nos. 93–95; pl. 17), fantastic zoomorphs (Maier and Karageorghis 1984: 26, fig. 3), multiple burials, and shaft graves cut deeply into limestone that, apart from typological distinctness, required considerably more labor than the construction of graves at other Chalcolithic sites. Although little is known of its settlement, the mortuary richness of Souskiou may be associated with a strategic role in contacts between regional groups.

No data are available on age/sex associations for the Souskiou picrolites, although at Lemba and Kissonerga a surprising correlation exists between picrolites and children in the mortuary population (Appendix, Table 6). At Kissonerga the four graves with picrolites all belonged to children; not one of the dozens of adult burials yielded that material. In the one Lemba burial where it may have accompanied an adult (Grave 23), there is considerable doubt concerning the association and it was not included as grave goods in the final report. None of the remaining 13 adult burials contained picrolites.

It seems, therefore, that a proportion only of buried children had picrolites; and since so many picrolites have been recovered from general settlement debris, it might be surmised that after a certain age, people no longer were buried with picrolite ornaments. Some living adult females probably did wear cruciform symbols, and one figurine, fig. 1c.18, depicts the manner in which they were suspended. The birth pendants were not exclusively reserved for adult females, however, since one was found at the neck of a child in Kissonerga Grave 563.

Lunt (in Peltenburg et al. 1985: 246) remarks on the preponderance of very young children in the burial population at Lemba; the same is true at Kissonerga (Lunt: personal communication). It may indicate an unusually high infant mortality rate, which may explain the proliferation of birth figures during the Chalcolithic. Another possibility is that some adults were buried elsewhere. The exceptional character of Souskiou, some 25 km east, has been noted (above); but unfortunately no data are currently available on the age structure of its burial population. If Souskiou adult burials possess picrolites, the site is further distinguished from other settlements and perhaps functioned as a regional cemetery.

INITIAL ASSESSMENT OF PROCUREMENT STRATEGIES

Kouris and Karyotis river sources are postulated for most if not all picrolite ornaments (above). River pebbles have been found at three Aceramic sites, one Late Neolithic, and nine Chalcolithic (Appendix, Tables 1–5). Some have been artificially smoothed and polished. Such pebbles could be finished items for an unknown use, or blanks; hence the distribution of the unworked raw material may be more limited than the numbers suggest. The largest concentration of unworked pebbles is a recently discovered cache from painted Building S. 122 at Khirokitia. According to Le Brun (personal communication, 23 Jan. 1991), one may be partly worked, so here is further evidence for transport of raw material from secondary deposits in rivers and for small-scale ornament production at settlements. Painted buildings are rare in Aceramic Cyprus (e.g., Todd 1987: fig. 39), so the association here may prove special. Wasters are recorded at three Aceramic sites, one Late Neolithic and four or five Chalcolithic (Appendix, Tables 1–5). As with pebble cores, that cannot be interpreted without qualification as evidence for local production from imported raw material. While obviously retooled objects are excluded from consideration, it is not always easy to distinguish between a partly recycled old object and discard from a nearly completed new product. Nonetheless, enough evidence is certain to permit the inference that in all periods raw material was taken from the Kouris and Karyotis for on-site production. The clearest evidence occurs at sites where pebbles and wasters occur together (e.g., at Kholetra). A sizable pebble from Mari indicates that relatively large objects were made locally from transported raw picrolite (Appendix, Table 1).

A pattern of dispersed production therefore characterizes the picrolite network. There is no evidence for the dispatch of finished products from centralized manufacturing points. Had the latter occurred, one would expect masterpieces at Erimi, yet work there is of indifferent quality. In the Chalcolithic, quality of workmanship seems to vary in inverse relationship to abundance of readily available material, with the most sophisticated cruciform figure from distant Yalia (fig. 1c.18). That may be due to the ease with which the soft material (3.5 on the Mohs scale) can be worked and the greater care given to production in distant locales where it was harder to obtain picrolite. Thus, there is little evidence for a "picrolite industry" (Knapp 1990: 157) or specialists (Bolger 1988: 118). Finlayson easily replicated a cruciform from a pebble within one hour as part of chert wear analysis experiments (personal communication).

Absence of specialist production is also indicated by relative complexity in the expanded pendant repertoire and the stylistic variability of anthropomorphs within the cruciform parameter. Vagnetti (1980: 37, n. 27; cf. 39, n. 37) can attribute only three to the same workshop on the basis of standardization. Others likely to be from the same hand come from Kissonerga (Peltenburg 1988: 233, fig. 2) and, allegedly, from Souskiou (Karageorghis, Peltenburg, and Flourenzos 1990: 42, no. 32). Simplification and lack of standardization not only corroborate on-site production but also point to highly localized, part-time craftsmen rather than distribution and manufacture by itinerant carvers.

If we apply Renfrew's model (Renfrew, Dixon, and Cann 1968) for Near Eastern obsidian procurement to the data here, picrolite may have been acquired directly rather than through an exchange network. The longest distance between picrolite source and artifact, ca. 100 km, is well within the 300 km radius he postulates as the supply zone for obsidian exchange.[7] However, other mechanisms may account for the very high proportions of obsidian in lithic assemblages within that zone. In Cyprus, direct access often means passing through the territories of many villages, and the considerable travel difficulties in pre-pack animal Cyprus have been noted above. Strong or ulterior motives were required for a picrolite fetch-and-carry system in which villages had direct access to the Kouris or Karyotis river resource. Such motives may have existed, and the tunny fish explanation for the

distribution of obsidian in the Aegean provides two possible insights into how that system may have operated in Cyprus.[8]

The first aspect of the model is that raw material transport is an adjunct of a subsistence economy in which there is direct acquisition of foodstuffs. As was argued above, there is only tenuous evidence for the exchange of edibles in prehistoric Cyprus. Seasonal transhumance, which often figures in discussions of the economies of the Near East and of Mediterranean islands, also provides the necessary mobility for direct access procurement; but there is no tradition or evidence for it in Cyprus (Stanley Price 1979a: 71–73). The popular nondomestic fallow deer had a circumscribed habitat in woodlands and valleys, so it did not require long-distance hunters into the Central Troodos where the picrolite-bearing serpentines were located. There is little evidence, therefore, to support the notion that a fetch-and-carry supply of picrolite was embedded in a land-based subsistence strategy.

The second element is sea transport by fishermen who may have been more important to the Cypriot economy than is suggested by the scantiness of fishbones on sites. Inshore fishermen would have little reason to travel far, but specialist deep sea fishermen may have moved further along the coasts, bringing along esoteric valuables like picrolites. The distribution of the latter would be most dense at coastal sites regardless of distance from source, as Ammerman (1979) suggests in the case of obsidian in the central Mediterranean. All things being equal, therefore, this could be monitored by measuring rates of consumption at coastal and inland sites. All things, however, are far from equal and a regional analysis by means of the graphical approach used by Renfrew and his associates is fraught with difficulties.

Regression analysis of obsidian distributions, among the most advanced in archaeology, has led to conflicting interpretations of exponential and other fall-off patterns. In a review of such studies, Torrence (1986: 23) concludes, "Archaeology still lacks an effective methodology for measuring consumption on a regional level." The meaning of graphs that show relative frequencies of picrolite in assemblages of personal ornaments is thus open to several reconstructions of acquisition. Based simply on numbers, picrolites at (in order of distance from source) Erimi, Sotira, and Souskiou comprise more than 80 percent of the total, at Ayious 40 percent,

at the Lemba cluster of sites 30–60 percent, at Khirokitia 50 percent and Ayios Epiktitos 10 percent.[9] Not surprisingly, frequency of occurrence declines with increasing distance. Sample weight might provide another picture. More instructive than either may be color since unblemished monotone blue-green seems to have been preferred and there are many inferior, mottled, and olive-brown picrolites. But in virtually all cases, the sample base of excavated sites is too slender to provide meaningful results; it includes sites of different sizes, cultures, and volumes of recovered soil, serving contrasting functions and excavated with disparate retrieval procedures.

Another limiting factor is that models for obsidian exchange are primarily intended for utilitarian goods whose appearance at sites equates with unilinear distance from source. There is no consideration of the impact of the circulation of consumer items on distance decay curves. Depending on their social role, figurines and pendants may well have been personal effects that traveled contraflow to material from source. The identity of cruciforms from Kissonerga-Mosphilia and Souskiou (Peltenburg 1988: 233, fig. 2; Karageorghis, Peltenburg, and Flourenzos 1990: 42, no. 32) suggests that, in addition to the raw material, there was also movement of finished items.

Although the archaeological record provides little evidence to allow differentiation between direct access and exchange, it is suggested that during the Chalcolithic a localized exchange system in picrolite pebble cores did exist. Reasons for favoring that procurement system include the preexisting need for communities to be engaged in information networks, the likely operation of a least-effort principle, the general lack of evidence for long-distance mobility, and topographic constraints on long-distance travel.

SUMMARY AND CONCLUSIONS

Production of picrolite ornaments remained unspecialized in pre-Bronze Age Cyprus. The largest concentration of raw material, a cache of 25 pebbles at Khirokitia, fits that pattern, since it constitutes no more than the contents of a single bag, readily carried and worked by one person. Production was carried out inside settlements, and required limited labor that could be contained in an agricultural regime. Production reached its zenith during the

Middle Chalcolithic due to the expansion of a symbolic system, rather than the greater prevalence of metal for carving (see Vagnetti 1980: 52 for the dismissal of metal). It may have been severely curtailed during the Late Chalcolithic when other blue items such as faience beads appear.

It is possible to discuss consumption only when there is useful contextual information, in the Chalcolithic period. Exogamy was important then, and it has been argued (above) that the exchange system may have been linked to marriage networks. The cruciform images however were not exclusively used in marriage contracts, as suggested by Talalay (1987) for the broken terracotta figurines in Greece, since virtually all those in graves accompany children. Few children were buried with the figures, and this may be accounted for by ascribed status. The many cruciform birth symbols from general habitation deposits were probably worn by adult females only at certain times, and discarded—after child-bearing age, for example. Contextual evidence therefore suggests that consumption of this prized import was geared to rank and status in small-scale society.

Hastorf (1990) posits two types of exchange systems, local and exogenous. The former functions "to maintain intergroup relations, to perpetuate the system, and to gain access to needed goods" (Hastorf 1990: 153). Primitive valuables are a common feature of reciprocal systems, and the Cypriot picrolite network conforms to that exchange type. Even at the height of its distribution, in Middle Chalcolithic times, there is no evidence that intensification of demand triggered escalation in the movement of a variety of potential exchange goods, or systemic change. There are no signs of special structures or concentrations of exotic preciocities to match contemporary Palestine (Alon and Levy 1989), but few Cypriot Chalcolithic sites have been excavated. The picrolite exchange system therefore may be viewed as a regulatory mechanism that helped to maintain intercommunity contacts, ensure the arrival of essentials (Rappaport 1967), and apparently—according to mortuary associations—sustain divisions within small-scale societies.

As the only Chalcolithic site near the Kouris source, Erimi may have exercised a monopoly in the supply of the valuables to nearest neighbors. The socioeconomic impact of that control may be one factor in its growth into the largest settlement in Chalcolithic Cyprus (see Peltenburg, this issue,

pp. 17–35). At no other time did a Kouris river valley site achieve such prominence (Bolger 1988). However, the quality of recovered picrolites is mediocre and Erimi is unlikely to have developed as a specialist distribution point for finished articles. What then did it receive in return for the dissemination of raw picrolite? Dikaios' sounding was too small to provide the broader perspectives to see how trade was adjusted to local structures, but there is no clear density of imported goods. Increased population is the most obvious feature of the period, and that may be correlated with exchange for more regular supplies of foodstuffs. During the Middle Chalcolithic period, bulk, intramural storage of food is attested for the first time. New containers, pithoi, were developed then (e.g., Peltenburg et al. 1985: 35, fig. 55.4). While storage is important to buffer local subsistence fluctuations, it also provides surplus for exchange. Cyprus is subject to severe and recurrent droughts (Christodoulou 1959: 28), and Erimi may thus have benefited from imported food during times of diminished harvests. Increased population, pithoi, and intensified exchange may have been interacting variables that provided the necessary stability for growth at Erimi.

The exceptional quality and number of picrolites at Souskiou—a settlement that remained small even if some of it has been eroded by the Vathyrkakas River—may be due to source capture (note pebbles at Prastio further up the Dhiarrizos river, Appendix, Table 5), or to its role as a special redistribution center along a frontier, or as a ceremonial center. This Middle Chalcolithic site pro-vides the first evidence in Cyprus for "wealthier" burials, and those are associated with high concentrations of picrolite.

As discussed (above), one impact of the picrolite network was the growth of settlement-size hierarchy by the Middle Chalcolithic. That process of increasing social differentiation apparently continued into the Late Chalcolithic. The cessation of picrolite production and distribution thereafter (Appendix, Table 5, bottom) should be viewed in the broader historical context of its socioeconomic role and developments in the eastern Mediterranean in the mid-third millennium B.C. Its demise cannot be regarded as simply the result of the disappearance of a number of participating sites, for their inhabitants could have moved to new locations within the island. The cessation concerns more the breakdown of the whole infrastructure of production, exchange, and consumption—of the disappearance, in other words, of important means of community integration. Since it played a causative role in the creation of site hierarchies, a major stimulus toward social complexity was removed. The succeeding exchange pattern, based on copper extracted from northern ore bodies, involved different sources, routes, and extractive processes, and hence the growth of social complexity in the Bronze Age was not an elaboration of preexisting exchange networks. The disappearance of the age-old picrolite network reflects and probably was instrumental in the transformation of Cypriot society that is but one aspect of the profound crises in the eastern Mediterranean in the mid-third millennium B.C.

ACKNOWLEDGMENTS

I am grateful to A. Papageorghiou, Director, Department of Antiquities, Cyprus, for permission to sample artifacts. A. Livingstone and E. Slater carried out initial analyses, and C. Xenophontos developed further analytical programs, and discussed results with me. A. Le Brun and A. South kindly made material available for study, and W. Fox allowed me to use information from the forthcoming paper by Hancock and Fox (in press). A. Le Brun also generously commented on a first draft of this paper, although I remain responsible for the opinions expressed here. G. Thomas and S. Stevenson produced the illustrations.

NOTES

[1]More recent finds of obsidian have not altered the general situation presented in Peltenburg (1979: 24–26).

[2]Publication of a much expanded analytical database will follow. Low scandium currently provides the best source "fingerprinting," but it is clearly desirable to have more than a single element to source those picrolites.

[3]There are, in addition to the problems of identification, problems of nomenclature. For the American preference for the term "antigorite" see, for example, Swiny (1986: 29, n. 1), and Hancock and Fox (in press). The related serpentinite also occurs occasionally on prehistoric sites.

[4]For doubts on authenticity, see Vagnetti (1974: 29, n. 1). Many picrolites have been attributed to Souskiou, but here only those accepted by Vagnetti (1980) are included.

[5]This situation may be alleviated by the final publication of Kalavassos-Tenta and Le Brun's (1984) continuing excavations at Khirokitia.

[6]Our understanding of these intriguing fills could be extended significantly by intrasite analysis of finds and especially by closer attention to site formation processes.

[7]A supply zone is an area in which users have direct access to sources (Renfrew, Dixon, and Cann 1968: 329).

[8]The central plank of the model is that fishermen exploited Melian obsidian quarries during their tunny fish expeditions (Bintliff 1977: 117–25, 538–43). Minimal social transfer of information is inherent in this model of direct acquisition.

[9]The figures for Khirokitia (and new ones for Cape Andreas) will require major adjustments when the many newly discovered picrolites are studied through the kindness of A. Le Brun.

BIBLIOGRAPHY

Alon, D., and Levy, T.
1989 The Archaeology of Cult and the Chalcolithic Sanctuary at Gilat. *Journal of Mediterranean Archaeology* 2: 163–221.

Ammerman, A.
1979 A Study of Obsidian Exchange Networks in Calabria. *World Archaeology* 11: 95–110.

Bender, B.
1985 Emergent Tribal Formations in the American Midcontinent. *American Antiquity* 50: 52–62.

Betts, A.
1987 The Chipped Stone. Pp. 10–14 in *Excavations at Kissonerga-Mosphilia 1986*, by E. Peltenburg *et al. Report of the Department of Antiquities of Cyprus*: 1–18.

Bintliff, J.
1977 *Natural Environment and Human Settlement in Prehistoric Greece*. BAR Supplementary Series 28. Oxford: British Archaeological Reports.

Bolger, D.
1988 *Erimi-Pamboula. A Chalcolithic Settlement in Cyprus*. BAR International Series 443. Oxford: British Archaeological Reports.

Bradley, R.
1985 Exchange and Social Distance—The Structure of Bronze Artefact Distributions. *Man* 20: 692–704.

Cherry, J.
1981 Pattern and Process in the Earliest Colonization of the Mediterranean Islands. *Proceedings of the Prehistoric Society* 47: 41–68.

Christodoulou, D.
1959 *The Evolution of the Rural Land Use Pattern in Cyprus*. Bude: Geographical Publications.

Christou, D.
1989 The Chalcolithic Cemetery 1 at Souskiou-Vathyrkakas. Pp. 82–94 in *Early Society in Cyprus*, ed. E. J. Peltenburg. Edinburgh: University of Edinburgh.

Colledge, S.
1980 Plant Species from Kissonerga-Mylouthkia Feature 16.3. Pp. 18–20 in Lemba Archaeological Report, Cyprus, 1978: Preliminary Report, by E. Peltenburg. *Levant* 12: 1–21.

Daniel, J.
1938 Excavations at Kourion: The Late Bronze Age Settlement-Provisional Report. *American Journal of Archaeology* 42: 261–75.

Desse, J., and Desse-Berset, N.
1984 Les poissons de Khirokitia. Pp. 223–33 in *Fouilles récentes à Khirokitia (Chypre) 1977–1981*, by A. Le Brun. Recherche sur les civilisations, Mèmoire 41. Paris: Association pour la Diffusion de la Pensée Française.

Dikaios, P.
1934 Two Neolithic Steatite Idols. *Report of the Department of Antiquities of Cyprus*: 16.
1936 The Excavations at Erimi 1933–1935. *Report of the Department of Antiquities of Cyprus*: 1–81.
1953 *Khirokitia*. Oxford: Oxford University.
1961 *Sotira*. Philadelphia: University of Pennsylvania.
1962 The Stone Age. Pp. 1–204 in *The Swedish Cyprus Expedition* IV. 1A. Lund: Swedish Cyprus Expedition.
1969 *Enkomi Excavations 1948–1958*. Mainz am Rhein: von Zabern.

Elliott, C.
1981 Observations on Ground Stone Adzes and Axes from Lemba Lakkous. *Report of the Department of Antiquities of Cyprus*: 1–23.
1983 Kissonerga Mylouthkia: An Outline of the Ground Stone Industry. *Levant* 15: 11–37.

Ericson, J.
1977 Egalitarian Exchange Systems in California: A Preliminary View. Pp. 109–26 in *Exchange systems in Prehistory*, eds. T. Earle and J. Ericson. New York: Academic.

Fox, W.
 1987 The Neolithic Occupation of Western Cyprus.
 Pp. 19–42 in *Western Cyprus Connections*,
 ed. D. Rupp. Studies in Mediterranean Ar-
 chaeology 77. Göteborg: Åström.
 1988 Kholetra-Ortos: A Khirokitia Culture Settle-
 ment in Paphos District. *Report of the De-
 partment of Antiquities of Cyprus*: 29–42.
Frankel, D.
 1974 *Middle Cypriot White Painted Pottery. An
 Analytical Study of the Decoration*. Studies
 in Mediterranean Archaeology 42. Göteborg:
 Åström.
Gjerstad, E.; Lindros, J.; Sjöquist, E.; and Westholm, A.
 1934 *The Swedish Cyprus Expedition I: Finds
 and Results of the Excavations in Cyprus
 1927–1931*. Stockholm: Swedish Cyprus
 Expedition.
Goring, E.
 1988 *A Mischievous Pastime. Digging in Cyprus in
 the Nineteenth Century*. Edinburgh: National
 Museums of Scotland.
Hancock, F., and Fox, W.
 In press Prehistoric Antigorite Procurement in Cy-
 prus. *Archaeometry*.
Hastorf, C.
 1990 One Path to the Heights: Negotiating Political
 Inequality in the Sausa of Peru. Pp. 146–76
 in *The Evolution of Political Systems. So-
 ciopolitics in Small-Scale Sedentary Socie-
 ties*, ed. S. Upham. Cambridge: Cambridge
 University.
Held, S.
 1989 *Early Prehistoric Island Archaeology in
 Cyprus: Configurations of Formative Cul-
 ture Growth from the Pleistocene/Holocene
 Boundary to the Mid-3rd Millennium B.C.*
 Ph.D. dissertation, University of London.
Hennessy, J.; Erikson, K.; and Kehrberg, I.
 1988 *Ayia Paraskevi and Vasilia. Excavations by
 J. R. B. Stewart*. Studies in Mediterranean
 Archaeology 82. Göteborg: Åström.
Heywood, H.; Swiny, S.; Whittingham, D.; and Croft, P.
 1981 Erimi Revisited. *Report of the Department of
 Antiquities of Cyprus*: 24–42.
Iliffe, J., and Mitford, T.
 1952 Excavations at Aphrodite's Sanctuary at Pa-
 phos. *Liverpool Bulletin* 2: 24–66.
Karageorghis, J.
 1977 *La grande déesse de Chypre et son culte*.
 Lyon: Maison de l'Orient.
Karageorghis, V.
 1982 *Cyprus from the Stone Age to the Romans*.
 London: Thames and Hudson.
 1987 *Annual Report of the Department of Anti-
 quities for the Year 1987*. Nicosia: Department
 of Antiquities of Cyprus.

 1988 *Annual Report of the Department of Anti-
 quities for the Year 1988*. Nicosia: Department
 of Antiquities of Cyprus.
 1989 Chronique des fouilles et découvertes arché-
 ologiques à Chypre en 1988. *Bulletin de Cor-
 respondance Hellénique* 113: 789–853.
Karageorghis, V., and Demas, M.
 1985 *Excavations at Kition* V. Nicosia: Department
 of Antiquities of Cyprus.
Karageorghis, V.; Peltenburg, E. J.; and Flourenzos, P.
 1990 *Cyprus before the Bronze Age. Art of the
 Chalcolithic Period*. Malibu: J. Paul Getty
 Museum.
Knapp, A.
 1990 Production, Location, and Integration in
 Bronze Age Cyprus. *Current Anthropology*
 31: 147–76.
Kyllo, M.
 1982 The Botanical Remains: Identifications and
 Discussion. Pp. 415–36 in *Vrysi: A Subter-
 ranean Settlement in Cyprus*, by E. J. Pelten-
 burg. Warminster: Aris and Phillips.
Le Brun, A.
 1981 *Un site néolithique précèramique en Chypre:
 Cap Andreas-Kastros*. Recherche sur les civili-
 sations, Mèmoire 5. Paris: Association pour
 la Diffusion de la Pensée Française.
 1984 *Fouilles récentes à Khirokitia (Chypre) 1977–
 1981*. Recherche sur les grandes civilisations,
 Mèmoire 41. Paris: Association pour la Diffu-
 sion de la Pensée Française.
 1989 Le traitement des morts et les représentations
 des vivants à Khirokitia. Pp. 71–81 in *Early
 Society in Cyprus*, ed. E. J. Peltenburg. Edin-
 burgh: University of Edinburgh.
Lehavy, Y.
 1989 Dhali-Agridhi: The Neolithic by the River.
 Pp. 203–43 in *American Expedition to Ida-
 lion, Cyprus 1973–1980*, by L. Stager and A.
 Walker. Oriental Institute Communication 24.
 Chicago: University of Chicago.
Lubsen-Admiraal, S., and Crouwel, J.
 1989 *Cyprus and Aphrodite*. 's-Gravenhage: SDU
 uitgeverij.
Maier, F.
 1974 Ausgrabungen in Alt-Paphos. Sechster Vor-
 laufiger Bericht: Grabungskampagne 1971
 und 1972. *Archäologisher Anzeiger*: 28–51.
 1981 Excavations at Kouklia (Palaepaphos). Elev-
 enth Preliminary Report: Seasons 1979 and
 1980. *Report of the Department of Antiquities
 of Cyprus*: 101–5.
Maier, F., and Karageorghis, V.
 1984 *Paphos, History and Archaeology*. Nicosia:
 Leventis Foundation.
Morris, D.
 1985 *The Art of Ancient Cyprus*. Oxford: Phaidon.

Niklasson, K.
1985 The Graves. Pp. 43–53, 134–49, 241–44 in *Lemba Archaeological Projects* I. *Excavations at Lemba-Lakkous 1976-1983*, by E. Peltenburg. Studies in Mediterranean Archaeology 70:1. Göteborg: Åström.

Nicolaou, K.
1967 The Distribution of Settlements in Stone Age Cyprus. *Kypriakai Spoudai* 31: 37–52.

Panatazis, T.
1980 Steatite. Pp. 68–70 in Figurines and Minor Objects from a Chalcolithic Cemetery at Souskiou-Vathyrkakis (Cyprus), by L. Vagnetti. *Studi Micenei ed Egeo-Anatolici* 21: 17–72.

Peacock, D.
1988 The Gabbroic Pottery of Cornwall. *Antiquity* 62: 302–4.

Peltenburg, E.
1979 Troulli Reconsidered. Pp. 21–45 in *Studies Presented in Memory of Porphyrios Dikaios*: 21–45. Nicosia: Lions Club of Nicosia.

1980 The Lemba Lady of Western Cyprus. *Illustrated London News* (February, no. 6979), Archaeology 2956: 57–58.

1981 Lemba Archaeological Project, Cyprus, 1979: Preliminary Report. *Levant* 13: 28–50.

1982a *Vrysi: A Subterranean Settlement in Cyprus.* Warminster: Aris and Phillips.

1982b Early Copperwork in Cyprus and the Exploitation of Picrolite: Evidence from the Lemba Archaeological Project. Pp. 41–62 in *Early Metallurgy in Cyprus, 4000-500 B.C.*, eds. J. Muhly, R. Maddin, and V. Karageorghis. Lanarca: Pierides Foundation.

1985 Settlement Aspects of the Later Prehistory of Cyprus: Ayios Epiktitos-Vrysi and Lemba. Pp. 92–114 in *Archaeology in Cyprus 1960-1985*, ed. V. Karageorghis. Nicosia: A. G. Leventis Foundation.

1988 Lemba Archaeological Project, Cyprus, 1986. *Levant* 20: 231–35.

1990 Lemba Archaeological Project, Cyprus, 1988. *Levant* 22: 155–56.

In press Toward Definition of the Late Chalcolithic in Cyprus: The Monochrome Pottery Debate. In *Cypriot Ceramics: Reading the Prehistoric Record*, eds. J. Barlow, D. Bolger, and B. Kling. Philadelphia: University of Pennsylvania.

Peltenburg, E., ed.
1989 *Early Society in Cyprus.* Edinburgh: Edinburgh University.

Peltenburg, E. *et al.*
1985 *Lemba Archaeological Project I. Excavations at Lemba Lakkous, 1976-1983.* Studies in

Mediterranean Archaeology 70:1. Göteborg: Åström.

Plog, S.
1980 Village Autonomy in the American Southwest: An Evaluation of the Evidence. Pp. 135–46 in *Models and Methods in Regional Exchange*, ed. R. Fry. Society for American Archaeology Papers No. 1. Washington: Society for American Archaeology.

Rappaport, R.
1967 *Pigs for the Ancestors.* New Haven: Yale.

Renfrew, C.; Dixon, J.; and Cann, J.
1968 Further Analysis of Near Eastern Obsidians. *Proceedings of the Prehistoric Society* 34: 319–31.

Runnels, C., and van Andel, T.
1988 Trade and the Origins of Agriculture in the Eastern Mediterranean. *Journal of Mediterranean Archaeology* 1: 83–109.

Rupp, D., ed.
1987 *Western Cyprus Connections: An Archaeological Symposium at Brock University, March 21-22, 1986.* Studies in Mediterranean Archaeology 77. Göteborg: Åström.

Rupp, D. *et al.*
1986 Canadian Palaipaphos Cyprus Survey Project: Third Preliminary Report. *Acta Archaeologia* 57: 27–45.

South, A.
1985 Figurines and Other Objects from Kalavasos-Ayious. *Levant* 17: 65–79.

Stager, L., and Walker, A.
1989 *American Expedition to Idalion, Cyprus 1973-1980.* Oriental Institute Communications 24. Chicago: University of Chicago.

Stanley Price, N.
1977 Colonization and Continuity in the Early Prehistory of Cyprus. *World Archaeology* 9: 27–41.

1979a *Early Prehistoric Settlement in Cyprus 6500-3000 B.C.* BAR International Series 65. Oxford: British Archaeological Reports.

1979b The Structure of Settlement at Sotira in Cyprus. *Levant* 11: 46–83.

Stewart, J.
1962 The Early Cypriote Bronze Age. Pp. 205–401 in *The Swedish Cyprus Expedition* IV. 1A. Stockholm: Swedish Cyprus Expedition.

Stos-Gale, Z.; Gale, N.; and Zwicker, U.
1986 The Copper Trade in the South-east Mediterranean Region. Preliminary Scientific Evidence. *Report of the Department of Antiquities of Cyprus*: 122–44.

Swiny, S.
1985 The Cyprus American Archaeological Research Institute Excavations at Sotira-Kaminoudhia and the Origins of the Philia

Culture. Pp. 13–26 in *Acts of the Second International Conference of Cypriote Studies*, eds. Th. Papadopoulos and S. Xatsistelli. Nicosia: Leventis Foundation.

1986 *The Kent State University Expedition to Episkopi Phaneromeni*, Part 2. Studies in Mediterranean Archaeology 74:2. Göteborg: Åström.

Talalay, L.
1987 Rethinking the Function of Clay Figurine Legs from Neolithic Greece: An Argument by Analogy. *American Journal of Archaeology* 91: 161–69.

Todd, I.
1977 Vasilikos Valley Project: First Preliminary Report, 1976. *Report of the Department of Antiquities of Cyprus*: 5–32.

1979 Vasilikos Valley Project 1977–1978: An Interim Report. *Report of the Department of Antiquities of Cyprus*: 13–68.

1986 The Foreign Relations of Cyprus in the Neolithic/Chalcolithic Periods: New Evidence from the Vasilikos Valley. Pp. 12–28 in *Acts of the International Archaeological Symposium on Cyprus between the Orient and Occident*, ed. V. Karageorghis. Nicosia: Department of Antiquities of Cyprus.

1987 *Vasilikos Valley Project 6: Excavations at Kalavasos-Tenta* I. Studies in Mediterranean Archaeology 71:6. Göteborg: Åström.

Torrence, R.
1986 *Production and Exchange of Stone Tools. Prehistoric Obsidian in the Aegean.* Cambridge: Cambridge University.

Vagnetti, L.
1974 Preliminary Remarks on Cypriote Chalcolithic Figurines. *Report of the Department of Antiquities of Cyprus*: 24–34.

1975 Some Unpublished Chalcolithic Figurines. *Report of the Department of Antiquities of Cyprus*: 1–4.

1979 Two Steatite Figurines of Anatolian Type in Chalcolithic Cyprus. *Report of the Department of Antiquities of Cyprus*: 112–14.

1980 Figurines and Minor Objects from a Chalcolithic Cemetery at Souskiou-Vathyrkakas (Cyprus). *Studi Micenei ed Egeo-Anatolici* 21: 17–72.

Watkins, T.
1969 The First Village Settlements. *Archaeologia Viva* 2, 3: 29–50.

Welinder, S.
1988 Exchange of Axes in the Early Neolithic Farming Society of Middle Sweden. Pp. 41–48 in *Trade and Exchange in Prehistory, Studies in Honour of Berta Stjernquist*, eds. B. Hardh *et al.* Lund: Lund University.

Williams, B.
1983 *Excavations between Abu Simbel and the Sudan Frontier 5.* Oriental Institute Nubia Expedition 5. Chicago: University of Chicago.

Wobst, H.
1974 Boundary Conditions for Paleolithic Social Systems: A Simulation Approach. *American Antiquity* 39: 147–78.

Xenophontos, C.
1982 Steatite vs. Picrolite. P. 59 in Early Copperwork in Cyprus and the Exploitation of Picrolite: Evidence from the Lemba Archaeological Project, by E. Peltenburg. Pp. 41–62 in *Early Metallurgy in Cyprus, 4000–50 B.C.*, eds. J. Muhly, R. Madden, and V. Karageorghis. Nicosia: Pierides Foundation.

Zwicker, U.
1988 Investigations of Material from Maa-*Palaeokastro* and Copper Ores from the Surrounding Areas. Pp. 427–48 in *Excavations at Maa-Palaeokastro 1979–1986*, by V. Karageorghis and M. Demas. Nicosia: Department of Antiquities of Cyprus.

APPENDIX

The following tables provide a summary catalogue of provenanced picrolites in ninth to third millennium B.C. Cyprus. Abbreviations: amulet (A); bead (B); chisel (C); figurine (F); miscellaneous (M); nugget (N); pendant (P); pebble (Pb); "spindle whorl" (SW); waster (W); Cyprus Museum (CM); Cyprus Survey Collection (CS); Paphos Museum (PM).

TABLE 1. Picrolite Occurrences in Ninth to Sixth Millennium B.C. Cyprus

Site	n	Type	Reference	Comments
Akrotiri-Aetokremmos	2	B	Karageorghis 1988: 41	"Serpentinite," not stated if from surface or rock shelter
Cap Andreas-Kastros	?	B	Le Brun 1981: figs. 47–48	One "steatite" and one "greenstone" mentioned. Objects on display in CM are picrolite
Kalavassos-Tenta	86	Pb, M	Todd 1977: 23; 1979: 67; A. South personal communication 8 Mar. 1990	These and other finds described as "antigorite" (Todd 1987: 20). Minimal nos. pending final report
Khirokitia	85+	B, P, W, V, M	Dikaios 1953; Le Brun 1984, II: 132–33	Partly drilled pendants: Dikaios 1953: 53
Kholetra-Ortos	10+	P, Pb, W	Fox 1988: 41; Hancock and Fox in press; PM	Pebbles displaying retouch; partly drilled disc
Kritou Marottou-Ais Yiorkis	3	P, W	Fox 1987: 21	Includes fragment "from ornament production"
Mari-Mesovouni	10	Pb	A. South, personal communication 8 Mar. 1990	Includes large (L. 10 cm) pebble
Petra tou Limniti	1	B	Gjerstad et al. 1934: 1–2, pl. 5.3	
Rizokarpaso-Apostolos Andreas	1	N	Stanley Price 1979a: 122	"Lump"
Troulli I	2	B, P	Peltenburg 1979: 29	Both residual Aceramic types

TABLE 2. Picrolite Occurrences in Fifth Millennium B.C. Cyprus

Site	n	Type	Reference	Comments
Ayios Epiktitos-Vrysi	5	B, P	Peltenburg 1982a: 315–16, fig. 62	
Dhali-Agridhi	2	B	Lehavy 1989: 211	"Green serpentine"; could belong to previous millennium
Dhenia-Kafkalla	1	C	Nicolaou 1967	Period attribution uncertain; several components represented
Kandou-Kouphovouno	4	Pb	Stanley Price 1979a: 135	"Lumps"
Philia-Drakos A	10+	B, P, M	Watkins 1969: Ill. 31	On display in CM
Sotira-Teppes	29	B, P, M, W	Dikaios 1961: 200–201	None from first phase. Three partly pierced pendants; three blanks

TABLE 3. Picrolite Occurrences in Fourth Millennium B.C. Cyprus

Site	n	Type	Reference	Comments
Ayios Epiktitos-Mezarlik	1	P	Peltenburg 1985: 102, fig. 5.8	Rare type: cf. Kalavassos B and Lemba. 1A from here? (Stanley Price 1979a: 155)
Erimi-Pamboules	152	B, C, F, P, Pb/W, SW	Dikaios 1936; Bolger 1988	Bolger 1988: 80 (adze, chisel), 92 (mortar), 113 (unfinished figurine), 118 (wasters)
Kalavassos-Ayious	7	B, P	South 1985: 73	"Antigorite"
Kissonerga-Mosphilia 2–3	2	P	PM	
Kissonerga-Mylouthkia	9	F, P, M	Peltenburg 1980: 58, top right	Others in PM
Lemba-Lakkous 1–2	17	B, F, P, M	Peltenburg et al. 1985	M could include wasters
Souskiou-Vathyrkakas	88	B, F, P, W	Vagnetti 1980; Christou 1989	One F unfinished (Vagnetti 1980: 51, n. 90)

TABLE 4. Picrolite Occurrences in Third Millennium B.C. Cyprus

Site	n	Type	Reference	Comments
Kissonerga-Mosphilia 4–5	30	B, F, P, M	PM	M includes one polisher
Lemba-Lakkous 3	18	F, P, M	Peltenburg et al. 1985	3M could include wasters
Nicosia-Ayia Paraskevi	48	B, P	Stewart 1962: 261; Hennessy, Erikson, and Kehrberg 1988: 14–17	Stewart refers to "steatite" and does not define "pseudophite" beyond a greenstone
Philia-Vasiliko	2	P	Dikaios 1962: 174	
Vasilia	2	M	Hennessy, Erikson, and Kehrberg 1988: 26	1 pounder, 1 lid from dromos T.1

TABLE 5. Picrolite Occurrences in Fourth and Third Millennium B.C. Cyprus*

Site	n	Type	Reference	Comments
Akrotiri #19	1	M	Held 1989: 244	"Unworked antigorite"
Akrotiri-Shiloshtasha	?	?	Held 1989: 345	"Antigorite"
Androlikou-Ayios Mamas	10	F, P	Stanley Price 1979a: 140 and CS	
Chlorakas-Vrysoudhia	1	M	PM	
Erimi-Pamboula	7	F, Pb	Heywood et al. 1981: 34	"Serpentine (steatite)." Includes Late Chalcolithic material not found in Dikaios' sounding
Kalavassos B	1	P	Dikaios 1962: 138, fig. 65.26	
Kalavassos-Pamboules	2+	Pb	A. South personal communication 8 Mar. 1990	Others, unpublished, from Dikaios' work
Kathikas	1	F	Vagnetti 1975: 2	
Kissonerga-Mosphilia	39	B, F, P, Pb, M	PM	M includes a miniature axe, and adze, and wasters
Kouklia-Chiftlik	2	P	Maier and Karageorghis 1984: 105	
Kouklia-Germanus	1	Pb	Maier 1981: 105	"Unworked steatite"
Kouklia-Liskovouno	2	F, Pb	Fox 1987: 24	Multicomponent site; Pb 5th millennium B.C.?
Kythrea-Ayios Dhimitrianos	6+	B, C, F, P	Gjerstad et al. 1934: pl. 13.1–2; CS 1525	1P described as "blue stone." For another from Kythrea (?) see Vagnetti 1980: 65
Lapithos-Alonia ton Plakon W	1	SW	Gjerstad et al. 1934: pl. 9.42	
Loutros-Athkia	1	F	Nicolaou 1967	
Miliou-Rhodaeos	4	A, B, F	Stanley Price 1979a: 145; Peltenburg 1981: pl. 4B	1A could be unfinished axe pendant. Site also known as Miliou-Ayii Anargyrii
Neokhorio-Verikon	1+	Pb?	Stanley Price 1979a: 147	"Lumps of steatite"
Phasoula	1	F	Stanley Price 1979a: 137	
Plataniskia-Kasouliali	1	F	Vagnetti 1980: 66	
Plataniskia-Petrero	1	P	Vagnetti 1980: 46 no. 57	
Pomos-Kaminia	1	P	Dikaios 1934	
Prastio-Ayios Savvas tis Kononas	4+	F, Pb	Hancock and Fox: in press; PM.2928 = Karageorghis 1987: fig. 71	
Salamiou-Anephani	2	F	Vagnetti 1974: 29, n. 1	PM.1258, ascribed to Salamiou in Vagnetti 1975, is from Kissonerga-Mosphilia according to the PM register

TABLE 5. *Continued*

Sotira-Kaminoudhia	9	F, P	Swiny 1985: 16	Area A only; "serpentine"
Souskiou-Ayia Irini	1	F	PM.1005	
Souskiou-Laona	4+			
Souskiou-Teratsouthia	1	F	PM.1007	
Trimithousa-Kilistra	1	F	CM 1944/IV–22/13	
Vasilia-Alonia	2	Pb	Stanley Price: 1979a: 116	
Yalia-Appourkia	1	F	Dikaios 1934: pl. 6.1	

*Not attributable to a specific millennium, and additional to picrolites in Tables 3 and 4.

Note: Chalcolithic picrolites were reused in later times, for example figurines at Ayia Irini, Klavdia, and Maroni (Vagnetti 1980: 65), and pendants, possibly from Curium (Goring 1988: 45, nos. 2–4: possibly Early Chalcolithic objects, derived from Neolithic and Chalcolithic occupation known to exist at Episkopi), and Kition (Karageorghis and Demas 1985: 177, 312.860). The material was also occasionally exploited in later times. Bronze Age: Episkopi-Phaneromeni (Swiny 1986: 28–31), Episkopi-Bamboula (Daniel 1938: 269), Kalavassos-Ayios Dhimitrios (A. South personal communication, 8 March 1990), Enkomi (Dikaios 1969: 273.1597), unprovenanced (Lubsen-Admiraal and Crouwel 1989: 149, fig. 35a), and, perhaps, Kedares-Soumajero and Salamiou-Kokkinos (Hancock and Fox, in press). Iron Age: Amathus T. 556 (Karageorghis 1989: 811, fig. 85). Byzantine and mediaeval: Christian crosses (e.g., PM 1013, 1499, 1744, this type not to be confused with Morris 1985: 125, pl. 173, or the analogous example in Amsterdam: Lubsen-Admiraal and Crouwel 1989: 148–49, no. 34).

TABLE 6. Age Structure of Mortuary Population Associated with Picrolites at Kissonerga-Mosphilia and Lemba-Lakkous*

Site	Grave	Burial Age	Sex	Picrolite
Kissonerga	501	child[a]	?	Pendant (cf. fig. 1.21)
	548	child[a]	?	Pendant (cf. fig. 1.22)
	560	child[a]	?	Pendant (cf. fig. 1.25)
	563	children	?	Cruciform figurine and pendants (cf. fig. 1.13, 25, 30)
Lemba	20[b]	?	?	Cruciform figurine (fig. 1.13)
	21	6–7	?	Pendant (cf. Peltenburg *et al.* 1985: fig. 83.5)
	23[c]	ca. 30	?	Pendant
	46	4–5	?	Pendant (cf. fig. 1.22)
	47	1–2	?	Pendant (fig. 1.26)
	55	infant/child	?	Sliver

*Kissonerga data unpublished; Lemba from Peltenburg *et al.* 1985.

[a]Details pending.

[b]No body recovered: pit size indicates child or juvenile.

[c]Picrolite found below burial pit; dubious association.

Picrolite, Its Nature, Provenance, and Possible Distribution Patterns in the Chalcolithic Period of Cyprus

C. XENOPHONTOS
Cyprus Geological Survey Department
Nicosia, Cyprus

Neolithic and Chalcolithic stone decorative artifacts, in various shades of blue-green and green, have been referred to as steatite, "antigorite steatite," antigorite, serpentine, or simply green rock. Petrographic, chemical, and x-ray diffraction analyses of samples from such artifacts show the material to consist of a fine-grained mixture of the serpentine polymorphs chrysotile and lizardite. An identical rock, in the form of veins within serpentinized ultramafic exposures on the island, is known as picrolite.

A detailed field study revealed that suitable material for artifact manufacture is present only on Mt. Olympus, the highest point in the Troodos Mountains (1951 m), a source that could not have been easily accessible. All unworked or partly unworked fragments of this rock type found at Neolithic and Chalcolithic sites are waterworn river pebbles. An exhaustive river-bed survey identified the Kouris and Karyotis rivers, with headwaters on Mt. Olympus, as the only picrolite carriers on the island. The lower reaches of those rivers are proposed as the source areas from which the material was dispersed throughout Cyprus.

INTRODUCTION

A light green to olive green, massive, or banded or crudely fibrous, relatively soft rock was used in prehistoric Cyprus to manufacture an extensive repertoire of figurines, pendants, beads, vessels, and other decorative objects. Evidence from excavated sites points to a significant increase in the use of such material during the fourth and third millennia B.C., especially in the district of Paphos and Limassol (Peltenburg 1981). Despite the large number of artifacts available for study, the archaeological literature abounds with conflict as to the nature of the raw material. Dikaios (1962: 52), with geological advice, termed the material picrolite; but from 1961 to 1981 the term steatite was used exclusively (Vagnetti 1974: 24–34; 1975: 1–4; Crouwel 1978: 31–38). Xenophontos (1981: 59), using chemical analyses, showed the material to be indeed picrolite rather than steatite; and the former term has since been adopted by the Lemba Archaeological Project and

the Cyprus Museum. However, a number of researchers prefer terms such as serpentine, antigorite, and antigorite "steatite." Had this stone indeed been steatite it would introduce significant implications as to the trading patterns between the island and the surrounding countries, for local sources are scarce and where they are present the rock is schistose and unsuitable for the manufacture of such a varied repertoire of artifacts.

This article will define the material in more detail using petrography, geochemistry, and mineralogy. It will then describe its mode of formation, occurrence, and natural dispersion from the primary sources.

PETROGRAPHY

Petrographic analyses of Chalcolithic artifacts could not be carried out as only a small quantity of powder could be obtained from registered fourth and third millennium finds. However, thin sections were made from partly-worked and unworked

Fig. 1. Photomicrographs of Cypriot picrolites.
 a. Picrolite pebble from the Kouris River, showing *fine-bladed texture*.
 b. Partly worked picrolite pebble from the aceramic Neolithic site of Kholetria-*Ortos* showing a similar texture.
 c. Picrolite vein from Troodos showing *fine-laminated texture*.
 d. Picrolite pebble from Kholetria-*Ortos* with deformed fine-laminated texture obscured by growth of lizardite blades subparallel to the lamination.
 All microphotographs were taken with crossed polars and the length of each photograph is equivalent to 4.5 mm.

waterworn pebbles found at the Aceramic site of Kholetria-Ortos, almost halfway up the Xeropotamos River in the Paphos district. Examination of those thin sections with the petrographic microscope showed that the constituent minerals belong to the serpentine group and are very similar to vein material from serpentinized ultramafic rocks (serpentinized harzburgites); that material is called picrolite in the Cypriot geological literature (Wilson 1959).

A comprehensive collection of samples from all the known serpentinite outcrops and waterworn "nuggets" from the two exclusive picrolite carriers (the Kouris and Karyotis Rivers) were collected for analysis. Microscopic analyses of both source and artifact samples confirmed their similarity and

showed the existence of at least three textural types as follows:

Type 1. This is a light blue-green to olive-green, fine-grained, massive rock that is colorless under ordinary illumination but shows a *fine-grained, bladed* texture under polarized light. Constituent minerals are in the form of variously oriented, very small blades with extremely low, slightly anomalous birefringence colors (dark to faint blue) but also containing blades with first-order yellow birefringence colors (fig. 1a, b).

Type 2. These examples are a light blue-green to olive-green *laminated* rock; the laminations are extremely fine and barely visible to the naked eye. Some samples are banded on a larger scale, the banding defined by different shades of green. Under

Fig. 2. Photomicrographs of Cypriot picrolites, host rock, and veins of picrolite in serpentinized harzburgite.
 a. Picrolite pebble from the Kouris River showing *fine-grained matte texture*.
 b. Picrolite pebble from the Aceramic site of Kholetria-Ortos showing a similar texture.
 c. Inclusion of serpentinized harzburgite in a picrolite vein showing *mesh texture*. Irregular black area at lower left
 is anhedral isotropic garnet (andratite).
 d. High-quality picrolite veins in the Troodos serpentinites.
All microphotographs were taken with crossed polars and the length of each photograph is equivalent to 4.5 mm.

ordinary light the material appears colorless but polarized light reveals extremely thin, wavy laminae with birefringence colors ranging from first order white to dark gray. Even under high magnification individual mineral grains cannot be distinguished and the laminae consist of closely-packed, minute serpentine fibrils arranged at right angles to the lamination (fig. 1c). In some samples the laminae are disturbed by slippage during growth, so that the lamination is deformed and the fibrils are replaced by minute blades that subparallel the lamination (fig. 1d).

Type 3. The third texture is developed in samples that are megascopically identical with Type 1, but here the material has an extremely *fine-grained matte* appearance, which under polarized light

yields colors that vary from almost completely black to first-order gray and white. Individual mineral grains cannot be distinguished even under the highest magnification but there are broad bands or sharp laminae where such grains are similarly oriented, thus giving optical continuity. The orientation, however, differs from band to band or in different lamellae, which then extinguish at different angles (fig. 2a, b).

In many instances samples appear mottled when they contain inclusions of the host serpentinite, which is typically much darker, has a *mesh texture*, and may enclose anhedral garnet grains (fig. 2c).

The petrographic analysis shows the material to consist essentially of serpentine group minerals, but identification of the individual serpentine poly-

TABLE 1. Major Element Analyses of Picrolite and Talc

Element	1	2	3	4	5	6	7
SiO_2	40.90	39.25	39.98	43.62	42.02	38.11	62.61
Al_2O_3	1.41	4.51	2.65	0.69	0.14	4.41	tr*
Fe_2O_3	1.68	2.79	2.63	0.82	1.26	2.79	—
FeO	2.88	2.12	2.11	0.60	0.12	0.21	2.46
MnO	0.07	0.05	0.05	0.07	0.03	0.03	0.01
MgO	38.90	37.30	37.30	41.48	42.07	39.05	30.22
CaO	0.30	0.20	1.10	tr	tr	1.09	—
Na_2O	0.15	tr	0.25	tr	tr	tr	—
K_2O	tr	tr	tr	tr	tr	tr	—
TiO_2	0.10	0.10	0.10	0.01	0.01	0.08	—
P_2O_5	tr	tr	tr	0.10	tr	0.01	—
CO_2	0.12	0.10	0.10	0.04	0.25	0.99	—
H_2O+	13.26	12.86	13.06	12.29	12.95	12.54	4.72
H_2O-	0.62	0.70	0.72	0.07	0.89	0.47	—
Total	100.39	99.98	100.05	99.79	99.74	99.78	100.02

*tr trace

1, 2, 3 Picrolites from Cyprus (Pantazis 1980)

4, 5, 6 Picrolites from Vermont (Chidester, Albee, and Cady 1978)

7 Talc (Deer, Howie, and Zussman 1966)

morphs at best can be ambiguous because they are extremely small. What it has shown however, beyond reasonable doubt, is the absence of talc as a major constituent phase, which would be the case had the material been steatite. Use of the different textures as source discriminants has no validity since all of the textures are found in each of the probable source areas and even in individual samples.

GEOCHEMISTRY

The chemical composition of both lithic artifacts and probable source rocks has been used both for characterization of the materials and for finger-printing in sourcing studies (Elliott, Xenophontos, and Malpas 1986: 80–96; Xenophontos, Elliott, and Malpas 1988: 169–83; Williams-Thorpe 1988: 253–305). The major elements of Cypriot picrolites are presented in Table 1, together with those of picrolites from Vermont; talc, the major constituent of steatite, is included for comparison.

Both the Cypriot and the Vermont picrolites are characterized by rather low SiO_2 contents (38.11–43.62 wt.%), low Al_2O_3 (0.14–4.51 wt.%) and high MgO (37.30–42.07 wt.%), values that reflect the composition of the parent ultramafic rock and that

of the resulting serpentine minerals, which have the general formula $Mg_2 [Si_2O_5] (OH)_4$. In contrast, talc—and therefore steatite—although derived by the alteration of similar ultramafic rocks, has higher SiO_2 in its formula, $Mg_6 Si_8O_{20} (OH)_4$, than the serpentine minerals, which is reflected in its major element composition with SiO_2 at 62.61 wt.%.

The chemistry of the major elements considerably strengthens the petrographic findings; and taken together, they inevitably lead to the conclusion that the material is not steatite but picrolite.

Neutron activation analysis (NAA) is being carried out on 40 samples from all the possible source areas shown in fig. 3. and on ten artifacts from fourth and third millennium B.C. sites. Final results are not yet available, but the preliminary, uncorrected data from the source samples indicate uniformly low Sc values for picrolites collected from the Troodos area and the Kouris river. Picrolites from all other possible source areas have consistently higher Sc content. It appears that this element may yet prove to be a good discriminant.

X-RAY DIFFRACTION

X-ray diffraction analysis determines the mineral species in a rock, especially when these are ex-

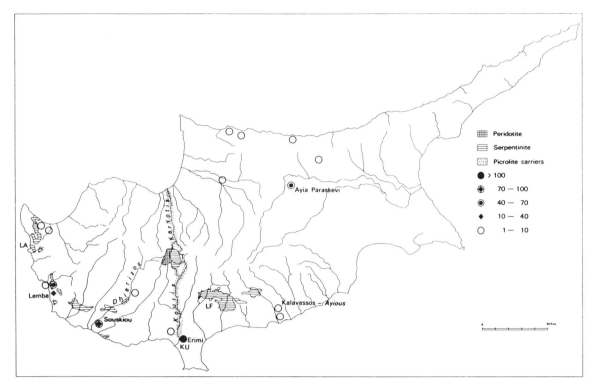

Fig. 3. Picrolite sources and artifact distribution from fourth and third millennium B.C. sites. KU=Kouris river, LF=Limassol forest, T=Troodos, LA=Lara.

tremely small—as with the material under study in this article—and cannot adequately be specified with the petrographic microscope. Since picrolite is made up of one or more of the serpentine polymorphs, it may be assumed that x-ray diffraction would adequately characterize the material and if differences existed in its mineral composition between the various possible sources, that information could be used to trace the artifact source(s). That supposition seemed especially attractive after information from Swiny (personal communication, 1981) that x-ray diffraction analysis had shown picrolites to consist of the serpentine polymorph antigorite; Swiny's data were at variance with the findings of Allen (1975).

Ten artifact samples (Kissonerga-Mosphilia, KM 535; Kissonerga-Mylouthkia, KMyl. 44; Lemba-Lakkous, LL 468, LL 368, LL 1051; Erimi, 101/33, 662; Vasilia-Alonia, CS 1525; Sotira, 257, and Miliou-Rodhaeos, CS 2467), were analyzed at the department of geology, University of Edinburgh by A. H. F. Robertson. Fourteen other examples (Kholetria-Ortos, KO 1, KO 2, KO 3, KO 4, KO 5;

Kouris river, KU 1, KU 2, KU 3; Troodos, T 2, T 17; Limassol forest, LF 1; Lara, LA 9; Mavro-kolymbos, M 6, and Ayia Varvara, AV 4), were analyzed by the author at the department of geology, Memorial University of Newfoundland, St John's.

The techniques used in both laboratories were very similar. They consisted of first grinding part of the sample to a fine powder, which was then slurried onto a glass slide with acetone. When the acetone had evaporated, the powdered slides were placed in standard x-ray units employing $CuK\alpha$ radiation. Scan rates of $2°$ of 2θ per minute and a counting rate of 400 cps generated satisfactory patterns. Different methods were used at the two laboratories to determine the serpentine polymorph(s). In Edinburgh, the diffraction information from each sample was fed into an on-line computer, which then scanned some 2750 mineral patterns on file for the best fit. At St John's, the polymorph(s) were determined from the diffraction patterns using criteria suggested by Wenner (1970) and by comparison with standard patterns

of relatively pure antigorite, lizardite, and chryso-
tile. Antigorite can be distinguished from lizardite
and chrysotile by the following:

- the absence of an asymmetric peak at $2\theta(Cu)=$
 $19.2°–19.4°$
- a major peak at $2\theta=35.5°$
- a moderate to strong peak at $2\theta=59.0°–59.1°$ and
 no peak beyond that.

In contrast, lizardite and chrysotile patterns have
the following:

- an asymmetric, moderate peak at $2\theta=19.2°–19.4°$
- a major peak at $2\theta=35.9°–36.0°$
- a moderate peak at $2\theta=60.2°$ and a smaller peak
 in the region of $61.7°$ for lizardite. Other distin-
 guishing peaks are at $2\theta=42.07°$ (lizardite) and
 $2\theta=43.16°$ for chrysotile.

All the artifacts and all the source rock samples
have a moderate to strong but undoubtedly asym-
metric peak in the 2θ region of $19.2°–19.6°$, indi-
cating that antigorite is either completely absent or
present in such small quantities that it does not
register on the patterns. The other peaks indicate
lizardite to be the main mineral phase, with chryso-
tile a minor constituent. Calcite and garnet (andra-
dite) are present in some of the samples.

Representative patterns from artifacts and pos-
sible source rocks are given in figs. 4–6; fig. 6 also
shows the peak patterns for various lizardites. Also
shown in fig. 5 (lower) is an x-ray diffraction pat-
tern from a typical Egyptian steatite. It differs mark-
edly from the Cypriot picrolites. While it provides
a satisfactory mineralogical characterization of the
material, the x-ray diffraction results cannot be
used to discriminate among the various sources
because they lack any significant and consistent
differences. Field and geological observations were
therefore used in the current study to find the most
probable source(s) of the material.

GEOLOGICAL OBSERVATIONS

Picrolite occurs in veins within serpentinized
harzburgite, the major occurrences of which are
shown in fig. 3. It is a product of the serpentiniza-
tion process and is formed during the late stages of
that process. Serpentinization is essentially a hydra-
tion process whereby hydrothermal fluids with a
temperature of up to 500° C invade fractured and
jointed harzburgite (olivine + orthopyroxene rock)
and transform it into a serpentinite. The serpentine
minerals lizardite and chrysotile are stable up to
200–300° C while antigorite is a higher temperature

phase, stable up to 500° C. In the Troodos area (fig.
3) some 200 km^2 of serpentinite is exposed east of
Mt. Olympus close to and north of the Amiandos
mine. The rock appears to have been serpentinized
in situ, possibly after its emplacement with little
postalteration penetrative deformation. Any subse-
quent deformation was confined to discrete faults
along which variably-sized blocks were rotated
(Allen 1975). Joints and fractures in those blocks
were filled by chrysotile (asbestos) and picrolite
and remained essentially intact after rotation. Pic-
rolite veins, varying in thickness from a few milli-
meters to three or four centimeters, are ubiquitous
(fig. 2d) and may extend for several meters. Colors
vary from light blue-green to dark olive-green. The
action of water and wedging by ice dislodge ser-
pentinite boulders, which then break open releasing
angular slabs of picrolite that are characteristic
among the slope talus material.

Serpentinite outcrops in the Paphos and Limas-
sol districts, however, are penetratively deformed
and sheared in such a way that no usable vein
material was produced. Although both picrolite
and chrysotile (asbestos) veins are present, these
are rarely more than a few millimeters thick (fig. 7a)
and almost certainly are not the material from
which most of the excavated artifacts were made.
If any of that material were ever used, it may have
been a chance find rather than quarried.

FIELD OBSERVATIONS

Surface finds at Kholetria-Ortos and at Dhiarizos-
Ayios Savvas in the Paphos district provided some
very important clues as to the raw material used on
site for the manufacture of bowls and decorative
artifacts. Unworked stone is in the form of well-
rounded pebbles (fig. 7b), some over ten centime-
ters in diameter and up to three centimeters thick.
Picrolite veins of that quality and size are found in
the Troodos outcrops around the Amiandos mine,
but the geometry of the "nuggets" suggests that
collection was not from the outcrop itself but from
downstream, after pieces had been transported by
water and rounded in the process. River transport
provides an efficient mechanism for producing
rounded pebbles and for sorting out good quality
picrolite from extremely thin or very closely jointed
pieces. The latter do not survive the wear and tear
of a river in flood and break down extremely small
and unsuitable for use. However, the rivers provide
an efficient mechanism for natural dispersion,

Fig. 4. Representative x-ray diffraction patterns of artifacts and of raw picrolites. Top, CS 1525=Vasilia-Alonia, LA 9=Lara; middle, LL 105, Lemba-Lakkous, T 17=Troodos; bottom, KU 2=Kouris river, 662=Erimi.

Fig. 5. Picrolite x-ray diffraction patterns from three possible source areas, a pebble from the Aceramic Neolithic site of Kholetria-Ortos, and an Egyptian steatite. Top, KO 4=Kholetria-*Ortos*, LA 9=Lara; middle, KU 1=Kouris river, T 2=Troodos; bottom, LF 1=Limassol forest, 388= Egyptian steatite.

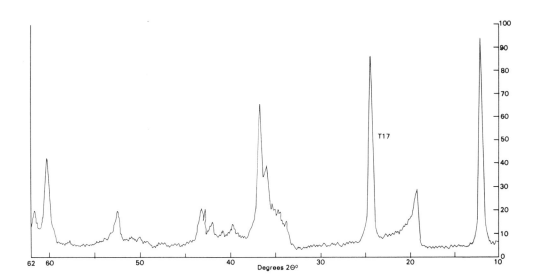

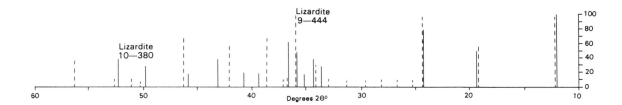

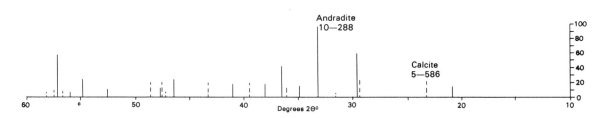

Fig. 6. Relatively pure lizardite, andradite, and calcite peak patterns used in the mineralogical identification of Cypriot picrolites. Top, T 17=picrolite from Troodos; middle, 10-380, 9-444=lizardites; bottom, 10-288=andradite and 5-586 =calcite.

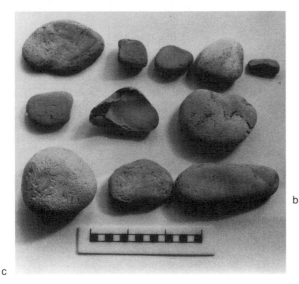

Fig. 7. Picrolite from possible source areas and from the aceramic Neolithic site of Kholetria-*Ortos*.

 a. Veins of picrolite in serpentinized harzburgite at Lara. Note poor quality and thinness of veins characteristic of all non-Troodos picrolites.

 b. Unworked, waterworn, rounded picrolite pebble found on the surface at Kholetria-*Ortos*.

 c. Pebbles of high quality picrolite collected from the Kouris river-bed near Erimi. One was broken purposely to show the characteristic conchoidal fracture.

 d. Pebbles of good quality picrolite collected from the lower reaches of the Karyotis River.

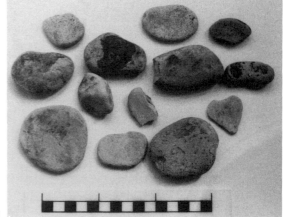

which made the raw material more readily available to the Chalcolithic inhabitants of the island.

A careful search was made of all the rivers that drain the Troodos Massif and of those that pass through the main serpentinite outcrops elsewhere on the island. Only the Kouris and Karyotis rivers (fig. 3) carried picrolite pebbles. A few minutes in the Kouris River, just before it enters the sea near Erimi, is sufficient to provide a bagful of excellent-quality pebbles up to 14 centimeters in diameter and up to 3.5 centimeters thick (fig. 7c). The lower reaches of the Karyotis river are equally productive, although the pebbles are slightly smaller (fig. 7d). Light blue-green colors predominate in both river beds but olive-green picrolite is also found.

Figure 3 shows the number of picrolite artefacts from excavated fourth and third millennium B.C. sites and survey finds from other sites of similar

age. The highest concentration is at Erimi, followed by those at Souskiou and Kissonerga-Mosphilia in the west and at Ayia Paraskevi in the north. Even discounting cemetery finds, the concentration in the south and west of the island is significant. Vagnetti (1974: 26) was not far wrong when she wrote, "The pattern of distribution of the steatite figurines might be linked to the source of the raw material which is located in the area between Paphos and Erimi."

A second concentration, centered in the north around the lower reaches of the Karyotis river, is predicted by this study but could not be confirmed because there are no excavated sites of the appropriate period and the results of the only survey done in the area have not been published.

CONCLUSIONS

Petrographic, major-element geochemical, and x-ray diffraction analyses confirmed that the light blue-green to olive-green stone, from which the Chalcolithic figurines, pendants, beads, and other decorative objects were manufactured, was picrolite, a material composed essentially of the mineral lizardite with chrysotile as a second component. None of the three types of analyses could pinpoint the source from which the Chalcolithic inhabitants obtained their supplies.

Rounded pebbles of picrolite found at an Aceramic Neolithic site and at a Chalcolithic site point to a river source with pebbles of appropriate size, color and quality. Geological field studies show the only possible sources to be the Kouris and Karyotis rivers, both of which drain the Troodos serpentinite outcrops that contain abundant picrolite veins of the required quality. From the lower reaches of those two streams men traded the raw material to all other parts of the island.

Other serpentinite outcrops carry picrolite veins that are very thin, irregular, fractured, and generally unsuitable for manufacture. Thicker veins, up to 1.5 cm, are extremely rare and their exploitation requires considerable excavation beyond the technology available then.

ACKNOWLEDGMENTS

Many thanks are due to E. J. Peltenburg, who made sure that the samples did not go astray in their travels around Scotland and that they reached the right persons at approximately the right time. V. Karageorghis allowed me to sample artifacts in the Cyprus Museum when he was director of the Department of Antiquities. A. H. F. Robertson, department of geology, Edinburgh University, carried out some of the x-ray diffraction analyses on very short notice. Special thanks are also extended to J. Malpas and the department of earth sciences at Memorial University, who allowed me the free use of their laboratories.

BIBLIOGRAPHY

Allen, C. R.
1975 *The Petrology of a Portion of the Troodos Plutonic Complex, Cyprus.* Unpublished Ph.D. dissertation, University of Cambridge.
Chidester, A.; Albee, A.; and Cady, W.
1978 *Petrology, Structure and Genesis of the Asbestos-bearing Ultramafic Rocks of the Belvidere Area in Vermont.* Professional Paper No. 1016. U.S. Geological Survey.
Crouwel, J.
1978 Cypriot Chalcolithic Figurines in Amsterdam. *Report of the Department of Antiquities of Cyprus*: 31–38.
Deer, W.; Howie, R.; and Zussman, J.
1966 *An Introduction to the Rock Forming Minerals.* London: Longmans.

Dikaios, P.
1962 The Stone Age in Cyprus. Pp. 1–204 in *Swedish Cyprus Expedition* IV.1A. Lund: Swedish Cyprus Expedition.
Elliott, C.; Xenophontos, C.; and Malpas, J. G.
1986 Petrographic and Mineral Analyses Used in Tracing the Provenance of Late Bronze Age and Roman Basalt Artifacts from Cyprus. *Report of the Department of Antiquities of Cyprus*: 80–96.
Pantazis, Th.
1980 Appendix III—Steatite. Pp. 68–70 in Figurines and Minor Objects from a Chalcolithic Cemetery at Souskiou-Vathyrkakas, by L. Vagnetti. *Studi Micenei ed Egeo-Anatolici* 21: 17–72.

Peltenburg, E. J.
 1981 Early Copperwork in Cyprus and the Exploi-
 tation of Picrolite: Evidence from the Lemba
 Archaeological Project. Pp. 41–61 in *Early
 Metallurgy in Cyprus, 4000–500 B.C.*, eds. J. D.
 Muhly, R. Maddin, and V. Karageorghis.
 Larnaca: Pierides Foundation.
Vagnetti, L.
 1974 Preliminary Remarks on Cypriote Chalco-
 lithic Figurines. *Report of the Department of
 Antiquities of Cyprus*: 24–34.
 1975 Some Unpublished Chalcolithic Figurines.
 *Report of the Department of Antiquities of
 Cyprus*: 1–4.
Wenner, D. B.
 1970 *Hydrogen and Oxygen Isotopic Studies of
 Serpentinization of Ultramafic Rocks.* Unpub-
 lished Ph.D. dissertation, California Institute
 of Technology.
Williams-Thorpe, O.
 1988 Provenancing and Archaeology of Roman

Millstones from the Mediterranean Area.
 Journal of Archaeological Science 15: 253–
 305.
Wilson, R. A. M.
 1959 *The Geology of the Xeros-Troodos Area.*
 Memoir No. 1, Geological Survey Depart-
 ment, Nicosia, Cyprus.
Xenophontos, C.
 1981 Steatite vs. Picrolite. P. 59 in Early Copper-
 work in Cyprus and the Exploitation of Picro-
 lite: Evidence from the Lemba Archaeological
 Project, by E. J. Peltenburg. Pp. 41–62 in
 Early Metallurgy in Cyprus, 4000–500 B.C.,
 eds. J. D. Muhly, R. Maddin, and V. Kara-
 georghis. Larnaca: Pierides Foundation.
Xenophontos, C.; Elliott, C.; and Malpas, J. G.
 1988 Major and Trace-Element Geochemistry Used
 in Tracing the Provenance of Late Bronze
 Age and Roman Basalt Artefacts from Cy-
 prus. *Levant* 20: 169–83.

Stone Sculpture in Chalcolithic Cyprus

LUCIA VAGNETTI

Instituto per gli Studi Micenei ed Egeo Anatolici
Via Giano della Bella 18
00162 Rome, Italy

Stone sculpture in prehistoric Cyprus has a long tradition that starts in the Aceramic Neolithic period. One can easily follow the development of the figurative tradition from Neolithic to Chalcolithic, when the use of picrolite, an attractive blue, soft stone native to southwestern Cyprus, becomes widespread and produces figurines of high craftmanship and style. There are also connections with the figurative tradition of neighboring areas, such as the Levant and Anatolia; similarities with Cycladic figurines are more superficial. This article reexamines the basic features of Chalcolithic stone sculpture in the light of recent finds from regular excavations. A general comparison of some features of stone and terracotta figurines is also attempted.

INTRODUCTION

Knowledge of stone sculpture in Chalcolithic Cyprus has evolved rapidly in the last 15 years thanks to a number of factors. A large amount of new material has come from regular excavations, some of which have received detailed and prompt publication (Peltenburg 1977: 140–43; 1985: 279–83; 1988: 289–99; Peltenburg *et al.* 1988: 43–52; South 1985: 65–79). There have also been recent studies of material known for a long time but which previously had not received appropriate attention (Bolger 1988: 103–32). Moreover, the detailed picture of the Chalcolithic period in Cyprus that is emerging from intensive field research, especially in the Ktima Lowlands and in the Vasilikos valley, is of great importance in placing the stone and terracotta sculptures of the period in their appropriate setting (Peltenburg 1977; 1979; 1982a; 1988; Peltenburg *et al.* 1983: 9–55; 1987: 1–18; Todd 1985; Swiny 1985; see also articles in this issue by Peltenburg and Todd).

When in the early 1970s, at the suggestion of V. Karageorghis, I first approached the study of picrolite figurines, very few elements were known apart from the large group of figurines and pendants from Souskiou cemetery, preserved in the Cyprus Museum and in private collections. In fact,

before studying and publishing in detail that important group, I felt it necessary to consider all the known material and to try to order it taxonomically, establishing typological and stylistic groups (Vagnetti 1974: 23–33; 1975: 1–4; 1980: 17–72; Morris 1985: 122–32). However, the limited information about contexts and chronology—due to clandestine excavation—and the consequent difficulty in understanding the meaning of the objects beyond their appearance, have affected the entire study.

The Symposium on Chalcolithic Cyprus provided an opportunity to reconsider the whole problem and to reevaluate the progress engendered by attempts to establish a wider view on the corpus of stone figures and figurines available today. In this article, I shall not discuss the function and meaning of the figurines, as those topics are treated elsewhere (e.g., Karageorghis, this issue, pp. 163–66).

NEOLITHIC PERIOD

Stone sculpture had a long tradition in prehistoric Cyprus. From the appearance of the early inhabitants on the island in at least the sixth millennium B.C.—the Aceramic culture of Khirokitia type, which seems to be the earliest evidence of human occupation and activity—there is a high degree of ability in stone working. Artifacts include

139

both human and animal figurines and utilitarian objects, especially andesite bowls that occasionally were decorated in relief.

Excavations in the main settlement of the period—Khirokitia, in the southern part of the island—have produced a number of figurines of varying degrees of complexity in workmanship, which Dikaios (1953: 296–301, pls. 95–97, 143, 144) divided into four main types. Recent research on the site has added a few more objects to the list of figurines and decorated bowls, but those have not substantially changed the picture (LeBrun 1984; Karageorghis 1985: 924, figs. 73, 74; 1988: 795–96).

In other sites representing the same culture, such as Petra tou Limniti, figurines have been found in limited number. No figurines, however, come from the site of Cape Andreas on the very tip of the Carpass peninsula (Gjerstad 1934: 1–12, pl. 8; LeBrun 1981).

The figural world of the Cypriots of the Aceramic Neolithic is rich and varied. A unique head of unbaked clay is highly naturalistic (Dikaios 1953: 299–300, pls. 98, 144:1063); in other examples the human figure is highly modified, varying from the schematized to the abstract. Among the most remarkable achievements are some heads in which very few facial features are indicated but which have a very powerful effect in expression (Dikaios 1953: 298, pls. 96, 144:1, 1068; Karageorghis 1989: 790, fig. 4a, b). In the case of a complete figure, even if the head and body are reduced to two different geometric masses, the figurine truly achieves a monumental appearance (Dikaios 1953: 297, pls. 95, 143:967). One cannot exclude the possibility that this figurine, which Dikaios considered unfinished, was originally intended by the sculptor to be completed as a bowl, although the thickness of the body would not allow a very substantial cavity. We do know of bowls with human shapes from Khirokitia and from Kholetria Ortos, a recently discovered Aceramic site in the Paphos region (Dikaios 1953: 298, pls. 98, 143: 929a, 1140; Fox 1988: 31, fig. 4:7). A human figure with upraised arms appears in relief on a bowl from the recent excavations at Khirokitia and the rich relief decoration of another bowl from the same site includes a cross composed of little bosses that could be interpreted as a very abstract anthropomorphic representation, especially in light of the great popularity of the cruciform figure in later iconography (Dikaios 1953: 248, pls. 56, 122:813 LeBrun 1989: fig. 11, 4;).

The preferred stones of that period are andesite and a gray, sometimes greenish, diabase. Also in that period, an interest in colored stones began to emerge.[1] Occasionally the attractive green-blue picrolite, which became very important in the Chalcolithic period, was used with carnelian for necklace beads and small ornamental objects such as a little fish from Khirokitia (Dikaios 1953: 302–4, fig. 107, pl. 68a:1485, 1486).

In the following period—the Ceramic Neolithic—there was a substantial decrease in production of stone sculpture, apparently without a compensating production of terracotta pieces. The main evidence comes from Sotira Teppes in the south and from Ayios Epiktetos Vrysi in the north. In both cases figurines are primarily highly stylized phallic representations (Dikaios 1961: 201–2, pl. 109:106; Peltenburg 1975: 28–30, pl. 5, lower; Karageorghis, Peltenburg, and Flourenzos 1990: no. 10).

CHALCOLITHIC PERIOD

In the Chalcolithic period, according to recent evidence, andesite and diabase, the two preferred stones of the Aceramic Neolithic, were still used, but picrolite became extremely prized for both small ornamental objects and figurines.

Picrolite, also referred to in other studies as steatite or antigorite, is an attractive, green-blue, soft stone. It is native to the Troodos mountains and is easily found along some river beds coming down from the Troodos, especially along the Dhiarrizos and the Kouris (Xenophontos 1982; see also Xenophontos, this issue, pp. 127–38). Although picrolite was a local Cypriot resource, it was not available everywhere on the island. It has been argued that settlements such as Erimi or Souskiou, where this important stone was readily available, were in fact particularly wealthy in the Chalcolithic period (Peltenburg 1982c: 41–58; Bolger 1987: 69–81).

Limestone and calcarenites were also often used, especially for the larger figurines. Those stones are more ubiquitous and were used primarily at sites where picrolite was not native (Peltenburg 1985: 281). Some early examples of picrolite figurines appear from the beginning of the Chalcolithic period, at Kissonerga-Mylouthkia (Peltenburg 1982b: 12–14), but they reached their highest popularity and artistic accomplishment in the second phase of the Chalcolithic, also called the Erimi period.

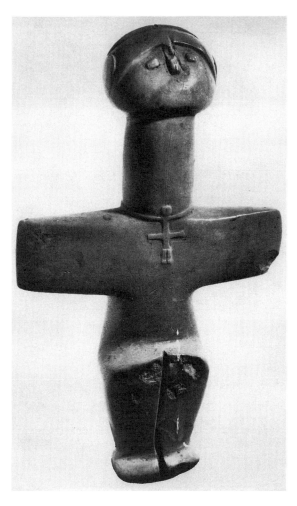

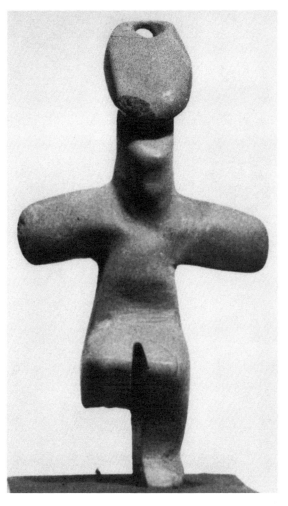

Fig. 1. Picrolite cruciform figurine from Yialia. Cyprus Museum 1934/III-2/2 (Photo Cyprus Museum).

Fig. 2. Picrolite cruciform pendant of the Kythrea variety from Kythrea. Cyprus Museum W 289 (Photo Cyprus Museum).

The most remarkable and numerous examples are still those found at Souskiou-Vathyrkakas, where they were used as tomb offerings (Vagnetti 1980; Christou 1989: 82–94; see also, Peltenburg this issue pp. 107–26 [Lemba]). The objects vary from free-standing figures of various types and sizes to tiny pendants used in necklaces that reproduce exactly the form of the larger figures. On the other hand, the use of small pendants shaped like human figures is well known since the discovery of the famous Yialia figure, which is still the most impressive example of this group, beautifully carved of green homogeneous picrolite with a shining surface (fig. 1). Its shape with tilted head, long

neck, outstretched arms, and drawn up knees summarizes all the main characteristics of the class. A miniature figurine with the same characteristics is tied around the neck of the figure (Dikaios: 1934: 16, pl. 6:1).[2]

The size of the picrolite figurines rarely reaches 15 cm, but in most cases they are no higher than 5 to 6 cm. Within the general cruciform shape are several variations. In the so-called Kythrea variety—named after the site where the first example was found—there is a complete absence of detail carved in relief or incised, including facial features (fig. 2). The figurines have an oval head set obliquely on the neck, sometime perforated at the back. The

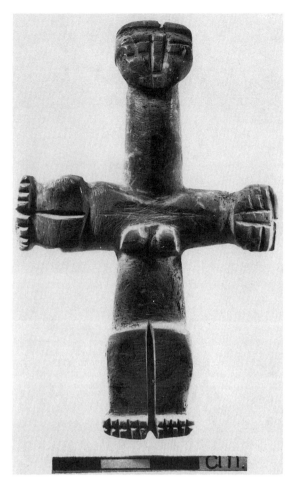

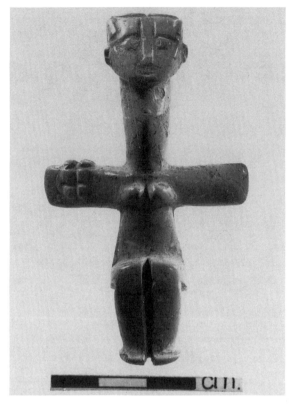

Fig. 4. Picrolite cruciform figurine from Souskiou Cyprus Museum 1981/V-4/10. = Karageorghis, Peltenburg, and Flourenzos 1990: no. 33.

Fig. 3. Picrolite cruciform figurine of the Salamiou variety from Souskiou. Before 1974 this was in the Hadjiprodromou collection, Famagusta (Photo Cyprus Museum).

long neck displays a prominent Adam's apple, and the legs are usually separated (Vagnetti 1974: 28–29, pl. 5:4, 5).

The so-called Salamiou variety is characterized by the intersection of two figurines (fig. 3). The outstretched arms are replaced by a second figurine, usually identical to the vertical one, with the head and feet in place of the hands (Vagnetti 1974: 29, pl. 6:2; see also Karageorghis, Peltenburg, and Flourenzos 1990: no. 30).

In shape and form the cruciform figurines range from stylized to abstract, displaying those characteristics in varying degrees (see Morris 1985: 116–17). This variation from figure to figure can be seen also in the ways in which the facial features are rendered. They can be in relief or incised or, more rarely, as a combination of the two techniques.

The Yialia figurine (above) is one of the best examples of the relief technique (fig. 1). The hair is represented in relief by two curves, one on either side of the forehead; the eyebrows make a continuous relief line with the nose, and the eyes are two small square bosses. The positioning and rendering of the facial features are remarkably similar to those of an unstratified head from Khirokitia which represents one of the examples of the development from Neolithic to Chalcolithic (Dikaios 1953: 298, pls. 96, 143:1404).

On a figurine from Souskiou-Vathyrkakas the facial features are rendered partially in relief, but the deeply incised lines around the big almond eyes result in a stronger and quite effective contrast of light and shadow (fig. 4; Vagnetti 1980: pl. 1:2; see also Karageorghis, Peltenburg, and Flourenzos 1990: no. 33).

On other figurines the facial features are rendered completely by incision. On a large, double figurine from Vathyrkakas (figs. 3, 5a), the oval surface of

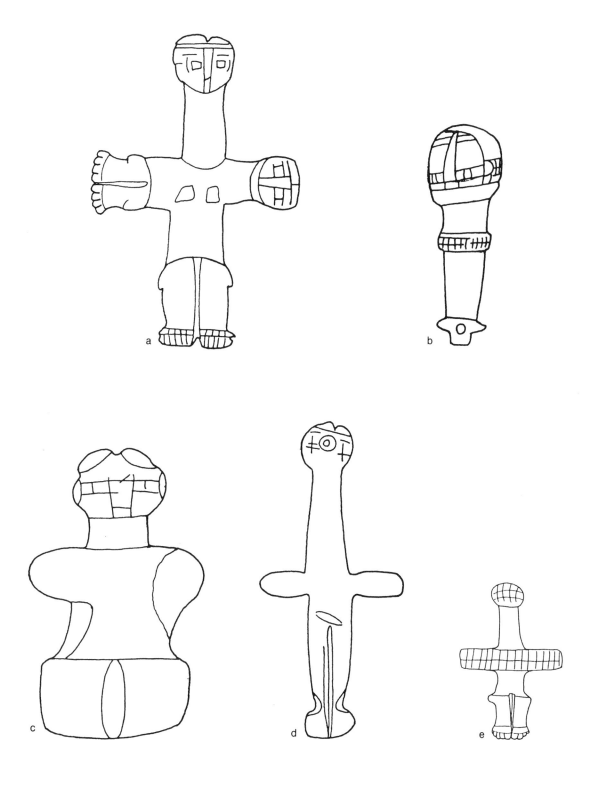

Fig. 5. Systems of representation of the facial features, from schematic to abstract, on picrolite figurines and pendants. **a.** = fig. 3; **b.** Pendant from Souskiou, before 1974 in the Hadjiprodromou Collection, Famagusta; **c.** Squatting figurine from Souskiou, before 1974 in the Hadjiprodromou Collection, Famagusta; **d.** Cruciform pendant from Souskiou, before 1974 in the Hadjiprodromou Collection, Famagusta; **e.** Cruciform figurine from Souskiou, before 1974 in the Hadji-prodromou Collection, Famagusta. (Figure slightly enlarged).

the horizontal figure's face is filled by two pairs of intersecting parallel incisions that, with the addition of smaller lines, define the long nose and the big, square eyes. A further incised line separates the hair from the forehead (Vagnetti 1980: pl. 4:10). A very similar disposition of lines, although with more detail, can be seen on a unique pendant from Souskiou-Vathyrkakas (fig. 5b). This strange object in a general way recalls a type of pendant very common at Erimi. Through the use of incised lines, however, it is transformed into an abstract human representation to be worn upside down (Vagnetti 1980: pl. 12:65).

The same pattern of representation can be observed in a picrolite figurine from Souskiou-Vathyrkakas, which does not belong to the cruciform type but can be described as squatting (fig. 5c; Vagnetti 1980: pl. 1:1). The facial features of this example, however, are much less accurate than those of the cruciform type, and perhaps could be considered a step toward the complete decomposition of their figural or representational value. The change may evolve eventually to examples with a few disorganized lines that are only reminiscent of the facial features (fig. 5d) or to others whose faces are entirely covered by lattice pattern (fig. 5e; Vagnetti 1980: pl. 3: 6, 7; see also Karageorghis, Peltenburg, and Flourenzos 1990: no. 36).

This consideration does not imply a chronological sequence from naturalistic to abstract. Although one can be seen as related to another, the different manners of representation seem to have been in use at the same time.

The cruciform figurines are the most characteristic among those of picrolite and are a striking artistic achievement of the Erimi culture. However, a picrolite figurine from Kissonerga-Mylouthkia, an early Chalcolithic site, does not conform to that scheme. Peltenburg (1982b: 12–14) suggests that it may indicate the evolution from Late Neolithic "cigar-shaped" figurines to the early steatite type at Mylouthkia and eventually to the characteristic cruciform type of Erimi (Peltenburg 1982b).

Peltenburg's convincing hypothesis seems to be corroborated by another recent find from Sotira Akrolies (Swiny and Swiny 1983: 56–59; see also Karageorghis, Peltenburg, and Flourenzos 1990: no. 11). The limestone figurine clearly represents a seated figure in an almost completely abstract way. However, it has several views and in each view takes a different representational value, becoming a representation of both male and female sexual

attributes (fig. 6a; Swiny and Swiny 1983: 56–69); Karageorghis, Peltenburg, and Flourenzos 1990: no. 11). In spite of its lack of context—it was a surface find—the two scholars suggested a date in the Chalcolithic period, stressing the similarity of the front view of the figurine with that of a normal cruciform figure without the arms. That date is now supported also by a second fragmentary figurine of the same type from Erimi, recently published (Bolger 1988: 103–22, fig. 34, pl. 18:342).

Karageorghis has rightly stressed the analogy of the Sotira figurine with Levantine Neolithic examples of the Yarmukian period. To the example from Sha'ar Ha-Golan (fig. 6b; Karageorghis 1986: 45–46) we now can add an example from Netir Hagedud (fig. 6c), whose analogy with the Cypriot examples is even more striking. Two small protuberances indicating breasts give the figure an even stronger bisexual meaning (Noy 1986: 63–67, 324, fig. 1).[3]

Other examples typologically intermediate between the Neolithic and the Chalcolithic types include two fragmentary figures recently found on the surface at Erimi. One of the figurines, unfortunately missing its head and arms, is of andesite, a favored stone of the Neolithic period (fig. 7). Its general outline, with little emphasis on the hips and pubic area, is reminiscent of Neolithic and Early Chalcolithic "cigar shape." The clear indication of breasts, however, seems a fully Chalcolithic characteristic (Vagnetti 1987: 19–21, pl. 5:1, 2; see also Karageorghis, Peltenburg, and Flourenzos 1990: no. 15).

The second figure is probably of diabase (fig. 8). It has more of a fiddle-shaped outline, which was known already in the Neolithic and developed in the Chalcolithic period (Vagnetti 1987: 19–21, pl. 5:3–5; Karageorghis, Peltenburg, and Flourenzos 1990: no. 14). A number of parallels exist among the figurines from Lemba. One of the figurines from the "hoard," or sanctuary, at Mosphilia also displays some common Chalcolithic characteristics such as the short stump arms and the wide hips with indication of the figurine's sex. The breasts are rendered in a different fashion (fig. 9; Peltenburg et al. 1988: pl. 5:3; Karageorghis, Peltenburg, and Flourenzos 1990: no. 29): on the figurine from Erimi they are simple pellets, but on the Mosphilia figure they are a bisected V in low relief. The bisected V is similar to the representation on the famous Lemba Lady (fig. 10) and to the large limestone figure now in the collection of the

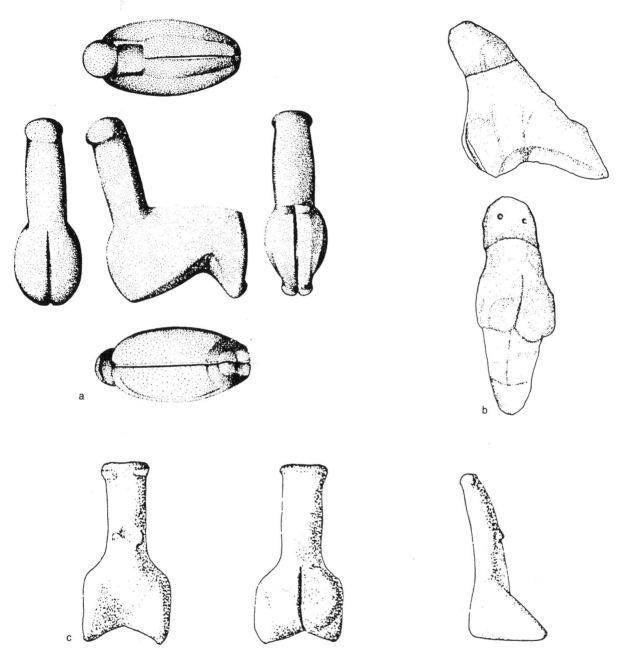

Fig. 6. a. Seated figure of limestone from Sotira Akrolies. Cyprus Museum 1981/VIII-19/1 = Karageorghis, Peltenburg, and Flourenzos 1990: no. 11 (after Swiny and Swiny 1983); **b.** Figurine from Shaᵓar Ha-Golan (after Karageorghis 1986); **c.** Figurine from Netir Hagedud (after Noy 1986). (not to scale)

Getty Museum (fig. 11; Karageorghis, Peltenburg, and Flourenzos 1990: nos. 12, 13).

These two figures show that the cruciform scheme typical of the picrolite examples is also adopted for larger figures in other stones. The Lemba Lady, with her extremely long neck and very large hips,

seems a synthesis of cruciform and squatting types, while the Malibu Lady is closer to the cruciform (see Peltenburg 1977; Getz-Preziosi 1984: 21–28).

There are several iconographic and stylistic points of contact between the stone and the terracotta sculptures. Goring (this issue, pp. 153–61)

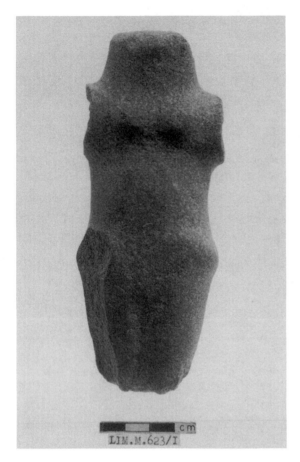

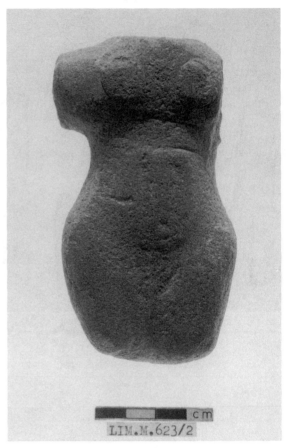

Fig. 7. Andesite figurine from Erimi. Limassol Museum LM 623/1 = Karageorghis, Peltenburg, and Flourenzos 1990: no. 15.

Fig. 8. Diabase figurine from Erimi. Limassol Museum LM 623/2 = Karageorghis, Peltenburg, and Flourenzos 1990: no. 14.

deals specifically with terracotta figurines, so they will not be discussed in detail here. However, features common to the two groups can be seen in the recently discovered figurine from Kissonerga-Mosphilia, which represents a woman giving birth. Her very long neck with tilted head is close to the familiar cruciform type. The facial features in relief are reminiscent of those on the Yialia figure; the arms, though not long, are outstretched; even the painted dot decoration set obliquely on the arms recalls the incised lattice pattern found on some picrolite figurines, perhaps alluding to a shawl. The long breasts divided by a groove are not dissimilar from the bisected V breasts of the Lemba Lady (Peltenburg 1988; Peltenburg *et al.* 1988).

It appears that the Cypriot artists of the Chalcolithic period shared a common figurative and decorative language which, even when it yields varying results according to the medium used, is usually easily detectable. We certainly do not know if the same craftsmen were able to work with various kinds and qualities of stone and terracotta, not to mention perishable materials such as wood. The techniques and equipment varied from one medium to another, and our ignorance of the arts and crafts production system in prehistoric times prevents us from speculating on this point. What seems certain however, is that the stone sculptor did not ignore the coroplast, and vice versa.

There is also some faint indication that occasionally the two techniques may have been combined. In fact the Pelathousa head (fig. 12), a white limestone piece about 7 cm high, seems to be an isolated and complete piece (Vagnetti 1975: 2, pl. 1:12). One

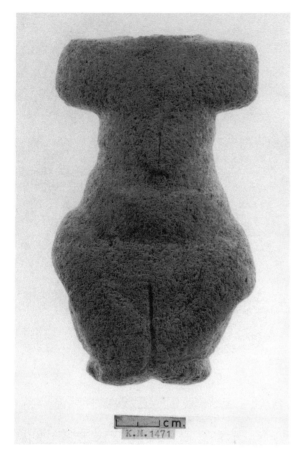

Fig. 9. Calcarenite figurine from Kissonerga = Karageorghis, Peltenburg, and Flourenzos 1990: no. 28.

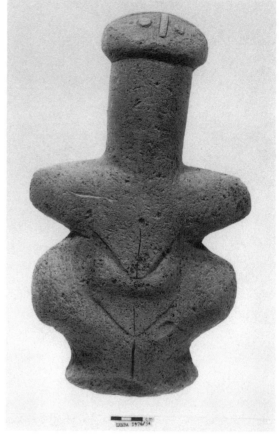

Fig. 10. Limestone figurine from Lemba = Karageorghis, Peltenburg, and Flourenzos 1990: no. 12.

can surmise that it might have been completed with a body of terracotta or perhaps unbaked clay, as known from examples from Neolithic Thessaly (Wace and Thompson 1912: 41, fig. 25).

The stone figurines of Chalcolithic Cyprus have several aspects that may be studied at a deeper level. One such aspect is the possible isolation of individual artists or workshops. Getz-Preziosi (1987) has developed a methodology for studying at a very sophisticated level the Cycladic marble sculpture. The corpus and quality of material from Cyprus probably do not allow a similar achievement. However, a first attribution of three figurines to the same workshop, is still possible.

The square head of a figurine in the Cyprus Museum (Karageorghis, Peltenburg, and Flourenzos 1990: no. 31), with big round eyes, long nose

extending down to the chin, and ears accurately shown in relief (fig. 13), is very similar to the head of a less precise figurine in the Menil collection (fig. 14), said to be from Souskiou (Karageorghis, Peltenburg, and Flourenzos 1990: no. 29). A third example, also from Souskiou, in the Severis collection (fig. 15), is also very similar (Vagnetti 1980: pl. 2:3).[4]

Some cultural and geographical connections can be made regarding the provenience of the Cypriot figurines. The main areas to be examined are Anatolia, the Levant, and the Aegean. Two picrolite figurines of unknown provenience can be connected to Anatolia (Vagnetti 1979). The schematic outline of those pieces—stalk head slightly enlarged at the top, outstretched arms, and sack-shaped body—have parallels with figurines known at Beycesultan

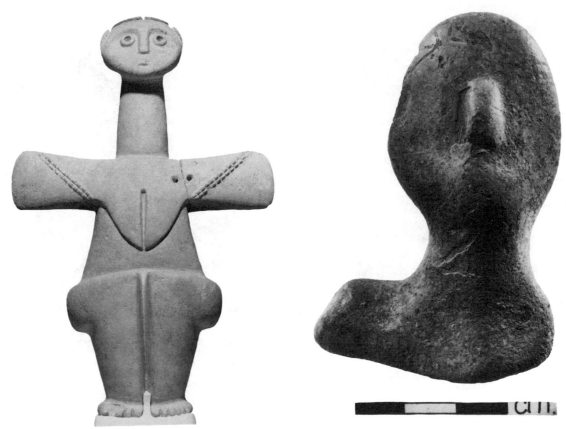

Fig. 11. Limestone figurine said to be from Souskiou. Malibu. J. Paul Getty Museum 83.AA.38. = Karageorghis, Peltenburg, and Flourenzos 1990: no. 13.

Fig. 12. Limestone head from Pelathousa. Before 1974 this was in the Hadjiprodromou Collection, Famagusta (Photo Cyprus Museum).

from EB I and II. Among recent finds from Mosphilia are other variations of the same scheme (Peltenburg 1988: pl. 5:7 [Goring's gingerbread type]).

The Levantine connections between the Sotira Akrolies figurine and examples of the Yarmukian culture (Karageorghis 1986: 45–46) have been discussed (above). The most discussed area of comparison is the Aegean: analogies with the Cycladic figurines have often attracted scholars' attention. The tilted up heads, long necks, the tendency toward schematization, and the limitation or absence of carved details create an apparent kinship between the two productions that is also in tune with modern taste. But the analogy cannot withstand deep analysis and does not seem to support any true connection between the Aegean and Cyprus. The only striking iconographic similarity is the representation of two figurines, one on top of the other, known in the Cyclades and in a Cypriot example in a private collection in Holland (Vagnetti

1974; 1980; Peltenburg 1977; Crouwel 1978: 35, pl. 4:11).

Other regions of the Aegean, such as Crete, offer even less potential for comparison. There is one exceptional figure, from the site of Pigadhia on the island of Karpathos; it is now preserved in the British Museum (Pryce 1928: 6–7, fig. 2; Melas 1985: 147–48, fig. 62a, b). At a height of 65 cm, this figure is really a "statue" rather than a figurine. It is of soft limestone and the only facial feature on its triangular head is the large, protruding nose. The outline of the body is very schematic, with stump arms and rounded hips. The back is flat. In contrast with this very schematized representation, the sexual characteristics are exaggerated. Two round bosses represent the breasts, and a triangle in relief, with a vertical incision, indicates the female genitalia. This emphasis is not so common in the Aegean, and in examining this piece one cannot ignore that the same emphasis is used on the Lemba

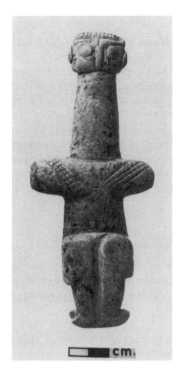 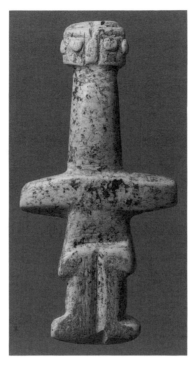 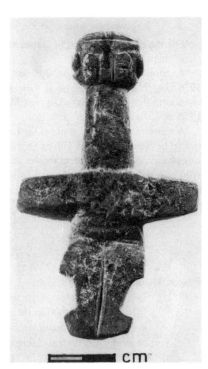

Fig. 13. (left) Picrolite cruciform figurine of unknown provenance. Cyprus Museum W290. = Karageorghis, Peltenburg, and Flourenzos 1990: no. 31.

Fig. 14. (right) Picrolite cruciform figurine said to be from Souskiou. Houston, The Menil Collection 74-51DJ = Karageorghis, Peltenburg, and Flourenzos 1990: no. 29.

Fig. 15. (center) Picrolite cruciform figurine said to be from Souskiou. Nicosia, Severis collection (Photo Cyprus Museum).

Lady, on which the triangular genitalia are repeated twice as a conventional way also to indicate the breasts. Also on the Lemba Lady, the arms are represented as stumps while other details, such as the head and the lower part of the body, are entirely different. However, the general outline of the Karpathos figure is not without parallels in Chalcolithic Cyprus, especially among the numerous figurines of the squatting type.[5]

Whatever the few occasional similarities with other areas may mean, the sculpture of Chalcolithic Cyprus has deep roots in the previous Neolithic tradition and remains an original achievement and an important invention. The ability of the Cypriot craftman, whose fantasy we know also from later periods, remains unrivaled in the eastern Mediterranean world in the fourth millennium B.C.

ACKNOWLEDGMENTS

I offer my warmest thanks to V. Karageorghis for his unfailing support during this and other research on the archaeology of Cyprus, to E. J. Peltenburg for the information he has supplied over the years about the progress of his excavations, to K. Hamma who most kindly revised my text and read it during the Conference in which, to my great disappointment, I was unable to take part in person. My absence, of course, prevented me from listening to colleagues' papers and to the following discussions, which would have certainly improved the quality of my final text. I also thank E. Macnamara for her invaluable assistance in the British Museum, where I was able to see the stone figure from Karpathos. I am also indebted to technicians of the Istituto per gli Studi Micenei ed Egeo-Anatolici for considerable help in preparing the slides (M. Petrarca) and for some of the drawings (A. Mancini).

NOTES

[1] For the characterization of stones see C. Elliot's article in this issue.

[2] A good color illustration appears in Karageorghis 1976 (fig. 25). The same use is now known also on a terracotta figure with painted decoration (see Peltenburg 1988, n. 1; fig. 3).

[3] A more eastern antecedent for the front view could be traced in Mesopotamia at Tell es-Sawwan, on anthropomorphic vessels made of alabaster (see el-Wailly and Abu es-Soof 1965: 17–32, pl. 28, fig. 68; a better illustration appears in *La Terra trai i due fiumi. Venti anni di*

archeologia italiana in Medio Oriente, April-May 1987: 295, upper figure; 352, no. 4.

[4] A unique figurine in blue mottled marble in a private collection could also be compared to the previous three for her facial features (see Getz-Preziosi 1984: 28, fig. 2a–c).

[5] A stone slab with a very coarse, human-shaped outline, placed under the dead in a tomb at Kissonerga-Mosphilia recalls the very simple outline of the Karpathos figure (see Karageorghis 1989: 821, fig. 103).

BIBLIOGRAPHY

Bolger, D.
1987 Is There a Western Cyprus? A Chalcolithic Viewpoint. Pp. 69–81 in *Western Cyprus: Connections. An Archaeological Symposium held at Brock University, March 21–22, 1986*, ed. D. W. Rupp. Studies in Mediterranean Archaeology 77. Göteborg: Åström.

1988 *Erimi-Pamboula. A Chalcolithic Settlement in Cyprus*. BAR International Series 443. Oxford: British Archaeological Reports.

Christou, D.
1989 The Chalcolithic Cemetery 1 at Souskiou-Vathyrkakas. Pp. 82–94 in *Early Society in Cyprus*, ed. E. J. Peltenburg. Edinburgh: Edinburgh University.

Crouwel, J.
1978 Cypriote Chalcolithic Figurines in Amsterdam. *Report of the Department of Antiquities of Cyprus* 35: 31–38.

Dikaios, P.
1934 Two Neolithic Steatite Idols. *Report of the Department of Antiquities, Cyprus* 16.

1953 *Khirokitia*. Oxford: Oxford University.

1961 *Sotira*. Philadelphia: University of Pennsylvania.

Fox, W. A.
1988 Kholetria-Ortos: A Khirokitia Culture Settlement in Paphos District. *Report of the Department of Antiquities of Cyprus*: 29–42.

Getz-Preziosi, P.
1984 An Early Cypriot Sculpture. *J. Paul Getty Museum Journal* 12: 21–28.

1987 *Sculptors of the Cyclades: Individual and Tradition in the Third Millennium B.C.* Ann Arbor: University of Michigan.

Gjerstad, E.
1934 Petra tou Limniti. Pp. 1–12 in *Swedish Cyprus Expedition*, vol. 1. *Finds and Results of the*

Excavations in Cyprus 1927–1931, by E. Gjerstad *et al.* Stockholm: Swedish Cyprus Expedition.

Karageorghis, V.
1976 *The Civilization of Prehistoric Cyprus.* Athens: Ekdotike Athenon.

1985 Chronique des fouilles et découvertes archéologique à Chypre en 1984. *Bulletin de Correspondence Hellénique* 109: 897–967.

1986 Kypriaka IX. *Report of the Department of Antiquities of Cyprus*: 45–54.

1988 Chronique des fouilles et découvertes archéologiques à Chypre en 1987. *Bulletin de Correspondence Hellénique* 112: 793–855.

1989 Chronique des fouilles et découvertes archéologiques à Chypre en 1988 *Bulletin de Correspondence Hellénique*, 113: 789–853.

Karageorghis, V.; Peltenburg, E. J.; and Flourenzos, P.
1990 *Cyprus Before the Bronze Age: Art of the Chalcolithic Period.* Malibu: J. Paul Getty Museum.

Le Brun, A.
1981 *Un site néolithique précéramique en Chypre: Cap Andreas-Kastros.* Recherche sur les civilisations, Memoire 5. Paris: Association pour la Diffusion de la Pensée Française.

1984 *Fouilles récentes à Khirokitia (Chypre): 1977–1981.* Recherche sur les civilisations, Memoire 41. Paris: Association pour la Diffusion de la Pensée Française.

1989 Le traitement des morts et les représentations des vivants à Khirokitia. Pp. 71–81 in *Early Society in Cyprus*, ed. E. J. Peltenburg. Edinburgh: Edinburgh University.

Melas, E. M.
1985 *The Islands of Karpathos, Saros and Kasos in the Neolithic and Bronze Age.* Studies in Mediterranean Archaeology 68. Göteborg: Åström.

Morris, D.
1985 *The Art of Ancient Cyprus.* Oxford: Phaidon.
Noy, T.
1986 Seated Clay Figurines from the Neolithic Period, Israel. Pp. 63–67 in *Archaeology and Fertility Cult in the Ancient Mediterranean.* Papers presented at the First International Conference on Archaeology of the Ancient Mediterranean, Malta September 1985, ed. A. Bonanno. Amsterdam: Grüner.
Peltenburg, E. J.
1975 Ayios Epiktetos Vrysi, Cyprus: Preliminary Results of the 1969–1973 Excavations of a Neolithic Coastal Settlement. *Proceedings of the Prehistoric Society* 41: 17–45.
1977 Chalcolithic Figurine from Lemba, Cyprus. *Antiquity* 51: 140–43.
1979 The Prehistory of West Cyprus: Ktima Lowlands Investigations 1976–1978. *Report of the Department of Antiquities of Cyprus*: 69–99.
1982a *Recent Developments in the Later Prehistory of Cyprus.* Studies in Mediterranean Archaeology Pocket-book 16. Göteborg: Åström.
1982b The Evolution of the Cypriot Cruciform Figurine. *Report of the Department of Antiquities of Cyprus*: 12–14.
1982c Early Copperwork in Cyprus and the Exploitation of Picrolite: Evidence from the Lemba Archaeological Project. Pp. 41–62 in *Early Metallurgy in Cyprus, 4000–500 B.C.*, eds. J. D. Muhly, R. Maddin, and V. Karagorghis. Larnaca: Pierides Foundation.
1985 *Lemba Archaeological Project, I, Excavations at Lemba Lakkous, 1976–1983.* Studies in Mediterranean Archaeology 70:1. Göteborg: Åström.
1988 A Cypriot Model for Prehistoric Ritual. *Antiquity* 62, 235: 289–93.
Peltenburg, E. J., and Project Members.
1983 The Prehistory of West Cyprus: Ktima Lowlands Investigations 1979–82. *Report of the Department of Antiquities of Cyprus*: 9–55.
1987 Excavations at Kissonerga-Mosphilia 1986. *Report of the Department of Antiquities of Cyprus*: 1–18.
Peltenburg, E. J.; Bolger, D.; Goring, E.; and Elliott, C.
1988 Kissonerga-Mosphilia 1987: Ritual Deposit, Unit 1015. *Report of the Department of Antiquities of Cyprus*: 43–52.
Pryce, F. N.
1928 *Catalogue of Sculpture in the Department of Greek and Roman Antiquities of the British Museum, I, 1. Prehellenic and Early Greek.* London: British Museum.
South, A. K.
1985 Figurines and Other Objects from Kalavasos-Ayious. *Levant* 17: 65–79.
Swiny, S.
1985 The Cyprus American Archaeological Research Institute Excavations at Sotira Kaminoudhia and the Origins of the Philia Culture. Pp. 13–26 in *Acts of the Second International Conference of Cypriote Studies*, eds. Th. Papadopoulos and S. Hatsistelli. Nicosia: Leventis Foundation.
Swiny, H. W., and Swiny, S.
1983 An Anthropomorphic Figurine from the Sotira Area. *Report of the Department of Antiquities of Cyprus*: 56–59.
La Terra trai i due fiumi. Venti anni di archeologia Italiana in Medio Oriente, April–May 1987.
1987 Torino: Il Quadrante.
Todd, I. A.
1985 The Vasilikos Valley and the Chronology of the Neolithic/Chalcolithic Periods in Cyprus. *Report of the Department of Antiquities of Cyprus*: 1–15.
Vagnetti, L.
1974 Preliminary Remarks on Cypriote Chalcolithic Figurines. *Report of the Department of Antiquities of Cyprus*: 24–34.
1975 Some Unpublished Chalcolithic Figurines. *Report of the Department of Antiquities of Cyprus*: 1–4.
1979 Two Steatite Figurines of Anatolian Type in Chalcolithic Cyprus. *Report of the Department of Antiquities of Cyprus*: 112–14.
1980 Figurines and Minor Objects from a Chalcolithic Cemetery at Souskiou-Vathyrkakas (Cyprus). *Studi Micenei ed Egeo-Anatolici* 21: 17–72.
1987 Two Chalcolithic Stone Figurines from Erimi. *Report of the Department of Antiquities of Cyprus*: 19–21.
Wace, A. J. B., and Thompson, M. S.
1912 *Prehistoric Thessaly.* Cambridge: Cambridge University.
el-Wailly, F., and Abu es-Soof, B.
1965 The Excavations at Tell es-Sawwan. First Preliminary Report (1964). *Sumer* 21: 17–32.
Xenophontos, C.
1982 Steatite vs. Picrolite. P. 59 in *Early Metallurgy in Cyprus, 4000–500 B.C.*, eds. J. D. Muhly, R. Maddin, and V. Karageorghis. Larnaca: Pierides Foundation.

Pottery Figurines: The Development of a Coroplastic Art in Chalcolithic Cyprus

Elizabeth Goring
Department of History and Applied Art
Royal Museum of Scotland
Chambers Street
Edinburgh, U.K. EH1 1JF

During the 1987 excavation season at Kissonerga-Mosphilia, the Lemba Archaeo-logical Project discovered a ritual deposit comprising some 50 objects packed in and around a bowl in the form of a building model. The objects included 18 figurines. This article discusses the eight pottery figurines and considers the new evidence they have contributed to our understanding of the coroplastic art of Chalcolithic Cyprus.

A brief survey of the general development of coroplasty during the period is followed by a more detailed presentation of the figurines from the deposit. Based on the evidence of their iconography and wear patterns it is suggested that all the figurines were associated with childbirth, and were perhaps used as teaching aids to explain the events that would occur during parturition or in connection with some kind of ritual that took place during the event itself.

In the final days of the 1987 season at Kissonerga-Mosphilia, the Lemba Archaeo-logical Project made a startling and signifi-cant discovery. It consisted of an unmistakably ritual deposit comprising some 50 objects packed in and around a large bowl (fig. 1). This was no ordinary bowl. It was constructed in the form of a building with a central hearth, raised floor parti-tions, and a door that opened and closed on a pivot. The assemblage of objects associated with the building model included stone tools; pottery vessels; bone needles; a triton shell; and, in particu-lar, 18 figurines, most of them anthropomorphic. Ten of the figurines were made of stone, the remain-ing eight of pottery. This article looks in detail at the eight pottery figurines and the new dimension they have added to an appreciation of the coro-plastic art of Chalcolithic Cyprus.[1]

Despite the large number of figurines known from the period, evidence for their development, significance, and function remains fairly thin. One reason is that a very high proportion of the extant figurines are extremely fragmentary. It is difficult to construct a meaningful framework or typology based on examples represented only by amputated heads, legs, arms, and torsos. A second reason is that only a small proportion come from good con-texts, and a number lack even a certain provenance. At Kissonerga-Mosphilia, a carefully excavated site that has produced nearly 130 figurines or figurine fragments to date (about half of pottery), a large number of the examples were extremely fragmen-tary and many came from disturbed contexts or were surface finds. Since figurines must take their function from their context (cf. French 1981: 173), a reasoned discussion of their significance and pur-pose is difficult. It is probably largely for those reasons that there has been no comprehensive study of pottery figurines so far, although previous au-thors have considered them briefly (e.g., Vagnetti 1974: 25–26). Stone figurines, especially picrolites, have been discussed in more detail, presumably because they tend to survive in better condition and often come from more immediately compre-hensible contexts, such as burials.

Stone figurines are discussed elsewhere in this issue, so this article presents a brief outline of the development of pottery figurines generally, to set the eight examples from the ritual deposit in their overall chronological context.

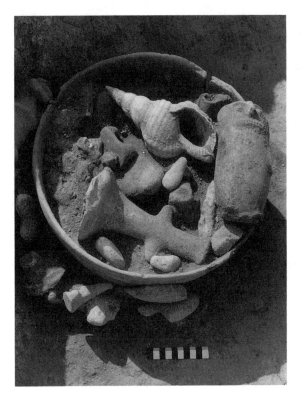

Fig. 1. The ritual deposit *in situ* at Kissonerga-Mosphilia.

The art of coroplasty commenced within the Chalcolithic period, but it seems likely that the stylistic tradition can be traced far back into the Neolithic. That period produced a number of highly sophisticated figurines alongside other stylistically simpler examples, often made from hard stones such as diabase. The materials used must have affected the styles produced to a significant degree. Nevertheless, the beginnings of features that became standard in the Chalcolithic can be found already within the Neolithic tradition: the elliptical shape for the face; the emphasis on brows, eyes, and nose, where facial features were rendered; the phallic form for the head and neck. It seems characteristic of the early figurines that there was little emphasis on the arms, which were sometimes shown as stumps but were equally often not even modeled. In addition there was little interest in indicating gender.

There is a single piece of evidence that Chalcolithic coroplasty might have had more than stylistic roots in an earlier period. That is the startling unfired clay head from Aceramic Neolithic Khirokitia, an object highly sophisticated in its impact (Dikaios 1953: pls. 98, 144). Although fired pottery figurines were unknown, the existence of that head argues for a familiarity with the modeling technique and an appreciation of the plastic qualities of clay. The contours of the face are sensitively shaped and the facial features carefully modeled. The confidence of the piece suggests it was not the first to be made by the sculptor.

It is probable that other work was also achieved in clay, and perhaps in perishable materials such as wood. Wood sculpting and stone modeling are fundamentally different techniques from the working of clay. The former techniques subtract material from a larger whole to create the end product. The latter manipulates or even adds to the material to reach the desired form. Despite the difference in approach and medium, the makers of stone, wood, and clay figurines presumably were working within a single artistic tradition. However there is no evidence for any continuity into the Chalcolithic, despite good settlement and burial finds from the intervening periods.

The Chalcolithic coroplasts produced a wide variety of pottery figurines in different fabrics and apparently in a wide range of types. There appears to be much more diversity of form among the pottery repertoire than among the picrolites, perhaps reflecting similar diversity of significance and function. In 1974, Vagnetti noted the difficulties of classifying the pottery figurines because of their fragmentary nature and decided to consider the heads and torsos separately (Vagnetti 1974: 26 n. 3). She distinguished two main styles of heads but did not attempt to classify the bodies. Excavations in the years since that article was written confirm the difficulty of using stylistic classification to group the figurines. The heads of the figurines do indeed tend to have recognizable and repetitive characteristics. However the overall forms of the figurines seem sufficiently diverse that attempts to impose too rigid a typology may be misleading. Only general groupings may be possible. The author is currently carrying out a thorough analysis of all the figurine material from Kissonerga-Mosphilia, and that work may produce more definite conclusions. However, with some exceptions, variety of type within a recognizable stylistic framework seems characteristic of Chalcolithic coroplastic art. Even where general groups may be

distinguished (for example, figurines seated on birthing stools), individuality of execution seems to be a feature.

It is not yet possible to trace the actual beginnings of true coroplastic art within the Chalcolithic. Kalavasos-Ayious, Kissonerga-Mylouthkia, and Kissonerga-Mosphilia all have produced early pottery figurines but the evolution of types currently remains unclear. Many of the known examples are so confidently executed that prototypes must surely lie further back in time or in other materials. Certain characteristics are common to the early examples. It is clear that there was an increased interest in the development of the human form in the Early Chalcolithic period. That may be related at least partly to the plastic nature of the medium.

Besides giving figurines more recognizably anthropomorphic outlines, the artists gave more attention to details of human features. Fragments of legs from Kalavasos-Ayious have divided toes, and hands have divided fingers (South 1985: figs. 3.4, 3.6). In particular, there seems to have been more interest in the arms themselves, which expanded from small buds to much more emphatic features. There was a tendency toward the deliberate indication of gender. Examples from Ayious have incised pudenda and carefully-shaped hips (South 1985: fig. 3.1). Most of the figurines where gender is shown are female. Painted decoration was already quite sophisticated and elaborate. Again from Ayious, there are fragments bearing all-over designs including parallel lines, latticing, and vertically-hatched panels. One leg fragment even bears vertical "tassels" between the leg and foot, a decorative motif found in a more sophisticated form later at Kissonerga-Mosphilia (South 1985: fig. 3.4). The site of Kissonerga-Mylouthkia has yet to be fully investigated but preliminary work has revealed fragments of fantastic zoomorphic creatures predating the later exotic creations from Souskiou. It seems reasonable to suppose that a fantastic repertoire coexisted alongside more realistic anthropomorphic types.

The makers of the figurines fully understood the plastic potential of clay. The fabrics are identical or very close to those used for making ceramic vessels, suggesting both a common source of materials and a common knowledge of manufacturing and firing techniques. The painted motifs do not differ markedly from those used in the pottery repertoire, suggesting a common source of inspira-tion. Later, the pots and figurines are linked by rare examples of vessels with modeled anthropomorphic features (from Erimi and Lemba-Lakkous, as well as Kissonerga-Mosphilia). Those products surely span the two crafts. It seems possible that the potters and the coroplasts were the same people, or at least specialists within a common medium. While drawing upon the same esthetic and technical sources they also utilized the artistic traditions of the local stone figurine makers (contrast Bolger 1988: 103).

During the Middle Chalcolithic period, the number of figurines increased and the repertoire expanded. The best evidence comes from the sites of Erimi, Lemba-Lakkous, Kissonerga-Mosphilia, and Souskiou. The tendencies noted in the earlier period continued, toward a more developed interest in the human form, the position of the arms, the indication of gender (usually female), and zoomorphic and fantastic types. Facial features show particular emphasis on the brows, eyes, and nose, the brows and nose usually in relief, the eyes punched or shown as pellets. There is often a general lack of emphasis on the mouth. It was sometimes omitted altogether, but more often shown as a slit or small hole. Sometimes, at Kissonerga-Mosphilia, it was outlined in red. Hair was often shown in paint, as wavy lines, and the hairline at the forehead could be painted or modeled and incised. The torsos, legs, and arms of Red-on-White figurines often were elaborately decorated. Jewelry was sometimes shown: bands around the neck, beads strung around the arms, and occasionally suggestions of earrings. The depiction of arms became more varied: stylized wedge-like arms tapering towards the ends (as on stone and picrolite figurines) apparently coexisted alongside fully modeled limbs. There was more variety in the actual position of the arms, which were not always simply outstretched. The indication of gender is more marked. The cemetery at Souskiou has produced spectacular zoomorphic figurines, hinting at a rich repertoire of more exotic types perhaps still to be paralleled at other sites. Erimi and Kissonerga-Mosphilia have so far produced relatively few fragments of zoomorphic figurines.

A range of ceramic fabrics was used for Chalcolithic figurines. Simple, crudely modeled clay examples with pinched outlines and of naive style were sometimes produced, but generally the fabrics parallel those in use for pottery vessels. At Erimi,

same phenomenon is apparent on stone figurines. The second development is that of scale. Erimi and Kissonerga-Mosphilia have both produced examples that, although now fragmentary, must be classed as statuary rather than figurines. Bolger (1988: 104) calculated that some of the Erimi examples are likely to have stood about 1 m high. That has major implications for their significance and function.

The eight pottery figurines from the ritual deposit at Kissonerga-Mosphilia (Unit 1015) provide exciting new evidence for the understanding of Chalcolithic coroplastic art. As a group, they are particularly important because they are exceptionally well-preserved and fairly intact, they have an identifiable style and form of decoration, and they come from a well-defined context. They are also important because they are a group. At Kissonerga-Mosphilia, figurines are usually very fragmentary; frequently they come from disturbed contexts and are found individually, usually unassociated with any other artifacts. The figurines from Unit 1015, therefore, add a new dimension to the evidence. They also have a unique importance individually. When the figurines were first cleaned and examined, each one provided some special detail and added a new fragment to the overall picture.

The date of the figurines can only be assumed from their context. Unit 1015 may be dated by its stratigraphy and ceramic associations to Period 3 at Mosphilia, falling within the Middle Chalcolithic. That does not mean that all eight are of the same age, or that they were all used at the same time. We know only that they were eventually deposited together.

The most unexpected (and revealing) of the eight was a large figurine shown at the very moment of giving birth (fig. 2). It is fully preserved from the head to the buttocks. It has an elliptical head tilted back at an acute angle on a thick, elongated neck (the whole effect unmistakably phallic). The facial features are indicated by relief, puncturing, and paint. The arms are outstretched and flung to either side, and they are ornamented with a pair of painted bracelets. The breasts are fairly flat and unemphasized, but the nipples are reddened with paint. The body expands to a flaring bell shape. There are latticed bands around the lower body, and the buttocks are emphasized as protruding bosses. The most remarkable feature is that which is shown on a flat panel provided between the (now

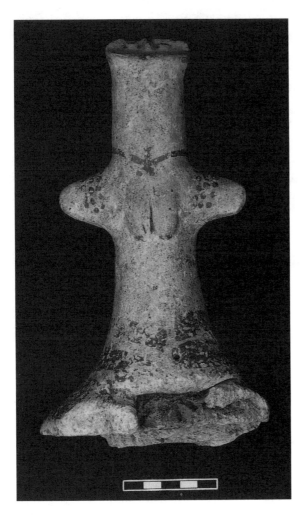

Fig. 2. Figurine depicting the moment of giving birth.

various styles in a number of different wares, construction methods, and decorative techniques occurred in every phase of habitation (Bolger 1988: 105). Well-preserved examples in fabrics other than Red-on-White include the two well-known lactation figures (one from Alaminos and the other, unprovenanced, in the Louvre) and the ejaculation figure now in the Pierides Foundation Museum (Caubet 1974: pl. 7; Karageorghis and Vagnetti 1981: fig. 1). Complete large and elaborate examples are exceptional.

Two other developments are worth briefly noting here. The first is a degree of deliberate sexual dimorphism. The female characteristics may be clearly marked on the torsos, but the heads and necks have an unmistakably phallic shape. The

missing) legs. Upon this, there is a large oblong dot between a pair of curved lines. This motif represents the head and arms of a baby emerging in the correct birth position. It appears head first, and the arms have just been freed. The artist has depicted the moment quite clearly, albeit in two dimensions. No equivalent motif has been found among the extensive repertoire already known on Red-on-White pottery, and the significance of the location places the interpretation beyond doubt. In addition, the figurine originally sat on a stool, undoubtedly a birthing stool, in a position that is entirely natural for giving birth.

Another important feature is the painted anthropomorphic pendant around the figurine's neck. The pendant apparently represents a figure very similar to the figurine itself. A tiny stroke is visible between the legs of the pendant, although slightly obscured by damage. This is no slip of the brush, but a rather significant element (see below).

Such a depiction of childbirth is so far unique and was totally unexpected. The figurine itself belongs to a recognizable group of seated female figurines of which several examples are now known from Kissonerga-Mosphilia. When the first was discovered, it was suggested that the posture indicated childbirth, and that the integrally modeled seat was a birthing stool (see, e.g., Morris 1985: 122). That interpretation has now been graphically confirmed. The first example to be discovered was a surface find (KM 299; Peltenburg 1984: pl. 20). Although it shares many features of the childbirth figurine, in other respects it is quite different. As on the childbirth figurine, the arms are outstretched, as if indicating straining. The body is bell-shaped, and the legs, complete with divided toes, are draped over the edge of the stool. The legs are set wide apart. This figurine also wears a painted anthropomorphic pendant. Here it is quite clear that the stroke between the legs of the pendant was not a slip of the brush but a deliberate feature. Is it possible that the pendant is shown at the very moment of birth, with a child depicted, albeit very schematically, emerging between the legs? As on the childbirth figurine, elaborate painted decoration is largely confined to the lower body. But here the similarities end. The decoration itself is far less sophisticated, consisting of simple but dramatic strokes of paint. There is no panel between the legs, but attention is drawn to that area by deeply marked pudenda and by the direction of the painted

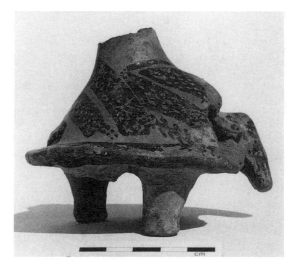

Fig. 3. Figurine of a pregnant woman seated on a birthing stool.

strokes. In particular, the belly is far more emphasized. One wonders if the figurine depicts a stage in labor before the child emerges.

Two more fragmentary examples of figurines on birthing stools were included in Unit 1015. One has only its lower half surviving, including an integrally modeled circular stool with four legs (KM 1463; fig. 3 here). It has well-preserved painted decoration consisting of latticed panels similar to those on the childbirth figurine. It has an exceptionally swollen belly, more swollen even than that of the surface find. It has neither a painted panel nor incised pudenda between the legs but a wide and deep cutaway gap. The surviving leg of the figurine has no toes but there is elaborate painted decoration all along it.

The third seated figurine from Unit 1015 (KM 1443) is also the most fragmentary. It shares features with the others, specifically the latticed panel decoration of the lower torso, the posture, and the swollen belly; but in addition the belly is emphasized by a double cross. It has no flat panel between the legs, no incised pudenda, no cutaway gap, only a simple curved area between the legs, covered in red paint.

A fragment of a fifth example of the same type is also known from Kissonerga-Mosphilia (KM 507). It is represented solely by a leg, once curved over the edge of a birthing stool. Like KM 299, it has divided toes and rather simple painted decoration, now very worn.

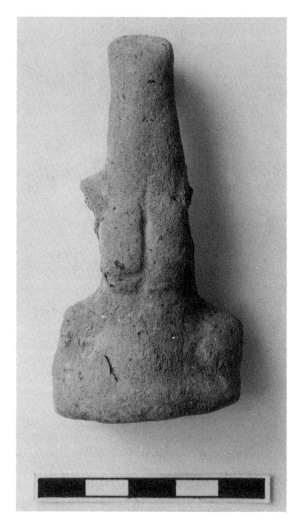

Fig. 4. Small figurine of a woman giving birth in a squatting position.

The group provides evidence for a very specialized type that must have a specific meaning and function. All are clearly associated with childbirth. However each figurine may be shown at a slightly different stage, and the crucial area between the legs could be treated in several ways. The existence of pendants around the necks of two of the figurines strongly suggests that some kind of wearable charm could be used when childbirth was in progress. But how could such pottery figurines have been used?

Some evidence may be obtained from a consideration of their form and their wear patterns. It is noticeable that the figurines with surviving upper torsos have decoration largely confined to their lower torsos. The natural place to hold the figurines

is between their outstretched arms and their flaring hips and buttocks, that is, around the waist, perhaps with the fingers over the belly. The wear patterns tend to confirm this. The childbirth figurine is very abraded over the front surface, around the waist, and the center of the back above the buttocks is scratched. What does this evidence amount to?

Ancient representations of women in childbirth, on pottery or in the form of figurines, do not show the woman alone in labor. She is always accompanied by supporters. She is assisted in her efforts by a close physical contact: another woman will grasp or cradle the woman from behind, usually under her arms and over her belly, giving her support, while the midwife in front receives the child.[2] The Chalcolithic figurines are therefore unusual in showing the woman alone in childbirth. Where are her supporters? Can the figurines have been used as teaching aids, meant to be handled, to show the expectant mother or the initiate what would happen during childbirth? Or might they have been handled as part of a ritual associated with the act of parturition? Both suggestions could provide a possible explanation for their iconography, their wear patterns, and their individual features.

If they did serve such functions, can the three childbirth figurines from Unit 1015 be associated in any practical way with the other five pottery figurines from the deposit? The most obvious link appears to be with an upright figure (KM 1464). It has the familiar elliptical head tilted back on an elongated, phallic-type neck. The brows and nose are shown in relief, the eyes and mouth punctured and highlighted by red paint. The breasts are indicated in low relief and the usual outstretched arms taper toward the ends. From the waist upward the resemblance to the childbirth figurine is very close. Below the waist, the body expands abruptly to wide, shelf-like hips. The belly is swollen, indicated by a relief curve. Below this there is a flat panel, now too damaged for us to be certain of its details. The figurine originally stood on two thick, wide-set legs. As with the seated figurines, the painted decoration is largely confined to the lower torso and legs. In this instance, the motifs are fairly simple curvilinear lines, zigzags, and dots. Like the other three seated examples, this one was already damaged when it was packed inside the building model. It had lost both its right arm and right leg.[3]

The thrown-back head and arms, the open mouth, the feeling of strain, and the general simi-

larities with the seated figurines suggest that this
figurine is also in labor. She is standing rather than
seated, but that would also be an acceptable posi-
tion to adopt during childbirth, especially if the
mother was supported.

Two much smaller upright figurines were also
associated with the deposit. One has a simple ellip-
tical head merging almost directly into the usual
elongated neck (KM 1442; fig. 4 here). Both arms
are missing but were probably outstretched. Thus
there are again very general similarities with the
figurines in labor. The breasts are flattish but un-
usually full, extending to the waist. Below the waist,
the hips shelve outward in a way similar to those of
the previous standing figure, but the posture is
different yet again. Light and sensitive modeling on
the flaring lower body show the figurine is squatting
with her legs wide apart. That is also a natural
childbirth position.

The second small figurine (KM 1460) is more
enigmatic, and also rather more damaged. The
remains of the neck indicate that it was thick and
long, but the head is missing. Both arms have been
broken away. The breasts are smaller and flatter,
and there are rolls of fat below the armpits. There
is no modeling on the lower body to indicate the
posture. Painted decoration consists of simple hori-
zontal bands. The lack of painted decoration on
the upper torso and the probable forms of the head
and arms are features shared with the previous
figurines, but otherwise the meaning of this ex-
ample is not explicit. The fact that both small
figurines are very worn, especially on the upper
torso, suggests that they were well handled and
were used for a specific purpose. Despite their rela-
tive simplicity, they have no exact parallels within
the general assemblage at Kissonerga-Mosphilia.

The two remaining pottery figurines from Unit
1015 are both very different. One (KM 1475; fig. 5
here) was found in a most striking position outside
the bowl, wedged between its outer wall and the
edge of the pit. It was lying on its side, facing the
doorway of the building model and completely
blocking it. One wonders whether the position had
special significance.

The modeling technique of this figurine differs
from the previous examples since the body and
neck are hollow. It stands firmly in a well-balanced
stance with the legs placed wide apart, one slightly
in front of the other. The position of the arms is
especially noteworthy. The hands rest on the shoul-
ders to either side of the neck. The arms are bent

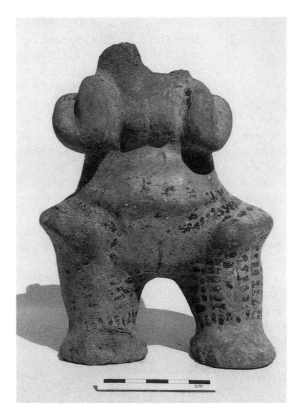

Fig. 5. Large standing figurine with arms bent upwards.

tightly upwards, almost giving the impression of
compressing the breasts between the elbows. Thus
far no exact parallel for this position of the arms
and hands has been found. The emphasis of the
modeling is on the grotesquely broad hips, the
belly with its swollen relief curve, and the exag-
gerated buttocks. The breasts, by contrast, are ra-
ther small although quite prominent. The details of
the modeling and paintwork draw attention to the
pudenda, indicated by an incised line on a flat
panel between the hips. There is decoration all over
the body, best preserved on the lower torso and
legs. There are traces of curvilinear motifs over the
belly and hips, and rows of thick, horizontal dashes
interspersed with a few dots over the back, but-
tocks, and legs. At the bottom of the legs is a single
row of vertical dashes resembling tassels or a fringe.

Similar vertical dashes have already been noted
on an earlier leg fragment from Kalavasos-Ayious.
There is even closer decoration on another leg
fragment from Kissonerga-Mosphilia. There may
also be a link with the more elaborate paintwork

on the legs of a very important figurine from Mosphilia, which was probably once an appliqué from the wall of a vessel (KM 778/854). It is difficult to know whether this and other decoration represents clothing, tattooing, or body paint. The fact that the pudenda may be visible through the decoration need not be conclusive. The consistency of use and location of the vertical dashes around the legs could suggest both a long continuity of tradition and the application of the motif for a particular event. For instance, perhaps this was a type of body decoration applied specifically on the occasion of childbirth.

The significance of this impressive figurine is open to speculation. It would have been interesting to have known the form of the head, and especially its position. The only other clue to its interpretation lies in the wear pattern. The flat genital panel was heavily abraded, and all the protruding rounded surfaces (the arms, breasts, hips, belly, and buttocks) were rubbed as if the figurine had been much handled.

The position of the arms might possibly suggest some comparison with lactation figurines. However although the modeling of the arms is superficially similar, on those the action is quite unambiguous: the hands are shown in the process of manipulating the nipples. I would suggest that the figure from Unit 1015 is actually standing in a position of great strain, and that the hands grasping the shoulders are providing a form of self-support. This figurine is probably also in labor, and is actually "bearing down."

The eighth pottery figurine from Unit 1015 (KM 1466) is in many ways the strangest and the most ambiguous. It is also the most damaged and worn. Only the torso survives. The figurine is hollow at the neck, but the arms and legs (now missing) were apparently solid. It is obviously female, with long pendulous red-painted breasts hanging down over a swollen belly. The decoration is very abraded but was once quite elaborate. A lozenge design over the neck may represent the remains of a necklace.

The condition of the figurine makes interpretation extremely problematic. The female could be pregnant, or just obese. A clue might lie in the decoration over the buttocks, which consists of latticed panels. Although that motif is very common on ceramic vessels, it was also used consistently on the three seated figurines, and it is possible that it had a particular relevance to depictions of childbirth.

In conclusion, it seems possible to argue that all the pottery figurines had some association with aspects of childbirth. They were much handled and used in some specific way prior to their burial in Unit 1015. They were not created solely to be buried and they were not made solely to be looked at. Although they had the capacity to stand unsupported, some kind of handling was an important part of their function. In addition, they were all damaged in some way. Most of the breaks were very sharp and fresh, and must have occurred shortly before interment. The figurines could have been used to explain procedure that would occur during parturition, perhaps as part of an initiation ceremony; or they may have been used in connection with some kind of ritual that took place during the event itself. For whatever reason, they were eventually broken, perhaps to negate their power, and were buried in a final ceremony with no intention ever to retrieve them. (The evidence for the interpretation of the deposit as ritual, and the full argument for these and other conclusions relating specifically to the figurines, will be presented in the forthcoming publication of Unit 1015.)

These suggestions should encourage us to look anew at other occurrences of pottery figurines, to look critically at their decorative motifs, their condition and wear patterns, and especially at their contexts. Some of them at least, like the picrolites, may have played a highly significant role in Chalcolithic society, a role not confined to the usual suggested uses as dolls, idols, or votives, but one absolutely fundamental to the continuity and transmission of life itself.

NOTES

[1] The Lemba Archaeological Project is based at the University of Edinburgh and is directed by E. Peltenburg. The final publication of the deposit is currently in preparation. Preliminary reports include Peltenburg *et al.* 1988: 43–52; Peltenburg 1988a: 289–93; 1988b: 3–15. I thank Dr. Peltenburg for permission to discuss the figurines in advance of the final publication, as well as for many useful comments.

[2] I am grateful to M. Bruno for drawing this to my attention.

[3] Unusually, however, the left leg and arm were also broken away but were placed separately within the building model. The arm was found resting on its broken end beside the hearth on the floor of the building model where it was at first mistaken for a small cone.

BIBLIOGRAPHY

Bolger, D.
1988 *Erimi-Pamboula: A Chalcolithic Settlement in Cyprus*. BAR International Series 443. Oxford: British Archaeological Reports.
Caubet, A.
1974 Une terre cuite Chalcolithique Chypriote au Louvre. *Report of the Department of Antiquities of Cyprus*: 35–37.
Dikaios, P.
1953 *Khirokitia*. Oxford: Oxford University.
French, E.
1981 Mycenaean Figures and Figurines, their Typology and Function. Pp. 173–74 in *Sanctuaries and Cults in the Aegean Bronze Age: Proceedings of the First International Symposium at the Swedish Institute in Athens*, 12–15 May 1980, eds. R. Hägg and N. Marinatos. Stockholm: Svenska Institutet in Athen.
Karageorghis, V., and Vagnetti, L.
1981 A Chalcolithic Terracotta Figure in the Pierides Foundation Museum, Cyprus. Pp. 52–55 in *Chalcolithic Cyprus and Western Asia*, ed. J. Reade. Occasional Paper 26. London: British Museum.

Morris, D.
1985 *The Art of Ancient Cyprus*. Oxford: Phaedon.
Peltenburg, E. J.
1984 Lemba Archaeological Project, Cyprus, 1982, Preliminary Report. *Levant* 16: 55–65.
1988a A Cypriot Model for Prehistoric Ritual. *Antiquity* 62, 235: 289–93.
1988b Prähistorische religion in Zypern. Der rituelle Hortfund von Kissonerga. *Antike Welt* 19.3: 3–15.
Peltenburg, E. J.; Bolger, D.; Goring, E.; and Elliott, C.
1988 Kissonerga-Mosphilia 1987: Ritual Deposit Unit 1015. *Report of the Department of Antiquities of Cyprus*: 43–52.
South, A. K.
1985 Figurines and Other Objects from Kalavasos-Ayious. *Levant* 17: 65–79.
Vagnetti, L.
1974 Preliminary Remarks on Cypriote Chalcolithic Figurines. *Report of the Department of Antiquities of Cyprus*: 24–34.

A Terracotta Pendant from Kalavassos-Ayious

V. Karageorghis

Foundation Anastasios G. Leventis
Nicosia, Cyprus

A terracotta pendant of the Chalcolithic period found at Kalavassos-Ayious was published as representing a fish. On one of its flat sides it is decorated with an engraved herringbone motif. An attempt is made to demonstrate that this pendant and other similar ones in clay and stone from Cyprus may represent the female vulva. Such representations are not unknown in the prehistoric art of the Levant and other regions and are in complete accord with the predominant role played by symbols of fertility from the Neolithic to the Chalcolithic periods and the "universality" of the "ideology" of fertility.

The purpose of this article is to propose an alternative interpretation for a small terracotta pendant found at the early Chalcolithic settlement site of Kalavassos-Ayious (no. K-AY 313) and already published by South (1985: 73–74, fig. 4.16). South describes it as "an unusual ceramic pendant with lightly incised decoration . . . [it] appears to represent a fish pierced through the eye" (South 1985: 73). Although fish pendants are not unknown in the Neolithic art of Cyprus (for example, the picrolite fish pendant from Khirokitia [Dikaios 1953: pl. 93.a, figs. 107, 408, no. 1476; Buchholz and Karageorghis 1971, no. 1171]), this article proposes to identify the Kalavassos pendant as representing not a fish but female genitalia. It is flat, elliptical in shape, with one rounded terminal pierced, and the other pointed. Its length is 4.3 cm and its maximum thickness is 0.8 cm (fig. 1). On one side are impressed (not engraved) linear designs forming a "herring-bone" motif; they may have been made with a sharp, thin piece of wood. The other side is plain.

The representation of female genitalia is known in Chalcolithic Cyprus by several examples. A small terracotta "figurine" from Dikaios' excavations at Erimi represents a vulva, but at the same time it has the characteristics of a standing human figurine, with a "head" and short "arms" (Bolger 1988: 111,

no. 33, Erimi no. 977; fig. 2 here). A diabase (?) stone pendant from Erimi, now in the Cyprus Museum, Nicosia (Inv. no. 1943/IV-27/1), found accidentally, has a conical-trapezoid form, slightly convex on one side and concave on the opposite side; it is perforated at the top for suspension (fig. 3a–c). On the convex side is a deep, vertical groove along the middle, with oblique parallel lines on either side at the upper part, forming parallel chevrons. There are also parallel chevrons at the upper part of the other sides (Flourenzos 1988: pls. 3, 5).

Erimi produced yet another terracotta pendant in the shape of the Kalavassos-Ayious pendant. It has a flat, elliptical shape and is pointed at one end and rounded at the other, with a perforation at the rounded end for suspension. Its length is 5.8 cm and its maximum thickness is 1.3 cm (Bolger 1988: 118–19, Erimi no. 355; fig. 4 here). On one side are painted cross-hatchings in orange-red matte paint (largely worn off). The other side is covered with solid paint of the same color. The grooves on one of its sides are accidental.

Another example from Erimi is very fragmentary, but it might have been very much like the Kalavassos-Ayious pendant. It had a perforation at the rounded end but the other end is missing. On one side is a deep vertical groove along the middle with oblique parallel lines on one side; those on the

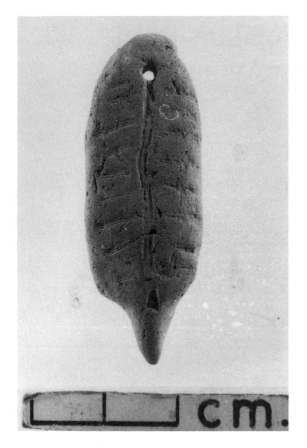

Fig. 1. Terracotta pendant, Kalavassos-Ayious no. 313.

Fig. 2. Terracotta pendant, Erimi no. 977.

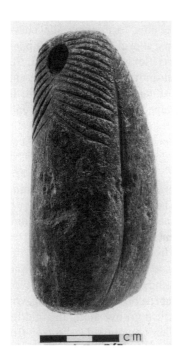 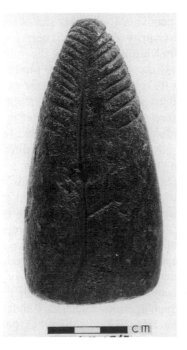 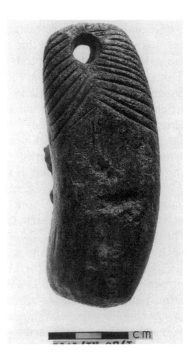

Fig. 3. Stone pendant from Erimi, Inv. no. 1943/IV–27/1.

Fig. 4. (left) Terracotta pendant, Erimi no. 355.

Fig. 5. (right) Fragmentary terracotta pendant, Erimi no. 1016.

other side are missing. Its preserved length is 7.5 cm; its thickness is 1.8 cm (Bolger 1988: 119, Erimi no. 1016; fig. 5 here).

It is very possible that those terracotta pendants may have had stone prototypes, as is usually the case (cf. Bolger 1988: 119); but similar stone pendants are known from Cyprus only from the Neolithic period. That there should be a continuity is not surprising. We propose as comparable material some of the grooved round stones from Khirokitia (e.g. Dikaios 1953; pls. 102.920, 138.914). Some of those stones are perforated, which suggests that they may have been worn as pendants (e.g., Dikaios 1953: pl. 102.46).

One could also offer parallels both from the Levant and from the Balkan region, but of a much

earlier date, for example the Natufian grooved pebbles from Mallaha, dating to ca. 10,000 B.C. (Gimbutas 1989: 100, fig. 163.2) and the Yarmukian engraved pebbles from the Levantine region, dating to the Neolithic period (sixth to fifth millennia B.C. (Stekelis 1972: pls. 56–57; Cauvin 1972: 72–79). The representation of the vulva as a fertility symbol is widely known in the Neolithic cultures of the Balkans and elsewhere (cf. Gimbutas 1989: 99–112). Furthermore, the parallel chevrons are closely associated with the divinity of fertility (cf. Gimbutas 1989: 3–18). Some other female figurines have a "herring-bone" engraved decoration above the vulva or in the place of the vulva, supporting the interpretation offered here for the Kalavassos-Ayious pendant. Those figurines include one in terracotta of the Vinca culture of Yugoslavia dating to ca. 5200 B.C. (Gimbutas 1989: 103, fig. 168.2) and a bone figurine from Neolithic Italy (Gimbutas 1989: 103, fig. 168.3). One might also mention a clay seal from Haçilar, engraved with a "herring-bone" motif, probably representing a vulva (Mellaart 1970: 164, pl. 119.g).

Besides the representation of the female genitalia the Chalcolithic Cypriots also wore pendants in the form of male genitalia. An example of bone from Palaepaphos is shaped in such a way as to look also like a human figurine, analogous to the vulva terracotta from Erimi no. 977 (Maier 1985: pl. 1.3).

The figurine from Kalavassos-Ayious constitutes a useful addition to the religious symbolism of Chalcolithic Cyprus, so closely related to fertility, as several communications at this conference have demonstrated. It also provides further evidence for the cultural continuity from the Neolithic to the Chalcolithic and furthermore for the "universality" of the "ideology" of fertility, which caused the creation of the fertility symbols. That ideology covers a wide range, both geographical and chronological: from the Levant to the Balkans through Anatolia and the Aegean, from the Natufian period through the Neolithic of Europe and the Chalcolithic of Cyprus and also of Anatolia and the Aegean.

ACKNOWLEDGMENTS

I would like to thank A. South-Todd for permission to reexamine and publish the figurine. M. True agreed to include this note in the proceedings of the Symposium on Chalcolithic Cyprus, although it was not included in the program of the communications that were read during this Symposium.

BIBLIOGRAPHY

Bolger, D.
1988 *Erimi-Bamboula. A Chalcolithic Settlement in Cyprus.* BAR International Series 443. Oxford: British Archaeological Reports.
Buchholz, H.-G., and Karageorghis, V.
1973 Prehistoric Greece and Cyprus: An Archaeological Handbook. London: Phaidon.
Cauvin, J.
1972 *Religions néolithiques de Syro-Palestine.* Paris: Librairie d'Amerique et d'Orient.
Dikaios, P.
1953 *Khirokitia.* Oxford: Oxford University.
Gimbutas, M.
1989 *The Language of the Goddess.* San Francisco: Harper and Row.

Maier, F.-G.
1985 *Alt-Paphos auf Cypern.* Mainz: von Zabern.
Mallaart, J.
1970 *Excavations at Haçilar,* vols. 1–2. Edinburgh: Edinburgh University.
South, A. K.
1985 Figurines and Other Objects from Kalavassos-Ayious. *Levant* 17: 65–79.
Stekelis, M.
1972 *The Yarmukian Culture of the Neolithic Period.* Jerusalem: Magnes.

Anatolian Contacts with Chalcolithic Cyprus

MACHTELD J. MELLINK
Department of Classical and Near Eastern Archaeology
Bryn Mawr College
Bryn Mawr, PA 19010-2899

Occasional contacts between Cyprus and the nearest stretch of Anatolian coast are attested as early as the Aceramic Neolithic period when a small amount of Anatolian obsidian reached Cyprus. In general, Cyprus followed an independent course in the Neolithic and Chalcolithic era, but contacts with Anatolia become noticeable in Cypriot Late Chalcolithic, when two classes of Cypriot pottery appear in Tarsus during the Early Bronze II: 3-6 period of Cilicia, ca. 2600-2500 B.C. On Cyprus, Anatolian influence suddenly became apparent in the Philia period, transitional from Late Chalcolithic to Early Cypriot. Types of pottery, spindle whorls, metal tools, and weapons, as well as some jewelry, compare well with counterparts in Tarsus of the final stage of Early Bronze II. The moving force behind the newly strengthened contact probably was the Anatolian-Cilician interest in the copper deposits of Cyprus, which at that stage may have begun to be exploited systematically with Anatolian advice.

INTRODUCTION

The north coast of Cyprus is no more than 75-100 km south of the Anatolian coast, and is closest to the stretch between Anamur and Silifke, where the coastal plain dwindles and the Taurus mountains of rough Cilicia rise to over 2000 m in height. We know little about this part of the Anatolian coast in prehistoric times. Historically it belonged to the kingdom of Tarhuntassa in the 13th century B.C. (Otten 1988: 3). Its eastern border was the Kalykadnos river, modern Gökçay, probably the Hittite Hulaja river. Its valley goes inland from modern Silifke to form a relatively comfortable pass through the mountains to Karaman and Konya (French 1965: 177–201). More is known about prehistory in the uplands, from Neolithic Çatal Hüyük near Çumra to Chalcolithic Can Hasan, 13 km northeast of Karaman.

The adjoining part of the Cilician coast east of Silifke is more accessible and inhabitable as it widens into Cilicia Pedias with its fertile plains and river valleys. Among the prehistoric and historic sites and harbors are Mersin, Tarsus, Adana, and Misis-Mopsouhestia. From that part of Cilicia, modern Çukurova, the distance to Cyprus is somewhat greater, but the plain was well settled from Neolithic (probably Aceramic) to historic periods.

Here the Taurus mountains recede from the coast but still present a formidable barrier, pierced by the age-old pass leading up from Tarsus via the Kydnos river to the Cilician Gates, accessible to seasonal traffic connecting Cilicia with the plateau: Niğde and Tyana, Aksaray, Acemhüyük, and the great obsidian resources of the Çiftlik region.

Obsidian from that part of the plateau reached Cilicia directly by the Cilician Gates in the Neolithic period. Both Mersin and Tarsus have evidence of extensive use of obsidian ca. 6000 B.C. A direct route could have brought some obsidian to Cyprus from the Mersin region rather than through the Kalykadnos valley. The quantity of obsidian found in Aceramic Neolithic Cyprus is low, but its stratified occurrence indicates that the developing coastal navigation from Cilicia to Byblos—attested by the distribution of Çiftlik obsidian—extended its range occasionally to Cyprus, without joining the island to the Syro-Cilician koine of ca. 6000 B.C.

RESOURCES FOR METALLURGY

The Chalcolithic development in the Cilician plain is marked by close interaction with northern Syrian and northern Mesopotamian communities. In the fifth and fourth millennia B.C., technical needs in Anatolia focused on metal, becoming less and less concerned with obsidian, although some demand remained for the latter to make luxury vessels. Prospectors and traders from northern Mesopotamian communities were interested in copper from eastern Anatolia, from resources like those at Ergani in the upper Tigris region, which had started Çayönü on the road to metallurgy by 7000 B.C. Other prolific copper resources lay in the eastern Pontic mountains.

The northward move of Mesopotamian interests along the Euphrates in the Ubaid period is becoming better known through recent excavations like those at Değirmentepe near Malatya (Esin 1983: 175–90). The northern Mesopotamian connections of Syro-Cilicia during the Middle Chalcolithic phase must mean that technological interests were shared in sites like Mersin and Tarsus. Important in the same context is the degree to which silver and other metals were available in the Taurus mountains north of Cilicia.

The most important region there is the Bolkardağ area just west and south of the road coming up through the Cilician Gates. It is protected at the north by the key site of Zeyve—Porsuk hüyük, a large mound from which traffic could be watched in and out of the Taurus (Dupré: 1983: 13; Hawkins 1982), probably the historical site of Atuna in the neo-Hittite record. The site was important also as a Hittite fortress and promises to yield evidence for the entire Bronze Age.

The mining area of Bolkardağ has recently been investigated by Yener with a team of archaeologists and scientists (Yener et al. 1989: 477–94). She observed considerable traces of early working of the silver mines and noted that the valley of Bolkardağ has habitation sites that may start in the Aceramic days of obsidian trade (Site B2, Mahmutsekesi) and continue in the Chalcolithic era (e.g., B26, Garyanı tası), presumably dating to one of the Ubaid phases.

The earliest historical allusions to the Silver Mountains, probably the Bolkardağ mines in the Taurus, date to the Akkadian period, about the 24th century B.C. But since Anatolia is still without written sources of its own for the third millennium

B.C., chronological coordination depends on archaeological data until Old Assyrian and Hittite texts begin in the second millennium B.C.

Chalcolithic and Bronze Age sites in the Bolkardağ valley provide a potential clue to the distinction of phases of early discovery and exploitation of metal ores in the Taurus north of Cilicia, although the range of metals extracted singly or in combination is not yet known. Silver and lead are evidently primary candidates. The question of tin has been raised and will be dealt with by Yener's team. Copper is not available in sufficient quantity at Bolkardağ, but an ancient copper mine may have been worked in the southern Taurus at Kızılca (de Jesus 1980: 261; Yakar 1984: 80).

In any case, the Taurus road of the Cilician Gates was functioning in the fourth and third millennia B.C. and served new purposes. Metallurgical practices were developing in many parts of Anatolia. The potential for trade and technical progress was there. The rising need of metal supplies and metal working determined many of the regional and foreign relations of Anatolia, including Cilicia. It is in this context that the Chalcolithic Cypriot contacts can be analyzed.

CHRONOLOGICAL CORRELATION: CYPRUS AND TARSUS (fig. 1)

The chronology of the contacts between Anatolia and Cyprus is difficult to determine with the aid of metal objects, which are distributed unevenly in the known record, and which tend to cluster in unpredictable hoards or unplundered cemeteries. We depend here on stratigraphic and ceramic data.

This brings us to Tarsus as the key site for the present state of information (Goldman 1956). The chronological framework is as follows: On best estimates, Aceramic and Ceramic Neolithic of Cilicia belong to the eighth and seventh millennia B.C.; Early Chalcolithic starts about 5800 B.C., judged by calibrated C-14 dates; Middle Chalcolithic (correlated with Halaf and Ubaid developments in the east) runs from ca. 5400–4500 B.C., and the long Late Chalcolithic phase probably extends to ca. 3400 B.C., overlapping with the northern Uruk era in Mesopotamia and Syria. Early Bronze IA as defined at Tarsus runs from 3400–3000 B.C.; Early Bronze IB, from 3000–2700 B.C.; Early Bronze II from 2700–2400 B.C.; with indirect links to Egypt; Early Bronze IIIA–B, from 2400–2000 B.C. The dates are all approximate and subject to adjustment

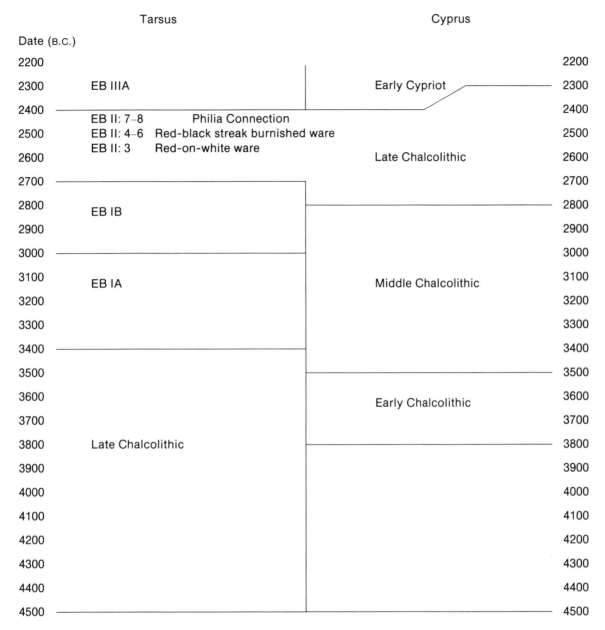

Fig. 1. Chalcolithic and Early Bronze Divisions of Tarsus and Cyprus.

as C-14 calibration is refined and other techniques (e.g., dendrochronology) provide accuracy.

The correlation with Cyprus in the Cypriot Chalcolithic era, therefore, roughly means that the Cypriot Early Chalcolithic runs parallel with final Late Chalcolithic in Tarsus, ca. 3800–3500 B.C.; Cypriot Middle Chalcolithic (3500–2800 B.C.), with most of Early Bronze I at Tarsus; Cypriot Late Chalcolithic (2800–2300 B.C.), roughly with Tarsus

Early Bronze II; and the Transitional Philia stage (2400–2000 B.C.), with Tarsus Early Bronze IIIA and B.

Those estimates cannot be precise, and the nomenclature is a bit arbitrary, but the use of Chalcolithic for Cyprus as far down as 2300 B.C. makes sense if we contemplate a continuity of early traditions, especially of settlement forms. If Lemba-Lakkous with its round houses and somewhat

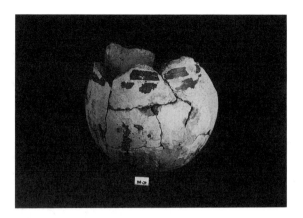

Fig. 2. Red-on-white jar, Tarsus EB II:3 (?). Height 8 cm (Goldman 1956: 130, fig. 263:379).

Fig. 3. Red-on-white sherds, Tarsus EB II:3 (?) (Left: Goldman 1956: 130, fig. 263:380, Right: Goldman 1956: 130, fig. 263:381).

parochial, conservative inventory is compared to the rectangular mudbrick rowhouses along the streets of Tarsus EB II, with a diversified inventory of partly wheelmade pottery, copper, and some bronze objects, seal-stamped pitchers, and evidence of trade and warfare, some difference in nomenclature is called for.

In the Early Bronze II of Cilicia, Tarsus enjoyed an increase in prosperity and was in economic contact with the Amuq and with the trans-Amanus region of northern Syria as well as with the Tarsus mountains and the plateau of Konya and Aksaray.

A ceramic Bolkardağ link is evident in the distribution of a hard-fired, yellowish-buff kind of pottery of special shapes and painted decoration that occurs in the Konya plain, at Bolkarmaden, at a plundered cemetery near Darboğaz south of Ulukışla, and quite frequently at Tarsus in EB II context (Özten 1989: 407–18; cf. Mellink 1989: 322).

There is physical evidence for contacts with Cyprus as well. It may be helpful to give the available evidence for types and contexts of the much discussed two kinds of Cypriot pottery encountered in Early Bronze II levels at Tarsus.

Red-On-White Ware

There was one more-or-less complete small jar in Room 119 or 120 at a level of about 16.00 m (Goldman 1956: 20, 130, fig. 263:379). That may indicate Subphase 3, relatively early in EB II, before the insertion of a fortification wall in that part of the settlement at Tarsus, ca. 2600 B.C.(?). The small jar (fig. 2) is only 8 cm high and is made of a

buff clay with grit and vegetable temper. Lustrous red paint decorated the exterior in bands around the neck and vertical lines on the body, but the paint has flaked off badly. Two other fragments of the same ware were recovered (Goldman 1956: 130, fig. 263:380–81). One is the rim fragment of a bowl with crossing red bands on a white slip inside and out; the rim probably was slightly everted; thickness about 7 mm, darkish core. The slip is smoothed; the paint originally may have been lustrous (fig. 3, left). The second fragment is of similar fabric with dark core and brick red crust. It is of an open vessel with finished slipped surfaces, red burnished on the interior, white slipped with lustrous red lattice design on the exterior, which seems burnished all over; it is ca. 6 mm thick (fig. 3, right). Both fragments are badly worn; they were collected from EB II fill. The fabric and ware of the three items led scholars to consider them genuine Red-On-White ware but their exact Cypriot provenience is difficult to pinpoint (Peltenburg 1982: 95–96).

These pieces provide proof of contact of Tarsus with Cyprus in the Cypriot Late Chalcolithic era, in the earlier part of the Tarsus EB II, not before 2700 B.C. There is not much of this kind of pottery in Tarsus. The three relevant pieces were spotted as different among a mass of other known local or imported identifiable material in the EB II levels.

Red and Black Streak Burnished Ware (figs. 4–7)

There is more evidence for import of this ware at Tarsus (Goldman 1956: 130, fig. 263:371–78; Peltenburg 1982: 96) in the form of many sherds,

Fig. 4. Neck of red and black streak burnished bottle, Tarsus EB II: 5–6, second fortification wall period. Preserved height ca. 11 cm (Goldman 1956: 130, fig. 263:372).

Fig. 5. Neck of red and black streak burnished bottle, Room 103 (Goldman 1956: 130, fig. 263:374).

although no complete vessels. The shapes are recognizable as bottles with sloping shoulders and straight or tapering necks (fig. 4). They are handleless and stand on flattened bases with rounded edges (fig. 7). Another clearly recognizable shape is a bowl with walls 11–13 mm thick and a diameter of ca. 25 cm; one such example has a hole pierced near the rim. The fabric is heavy in all instances. The core of the fabric is dark gray to black, with a reddish or light brown exterior crust. The ware is tempered with crushed stone, grits, lime, and sand and has rough breaks.

Interior surfaces of bottles are untreated and rather uneven, sometimes scraped. Exterior surfaces, rims of spouts, and interior surfaces of bowls have a very characteristic surface finish, which results in a burnished irregular red/black streaked effect. Matson suggested that a pre-firing coating of some organic material had been scraped before firing (in Goldman 1956: 358–59). After firing, the entire surface was burnished, except for one example. There is some mottling; one side of a bottle turned red all over and the black is sometimes

greenish; in secondary firing, most of the surface may turn black even in the area of the red streaks. The total count of bottle fragments is about 15; there are fewer bowls, perhaps three or four.

The ware is uncommon enough to qualify as having been imported into Tarsus. There seem to be some variants made of a dark gritty fabric covered with a thick-veined, black slip and with thin, red streaks of burnished slip going obliquely down neck and shoulder. The distribution in levels is clearly in the EB II range of Tarsus, with a large number of fragments in the area of the second fortification wall, period EB II: 5–6. The safest contexts are the floors of House 103–105–107, Level 15.22–15.88, which had fragments of three bottles in Room 103, a neck fragment in Room 105, and another piece in 107 (Goldman 1956: Plan 6, fig. 263:375–76; figs. 5, 6 here).

The chronological bracket of this ware in Tarsus is therefore in the second half of EB II, the time of the second fortification wall along the south side of the town; in absolute terms probably closer to 2500 B.C. than to 2400 B.C. In Cyprus that date would

Fig. 6. Two bottle fragments, red and black streak burnished ware, Room 203 (Goldman 1956: 130, fig. 263:375, 376).

Fig. 7. Base piece of red and black streak burnish bottle, Fortification wall fill (Goldman 1956: 130, fig. 263: 377).

come near the end of Late Chalcolithic, close to the transitional, or Philia, phase. In any case, the red and black streak burnished ware belongs to a later phase at EB II Tarsus than the few samples of Red-on-White ware that seem to antedate the fortification period.

The Tarsus pieces of red and black streak burnished ware have possible affinities to Cypriot Late Chalcolithic Black Slip and Combed ware or Red and Black Stroke Burnished ware, which occurs in the shape of bowls, flasks, and jars (Peltenburg 1987: 59, 65). The shapes of the Tarsus pieces seem to belong in the Cypriot tradition, and their somewhat uncouth but vigorous character must denote a region outside of Anatolia and Syria.

What this contact in the middle of the third millennium B.C. means in terms of regional and economic interaction between Cilicia and Cyprus cannot be explained with the aid of the extant sherds. Some of the imports are containers (the bottles) and could have been brought over for their contents, either by Cypriots or by Anatolians. In either case, they do indicate some navigation to and from the island and some sharing of interests.

STRONG CYPRO-ANATOLIAN CONTACTS
BY 2500 B.C.

The third phase or aspect of Anatolian-Cypriot contact follows closely upon the ceramic phenomena just discussed and yields many reflections of Anatolian material culture on Cyprus. That happens in the transitional period from Late Chalcolithic to Early Cypriot and was first recognized at sites in the Ovgos valley such as Philia B and C and Kyra Alonia. In recent years, evidence of sites attributable to that period has increased in the west (Kissonerga-Mosphilia) and south (Sotira-Kaminoudhia).

The major change is that in this third phase Cyprus itself produces evidence of contact with Anatolia beyond the limited acquisition of an occasional piece of obsidian such as took place in Aceramic Neolithic times.

The most obvious cue comes from the ceramic repertoire of the Philia period. The pottery shapes preserved as tomb gifts evoke an unhesitating recognition of Anatolian contacts: the beaked pitcher, hallmark of southern and western Anatolian pottery of the Early Bronze Age, was adopted and adapted by Cypriot potters, along with a sensible use of handles. Cypriot Chalcolithic pottery is mostly without handles, except for some lugs and knobs. The Philia potters put loop handles on pitchers, flasks, and jars. The Cypriots can only have learned that from their Anatolian colleagues,

because the potter in the Levant was no wiser about handles than his colleagues in Egypt or Mesopotamia.

From the Philia period on, the Early Cypriot ceramic repertoire has a strong Anatolian trait, especially in its fondness for pitchers with extravagantly long beaks and combinations of shapes. Few of the Philia pitchers and none of the later variants are literal copies of Anatolian prototypes, let alone imports. Some Anatolian pottery must have found its way to Cyprus, and Cypriots must have seen and appreciated Anatolian pottery regularly. The technique of plugging the loop handle into the body of the pitcher was similar in both areas.

From the ceramic traits of the Philia phase an approximate date can be determined for the Anatolian injection of ceramic features. In Tarsus those features would be largely still in the EB II period, before the striking transformation of the ceramic repertoire in Tarsus itself, where from EB IIIA on southwestern and western Anatolian features make a strong appearance in the form of tankards, depa, wheelmade dishes, and large red polished platters. Such EB IIIA traits are totally absent from the Philia repertoire. Other material features that link the Philia phase with Anatolia are also of EB II character. For example, the spindle whorls of Philia are of biconical EB II type (Dikaios 1962: fig. 96:4). In Anatolia they can also be used as beads in conjunction with toggle pins.

Central to the issue of technical contact are types, shapes, and composition of metal objects associated with the Philia period. The Cypriot tombs of that period have yielded metal objects in greater quantity and variety than Chalcolithic tombs. For the Philia stage there are flat celts, daggers or knives of various sizes, including specimens ca. 20 cm long resembling EB II counterparts from Karataş in northern Lycia, as noted by Swiny (1986: 37–39; figs. 3.10, 24). Toggle pins make their appearance, again comparable to counterparts from EB II Karataş as well as Tarsus. Shapes of spiral earrings with flattened ends are matched at both sides. The occurrence of tin bronze for earrings and an awl at Philia is a sign of special access to Anatolian bronze (Swiny 1986: 38; fig. 3:17, 25).

The inventory of the EB II tombs at Karataş is helpful for comparison since Tarsus so far has yielded a smaller quantity of metal, principally because the cemeteries of the Early Bronze Age have not yet been found at Gözlü Kule. At Karataş

in the plain of Elmalı, west of rough Cilicia and Pamphylia, there was considerable use of lead and silver in EB II. The tombs contain silver beads, pins, bracelets, earrings, belt ornaments, and decorations of (lost) wooden handles or scepters (Mellink 1969: pl. 74:17, 18; 1970: pl. 57:16, 17).

At Tarsus there is no silver in the frugal metal collection of EB II; but lead is found from Late Chalcolithic on, and a small lead bottle fragment came from the EB II level (Goldman 1956: 303; fig. 435:11).

Provenance studies will determine the trade routes of the copper, lead, silver, and tin that are available at Tarsus and Karataş in EB II. The connection for silver and lead is likely to be with the Taurus mines and Bolkarmaden; but other sources must have come into play for tin, and especially for the much needed copper.

The Philia phenomenon, judged from an Anatolian point of view, betrays Anatolian affinities and contacts in the late EB II. Tarsus of EB II was a thriving community with a well-developed economy extending its trade relations to the Taurus mountains and the plateau, to the Amuq and northern Syria as far as the Euphrates; Tarsus could well have initiated new contacts with Cyprus to bolster its copper supplies.

The material changes in the Philia culture were first interpreted as resulting from an influx of Anatolian refugees fleeing hostile events at the beginning of EB III (Dikaios 1962: 202–3; Peltenburg 1982: 98–101). More needs to be known about the settlements and architecture in the Ovgos valley to test that hypothesis. The assemblage from the Philia tombs is mixed and selectively Anatolianizing, not Anatolian. Metallurgy was beginning to thrive and seems to have begun the development that continued in the Early Cypriot period.

An alternate interpretation of the Anatolian connection is based on the strength of the EB II contacts of Cilician centers like Tarsus, which could have drawn Cyprus—always visible as a neighbor—into the orbit of their navigation and potential trade, via the Ovgos valley, a kind of approach familiar to Cilicians with their own harbors along estuaries. The motivation would have been knowledge of copper sources in Cyprus as potential suppliers for Cilicia; contacts with Anatolian demand and knowhow could rapidly have had a stimulating effect.

Thus the Anatolian initiative could have been developed before the EB III upheavals, and as a

successful interaction with Cyprus not at the refu-
gee level but at the level of technical and economic
enterprise. Watkins (1981: 19) proposed a similar
view.

The Cypriot economy presumably took an up-
turn after the Cilician approach. It may at the
same time have changed its farming orientation by
importing cattle from Anatolia. Little is known
about the Early Bronze situation in Cilicia, but the
Karataş economy in EB II shows cattle to be more
important than sheep and goat (Hesse and Perkins
1974: 149–60).

Cyprus may have escaped the hostile events of
Anatolian EB IIIA, although recent excavations in
the west suggest destructions at the end of Late
Chalcolithic (Peltenburg 1990: 18–19). In Cilicia,

Tarsus survived the war and rebuilt its town and
economy in conjunction with a contingent of new-
comers. Its range of communication reached to the
Aegean, but its connections with Syria were not
neglected. Cyprus remained a familiar neighbor
and probably supplier, soon to be attracting atten-
tion of Aegean merchants from Crete. The Cilicians
of EB II may have been instrumental, one way or
another, in the technical and cosmopolitan course
that Cyprus was gradually taking.

ACKNOWLEDGMENT

All photographs are published by permission of Tarsus
Archives.

BIBLIOGRAPHY

de Jesus, P.
 1980 *The Development of Prehistoric Mining and
 Metallurgy in Anatolia.* BAR International
 Series 74. Oxford: British Archaeological
 Reports.
Dikaios, P.
 1962 The Stone Age. Pp. 1–204 in *Swedish Cyprus
 Expedition* IV.1.A. Lund: Swedish Cyprus
 Expedition.
Dupré, S.
 1983 *Porsuk I. La céramique de l'âge du Bronze et
 de l'âge du Fer.* Mémoire 20. Paris: Editions
 Recherche Sur les Civilisations.
Esin, U.
 1983 Zur Datierung der vorgeschichtlichen Schich-
 ten von Değirmentepe bei Malatya in der
 östlichen Türkei. Pp. 175–90 in *Beiträge zur
 Altertumskunde Kleinasiens, Festschrift für
 Kurt Bittel.* Mainz: von Zabern.
French, D. H.
 1965 Prehistoric Sites in the Göksu Valley. *Ana-
 tolian Studies* 15: 177–201.
Goldman, H.
 1956 *Excavations at Gözlü Kule Tarsus II: From
 the Neolithic through the Bronze Age.* Prince-
 ton: Princeton University.
Hawkins, J. D.
 1982 The Neo-Hittite States in Syria and Anatolia.
 Pp. 372–441 in *The Cambridge Ancient His-
 tory* III.1. Cambridge: Cambridge University.

Hesse, B., and Perkins, D.
 1974 Faunal Remains from Karataş-Semayük in
 Southwest Anatolia. *Journal of Field Archae-
 ology* 1: 149–60.
Mellink, M. J.
 1969 Excavations at Karataş-Semayük in Lycia,
 1968. *American Journal of Archaeology* 73:
 319–31.
 1970 Excavations at Karataş-Semayük and Elmalı,
 Lycia, 1969. *American Journal of Archae-
 ology* 74: 245–59.
 1989 Anatolian and Foreign Relations of Tarsus in
 the Early Bronze Age. Pp. 319–31 in *Anatolia
 and the Ancient Near East. Studies in Honor
 of Tahsin Özgüç,* eds. K. Emre, B. Hrouda,
 M. J. Mellink, N. Özgüç. Ankara: Türk Tarih
 Kurumu Basivevi.
Otten, H.
 1988 *Die Bronzetafel aus Boğazköy: Ein Staatsver-
 trag Tuthalijas IV.* Studien zu den Boğazköy-
 Texten Beiheft 1. Wiesbaden: Harrassowitz.
Özten, A.
 1989 A Group of Early Bronze Age Pottery from
 the Konya and Niğde Region. Pp. 407–18 in
 *Anatolia and the Ancient Near East. Studies
 in Honor of Tahsin Özgüç.* Ankara: Türk
 Tarih Kurumu Basimevi.
Peltenburg, E. J.
 1982 *Recent Developments in the Later Prehistory
 of Cyprus.* Studies in Mediterranean Archae-
 ology Pocket-book 16. Göteborg: Åström.

1987 A Late Prehistoric Pottery Sequence for West-
 ern Cyprus. Pp. 53–67 in *Western Cyprus:
 Connections. An Archaeological Symposium
 held at Brock University March 21–22, 1986*,
 ed. D. W. Rupp. Studies in Mediterranean
 Archaeology 77. Göteborg: Åström.

1990 Chalcolithic Cyprus. Pp. 6–22 in *Cyprus be-
 fore the Bronze Age. Art of the Chalcolithic
 Period*, by V. Karageorghis, E. J. Peltenburg,
 and P. Flourenzos. Malibu, CA: J. Paul Getty
 Museum.

Swiny, S.

1986 The Philia Culture and Its Foreign Relations.
 Pp. 29–44 in *Acts of the International Archae-
 ological Symposium "Cyprus Between the
 Orient and the Occident,"* Nicosia 8–14
 September 1985. Nicosia: Department of An-
 tiquities of Cyprus.

Watkins, T.

1981 The Chalcolithic Period in Cyprus: The Back-
 ground to Current Research. Pp. 9–20 in
 Chalcolithic Cyprus and Western Asia, ed.
 J. Reade. British Museum Occasional Paper
 26. London: British Museum.

Yakar, J.

1984 Regional and Local Schools of Metalwork in
 Early Bronze Age Anatolia. *Anatolian Stud-
 ies* 34: 59–86.

Yener, A.; Özbal, H.; Minzoni-Deroche, A.; and Aksoy, B.

1989 Bolkardağ: Archaeometallurgy Surveys in the
 Taurus Mountains, Turkey. *National Geogra-
 phic Research* 5: 477–94.

STATEMENT OF OWNERSHIP, MANAGEMENT, AND CIRCULATION, 10/1/91

Title: *Bulletin of the American Schools of Oriental Research* . Pub. No. 0003-097X. Frequency: Quarterly. Four issues published annually. Subscription price: $57.00 institutions, $42.00 individuals. Location of office of publication: The Johns Hopkins University Press, 701 W. 40th Street, Baltimore, MD 21211. Headquarters of publishers: Same. Publisher: The Johns Hopkins University Press, 701 W. 40th Street, Baltimore, MD 21211. Editor: James Flanagan, Dept. of Religion, Case Western Reserve University, Cleveland, OH 44106. Owner: The American Schools of Oriental Research, 711 W. 40th Street, Suite 354, Baltimore, MD 21211. The purpose, function, and nonprofit status of this organization and the exempt status for Federal income tax purposes have not changed during the preceding 12 months.

Extent and nature of circulation	Av. no. copies each issue preceding 12 mos.	Actual no. copies single issue pub. nearest to filing date
A. Total no. copies printed	2179	2225
B. Paid circulation, mail subscriptions	1653	1725
C. Total paid circulation	1653	1725
D. Free distribution	88	100
E. Total distribution	1741	1825
F. Copies not distributed	438	400
G. Total	2179	2225

I certify that the statements made by me above are correct and complete. Marie R. Hansen, Associate Director for Journals Publishing.

ISBN 0-89236-207-3